FRAMING THE CHURCH

FRAMING
THE CHURCH

The Social and Artistic
Power of Buttresses in
French Gothic Architecture

MAILE S. HUTTERER

The Pennsylvania State University Press
University Park, Pennsylvania

Publication of this book has been aided by a grant from the Oregon Humanities Center at the University of Oregon.

Library of Congress Cataloging-in-Publication Data

Names: Hutterer, Maile S., author.
Title: Framing the church : the social and artistic power of
 buttresses in French Gothic architecture / Maile S. Hutterer.
Description: University Park, Pennsylvania : The
 Pennsylvania State University Press, [2019] |
 Includes bibliographical references and index.
Summary: "Examines Gothic architecture and the visual and cultural
 significance of the adoption of externalized buttressing systems
 in twelfth-century France. Demonstrates how buttressing
 frames operated as sites of display, points of transition, and
 mechanisms of demarcation"—Provided by publisher.
Identifiers: LCCN 2019025600 | ISBN 9780271083445 (cloth)
Subjects: LCSH: Architecture, Gothic—France.
 | Church architecture—France.
Classification: LCC NA5543.H88 2019 | DDC 720.944—dc23
LC record available at https://lccn.loc.gov/2019025600

The Pennsylvania State University Press is a member
of the Association of University Presses.

It is the policy of The Pennsylvania State University Press
to use acid-free paper. Publications on uncoated stock
satisfy the minimum requirements of American National
Standard for Information Sciences—Permanence of Paper
for Printed Library Material, ANSI z39.48–1992.

Additional credits: title page, figure 75; page vi,
detail, figure 70; page viii, detail, figure 61.

For Mike, Matilda, and Phoebe

CONTENTS

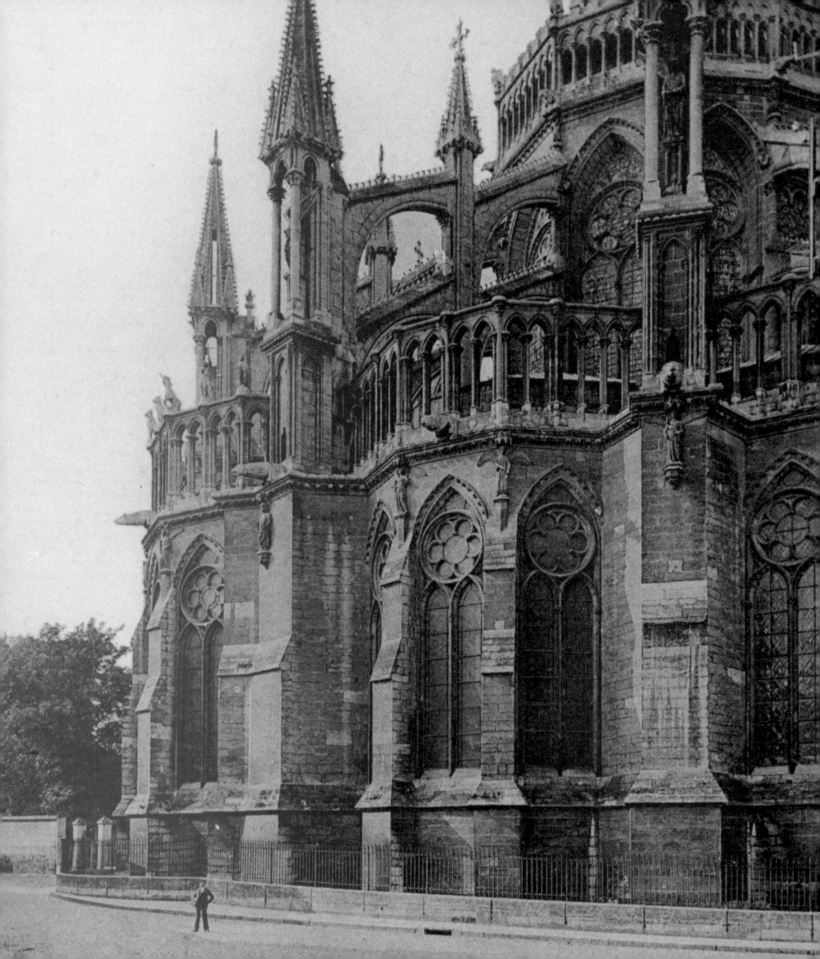

ILLUSTRATIONS

ACKNOWLEDGMENTS

My interest in Gothic buttressing began back in the early days of my graduate education. As a consequence, I have had the great fortune of receiving support and encouragement from innumerable individuals and institutions. It is a daunting task to thank adequately everyone who has contributed to this effort. I am truly humbled by all of the generosity I have been shown over the past decade or more.

I would first and foremost like to thank Marvin Tracht-enberg, my mentor and advisor, who inspired me to pursue this topic while I was a student at the Institute of Fine Arts at New York University. Marvin brought medieval buildings to life for me, and it was with his guidance that I came to see buttresses as objects of intrinsic aesthetic interest. I am especially thankful for Marvin's continued support following the completion of my doctoral work. I could not have asked for a better mentor. I am also grateful to the larger intellectual community that surrounded me while I was at the IFA. This included Jonathan J. G. Alexander, Brigitte Bedos-Rezak, and Priscilla Soucek, all of whom were a formative part of my intellectual growth. Special thanks go to Michael Davis, who also generously provided feedback and support beyond the Ph.D. Equally important were the many conversations I had with my fellow classmates in and outside of seminars. I benefited tremendously from these dialogues and am grateful for all of the things my friends and colleagues have taught me over the years.

Although this project had its genesis in my graduate work, it has changed substantially in the subsequent years. In many cases this growth is thanks to the keen observations of those who willingly read chapter drafts or listened to conference presentations. The list here includes more names than I could mention. I would like to highlight the contributions of Robert Bork, Jay Diehl, Jennifer Feltman, Jackie Jung, Donna Sadler, Ellen Shortell, Richard Sundt, Erik Thunø, and Stefaan Van Liefferinge. The anonymous reviewers of the manuscript also offered critical feedback that helped me refine my arguments. Thank you all for helping to make this book better. Ellie Goodman, my editor at the Pennsylvania State University Press, was enormously helpful and patient throughout the revising and production process, and her assistant, Hannah Herbert, always had answers to my questions. Many other individuals provided valuable feedback, words of encouragement, or intellectual community. In recognition I also thank Meredith Cohen, Keith Eggener, Erik Gustafson, Alexander Harper, Jamie Harper, Charles Lachman, Kate Mondloch, Johanna Seasonwein, Emily Spangler, Sarah Thompson, Akiko Walley, Shannon Wearing, Laura Weigert, and Carla Yanni. Christoph Linder, Brook Muller, Paul Peppis, and Roxi Thoren helped me secure institutional support from the University of Oregon, which was essential to completing the final stages of this book. I also thank my students for continuing to challenge me with unexpected questions.

I have been incredibly fortunate in terms of institutional support. A New Faculty Fellowship from the American Council of Learned Societies provided me with a reduced teaching load for two academic years in the vibrant and engaging Department of Art History at Rutgers University. Additional support for research and writing came from a Faculty Research Award from the Office of the Vice President for Research and Innovation and the Dean's Office of the School of Architecture and Allied Arts (now the College of Design) at the University of Oregon. Publication subventions came from a Kress Research and Publication Grant from the International Center of Medieval Art, the College of Design

Dean's Office, and the Oregon Humanities Center. Research for this book required access to great churches throughout northern France. I am grateful to the many deans, rectors, sacristans, and other church officers that generously allowed me to explore their buildings. I am similarly grateful to the many government offices of the French Cultural Ministry, including several offices of the Direction régionale des affaires culturelles (DRAC) and Services départementaux de l'architecture et du patrimoine (SDAP) that permitted me access to galleries, roofs, and vaults of numerous historical monuments. The representatives who patiently responded to my requests and generously escorted me through churches would fill pages. Among them are Fabienne Audebrand, Jerome Auger, Patrick Baptis, Jerome Berger, Solenne Blondet, Antony Carreras, Sabine Delanes, Jean-Claude Druesne, Lucie Evain, Annabelle Ferte, Laurence Fouqueray, Père Gilton, Jacques Guerin, Brigitte Lelièvre, Laurence Magnus, Frédéric Masviel, Mme Merceron, Père Olleir, Jean-Marc Pierrat, Fabrice Ply, Jack Proutheau, Louis Robiche, Hélène Schney, and Jacques de Vannoise. My work could not have been completed without the assistance of these individuals and institutions. Librarians, archivists, and the staff of reproductions and photography departments at the Bibliothèque nationale de France, Archives nationales de France, British Library, Morgan Library & Museum, Médiathèque de l'architecture et du patrimoine, Archives de l'Aube, Archives de la Marne, Archives de Paris, Bibliothèque municipale de Reims, Bibliothèque municipale de Rouen, Bayeux Museum, Musée de la ville de Poitiers, and New York Public Library also contributed to this book.

Finally, I thank my family, my ultimate inspiration and most valued support: Nancy, Karl, Kate, Matilda, Phoebe, Joe, and Jan. The person to whom I owe the most is undoubtedly my husband. Mike, without you this book would never have come into being. You have read every word of it (multiple times) and talked with me about every permutation that my argument has taken over the years. You have been my intellectual partner in this journey, and its completion is as much your success as it is mine.

All writing is the result of collaboration, and I am privileged that this project has benefited from the support of so many of my colleagues and friends. The mistakes that remain are my own. I ask the reader's forgiveness for them.

Note on the Fire at the Cathedral of Notre-Dame, Paris, 2019

On April 15, 2019, the Cathedral of Notre-Dame in Paris suffered a devastating fire. Like many, I spent most of the day following the increasingly dire reports about the fire's spread. The losses, which included medieval timbers supporting the roof, Viollet-le-Duc's spire, and potentially some of the stained glass, are heartbreaking. However, the fire also demonstrated the strength of the cathedral's construction: the stone vaults and the exterior walls, supported by the flying buttresses, largely survived. Ultimately, the strength of the medieval construction—as fascinating now as it was innovative in its own time—protected the church, the façade, and many of the cathedral's treasures. At the time of writing, critical stabilization work is ongoing and plans to restore the cathedral are underway. The course that these restorations will take is not yet clear, but I am optimistic about the cathedral's preservation, despite damages more severe than it had ever suffered in the past.

As a scholar who is primarily interested in the interaction between buildings and people, this most recent event demonstrated the many ways in which Notre-Dame continues to hold value. It is a historical monument of world heritage, but it also continues to play a role in daily life and the experience of the city. It is just as vibrant a node of social interaction now as it was eight hundred years ago. This book is primarily about these very notions of perception, value, and interaction in the space of the medieval cathedral. Amidst the horror of the fire, it was the collective response to Notre-Dame as a monument that demonstrates the continued need for a deeper understanding of the buildings, past and present, and the way in which people experience them.

April 29, 2019
Eugene, Oregon

INTRODUCTION

FEW VISITORS TO PARIS LEAVE the city without stopping on the Pont de la Tournelle to admire the chevet of Notre-Dame (fig. 1). This view of the cathedral rising from the Île de la Cité is among the city's iconic vistas. Its distinctiveness derives in large part from the drama produced by the cathedral's flying buttresses, which project dynamically from the clerestory and gallery walls. These long spindly arches, reminiscent of spiders' legs, enliven the cathedral's east end.[1] They rest on massive masonry slabs, the freestanding portions of which extend above the chapel and aisle roofs. The enormous bulk of these vertical piers resists the thrust generated by the cathedral's vaults, transferred to them by the flyer arches.[2] The visual effect is both powerful and theatrical, even for those who may not understand the tectonics of the cathedral's buttressing.

The dramatic single-sweep arches and towering vertical supports of Paris Cathedral create a largely externalized support system, what Stephen Murray has referred to as its "exterior space frame."[3] In his article on Notre-Dame's buttressing, Murray explores how the cathedral's new peripheral infrastructure anticipated a radically new structural arrangement in which heavy stone vaults appear to be supported on slender interior columns. The rigid structure of the buttress frame at once facilitated and transformed an earlier architectural paradigm of load-bearing walls and internal supports.[4] The present book takes up the concept of buttresses as frame

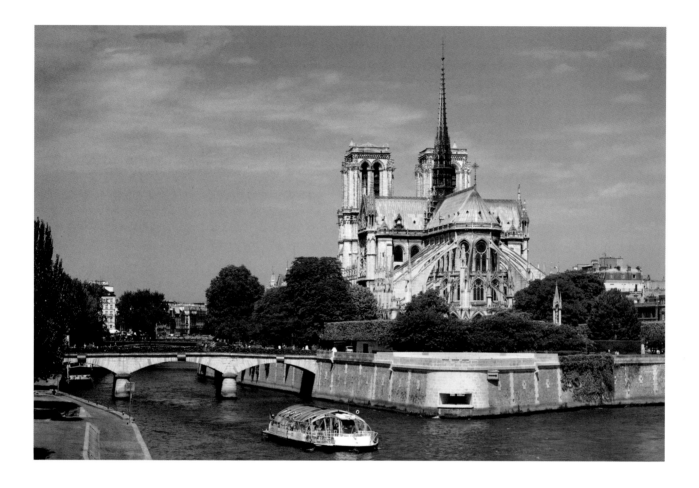

FIGURE 1
Paris Cathedral, view from the Pont de la Tournelle. Photo:
Wikimedia Commons (Joe deSousa). Licensed under CC0 1.0.

to explore how the multifunctionality of frames might apply to Gothic ecclesiastical architecture. I explore the relationships of buttressing frames to the buildings they encircle and the church surroundings they exclude—how they operated as sites of display and ornament, points of transition, and mechanisms of isolation.

The buttressing-frame system's fracturing of the closed envelope violated traditional architectural composition as practiced since antiquity (exemplified in fig. 5). Marvin Trachtenberg has argued that externalized buttressing was part of a new historical consciousness more interested in modernism and innovation than in historicism.[5] In both Roman and Romanesque construction, builders largely concealed structural supports within and behind walls. Where they extended outward from the wall in the form of spur buttresses or corbel tables, their projection represented only a fraction of the wall's thickness. The revelation of the previously internalized buttressing apparatus resulted in a form of structural exhibitionism.[6] Over the course of the later twelfth and early thirteenth centuries, what had once been a relatively planar exterior

FIGURE 2
Mantes-la-Jolie, Notre-Dame, view of the chevet. Photo: author.

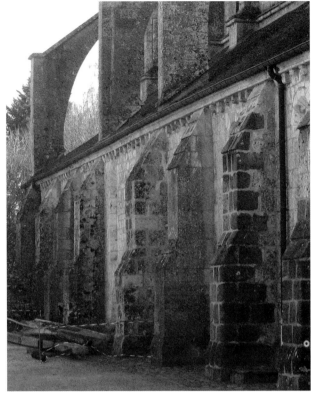

FIGURE 3
Voulton, Notre-Dame, view of the north façade, showing separation between buttress piers and buttress uprights that support the flyers. Photo: author.

with subdued vertical accents became a dynamic, three-dimensional choreography of void and solid, light and shadow, that endowed the outer shape of the church with increased plasticity and drama.[7] The incorporation of the explanatory support language of the column in many early flying-buttress systems demonstrates the radical nature of this transformation.[8]

The disjointing of the building edge is most potent where the entire buttressing system (pier, upright, and flyer) is exposed. Within the first several decades of flying-buttress use, numerous buildings overtly displayed their buttresses in this way. The example of the collegiate church of Mantes-la-Jolie (ca. 1175; fig. 2) illustrates this phenomenon.[9] Here the flyer, buttress upright, and buttress pier form a continuous masonry assemblage that punctuates the building's outline in their projection of mass out from the building's enclosing walls. In other early cases the buttress pier and buttress upright were visually or functionally separate from each other, as at Notre-Dame in Voulton (ca. 1160; fig. 3).[10] In this pattern, largely abandoned by the thirteenth century, the sense of fracture is most profound above the level of the aisle roof, where the mass of the buttressing is largely independent of the rest of the structure. Among the twelfth-century

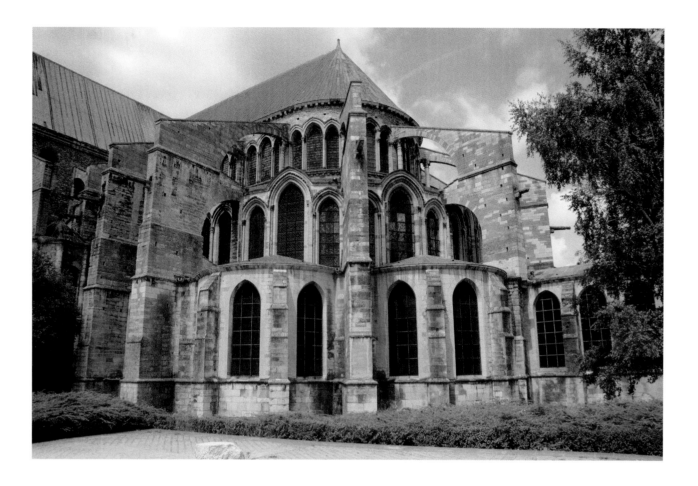

FIGURE 4
Reims, Saint-Remi, view of the chevet. Photo: author.

iterations, the flying buttresses of the chevet of Saint-Remi in Reims (ca. 1170–85) preserve particularly profound instances of outline disruption (fig. 4).[11] In this example, the extension of the buttress upright throughout two levels emphasizes its presence on the exterior and heightens its interrupting effect.

Some of the most substantial projections of exposed buttressing came in the major cathedrals constructed in the thirteenth century. Paris Cathedral, in particular, may have been a major force in the widespread adoption and acceptance of flying buttresses throughout northern France. The sheer size of Paris Cathedral, especially the height and span of its nave vaults, required substantial supports. The buttress piers of the nave projected from the outer aisle wall more than five meters—a stark departure from the comparatively modest protuberances of buttresses at buildings like Saint-Étienne in Beauvais (fig. 5).[12]

The construction of chantry chapels, first initiated at Paris shortly after 1228, reestablished the self-contained wall along the lower story of most churches.[13] However, the undulating rhythm of the exposed structural system remained a paradigmatic feature above the level of the aisle roofs. Even where the buttress pier is hidden, the uprights and flyers continue to act as an architectural

frame. The visual prominence of flying buttresses continued well into the French Renaissance. The church of Saint-Eustache in Paris, completed only in 1632, is only one of numerous examples from the late sixteenth and early seventeenth centuries (see fig. 92).[14] Although the articulation of these buttresses reflects the contemporaneous interest in Italianate neoclassicism (for example, in the use of Ionic columns as supports under the flyer heads), the forceful projection from the clerestory wall into the exterior space around the church remains unchanged. The sheer longevity of flying buttresses underscores their significance as an intermediary point of juncture. By the sixteenth and seventeenth centuries, externalized buttressing systems would likely have functioned as clear indicators of an easily recognizable ecclesiastical typology, even if their primary role was one of structural support.

Flying buttresses are a common and impressive feature of many great churches that employ a skeletal structural system in the French royal domain.[15] They are arguably the most spectacular manifestation of a shift toward externalized support. However, even within the limited geographic scope of this book, no single structural solution was omnipresent. As the example of the thirteenth-century Sainte-Chapelle demonstrates, flying buttresses are not an essential component of this larger trend (fig. 6). Even in the absence of flyers, the prominently projecting buttress piers of this building create a similarly peripheral infrastructure. Moreover, as Murray has argued for Notre-Dame, any use of exterior flying buttresses anticipates supporting piers, even in those cases where the visibility of the piers is minimized.[16] Thus, buttress piers and uprights are an integral part of what I refer to as the "buttressing-frame system."

For much of the twentieth century, scholars adhered to the position, championed by Eugène Lefèvre-Pontalis in 1919, that the architect of the nave of Paris Cathedral invented flying buttresses at the beginning of the

FIGURE 5
Beauvais, Saint-Étienne, view of the nave exterior. Photo: author.

thirteenth century.[17] Serious reevaluation of Lefèvre-Pontalis's thesis began in 1976, and the scholarly consensus now recognizes that they appeared at least by the mid-twelfth century somewhere in or around the area of Paris.[18] The site of their "invention" in France remains contested, largely because so many of the proposed buildings are destroyed or have undergone extensive restorations. Nevertheless, the scholarship of the past several decades has firmly established that flying buttresses were in use in northern France by the 1150s. Some of the early sites where builders experimented with them include Sens Cathedral,[19] the church of Saint-Germain-des-Prés in Paris,[20] and the church of Sainte-Marie-Madeleine in Domont.[21] In one of the early studies to rebuke Lefèvre-Pontalis for his dismissal of flying buttresses before 1200, Jacques Henriet made a case for their presence at the church of

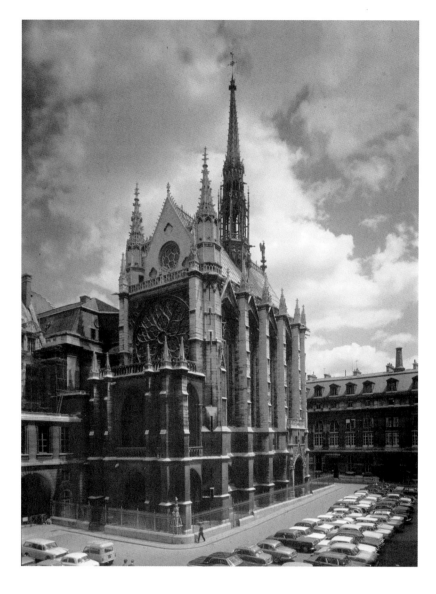

FIGURE 6
Paris, Sainte-Chapelle, exterior view. Photo:
Scala / Art Resource, New York.

Saint-Martin in Étampes, although Andrew Tallon has subsequently reappraised this hypothesis.[22] Mid-twelfth-century flying buttresses may also have been present at the churches of Saint-Maclou in Pontoise,[23] Saint-Laumer in Blois,[24] and Sainte-Madeleine in Châteaudun.[25] While most scholars have focused on the Paris basin as the origin of flying buttresses, some have posited that they were used earlier in Burgundy, Italy, or Byzantium.

The question of whether medieval French or Burgundian masons employed flying buttresses before the 1150s remains open. Scholars continue to debate the possibility of flying buttresses in Abbot Suger's chevet of Saint-Denis, which would push their use back to around 1140.[26] Arnaud Timbert has proposed that flying buttresses were used at Sainte-Marie-Madeleine in Vézelay as early as the 1130s.[27] Following Kenneth Conant, he has also argued

that the great Burgundian abbey church of Cluny III employed flying buttresses, presumably installed after a partial collapse in 1126.[28] Anne Baud and Andrew Tallon have separately suggested that the Cluny III flyers were added later, Tallon plausibly suggesting that their addition could have been as late as the sixteenth century.[29] In summary, while it is possible that flying buttresses were used before the 1150s, the evidence unearthed thus far is difficult to interpret. Scholarship has not yet conclusively demonstrated that they were employed in Burgundian Romanesque structures in the 1120s and 1130s. Finally, some scholars have suggested that flying buttresses appeared even earlier at San Lorenzo in Milan or Hagia Sophia in Constantinople.[30] However, these would be isolated instances, distinct from the development of a widely used architectural paradigm.

While the evidence for the earliest use of flying buttresses in France remains inconclusive, this renewed attention to the buttressing of mid-twelfth-century churches has revealed the extraordinary creativity of contemporaneous masonry practice.[31] Tallon, in particular, has noted that flying buttresses were not the inevitable result of construction based on the rib vault and pointed arch but rather one potential solution among many explored by masons.[32] Moreover, while the proposed date of flying-buttress origins has been pushed back to around the middle of the twelfth century, we now know that it took several decades for the form to gain the widespread acceptance it eventually achieved in France.[33] Finally, this wave of scholarship has refined our understanding of early flying-buttress forms. For example, Robert Mark, Jacques Heyman, Rowland Mainstone, Maria Nikolinakou, and Andrew Tallon have explored how the shape and placement of flying buttresses and the use of pinnacles affect the structural efficiency of buttressing-frame systems.[34] In addition, thanks to the work of Stephen Murray, it is now clear that the twelfth-century buttressing of Notre-Dame's chevet was similar to the rebuilt buttressing designed by Jean-Baptiste-Antoine

Lassus and Eugène-Emmanuel Viollet-le-Duc in the nineteenth century—a testament to the skill and daring of medieval builders and to the experimental nature of church construction in the mid-twelfth century.[35]

The buttresses of buildings like Paris Cathedral rarely fail to impress modern spectators, but it is less clear what power they may have held for their medieval audiences, whether ecclesiastical patrons or casual lay observers. Their size, ornamentation, expense, and visibility suggest their importance to the cathedral, but the degree and nature of their aesthetic and cultural significance for medieval viewers can be explored further. Buttressing-frame systems were fundamental and transformative components of late medieval church architecture in northern France. A contextual understanding of these structural frames enhances our comprehension of their artistic, social, and iconographic ramifications for ecclesiastical architecture and its changes over the course of the Middle Ages. Many architectural components—including columns, galleries, and screens—have been the subject of concentrated historical studies that consider their form, decoration, meaning, and/or social use.[36] However, despite the long-recognized importance of flying buttresses as distinctive, and visually impressive, components of Gothic architecture, there is much yet to learn about these aspects of buttresses.[37]

The past several decades have been an exciting time for the study of masonry structure and medieval buttressing. Modern advances in measuring and modeling techniques have paved the way for innovative approaches to the study of medieval architecture, including many of the publications cited above. The present book complements this discourse. Focused on buttresses as sites of social action and display, it assumes the fundamental structural role of buttresses but does not take this aspect of their design as its principal subject. My own interests lie primarily in how architecture reflects, shapes, and influences social processes. This study is my attempt to

add to an understanding of buttresses' multifunctionalism through an exploration that prioritizes their social and visual significances as points of transition.[38] In the following chapters I probe the extrastructural roles of buttresses in high and late medieval France, offering some thoughts on the importance of aesthetics, symbolism, and meaning in buttress design.

TOWARD A CULTURAL INTERPRETATION OF BUTTRESSING IN GOTHIC FRANCE

This study focuses on buttressing-frame systems as visual and cultural objects. It considers a variety of case studies, mostly within the French royal domain, in relation to broader cultural and historical trends. Drawing on select examples spanning approximately five hundred years, I argue for buttressing's relevance in shaping individual architectural projects, defining the limits of church space, and signifying the Universal Church through its constructed manifestation. Underlying all of these propositions is the assumption that medieval society recognized and exploited buttressing for its structural advantages but also for reasons beyond this utilitarian functionality. Although French masons employed many variations of the theme, flying-buttress systems typically followed the same general pattern of an exposed arch topped with a sloped coping, together supported by a massive vertical assemblage. The consistency of this formula within the royal domain and its nearly exclusive use on church architecture made it a potent signifier of architectural typology even as it redefined the margins of that type.

In the Middle Ages, the built church was a commanding symbol of the power of the institution and its role in the biblical history of salvation. The awesome size of thirteenth-century cathedrals reflected contemporaneous economic growth, which increased the resources available to ecclesiastical and lay donors.[39] At the same time,

building programs could underscore the economic and political authority of chapters over the townspeople.[40] These claims derived in part from the spiritual privileges of the institution, which mediated between the heavenly and earthly realms for the faithful. The early Christian theologian Saint Augustine (354–430) viewed the built church as a mechanism through which one could access the house of God. As such, every element of the building, from its pavement to its beams and roof tiles, was open to interpretation as part of the larger message of salvation.[41] Liturgical handbooks of the twelfth and thirteenth centuries developed this theory of signs to an almost encyclopedic extent, although they curiously omit direct references to buttressing.[42]

I argue that buttresses were part of these intertwined messages of terrestrial authority and spiritual salvation, not only physically facilitating the overwhelming height of the period's largest buildings but also constituting some of their most readily visible exterior components. The open envelope of externalized, independent arches and forcefully projecting piers suggested the miraculous structure of divine architecture. These associations continued to have relevance well into the early French Renaissance, when ecclesiastical architecture continued to use flying buttresses despite a growing interest in Italianate neoclassicism. The symbolic value of buttressing-frame systems as markers of divine space, as may have been true for the Gothic style in general by the mid-fifteenth century, helps explain their continued use.[43] The verticality of the buttress piers constructs imposing perimeters evocative of fortified structures. At the same time, they create pockets of space that chapters exploited to increase revenues and demonstrate their spiritual or juridical authority.

The connection between buttresses and spiritual salvation is further strengthened by the examination of buttress sculpture. A wide range of decorative elements, from carved moldings to fanciful grotesques to monumental figural sculpture, enliven many flying buttresses and their

supporting piers. Much of this decoration remains largely unexplored, in contrast to the portal sculpture of the same buildings, the subject of numerous studies.[44] In many cases the iconography of buttress sculpture has yet to be identified, a problem compounded by the poor condition of figures that have received less regular restoration and fewer protection measures than their counterparts around portals. Moreover, the iconographical connection between the sculptures and their architectural context remains unknown. I suggest that the sculpture attached to Gothic buttressing reinforced many of the same themes of authority and salvation manifested in the architecture and the metaphorical reading thereof.

The aesthetic effects of Gothic buttresses have been the subject of critical inquiry since at least the seventeenth century. For some critics, the flyers' characteristics of verticality, projection, and diagonality epitomized the style's supposedly monstrous character. The English architect Christopher Wren (1632–1723) writes, "Oblique positions are discord to the eye, unless answered in pairs, as in the sides of an equicural [sic] triangle; therefore Gothick buttresses are ill favoured, and were avoided by the ancients."[45] For others, these same characteristics signaled the distinctive quality of Gothic invention, dynamism, or logic. The architect and theorist Viollet-le-Duc's concept of structural rationalism, arguably one of the most influential theories of Gothic architecture, postulated that structural function was the driving force behind design and that the Gothic style resulted from a rational logic of construction—"the manifestation of an ideal based on a principle."[46] For Viollet-le-Duc, the externality of flying buttresses expressed their purpose. In his *Dictionnaire raisonné*, he describes them as the logical expression of a point-support system, in which builders retained only the essential slices of what had been a continuous half barrel vault: the arches at the bay divisions.[47] He further argues that by eliminating the extraneous portions of this earlier support system, builders achieved the "most frank

and most energetic expression of the mode adopted by builders of the Middle Ages."[48] The rhythmic outward projections of the buttressing thus provide a key element in his idea of Gothic functionalism.

Twentieth-century scholars likewise considered the aesthetic effects of buttressing in their analysis of Gothic style. One of the most vivid descriptions appears in Paul Frankl's *Gothic Architecture*, first published in 1962, in which Frankl characterizes the Gothic architectural experience as one of optical diagonality.[49] Frankl's emphasis on the oblique angle appears in the section of the book devoted to the development of flying buttresses:

> The flying buttresses turn their flanks towards us and create an intermediate zone of uncertain boundaries which is not exclusively a part of the exterior, but rather a continuation of the interior. Whether the sun or the moon shines, and casts the shadows of the buttresses on to the roofs and the walls; or whether there is snow or mist moving between them and the walls; or whether the weather is gloomy or the light fails, the exact outline of the building can never be traced. The side views of Romanesque churches are wonderfully closed: those of Gothic churches are wonderfully open.[50]

In this passage, Frankl describes the buttressing zone as a third, amorphous space, neither in nor out, which surrounds the building and marks its edges even while rendering the building accessible to its surroundings. Buttresses are, in effect, a new type of frame that Frankl juxtaposes with the closed volumes common to the churches of the eleventh and early twelfth centuries. He further argues that flying buttresses were a "welcome addition to the store of Gothic forms" that "unite[d] the interior and exterior into an organic whole."[51]

Jean Bony also discussed flying buttresses as a means of connecting the exterior to the interior. In *French Gothic*

Architecture of the 12th and 13th Centuries, he writes that flying buttresses "developed into one of the dominant elements in the organization of Gothic structures, systematically applied and particularly striking visually for the way in which [they] imprinted on the exterior of the building with the greatest immediacy the repetitive pattern of the bays."[52] Later, in his description of Chartres Cathedral, he observes that the buttress uprights "insistently bar the interior elevation" and that the flying buttresses "cut deep into the exterior space itself and do so even more vigorously than the corresponding bay divisions in the interior."[53] The design of the Chartres buttresses is fully integrated into the building's larger organizational system of narrow bays and verticality, a system that Bony juxtaposes to the refined lines and spatial unity he describes at Bourges.[54]

Perhaps the study that most explicitly addresses the aesthetics of flying buttresses is the article co-authored by Robert Bork, Robert Mark, and Stephen Murray on the openwork flyer, a flying buttress in which tracery panels replace the coursed masonry between the upper and lower limits of the buttressing arch.[55] They suggest that such a lightweight design may have been necessary within the context of the fragile superstructures of buildings like Auxerre Cathedral and the collegiate church of Saint-Quentin.[56] However, structural concerns fail to explain the introduction of openwork flyers at Amiens Cathedral by its third master mason, Renaud de Cormont. The authors posit that aesthetics and symbolism lay behind this change instead. They champion the virtues of the openwork flyer's enticing lacy effects, which they argue medieval masons pursued out of a desire to achieve structural systems that were both functional and decorative.[57] The aesthetic advantages of the openwork design at Amiens testify to the powerful visual effects of buttressing-frame systems.

As this heavily abbreviated historiography makes clear, there is nothing revolutionary in the idea that buttresses operate both structurally and visually. However, I would argue that there is much yet to say about medieval buttressing. For example, it is still unclear how masons balanced aesthetic concerns with structural ones and how frequently they vied with one another. There is also the largely unanswered question of sculptural decoration, which introduces monumental and small-scale figural decoration (and its accompanying iconographical meanings) to buttressing systems. This sculpture would have informed the medieval audience's visual experience of buttressing as much as any other aspect of its masonry, even though it provided no structural utility. Viollet-le-Duc suggested that the incorporation of sculpture minimized the contrast between the solidity of the buttresses and the lightness of the fenestration.[58] While true, this explanation ignores the sculpture's meaning and deprives it of agency. Beyond the aesthetic significances lies the related question of the connection between buttressing and ecclesiastical space. The frequent representation of buttressing as an architectural motif underscores its importance in the medieval landscape. One way to gain an understanding of the medieval fascination with buttressing is to explore its representation on a smaller scale in so-called microarchitecture—that is, objects on a smaller scale that replicate the forms of monumental structures. The scholarly exploration of microarchitecture and architectural frames has yielded a wealth of examples in varied media that demonstrate the richness of microarchitecture as a subject of inquiry.[59]

It is admittedly unorthodox to discuss a structural element in the absence of structural analysis. However, just as astronomers observe the solar atmosphere by blocking out the direct view of the sun itself, the extrication of buttressing from structural concerns best permits a broader social analysis of buttresses and their spaces, which is the primary aim of this project.[60] Because buttressing is by definition a support, the consideration of structure almost demands a prioritization of the structural over the social

and the aesthetic. This hierarchy appears in many modern studies. For example, immediately after describing flying buttresses as visually striking, Bony goes on to say that "however far-ranging the aesthetic consequences which were to be derived from this whole-hearted acceptance of the new mode of buttressing, it was not on aesthetic grounds that the flying buttress won its new eminence: it had won its place in the minds of Gothic builders on its value as a powerful device of engineering."[61] This statement, however accurate it may be, stands in tension with Bony's assessment of the aesthetic importance of buttressing in the formation of a new architectural mode. My own interest in the aesthetic and social significances of Gothic buttresses is best served by excluding structural analysis to avoid this friction. At the same time, it is important to recognize the artificiality of the structure-versus-aesthetics binary. Structure is not an end in itself but a tool that facilitates aesthetic effects, including the large clerestory windows of Gothic churches and the dynamic exoskeleton at the heart of the present book.

A BRIEF NOTE ON TERMINOLOGY

This book has as its primary subject the externalized support systems popular in ecclesiastical architecture from the mid-twelfth to the sixteenth century in the French royal domain. In this region the structural exoskeleton of great churches frequently took the form of flying buttresses supported by massive vertical piers. Problematically, no English or French word encompasses the entirety of this system.[62] The English term "flying buttress" and the French equivalent *arc-boutant* (literally, "buttressing arch") refer to the arch that transmits the thrust of the main vault from the outer wall of the church to the pier.[63] The pier itself is linguistically divided into the buttress upright (*culée*, the portion of the support that rises independently above the aisle or ambulatory roofs)

and the buttress pier (*contrefort*, the part of the support that abuts the building's outer wall).[64] The English terms "buttress pier" and "buttress upright" can be cumbersome in their repetition of "buttress," leading some to drop the word and refer simply to the pier and the upright. This repetition, however, has the advantage of making clear the physical link between these two components, which in fact very often combine to form a single towerlike assemblage.[65]

I consider flying buttresses and their supporting piers (i.e., buttress uprights plus buttress piers) as linked parts of a larger structural scheme. After all, it is not just flyer arches that create Frankl's "intermediate zone of uncertain boundaries" or Murray's "exterior space frame" but also the forceful projection of the piers on which they rest. The term "buttressing-frame system" encompasses the entire externalized buttressing assemblage of a building. Where it is necessary to single out the flyer from its attached pier, I use the term "flyer" or "flyer arch" to clarify that I am referring to this component alone. Similarly, "buttress upright" (or simply "upright") specifically references the part of the pier support that rises above the level of the aisle roof, and "buttress pier" refers to the attached portion of the pier below. "Supporting pier" and "flyer support" refer to the pillar in its entirety.

GEOGRAPHIC AND CHRONOLOGICAL SCOPE

Since this project is thematic rather than monographic, it draws on a variety of examples to piece together an image of the significance of Gothic buttresses for their medieval audiences. Although the book incorporates a variety of case studies, none should be taken as necessarily universal or comprehensive. Far from being an exhaustive account of buttressing in Gothic France, what follows is an exposition of select examples chosen because they exemplify an aspect of buttress use, design, or meaning. Even through

my analysis is limited to a fraction of the possible case studies, the chronological and geographic scope allows me to investigate synchronic and diachronic trends—something that is more difficult within the constraints of single-building studies.

I focus on buttressing-frame systems in France, defined here as the French royal domain. Consequently, my subject is limited to a relatively narrow group of buildings and geographic area. Some additional examples come from regions tied geographically, politically, or culturally to the royal domain. To some extent any decision about where to limit a project's scope is artificial. That said, my choice to focus on the royal domain is informed by the history and historiography of flying buttresses. Although they may have appeared in Constantinople and Milan before their appearance in France, these would have been exceptional cases, likely generated by a symbolic association with Constantinian architecture.[66] In contrast, the experiments with architectural structure in and around twelfth-century Paris demonstrate a concentrated and sustained interest in buttressing solutions and the formation of a new type of architecture linked to externalized structure. In addition, the full exploitation of the structural implications of flying buttresses can be located in France, arguably at Notre-Dame in Paris, as can the first aestheticization of the flying buttress, perhaps at Sainte-Marie-Madeleine in Domont, although scholars have traditionally cited Chartres Cathedral.[67] Buttressing-frame systems were by no means unique to northern France. However, the prevalence of flyers in the royal domain helped shape their social context and may have amplified their meaning.

My decision to focus on the royal domain has the pitfall of potentially reinforcing the erroneous idea that its buildings should define the standards by which all other Gothic churches are measured. This is not my intention. I would argue that because buttressing patterns in other regions of Europe varied, they warrant their own aesthetic

and contextual analyses. It is a common observation, for example, that English buildings do not display the same systematic use of flying buttresses typical of buildings from the royal domain. In England flying buttresses were applied more irregularly, as in the nave at Salisbury Cathedral, where flyers appear at some bay divisions but not others. Similarly, the greater popularity of the hall church, which does not require extensive external buttressing, in the Holy Roman Empire suggests that different cultural forces may have been at work. Here, and perhaps elsewhere, the choice to employ an externalized space frame may have been partly sociological in distinguishing between parish churches and cathedrals. In light of these variations to buttressing forms and their applications, it strikes me as prudent to limit my geographic scope. There is no reason to assume that these disparate buttressing patterns carried a uniform meaning, although that too remains a possibility. The conclusions I reach here are not intended to represent a "normal" interpretation of Gothic buttressing. Only additional research will determine the degree to which they apply to sites where masons or patrons consciously imported all or part of the paradigm of the royal domain. A more complete assessment of the aesthetics and iconography of buttresses remains to be determined.

The boundaries of the French royal domain were not static throughout the medieval period. To the contrary, they fluctuated a great deal between the second half of the twelfth century and the middle of the seventeenth century. In the twelfth century the domain comprised few lands outside of the Île-de-France, although one could argue that it included the regalian bishoprics of Reims, Orleans, and Soissons.[68] Despite the limited range of direct royal control, the reach of royal power in the twelfth century extended to areas heavily linked to the French royal orbit. These regions included the Blois-Chartrain, Champagne, and Brie, all of which were controlled by the Count of Champagne, an important

vassal of the king of France in the twelfth and thirteenth centuries. The counts of Champagne broke fealty to the king of France only once, briefly swearing fealty to the Duke of Burgundy instead.[69] In 1284 these lands passed to the French Crown when Jeanne, daughter of the last Count of Champagne, Henri I de Navarre (also known as Henri III de Champagne), married Philippe IV le Bel, the future king of France.[70] Also linked to the French royal orbit in the twelfth and thirteenth centuries is the area of Picardy, a region to the north of Paris. At this time Picardy itself was a contested border region between the French royal domain and the lands of the Count of Flanders. As Picardy was the southernmost part of this contested region, it was frequently occupied by the king of France and often under his control via marriage alliances or as the patrimony of a cadet branch of the Capetian royal house.

In these formative years for the development of buttressing-frame systems, the influence of French royal power in this region was felt most heavily in the Vermandois, Artois, Hainault, and Amiénois.[71] In contrast, the Maine, Touraine, and Poitevin parts of the counties of Anjou and Poitou were more closely linked to the political and cultural influence of the dukes of Aquitaine and the Angevin kings of England. Likewise, the northern reaches of the county of Flanders and the continental territories of the king of England in Normandy remained culturally distinct from the more southern parts of the Seine basin. This separation was perhaps due in part to the dominance of the Count of Champagne in royal affairs. However, in Normandy—and in southern Normandy near the Vexin in particular—many church designs were heavily influenced by their proximity to the French royal domain, which produced common patronage and familial ties among both church officials and their lay supporters, despite the nearly continuous warfare between the English and French Crowns. Although this study focuses primarily on the north and northeast of France, I occasionally draw on examples from outside that geographic range. Where I do, in such examples as the cathedral of Saint-Just-et-Saint-Pasteur in Narbonne and the cathedral of Saint-Julien in Le Mans, the cases generally represent a deliberate adoption of church patterns more typical of the royal domain and/or have other cultural or political connections to the kingdom of France.[72]

The bulk of the case studies explored below come from the thirteenth century, although the book also considers select examples from earlier and later periods. The chronological range spans the twelfth to the sixteenth centuries. Admittedly, with such a long chronological scope, the examples cannot support any in-depth exploration of these earlier and later periods, since the political climate was obviously very different. However, this long lens permits examination of change over time. Most studies of buttresses focus specifically on buildings of the twelfth and thirteenth centuries, whereas buttresses of the later Middle Ages and early French Renaissance have received much less attention. In extending the chronological scope, it is possible to integrate the study of later buttresses into the larger narrative. This approach highlights the fact that buttressing-frame systems continued to be part of new church designs well into the reign of François I (1515–47). This longevity speaks to the importance of buttressing and provides essential information for understanding how they operated as visual components of ecclesiastical architecture. The noticeable differences between the buttresses of Bourges Cathedral (fig. 7) and those of Saint-Madeleine in Montargis (fig. 8) demonstrate that the integrative study of Gothic buttressing over time enhances our understanding of their aesthetic significance. Whereas the slender flyers of Bourges descend on a steep slope, giving the impression of straight struts, those at Montargis employ an elaborate neo-antique vocabulary and take the form of half triumphal arches.[73]

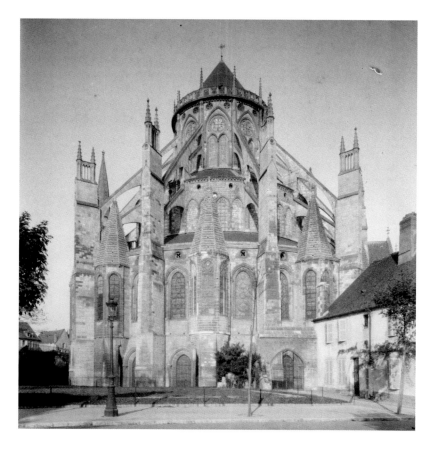

FIGURE 7
Bourges Cathedral, view of the chevet from the east; pinnacles added to buttress uprights in the nineteenth century. Médiathèque de l'architecture et du patrimoine, Charenton-le-Pont, France, inv. DNX11121. Photo: Henri Deneux, 1928 © Ministère de la Culture / Médiathèque du Patrimoine, Dist. RMN-Grand Palais / Art Resource, New York.

CHAPTER OUTLINE

The book is divided into four chapters, each concerned with a different aspect of buttressing-frame systems in medieval France, beginning with a consideration of buttress aesthetics in chapter 1. The first half of this chapter presents three case studies in which buttresses complement or enhance a building's visual effects. Analysis of the openwork flyers of the sixteenth-century church of Saint-Jean-au-Marché in Troyes builds on earlier scholarship to highlight the prevalence with which designers were willing to risk structural stability to achieve a desired look. Similarly, precarious designs were repeated with surprising frequency for centuries. Further, case studies of Saint-Urbain in Troyes and the cathedral of Saint-Julien in Le

Mans demonstrate how buttress design could epitomize and project a mason's individual architectural style. These examples develop existing ideas about the multifunctionality of buttressing in Gothic construction, like those of Frankl, Bony, Bork, Mark, and Murray, discussed above. My aim is to highlight instances where aesthetics were fundamental to buttress design and to show that this balance of the visual and structural occurred with some regularity. This idea may be familiar to specialists of Gothic architecture, but it bears emphasis here as a launching point for a study of buttressing's extrastructural significances.

The chapter concludes by looking at buttressing as an architectural motif in microarchitecture and architectural frames. This analysis highlights the cross-media use of buttresses as framing devices for delimiting and

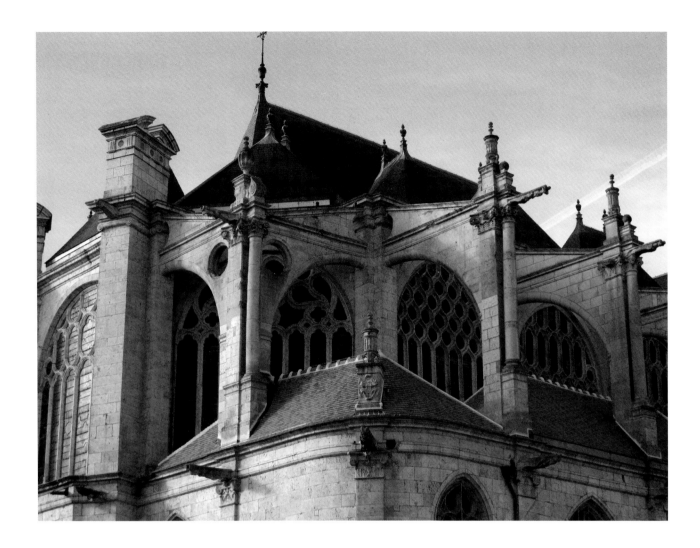

FIGURE 8
Montargis, Sainte-Madeleine, view of the chevet. Photo: author.

organizing space. I argue that the peripheral location of buttresses on large- and small-scale works places them in a space of transition between viewer and object, a situation of topographical relationship that scholars often identify as a margin. Consequently, I suggest that conceiving of buttresses as architectural marginalia is a useful lens for understanding the many ways that buttresses physically, visually, and symbolically reinforce the larger building of which they are a part.

In adopting the externalized structure of buttressing-frame systems, medieval masons redefined not only the optics of church perimeters but also their topography. The buttress piers that ultimately supported flyer arches extended well beyond the cathedral's exterior walls and framed sizable pockets of space along the building's edges. The second chapter considers how ecclesiastical communities governed these buttress interstices, which were unintended consequences of the redesign of church

structure. While in many cases they were later incorporated into church interiors through the erection of chantry chapels, they remained external at both Chartres and Reims Cathedrals. Documentary evidence from chapter records demonstrates that the ecclesiastical communities actively used these spaces for financial gain through the exploitation of jurisdictional rights. Thus, while they were not used as places for prayer or liturgy, they were nevertheless appropriated as places where the chapter demonstrated its authority.

The third chapter examines the monumental sculpture attached to buttress piers and clerestory walls either above or below flyer heads. I posit that these programs of bishops, saints, and angels petrified the temporal action of ritual processions, and I consider the symbolic importance of the figures that occur most frequently in these processions. I further connect buttress sculpture to architectural metaphors in medieval ecclesiology, in which bishops and church fathers are compared to the supports of the institutional body. Many of these architectural metaphors appear in the writings of reform-minded theologians, who stressed the sanctity of consecrated ground and its distinction from unconsecrated places, even those with other religious functions. Like other types of architectural boundaries, including choir screens and dividing walls, the buttressing-frame systems emphasize points of transition in ecclesiastical space. In the case of buttressing, the sculpted processions they support further punctuate this limit. In this way the architecture and its iconographic program resonate with the contemporaneous reformation movements that increasingly categorized and compartmentalized social hierarchies of place and person.

The final chapter expands on the ideas introduced in chapter 3, particularly the way in which buttressing-frame systems visually indicated the privileges associated with consecrated ground. This chapter first considers the relationship between buttressing-frame systems and nonecclesiastical architecture. Flying buttresses only very rarely appear on buildings other than churches, but the supportive function of the powerfully vertical buttress pier shares some conceptual parallels with military architecture, specifically with regard to the idea of point-based support. Although these forms are visually distinct, late twelfth-century moralizing texts on building draw on the parallels between the two in their criticism of the quasi-military appearance of contemporary church architecture. I argue that like crenellations and other military features, buttressing-frame systems spoke to the physical and spiritual protections offered within churches. Although gargoyles constitute particularly problematic source material, their often fearsome appearance resonated with this protective message.

Ultimately, I suggest that Gothic buttresses, as a frame for the church, hold a special importance in presenting the building to its viewers. The rhythmic projections of the buttressing create a permeable perimeter that extends forward from the church walls. This "intermediate zone of uncertain boundaries" exists on a continuum between interior and exterior, and yet it is its own three-dimensional space, with distinct properties and meanings. Such a thick edge (both in its command of space and deep meaning) can function simultaneously as a transitional space between the object and its exterior and as an oppositional space that comments on and challenges the place it defines. This book presents my ruminations on some of the multifaceted meanings of the buttress frame and its significance as an important architectural element within medieval society.

VISUALIZING BUTTRESSING
AND THE AESTHETICS OF THE FRAME

THE FLYING BUTTRESSES OF THE north side of the nave at Chartres Cathedral project forcefully from the building, breaking up the monotony of the walls and enlivening its expansive surface (fig. 9). The horizontal and vertical protrusions of the quasi-independent buttress piers and the arches they support enliven its expansive surface. In daylight the highlights on the protruding buttresses contrast sharply with the dark planes of the stained-glass windows. Together, the buttressing elements of piers and arches create a dramatic push and pull along the building edge. Buttressing-frame systems like that at Chartres are among the recognizable features of the great thirteenth-century cathedrals of northern France. Their prevalence in French church construction produced similar visual effects in a wide range of buildings, from great cathedrals to parish churches (see fig. 3).

The great churches of medieval Europe dominated their surroundings. Their scale alone differentiated them from quotidian architecture. However, other formal characteristics accentuated this differentiation. For example, the externalized assemblage of buttressing arches and supporting piers contrasts markedly with the closed massing common to most of the architectural landscape, including nonsanctified ecclesiastical buildings and civic or domestic structures. Of the many surviving medieval buildings in the town of Chartres, the churches are the only structures that sport flying buttresses. Like the lofty vaults and jewel-colored windows of the interiors, the

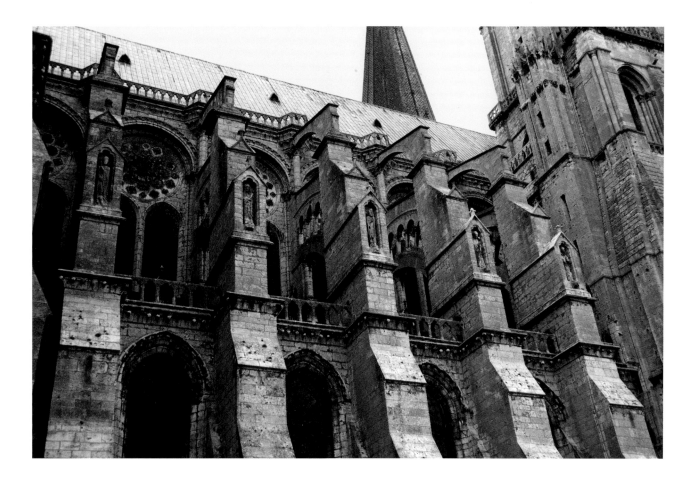

FIGURE 9
Chartres Cathedral, view of the exterior of the north side of the nave.
Photo: author.

flying buttresses of their exteriors distinguish them from the more planar surfaces of many of the town's other buildings through the resultant play of extension and recession, light and shadow.

Distance views of Chartres Cathedral preserve the visual effects of flying-buttress systems within the medieval landscape (fig. 10). Whereas modern scholars frequently note the ethereal colored light of church interiors,

the complex pattern of light and dark formed by the buttressing's undulation stands as an external counterpart, itself a distinctive manipulation of light. On the interior, light takes on color when it penetrates a stained-glass window. On the exterior, sunlight hitting the projecting flyers and piers produces a complicated and ever-shifting pattern of light and shadow that plays across the planes of the structure and amplifies the building's visibility through its three-dimensional armature. The resulting dynamism of the nave of Chartres is best appreciated in comparison to churches without buttressing-frame systems, such as the nave of the church of Saint-Étienne in Beauvais (1130s–40s).[1] The slim buttresses of Saint-Étienne's aisle

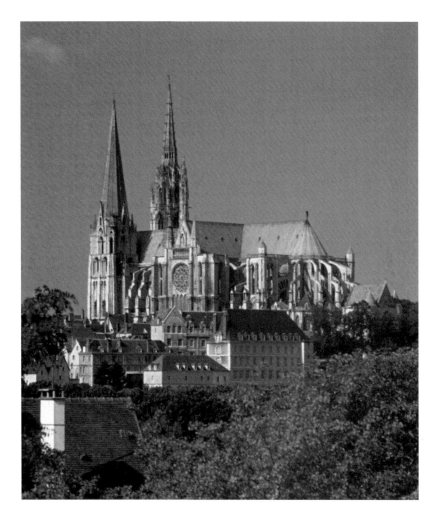

FIGURE 10
Chartres Cathedral, view from a distance. Photo
© Vanni Archive / Art Resource, New York.

and clerestory wall do not cast shadows of comparable intensity (see fig. 5). Instead, light falls more or less uniformly on the nave wall, underscoring its flatness. In contrast, the visual effects produced by a flying-buttress system transform the exterior of a church into a theater for the creative display of architectural ingenuity.

Given the apparent drama of buttressing-frame systems for modern viewers, it is striking that no surviving medieval texts record the aesthetic intentions behind their designs, describe how they transformed building exteriors, or otherwise react specifically to their appearance. The thirteenth-century sketchbook by the French draftsman Villard de Honnecourt furnishes both detailed drawings of the flying buttresses at Reims Cathedral and the first known instance of the Old French term *ars boteres* but does not provide a written assessment of their appearance.[2] Villard's drawing of buttresses attests to his interest in this technology, but it is difficult to tell what he thought about its visual effects. In its relative paucity of overt response to buttressing forms, Villard's text conforms to the nature of medieval architectural description more broadly. As Lindy Grant has argued, medieval

authors favored descriptions of liturgical furnishings and objects over architecture.[3] While writers might note the use of monolithic columns or the placement of towers, accounts of a building's techniques, structure, or style are exceptional.[4] Those medieval texts that explicitly address Gothic buttressing often take the form of an expertise in which a committee of experts assess the stability of a building.[5] Although these experts might make recommendations on how to reinforce the buttressing, they do not generally offer substantial comments on issues of visual character or aesthetics, nor are they ekphrastic. Through a series of case studies, this chapter explores how buttressing-frame systems generate optical effects. The small sampling cited in this chapter reflects the diversity of a nearly ubiquitous feature of great-church construction in later medieval France, a feature that varied widely over time and place. The buildings discussed below showcase buttresses' visual power and their visual utility as frames, either as sites of ornamentation or as means of spatial definition, in addition to their role as a rigid structural support. The chapter concludes by looking at the motif of the buttressing frame in other media, first as part of a church's image and then as a framing motif in its own right.

ON THE DESIGN OF FLYING BUTTRESSES: THREE CASE STUDIES

When modern scholars consider the aesthetics of buttressing-frame systems, they frequently cite the flying buttresses of the nave of Chartres Cathedral (fig. 9).[6] Here wheels of radially placed columns and round-headed arches join two flyers, transforming them into a single unit. The columns' radial arrangement corresponds to the tracery of the west façade's rose window, unifying the west front with the north and south flanks through the repeated motif of round-headed arcades.[7] While the

Chartres buttressing may be the most frequently invoked example, many other buildings similarly demonstrate that masons exploited the visual possibilities of buttressing-frame systems. The following case studies of Saint-Jean-au-Marché in Troyes, Saint-Urbain in Troyes, and the cathedral of Saint-Julien in Le Mans emphasize the profound aesthetic value of buttress frames.

The wide variety of buttressing-frame systems demonstrates that the particular aesthetic concerns of their builders affected buttress design, at times even risking a building's structural security. The design of the buttressing at Saint-Jean-au-Marché in Troyes, which derives from the problematic system of Troyes Cathedral, is a particularly compelling case for a persistent and structurally risky emphasis on visual effects. The examples of the flying buttresses on the porches of Saint-Urbain in Troyes and the bifurcated buttresses used in the chevet of the cathedral of Saint-Julien in Le Mans further underscore their aesthetic potential in exemplifying the larger working style of a single master mason. Whereas the latter two examples show the importance of aesthetics through singular solutions, the prevalence of the openwork or tracery flyer at Saint-Jean does so through its continued popularity as a viable model in the face of catastrophic structural failings. In all three cases, the buttresses act as sites of display and harmonize with the architecture of the rest of the building that they delineate.

Saint-Jean-au-Marché and the Openwork Flying Buttress

The flying buttresses of the choir of Saint-Jean comprise two distinct halves (fig. 11).[8] In the lower half, three or four small oculi pierce the coursed masonry that connects the lower arch to the upper strut. In the upper half, three to four trefoil arches separated by vertical mullions replace the coursed ashlar. The delicate linear tracery of the upper flyer visually defies the buttressing's structural role, transforming a physical support into a diaphanous

FIGURE 11
Troyes, Saint-Jean-au-Marché, detail of flying buttress. Photo: author.

screen. The Saint-Jean buttressing is of the openwork type. The openwork flyer originated at Chartres Cathedral at the start of the thirteenth century and was refined from the 1230s to the 1260s at the collegiate church of Saint-Quentin and the cathedrals of Auxerre, Troyes, and Amiens (figs. 9, 12, and 13).[9] This type of flying buttress

proved to be structurally problematic, with Saint-Quentin, Auxerre, Amiens, and Troyes all requiring significant repairs during the medieval and modern periods.[10] Nevertheless, Saint-Jean's choir flyers, with their trilobed arcade, closely resemble those of the nearby Troyes Cathedral.[11] The cathedral's history of repeated collapses suggests that extrastructural concerns likely influenced its choice as a model for Saint-Jean.

As Stephen Murray has noted in his study of the late Gothic campaigns of Troyes Cathedral, the upper

FIGURE 12
Troyes Cathedral, view of the flyers of the north side of the nave from the east. Photo: author.

FIGURE 13
Amiens Cathedral, view of chevet flying buttresses. Photo: author.

choir of the cathedral was itself a site where builders prioritized optical effect over structural security to some degree. However, the cathedral's many successive masters reproduced the same defective design over and over for centuries. The model of light supporting piers and openwork tracery flyers, first established in the choir, was largely responsible for both the building's exquisite brittle aesthetic and its structural deficits.[12] Construction of the choir buttresses likely occurred around the 1230s as part of a building campaign that imposed several modifications on the design, including a glazed triforium and increased overall height.[13] The openwork design of the choir flyers was a structural solution that married this more ambitious plan to the earlier construction. It provided support for the high vault in a form that was light enough to rest on the previously executed buttress piers, which had been designed for a lower building.[14] In the 1350s the local master Jehan of Torvoie repeated this design in the easternmost bays of the nave.[15] However, in 1362 the visiting master mason Pierre Faisant raised structural concerns about two of the choir flyers and Jehan's "new work."[16] The 1389 collapse of the upper nave bore out Faisant's concerns.[17]

As Murray discusses, Faisant reported that Jehan had placed his flyers too high, and the abutment point was subsequently lowered.[18] In Faisant's criticism of the choir flyers, he noted that the one located near the archdeacon's house had been strengthened with plaster and cement, suggesting that its light form was not adequate. This necessary strengthening and later collapse underscored the cathedral's persistent structural problems—yet Jehançon Garnache, the mason who oversaw the completion of the upper nave in the 1480s and 1490s, returned to the openwork form. Of the eight nave flyers, Garnache built two *ex novo*. The other six he rebuilt from largely reused masonry, essentially reinstituting a design that had failed spectacularly.[19]

Garnache's flyers incorporated some modifications to Jehan's fourteenth-century work, although it is not clear to what degree he intended these changes to be structural fixes. The rebuilt flyers include a diagonal brace that intersects the tracery arcade (fig. 12, front). However, this feature may have been introduced when the flyers were modified as provisional supports following the 1389 collapse.[20] Thus, the strut cannot be assumed to have been a strengthening device intended to resolve a deficit in the openwork design itself, nor can this possibility be entirely discounted. Garnache's two new flyers replace the arcading with trefoils, quatrefoils, and other related motifs (fig. 12, back). He may have seen this revised tracery design as a sturdier alternative to vertical arcades, but it is equally possible that it reflects changing architectural fashions. In either case, Garnache's continued use of openwork tracery, and especially the largely unchanged rebuilding of the six collapsed flyers, demonstrates his adherence to a model with a known record of structural failure.

In the context of the dramatic structural disasters of Troyes Cathedral, the reappearance of trilobed arcades at Saint-Jean-au-Marché becomes all the more remarkable. The first stone of Saint-Jean's new choir was laid in 1520, only a few decades after Garnache completed his work on the cathedral's nave buttressing.[21] The lead mason was Martin de Vaux, son-in-law of Jehan Gailde, who had worked on the cathedral and presumably knew the storied history of its buttressing.[22] Construction of the parish church's flying buttresses probably occurred between 1545 and 1548 under Martin and his son Jean de Vaux.[23] The troubled history of the cathedral's openwork flyers was very likely still part of the city's collective memory, especially since the deformation of parts of the cathedral would have been visible throughout the Middle Ages as they are today. Nevertheless, the structural failings of the cathedral's flyers did not dissuade Martin and Jean from using a similar design.

Saint-Jean's flying buttresses repeat the trilobed tracery arcade employed in the cathedral's choir and nave. They follow the model that Faisant criticized in

1362 and that was responsible for the 1389 collapse (fig. 11). In design they most closely resemble the flyers of the cathedral's choir, since they lack the additional strut of the six nave flyers rebuilt by Garnache.[24] The Saint-Jean flyers are also generally lighter in appearance than those of the cathedral's nave despite the several courses of masonry used in the bottom half of each flyer. Amazingly, the mason of Saint-Jean deployed this demonstrably flimsy design with considerable daring. On the north side of the church the flyers initially spanned an extremely wide side aisle without an intermediary support.[25] It was an audacious and risky design that employed a structurally deficient model without correcting for its failings.

Unsurprisingly, Saint-Jean suffered a pattern of instability and repair comparable to the cathedral's. The length and low inclination of the flyers of Saint-Jean's buttressing proved unsustainable within a decade of their construction. Between 1553 and 1555 each flyer received a small support to brace its intrados.[26] These supports only created a new problem, as the extra pressure they put on the transverse arches of the side aisle forced the choir piers to bow. Consequently, a substantial modification of the interior of the church began in 1561 under the supervision of Jean Prince.[27] Instead of redesigning the buttressing system, Prince added three additional piers to the church interior, transforming the north side aisle into two parallel spaces. This solution preserved the exterior appearance of the building even as it dramatically altered the vaulting and bay divisions. The structural lessons learned in the construction of Troyes Cathedral seem to have had remarkably little effect on the form of buttress design employed at Saint-Jean. Instead, the appearance of the cathedral's flyers was ultimately much more influential.

This emphasis on the visual effect of flying buttresses, even to the detriment of structural integrity, extended beyond the city of Troyes. Just as later building campaigns in Troyes referenced the openwork flyers of the cathedral's choir, the rebuilding of Saint-Riquier under the abbacy of Eustache Le Quieux (1480–1511) incorporated flyers, now heavily restored, derived from those of the nearby cathedral of Amiens (figs. 13 and 14). The mason responsible for the abbey's flyers, Nicolas Lesviellé, was intimately familiar with the structural failings of those at Amiens, as he participated in an assessment of the cathedral's buttressing in 1503.[28] Even in the face of the significant repairs that he and his fellow inspectors suggested for Amiens, Lesviellé's design for the flyers at Saint-Riquier features a very similar panel of tracery lancets.[29] Modifications to the Amiens model suggest that Lesviellé was aware of the structural deficiencies of his visually compelling model and tried to account for them. He thickened the design substantially and reduced the number of lancet pairs from seven to four. However, the bulkiness of the arch was not increased to the point where it became a conventional solid flyer, as was sometimes the case.[30] Despite these adjustments, the Saint-Riquier flyers remain more like than unlike their model. Moreover, even though their increased size and fewer openings may have slowed the speed with which structural problems appeared, the total rebuilding of the flyers in the nave during the nineteenth century points to an inadequacy in the overall design.[31] Modern replacement may not demonstrate medieval knowledge of the limits of these modified openwork designs, but the repeated failure of this copy of the Amiens openwork flyer nonetheless indicates the inherent structural risks of the design, risks that masons (or potentially patrons) repeatedly accepted.

A final example of such acceptance of structural risk for aesthetic gain is the buttressing at Évreux Cathedral. Originally constructed between ca. 1298 and ca. 1310,[32] the flying buttresses of the chevet are of a modified openwork design. They are thicker than those of the 1230s to 1260s and feature inscribed foliations instead of vertical mullions (fig. 15). However, visible distress in the buttressing and cracks in the vaults led to the modification of the buttressing during the reign of Louis XI (r. 1461–83).

as the lantern, noting that reinforcement was required to prevent the collapse of these pillars, the chancel, and the nave. Continuing, the bull states that the canons would not enter the choir to celebrate the hours or liturgical services.[34] Following Eugene's indulgence, masons transformed the double-volley system, in which intermediary uprights separate the flyers over the chapels from those that span the aisles, into a single-volley, double-rank system, where two flyers are stacked one above the other, each springing from the same upright. In other words, the masons stabilized the building by consolidating the intermediate and outer buttress uprights into a single unit, swallowing the outer flying buttress, and constructed new flyers at the level of the triforium.[35] Like the repairs of the buttressing at the cathedrals of Amiens and Troyes, those at Évreux point to the risks associated with puncturing the building's supporting frame. However, despite the apparent "incompetence" of the original masters, those in charge of the repairs continued to employ a similar openwork design. Just like the upper flyers, those at the triforium level, near their juncture with the triforium wall, incorporate openwork tracery at the flyer head. Thus, as at Saint-Jean, an unsound design was repeated as part of a subsequent repair.

The above examples illustrate the profound and lasting influence of the openwork flyer. For centuries masons struggled to find a solution that would preserve its diaphaneity while mitigating its performance deficits.[36] The examples of Troyes Cathedral, Saint-Riquier, and Évreux Cathedral illustrate some of the strategies used to strengthen the flyer itself. Other solutions resulted in a visual or physical separation of the flyer arch and tracery panels. Such is the case at the chevet of Saint-Merri in Paris (finished ca. 1552), where the vertical tracery panels connect upper and lower flyers in a manner similar to that at Chartres Cathedral (fig. 16). Another alternative was to remove all intervening elements between the intrados arch and straight tangent, as seen in the chevet

By the fifteenth century the cathedral was in such a dire state and the resources for repairs were so insufficient that Rome granted indulgences for repair of the cathedral three times, in 1427, 1431, and 1447.[33] The last of these indulgences came in a bull issued by Pope Eugene IV, which blames the ruinous state of the cathedral on the inattention or inexperience of its builders, its age, or a lamentable fire to which it had been subjected. The pontiff further states that there was particular concern for the three pillars supporting the stone tower, known

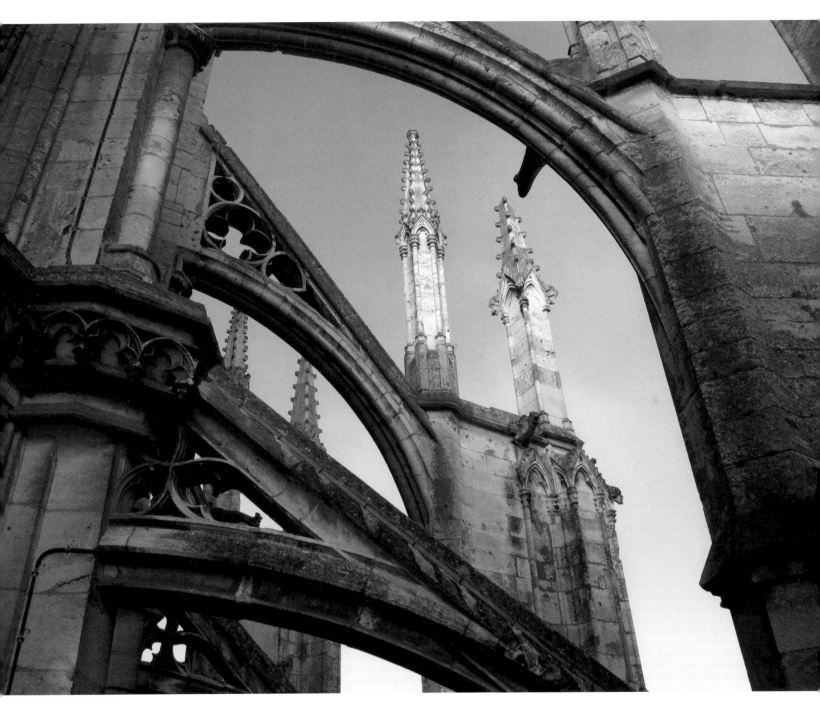

FIGURE 15
Évreux Cathedral, view of chevet flying buttresses. Photo: author.

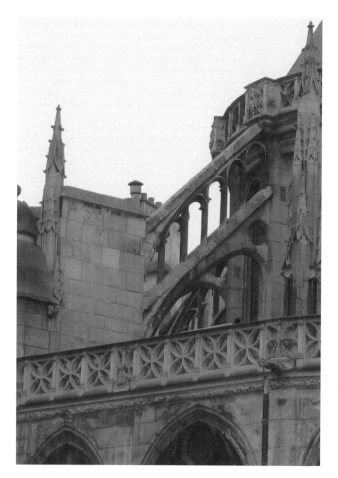

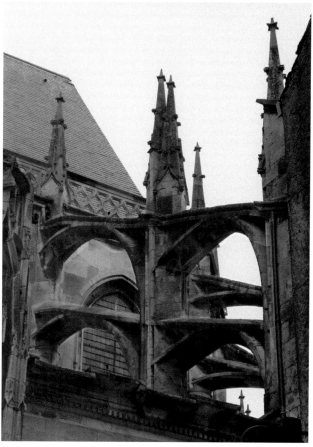

FIGURE 16
Paris, Saint-Merri, view of chevet buttressing. Photo: author.

FIGURE 17
Chaumont, Saint-Jean-Baptiste, view of chevet buttressing. Photo: author.

of Saint-Jean-Baptiste in Chaumont, from the fifteenth century (fig. 17). In this pattern, openings appear where the arch and inclined coping separate at either end of the flyer. However, such modifications did not always ensure stability, nor were they consistently applied. And yet the openwork form persisted. Its longevity points to the intrinsic value of the visual and aesthetic characteristics of buttressing—a demonstration that masons, patrons, or some combination thereof were time and time again willing to take risks to achieve a particular look. These

risks were well known to masons, many of whom had examined or worked on buildings that suffered or were in danger of suffering collapse. As the example of Saint-Jean-au-Marché shows, the choice to favor optical effects over structural security was not isolated to the choir of Troyes Cathedral but rather was widespread and repeated. Such risk-taking suggests that visual or symbolic interests acted as powerful stimuli in the design process. Aesthetic grounds could in fact inspire the replication of and dissemination of new buttressing patterns—in addition

to, or perhaps sometimes in spite of, considerations of engineering power.[37]

The relationship between structure and aesthetics was not a zero-sum game, and I do not mean to suggest that the presence of openwork flyers implies a suppression of structural concerns. The motivations underlying the use of openwork flying buttresses were numerous and likely varied over time and place. Robert Bork, Robert Mark, and Stephen Murray have demonstrated that the catalyst for the popularization of this style was in fact structural. As at Troyes, masons at Amiens, Saint-Quentin, and Auxerre faced the obstacle of substructures that could not support the traditional form of heavier masonry flyers like those used at Soissons Cathedral. The openwork variant was a lighter alternative to the solid masonry flyer, thus offering a solution to these constructional and structural hurdles.[38] The creative ingenuity of this solution should not go unnoticed, even if it ultimately proved untenable in some instances. Rather, the repetition of failed openwork designs demonstrates the medieval valuation of buttressing aesthetics. For churches like Saint-Jean, where there was no significant change in vault height during construction, the advantages of lightweight openwork tracery held less value.

In the fourteenth century, the continued use of openwork flyers is perhaps best explained by their look. Aesthetically, the incorporation of tracery into the buttressing harmonized with the delicate linearity popular in mid-thirteenth-century buildings of northern France. The relative insubstantiality of openwork flyers in comparison to their solidly coursed cousins may also have accentuated the sanctity of the church building as a vision of Heavenly Jerusalem or symbol of God's power more generally, since the building stood even though its supports appeared to be insubstantial. For observers untrained in engineering or architecture—most of the population of medieval France—the stability of buildings constructed with so many openings and supported by buttresses

incorporating voids must have appeared miraculous. Finally, the transformation of a solid support into one that includes openwork tracery elaborated on the opening of the building envelope by the appearance of buttressing-frame systems in the first place. Just as buttressing frames initially transformed an essentially planar wall into a rhythmic alternation of voids and solids, the openwork flyer integrated voids into the formerly solid masonry projections. It is thus possible that masters who favored innovation may have been particularly attracted to openwork flyers as a refinement of the buttressing form—similar to the progressive subdivision seen in tracery patterns more generally.

The case of Saint-Jean and the openwork flyer documents a continued interest in delicate tracery flyers despite their history of structural misfortune. Buttress design also reflected the idiosyncratic concerns of individual projects and masons. Stephen Murray has demonstrated how Renaud de Cormont's introduction of openwork flyers in the choir of Amiens extended his aesthetic vision to the cathedral's structure.[39] The following examples of Saint-Urbain in Troyes and the cathedral of Saint-Julien in Le Mans similarly illustrate how buttressing could exemplify stylistic choices. In both cases a change in master mason precipitated modifications to building design, including the buttresses.

The Porches of Saint-Urbain in Troyes

The porches of the collegiate church of Saint-Urbain provide a particularly illustrative example of the exhibition of structure as an aesthetic motif in its own right. This configuration emphasizes that the externalized buttressing-frame system was a visual statement even in the absence of tracery or sculptural decoration. Jacques Pantaleon founded Saint-Urbain in 1262, one year after his election as Pope Urban IV (figs. 18–21). Construction occurred in three phases.[40] The first campaign lasted until 1266. After a brief hiatus, construction resumed in

FIGURE 18
Troyes, Saint-Urbain, plan. Photo: Arch. dép. Aube, 2J 697.

original bequest.[42] Perhaps in part because of the project's reduced financial state, this building phase displays a frank simplicity, especially when compared to the complex linear patterns and layering of light and stone achieved in the earlier campaign, particularly the heavily glazed area of the choir (fig. 19). However, the restraint of the second campaign combines with the openness of the church's porches (figs. 20 and 21), produced by their unusual use of flying buttresses, to achieve a remarkably clear structural expression.

Teasing apart the contributions of the first two masters requires distinguishing the plan of the porches from their execution. The layout of the porches displays the same delicacy that characterizes the work of Saint-Urbain's first mason. Each porch consists of two square rib vaults. The outer ribs rest on one of three slender columns, each of which is reinforced by a flying buttress that springs from a freestanding pier. The eastern and western piers each support an additional flyer that abuts the wall buttresses framing the transept. The flying buttresses of the porches reduce the structural role of its columns, which are particularly slender (fig. 21). The buttressing also extends the reach of the porches so that the total area of each, from the wall to the outer edge of the buttress piers, approximates one transept bay. Unlike the transept, however, these northern and southern extensions are delimited not by solid walls but by quasi-independent blocks that allow the continued circulation of light and air. The broken outline of the porch thus epitomizes the permeable perimeters created by the projecting point-support of buttressing-frame systems. Its arrangement of freestanding piers and columns suggests a dematerialization comparable to the flickering tracery and diaphanous screens of the choir (fig. 19).

Whereas the lightness of the porches' diffuse layout may reflect the aesthetics of the initial project, the sparseness of their detailing embodies the marked simplicity of the second campaign.[43] The buttress piers

the 1270s, but the church remained unfinished until the nineteenth century, when it was completed in a third campaign. Michael Davis has demonstrated that the ground plan for the church follows a consistent geometry despite these construction breaks, which suggests that the entirety of its layout can be attributed to the first master (fig. 18).[41] Davis has also established that construction of the porches dates to the second campaign, which followed Urban IV's death and the exhaustion of most of his

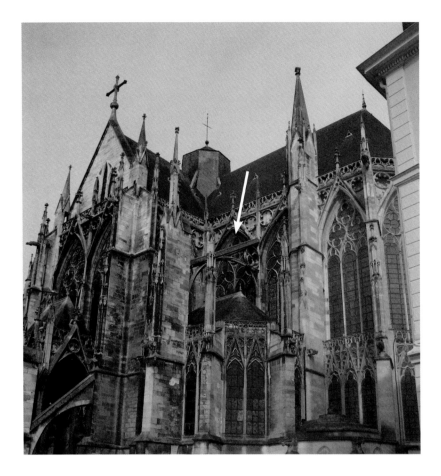

FIGURE 19
Troyes, Saint-Urbain, view of the chevet, with arrow pointing to openwork flyer. Photo: author.

are remarkably spare, with no applied decoration to mask their bulk. Rising from a short base, each rectangular pier reduces in mass about halfway up its height, ringed there by a drip molding. A gable roof caps each pier. The middle pier of the south porch is exceptional (fig. 20, center). Instead of showing the flat plane of a simple setback above the drip molding, the outer face of the pier is decorated with an applied strip of masonry that presents a prominent centered vertical ridge. The two visible sides of this ridge curve inward, and the whole strip is framed with blind tracery. A pinnacle surmounts the front of the buttress, and the gable roof extends behind it to cover the rest of the pier. The use of rotated squares to

articulate setbacks was common in the late Middle Ages. It is extraordinary here only because the other piers of the porch do not use it—an absence made more notable because it appears on spur buttresses of the western end of the north and south transept arms. This isolated use of decoration accentuates the unrelieved mass of the remaining five piers, which is not masked by applied ornament or thinned through tapering or pointing. Also notable is that the nearly full rejection of tracery extends only to the buttressing, whereas the canopy features gables inscribed with trefoils (fig. 20).

Not only lacking tracery, the porch buttresses also lack significant sculptural decoration. Each pier sprouts

FIGURE 20 (OPPOSITE)
Troyes, Saint-Urbain, view of the south porch. Photo: author.

FIGURE 21
Troyes, Saint-Urbain, view of the north porch. Photo: author.

a single gargoyle. Beyond this, the only nods to figural sculpture are the corbels that support the outermost flyer arches where they meet the buttress piers. Some of these corbels are carved to look like monstrous faces. The corbels are quite large, ostensibly making up the final stone of the flyer's masonry arch. The flyers are just as spartan as the piers that support them. None of the porch flyers integrate tracery or openings of any kind. The inner three flyers on either side have bulbous roll moldings that highlight the curve of the arch and the diagonal line of the flyer top, but even these decorations are absent from

the outer two flyers, which are essentially blank slabs of masonry.

The flying buttresses used in the porches of Saint-Urbain contrast starkly with the buttressing employed in the choir, where openwork tracery voids the body of the flyer, and crockets and pinnacles abound on the buttress uprights (fig. 19 at arrow). The popularity of the openwork flyer in Troyes has already been discussed, so its absence in the porches of Saint-Urbain is particularly remarkable. Whereas the buttressing of the first master dissolves into delicate sweeps of stone and spiky outcroppings, that of

his successor exhibits expanses of unrelieved masonry. The second master essentially rejected the open, intricate network of seemingly insubstantial lines of his predecessor in favor of unbroken masonry masses—even as he materialized a plan featuring open forms, slender columns, and structural daring. The choir resists a structural reading, instead seeming to be a miraculous engineering feat that stands only through the tricks of architectural ingenuity, perhaps suggesting the grace of God. In contrast, the structure of the porches is articulated through the solidity of the flying buttresses extending from them.

The porches were not the only places where the second master of Saint-Urbain opted for a dense, muscular style. In general, his work at the collegiate church favors heavier forms and moves away from the preciousness and complexity of the earlier campaign.[44] The dramatic shift in style between the two masters likely derives from the reduced financial circumstances of the project following Urban IV's death.[45] Nevertheless, the buttress piers capitalize on the simplicity of form. Their dense, compact construction articulates their strength and contrasts with the porches' sticklike columns.

Paradoxically, while buttressing often formed a primary element of a building's exterior expression, most of its bulk usually stood at heights far above the viewer's head. The buttressing may have affected the exterior appearance of the church, but a viewer's interaction with that buttressing was limited by distance and accessibility. In contrast, the porch buttresses of Saint-Urbain thrust into the viewer's space, and the open arcades of the porch make visible the placement of the flyer head at the level of the springing of the interior vault. In this context, the blatant materiality of the buttressing form (distinguished from the porches' layout) lucidly expresses their supportive role and physical power. They make visible the structure with virtually no ornamentation to obfuscate this logic. The steeper incline of the porch flyers vis-à-vis those of the choir emphasizes the dynamic role of the

buttresses within this structural system. Thus, while it is unclear how well those outside the architectural professions understood building mechanics, the arrangement of the porches presents an architectonic vision of unusual clarity. The openness of the porches permits a direct observation of the relationship between vault and buttressing that epitomizes the muscular style of the second master, whether or not this choice was primarily motivated by financial or aesthetic concerns.

The paucity of examples comparable to the Saint-Urbain porch buttresses supports the idea that both their layout and ultimate articulation followed from the specific concerns of the church's first and second building phases, respectively. Whereas the openness of the layout suggests the ethereal lightness of the first master, the simplicity of its ultimate realization expresses the rationality of the second master. Often, when flying buttresses spring from piers fully independent of the walls, they seem to have been afterthoughts, essentially expedient Band-Aids, as was the case at the abbey of Noirlac, the cloister of Laon, and the north side of the chevet of Auxerre Cathedral.[46] In each of these instances, the use of flying buttresses below the level of the lowest roof is limited to a small portion of the structure and not employed systematically around the entire building.

There are only a few other examples in France where master masons used ground-level flying buttresses that spring from supports fully independent from the church walls as part of premeditated designs.[47] The buttressing of the chevet of Saint-Eusèbe in Auxerre (fig. 22) may have been inspired by the more crisis-driven solution at the nearby cathedral. There, three flyers were added along the top of the roof of the treasury on the north side of the chevet in response to fears about the building's stability in the fourteenth century.[48] Constructed in the sixteenth century, the chevet of Saint-Eusèbe sports two levels of flying buttresses, one that abuts the clerestory and another that braces the radiating chapels.[49] Their general

FIGURE 22
Auxerre, Saint-Eusèbe, view of the chevet. Photo:
author.

appearance reflects the local style, favoring tall, thin buttress piers, which was first established at the nearby church of Saint-Pierre and also used at Auxerre Cathedral.

The chapel buttresses are arranged symmetrically around the chevet, with one in between the westernmost chapels on either side and two more supporting the axial chapel. Matching the inner rank of buttressing in style, they extend the reach of the chevet outward and reinforce the stepped outline of the exterior massing. Because they are freestanding, the buttress piers also create what might be described as an exterior aisle in the space between the pier and the outer wall of the chapel. Unlike at Saint-Urbain, the flying buttresses at Saint-Eusèbe, supported by fully independent piers, are part of a local style—a conscious copying of the buttressing at a larger, more prestigious building. Even in this case, however, because

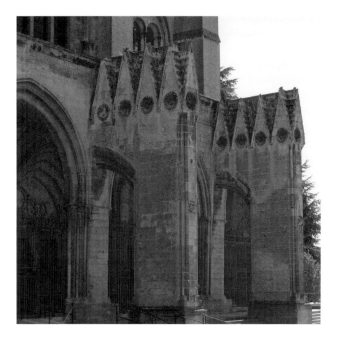

FIGURE 23
Noyon Cathedral, view of the west front. Photo: author.

instead carry level courses of masonry that extend unbroken to the buttress pier. The buttresses are topped by a series of crocketed gables inscribed with quatrefoils. The buttress piers themselves carry little decoration other than thin colonnettes, one on either side of the outer face. The resulting effect is one of static weight, a sensation that resonates with the unrelieved plane of the porch's western face and its substantial spur buttresses. Despite their upper gables, the porch buttresses align with the austerity of the twelfth-century design. In combination, the porch and its bracing appear as a mighty platform supporting the bulk of the upper two stories of the façade and its towers. While the flying buttresses are the first element one encounters when approaching the main entrance to the church, as they are on the porches at Saint-Urbain, those at Noyon differ dramatically in their placement and visual character—and in any case they postdate Saint-Urbain's porches.

In summary, the ultimate articulation of Saint-Urbain's porch buttresses exemplifies the divergent styles of the church's two masons. The plan reflects the linear airiness of the first master, while the unadorned forms of the buttresses, which flaunt their mass, characterize the stylistic changes under his successor. The limited use of decoration on a single buttress pier may suggest that the second master made a conscious choice to put their physical bulk on display. In this context, the unusual display of architectonics showcases the fortitude of the church. Furthermore, although the use of flying buttresses that rest on piers fully independent from exterior walls was not exclusive to Saint-Urbain, the case of Saint-Eusèbe suggests that in Auxerre just such a configuration may have been inspired by a makeshift solution adopted at the nearby cathedral. As with Saint-Urbain, the choice to use such buttressing involved a stylistic choice.

The Chevet of the Cathedral of Saint-Julien in Le Mans

I have argued that the unusually low placement of the porch flyers at Saint-Urbain resulted in a frank and

the heads of the flyers at Saint-Eusèbe abut a solid wall (instead of freestanding columns as at Saint-Urbain), the relationship between buttressing and vault is obscured.

A pair of the particularly curious flying-buttress-like appendages on the porch of Noyon Cathedral are similar (fig. 23). Likely part of a reconstruction campaign following a fire of 1293, the fourteenth-century buttresses consist of substantial, bulky piers from which arches spring to meet the supporting pillars of the porch.[50] Unlike the patchwork solutions mentioned earlier, the rebuilding of the thirteenth-century west façade was extensive, including reconstruction of a large portion of the north tower and the upper parts of the porches themselves.[51] As such, it is fair to consider these braces as part of a more fully formed design as opposed to an emergency fail-safe. The Noyon porch buttresses do not support an inclined straight prop, as typical French flying buttresses do, but

approachable display. It is the flyer itself, its straightforward presence, that becomes a visual statement. The position of these flyers finds parallels in only a handful of other examples, all of which seem to be singular solutions separated by time, space, and design. Similarly, the composition and arrangement of the flying buttresses at the cathedral of Saint-Julien in Le Mans produced heightened visual appeal. Construction of the chevet of Saint-Julien began around 1220 and progressed over the course of three distinctive campaigns under successive master masons.[52] The cathedral shares several formal similarities with the cathedral of Saint-Étienne in Bourges, including its staggered section. Whereas the second master of Saint-Urbain pulled flyers down from the clerestory, the third master of Le Mans multiplied the number of flyers by doubling the buttress piers, ultimately creating a forest of towers that support a virtual canopy of arches (fig. 24).

In designing his three-pier flying-buttress system—Y-shaped, or bifurcated, in plan—the third Le Mans master mason fashioned a complex web of masonry that casts shifting patterns of light and dark across the relatively flat expanses of glass and stone that enclose the interior spaces. Modern scholars have often noted the interplay of light and air in and around flying buttresses, but the Le Mans system exploits this attribute of externalized buttressing arches to an exceptional degree. Moreover, the doubling of the outer buttress piers and flyers visually confuses, such that the exact number and alignment of the parts become difficult to discern when viewed from a distance. Instead of unidirectional, clearly articulated forms, the flyers and uprights dissolve into a thorny net of arches and vertical projections due to changes in bearing. The doubling plays tricks with a viewer's perception of depth and angle, making it hard to untangle one buttress from another and understand how they meet each other or abut the piers and church walls. A drawing by Étienne Martellange, a Jesuit architect and artist (1569–1641), underscores the complicated visual pattern of the

buttressing (fig. 25). Martellange's image fails to produce the full assemblage of flyers around the chevet accurately, misaligns the relationship between flyers, windows, and chapels, and misrepresents the point where the buttressing splits.

The bifurcation of the buttresses at Le Mans appears only in the turning bays of the chevet. The design likely dates to the reconstruction of the east end undertaken during the third campaign, in the 1250s.[53] By this time large portions of the chevet had already been constructed. The first campaign (ca. 1220–ca. 1230) established the ring of radiating chapels using a design where ambulatory windows separate independent chapels.[54] Michel Bouttier has argued that this first plan was a highly conservative project and may not have included flying buttresses at all.[55] On the other hand, if Le Mans's five-aisled plan derives from Bourges, as other scholars have argued, this would suggest that a flying-buttress system was planned from the outset, even if the design of the chapels is *retardataire*.[56]

The second campaign, dated to the 1230s and 1240s, initiated a more forward-looking design. The master of this phase is usually credited with establishing the cathedral's stepped section, with two ambulatories of varied height, likely following the model of Bourges Cathedral.[57] As at Bourges, the stepped section at Le Mans results in a spatial ambiguity where the arcade of the main vessel reveals the elevation of the side aisle. In other words, the interior of Le Mans can be read as having either two or four stories. When focusing on the main vessel itself, the elevation consists of the nave arcade and clerestory. However, when looking through the nave arcade into the aisle, the elevation reads as arcade, triforium, clerestory of the aisle, and clerestory of the nave.

The master of the second campaign also oversaw construction of the buttressing in the straight bays of the chevet. His buttress piers fill the spaces in between the radiating chapels, each blocking an ambulatory window and two chapel windows. Although he apparently

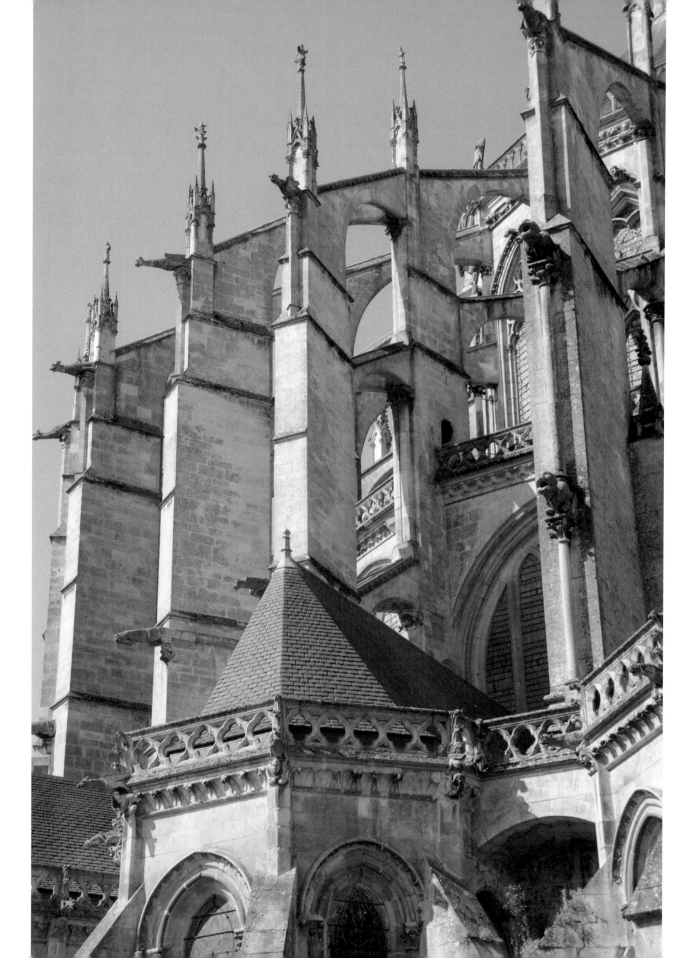

FIGURE 24 (OPPOSITE)
Le Mans Cathedral, view of chevet flying buttresses. Photo: author.

FIGURE 25
Étienne Martellange, *Veüe de l'Église de St. Jullien au Mans*. Bibliothèque nationale de France, Paris, Département des Estampes et de la photographie, Reserve UB-9-Boîte FT 4. Photo: BnF.

modeled the section of Saint-Julien on that of Bourges, his buttressing shares little with this prototype. The chevet at Bourges sports steeply pitched, attenuated flyers supported by very low buttress uprights, to which neo-Gothic pinnacles were added in the nineteenth century (see fig. 7).[58] As constructed in the thirteenth century, the uppermost of the two registers of flyers at Bourges consisted of two arches split by an intermediary upright but

connected by a continuous coping that surmounted both arches and the interrupting support. The lower register similarly comprised two flyers, clearly divided such that one supported the clerestory zone of the main vessel and the other the clerestory of the inner ambulatory.

The steep inclination of the visually unified upper flyer at Bourges follows the pyramidal steps of the interior volumes, forming a triangular outline for exterior massing

FIGURE 26
Heures de Louis de Laval, Bibliothèque nationale de France, Paris, MS lat. 920, fol. 265r, detail showing the church of Saint-Martin at Tours. Photo: BnF.

Saint-Martin at Tours used a long single sweep of flying buttresses that spanned the inner and outer ambulatories of the chevet (fig. 26). As pictured by Jean Fouquet in a miniature of ca. 1450, they even appear rather steeply pitched, although they lack the intermediary upright.[59] The lack of an intermediary upright in Fouquet's drawing should not necessarily be taken as a point of divergence from the design at Bourges. Images of the Bourges chevet sometimes also omit the intermediary upright, perhaps because it did not project above the flyers. It is thus possible that Saint-Martin's system followed Bourges's more closely than previously thought.[60] Similarly, while not as steeply pitched as those at Bourges, the flyers at Coutances Cathedral span the entire distance between the clerestory and outer side aisle in a single sweep, springing from relatively low buttress supports. Thus, despite their milder incline, they similarly showcase the triangular massing of the east end of the building. Additionally, both the buttress uprights and flyers themselves are slender and reasonably plain, recalling the simple, light design at Bourges.[61]

In summary, other systems may have more closely followed the buttress pattern of the Bourges choir, although these appeared infrequently. However, while the second master of Le Mans borrowed the stepped massing from Bourges, he rejected its buttressing, opting to conform to predominant trends regarding height and inclination, which favored tall buttress supports and gently angled flyers. The master of the third campaign at Le Mans revised the buttressing design of his predecessor, doubling the outer volley by dividing the outer buttress support while retaining the scheme's emphasis on verticality. By splitting the buttress piers, the third master preserved the ambulatory windows, although he still sacrificed two lancets of each chapel, evidenced today by the remnants of tracery mullions that once separated the two parts of the window openings.[62] In the turning bays of the choir, each intermediary buttress pier receives six flyers from two outer piers,

that emphasizes the cathedral's width. In contrast, the tall buttress towers of Le Mans emphasize height, pulling the eye upward rather than outward (see fig. 24). Whereas the outer buttress uprights at Bourges initially rose to about the level of the top of the inner aisle, those at Le Mans reach the middle of the clerestory windows. This difference in the relative height of the flyer supports fundamentally changes the exterior appearance of the buildings. The addition of pinnacles surmounting the outer and intermediary uprights at Le Mans, elements originally omitted at Bourges, only further underscores the buttressing's verticality.

While no other project, not even the nave of Bourges Cathedral, replicates the buttressing of Bourges's east end, some come much closer than those at Le Mans. Graphic evidence suggests that the now-destroyed church of

three flyers springing from each. From each outer pier, two flyers abut the intermediary pier at the level of the clerestory, and the third meets the intermediary pier at the level of the inner aisle windows. It appears almost as if the outer portion of the flying buttress has been hewn in two, split at the center and pulled apart.

The multiplication of the flyers amplifies their role as a defining characteristic of the chevet exterior. In other words, by doubling the number of piers and flyers between the outer and inner aisle, the master has made them more prominent, such that the flying buttressing dominates the outer elevation. Indeed, the piers and flyers crowd the empty space voided by the graduated tiers of the interior volumes. Again, as at Saint-Urbain, their appearance should be regarded as a conscious and deliberate design choice. After all, nonbifurcated buttresses support the straight bays of the east end, demonstrating their adequacy as functional supports, suggesting an alternate motivation.

The redesign of Le Mans's east-end buttressing has usually been explained as a means of preserving the ambulatory windows between the radiating chapels, which were part of the first design. Without a doubt, this is one of the advantages of the third master's buttressing scheme. It is worth noting, however, that this solution diverged from the model of Bourges Cathedral. At Bourges the buttress piers fall in between flanking ambulatory windows, the combination of which separates the choir chapels from each other.[63] This pattern was also followed at Saint-Martin in Tours (ca. 1210–30). It was not possible at Coutances, where the choir chapels are contiguous. It was, however, followed at Saint-Martin in Étampes, where the buttress piers fall between ambulatory windows, which are narrower than those that illuminate the chapels.[64] Given the many similarities between Le Mans and Bourges, it is worth questioning why the third master did not attempt a similar solution, perhaps by using narrower buttress piers. At the very least, his

divergence from an established pattern reifies the creativity of his solution in its totality—structural security, interior light, and exterior optical effects.

As a design decision, the buttressing of the third campaign reveals a delight in ambiguity that matches that of the interior. Just as the complications of the interior elevation conjure a space with both two and four stories, the visual complexity of the split buttressing conjures a system of flyers of ambiguous number and arrangement. Thus, the designer not only allowed for greater illumination in the ambulatory but also transferred some of the spatial play of the interior to the exterior, something that is less obvious at Bourges. That is, the master expanded on a design concept already in play and transmitted that idea to parts of the building not yet involved. I would argue that aesthetic and practical concerns played complementary roles in catalyzing an ultimate design that embraced experiments and risk.

Le Mans embodies a design sequence, clearly preserving three distinct visions that successively transitioned from a conservative to an innovative project. Whereas the first campaign adopted an antiquated pattern of isolated chapels and possibly rejected new structural technologies, the final plan married the 1220s design with the sophisticated architectural invention of the 1230s through implementation of a highly experimental support system. In splitting the outer buttress pier, the master of the third campaign preserved the windows of the ambulatory and, importantly, translated the spatial ambiguity of the interior to the exterior massing. The chevet flyers at Le Mans similarly reveal an originality and a willingness to experiment with new forms. Building on the pattern set in the second campaign, the master of the third campaign continued to counterbalance the building's width with the height of the buttress towers while simultaneously integrating a greater play of depth and light. Moreover, the lively tridentate design at Le Mans creates optical illusions that dazzle the eye, especially when the cathedral is viewed from afar.

Ultimately, the buttressing at Le Mans defines the outline of the building's exterior and forms a major component of its visual character. Indeed, comparison of the Bourges chevet buttressing with that of the third design at Le Mans highlights the aesthetic implications of buttressing design for building exteriors. The difference between an emphasis on width and an emphasis on height has already been noted, but also noteworthy is that the Bourges flyers reveal the forms of the building's volumes, whereas those at Le Mans obscure. The difference is particularly significant given the similarities of the buildings in ground plan and section. As critical to the visual character as they were to the stability of the church, the Le Mans buttresses stand as artistic structures, defined as functional support that is simultaneously designed for maximum visual appeal.

As unusual as the Le Mans buttresses are, they do not exist in a vacuum. An earlier example of split flyers appears at Notre-Dame in Paris, where they buttress the tribunes of the choir. It is possible that the master of Le Mans derived his design from this earlier example.[65] Perhaps the closest comparable use of bifurcated buttresses lies significantly further afield and beyond the territories of medieval France, around the chevet of Toledo Cathedral (ca. 1222–47).[66] Here the buttressing splits twice and is arranged in tiers. The lower flyers of the outer volley also spring from their own piers instead of sharing piers with the upper flyers. While these examples point to something of a lineage of Y-shaped buttressing, in neither case is the branching anywhere near as visible as it is at Le Mans. At Paris the split occurs only in the lower buttresses, which are obscured by the flyers above. At Toledo the entire buttressing system is rather low to the ambulatory roof. Moreover, any additional confusion generated by the further multiplication of the flyers at Toledo is mitigated by the disjunction between the inner and outer brackets of the buttressing, which separates one flight from the other. In contrast, the height of the buttressing

at Le Mans exhibits its duplication and suggests that its designer reveled in his experimentation, putting it clearly on display.

The example of Le Mans demonstrates two fundamental aspects of the visual importance of flying-buttress design. First, comparison of Le Mans with Bourges exposes its impact in determining the look of a building's exterior: simply by changing the height of the buttress piers and inclination of the flyers, a master mason could dramatically alter the nature of his structure. Second, by extending spatial play to the exterior of the building, Saint-Julien's divided buttresses signal the ambiguity of the interior elevations. Although it is not the only building whose buttresses possess a sculptural quality, their distinctive form and their play with light and depth demonstrate how the buttressing mediates between interior and exterior. As a frame for the former, it prepares viewers for the spatial and aesthetic arrangement they encounter once inside.

FLYING BUTTRESSES AND ARCHITECTURAL MARGINS

The three case studies explored above highlight the visual effects produced by buttressing-frame systems and suggest that aesthetics was an important consideration in their design. The rest of this chapter examines images of buttresses, demonstrating the medieval recognition of externalized buttressing, especially projecting buttress piers, as a framing device and the contemporaneous application of their visual effects to other media. The semi-independence of flying buttresses and their supporting piers, their removal or extrusion from the wall, makes a natural frame for the church. This frame's intermediary placement forms a bridge between the primary object and its audience. One of the most significant and direct consequences of the adoption of flying buttresses is the

fracture of building outlines. The prominent interstitial projection of the buttress piers, buttress uprights, and flyers from church walls propagates this rupture, as at Chartres (fig. 9).[67] These projections are multidirectional, extending both horizontally and vertically, as the buttress piers and uprights protrude from the church walls, in plan and in elevation, into the narrow margins that separate the church from other nearby structures. The flyers also participate in this splintering, similarly constituting a series of periodic protuberances. In its extension, the buttressing assemblage marks a new limit for the building, now defined by the broken line of its outermost edge. However, unlike uniform walls, this new edge maintains permeability as a consequence of its discontinuous nature. Thus, between the interior of the church and its exterior surroundings the buttressing adds a third space—an intermediate zone of open formwork around the closed volumes of the nave, choir, and aisles. Neither within the church nor fully independent from it, the buttressing forms a porous membrane that marks a limit yet does not entirely cut that space off from its surroundings.

The graphic representation of buttresses is a crucial witness to the extratectonic values of Gothic buttressing, since structural concerns were naturally absent in two-dimensional images. The richness of this material warrants a book in itself, but the following selective survey demonstrates the importance of buttressing in representing contemporaneous building practices. There are two general categories of buttress representations: buttresses that appear in a larger image of a church and buttresses that operate primarily as part of a fantastical architectural frame, although the line between these categories is somewhat fluid. This graphic evidence speaks most directly to a post hoc, but still medieval, appreciation of the visual effects of buttresses as artists capitalized on their aesthetic potential in the creation of other works of art. However, when combined with the case studies presented above, it underscores the rich multifunctionalism of Gothic buttressing.

FIGURE 27
Chartres Cathedral, panel 3 of window 17. Donors: the masons. Photo © Painton Cowen, www.therosewindow.com.

Aesthetics Without Structure

Buttressing-frame systems are common features of thirteenth- and fourteenth-century images representing church exteriors.[68] Many such representations appear as part of narrative cycles—for example, in hagiographic narratives when a saint builds or dedicates a church. A particularly telling representation of flying buttresses appears in the donor panel of the Saints Savinian and Potentian window (ca. 1215) at Chartres Cathedral (fig. 27). This stained-glass panel, produced while the cathedral was still under construction, shows a mason at work.[69] Tool in hand, he stands against an ambiguous blue ground, immediately to the left

FIGURE 28
Chartres Cathedral, panel 20 of window 18. Becket goes to Canterbury.
Photo © Painton Cowen, www.therosewindow.com.

FIGURE 29 (OPPOSITE)
Beauvais Cathedral, panels 9 and 10 of window 2. Theophilus repents.
Photo © Painton Cowen, www.therosewindow.com.

of two flying buttresses. In this representation of masonry practice, the inclusion of flying buttresses suggests that they had become an attribute of state-of-the-art techniques.[70]

The architectural literacy of glaziers and illuminators varied considerably, resulting in an inconsistent presentation of buttressing frames. However, a panel from the Thomas Becket window of Chartres Cathedral (ca. 1215) presents many of the more consistent features shared by representations of Gothic buttresses (fig. 28). This panel depicts the church from two juxtaposed perspectives so that the west front and south lateral façade both face the viewer.[71] The glazier used different colors to indicate distinct architectural features. The yellow buttresses of the lateral façade, each presented as a vertical pier with an

arch springing from its top, stand out against the red and blue body of the church. It is possible that the selection of a lighter color for the buttressing reflects the lighting effects discussed above. The consistent use of yellow/orange for the flyer arches and supporting piers indicates their unity in the mind of the glazier, and the use of this distinctive color differentiates buttress from church body, whose walls are the same color as the background. Whereas the Becket panel from Chartres depicts a building with a stepped profile, clearly indicated by the contrasting color with which the roof of the side aisle is rendered, a comparable image at Beauvais does not (fig. 29). In this case it is unclear what the flyer arches fly over. In addition, the sections of pier support are not always

FIGURE 30
Psalter of Saint Louis, Bibliothèque nationale de France, Paris, MS lat. 10525, fol. 192r. Psalm 97. Photo: BnF.

aligned. In this example the abutment point of the flying buttresses is also too high. They meet the clerestory wall just below the roof and consequently could not effectively stabilize a vault. Other comparable stained-glass images similarly represent a misunderstanding of buttress structure.[72] In many cases, images of buttressing in stained glass do not mimetically represent their structural dynamics but rather use buttresses to focus attention and offset the church from its background.

On the other hand, several thirteenth-century images of churches demonstrate close attention to contemporary construction practices. The donor panel from Chartres

illustrates each buttress with a straight diagonal coping, in contrast to the more common depiction of a single arch (compare fig. 27 to fig. 28).[73] Artists also integrated morphological changes derived from contemporaneous construction practices. For example, in the Becket window from Chartres, the upper flyer arch springs directly from the top of the buttress upright. In contrast, an image of a church from the Psalter of Saint Louis (1253–70) shows the flyer springing from the inner side of the buttress upright, although the exact relationship between buttress, window, and wall remains ambiguous (fig. 30). This change in the springing point occurred over the course of the later twelfth century.[74] In addition, in the psalter a pinnacle tops the supporting pier. An early example of pinnacles on flying-buttress uprights are those at Reims Cathedral, constructed around 1230.[75] The artist of the psalter was aware of this recent development in flying buttresses, showcasing an attentiveness to their form outside of the architectural profession. These examples imply that at least some artists were attuned to changes in buttress morphology even if their representation of masonry structure was nonmimetic.

Reims Cathedral houses a unique program of architectural representation in the clerestory lancets of its choir. The windows of the eleven bays of the choir represent Henri de Braine and his suffragan bishops, including images of nine cathedral "façades." Scholars have traditionally held that these panels bear little resemblance to the actual buildings they purportedly represent, depicting the idea of a cathedral rather than its portrait.[76] In 2002 Peter Kurmann successfully challenged this notion, demonstrating that the façades share more formal similarities with their sites than previously recognized.[77] Most of the nine images depict twin-towered façades. However, in two examples, Reims (fig. 31) and Beauvais, buttress uprights take the place of flanking towers. The model for these images was almost certainly a tenth façade image,

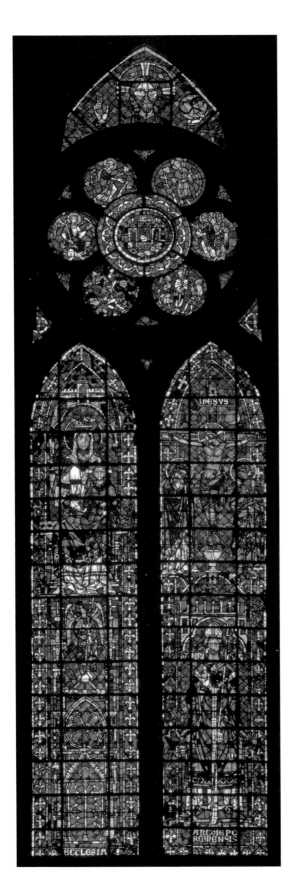

FIGURE 31
Reims Cathedral, window 100, showing the Reims Cathedral façade in the lower row of the left lancet. Photo © Painton Cowen, www.therosewindow.com.

FIGURE 32
Reims Cathedral, window 118, right lancet, showing the Reims Cathedral façade. Photo © Painton Cowen, www.therosewindow.com.

which also represents the cathedral of Reims, now located in the south transept (fig. 32).[78]

The stained-glass façade from the south transept demonstrates close affinities with the buttressing design of the structure it ornaments, including crocketed pinnacles, two levels of crocketed flyer arches, and a system of water evacuation ending in gargoyles (see fig. 61). The later lancet of the choir omits the flyer arches but more closely replicates the buttress uprights. The stained-glass buttresses copy the aediculae of the built cathedral and the pyramidal arrangement of five pinnacles at the top of the buttress uprights. It is more difficult to argue for a similar resemblance in the buttresses of the Beauvais façade, since only the lower portions of the buttress piers of the straight bays of the choir were constructed by the early 1230s, when this window was likely installed.[79] Nevertheless, if the image of the Beauvais façade replicates the original design of the transept, as Kurmann has argued, the presence of projecting buttress piers would be in keeping with this construction campaign.[80] The prominence of the buttress-pier supports in the stained-glass windows—and their faithfulness to the built cathedrals—indicates that the buttressing was an identifying feature of these buildings.

The Motif of the Buttressing Frame

The quasi-independent projections of flying buttresses rest between the body of the church proper and the church's exterior surroundings, in what might be deemed the immediately accessible space of a building's margins. Flyers, piers, and uprights are parts of a church's surface that lie immediately within its boundary yet are distinguished from the rest of that surface. Moreover, they are structurally integral parts of the larger building. These are characteristics that find parallels in the study of medieval margins more generally.[81] The most inclusive consideration of cathedral margins remains Michael Camille's provocative book *Image on the Edge*. However, while Camille locates these margins topographically, referring

specifically to narrow passages, like the parvises that front cathedrals, he focuses on figural sculpture rather than the architecture itself.[82] The position of buttresses relative to the church, standing at the junction between sacred space and the earthly world, places them in a contested zone comparable to that of the parvis. That they are the site of marginal sculpture like gargoyles and grotesques only reinforces their position "betwixt and between."[83] I argue, therefore, that the buttressing zone comprises what might be termed "architectural marginalia."

The term "marginalia" typically refers to images placed between the edge of the page and the area reserved for the central text and its associated illustrations, usually in thirteenth- and fourteenth-century manuscripts.[84] Kathryn Smith has noted that in the fourteenth and fifteenth centuries "margin" and "marginal" operated spatially, indicating an edge or border. This topographic understanding easily maps onto architecture, as with Camille's identification of the parvis as a marginal space in front of the building.[85] However, a building's border encloses it on all sides, and so the idea of an architectural margin must equally encompass its lateral façades.

Scholarship has long since put to rest the notion that marginalia represent meaningless extemporaneous decoration.[86] The specific relationship of marginalia to the primary text or image varied, and several scholars have noted that generalized or universal meanings remain elusive.[87] These images operated as mediators between viewer and manuscript. They were often preplanned and designed according to the manuscript's contents, patronage, ownership, and circumstances of production.[88] According to Smith, "the medieval margin was regarded as a zone of structural, semantic, or esthetic significance, and as integral to the entity of which it formed a part."[89] Applying the concept of the margin to the peripheralized buttresses of Gothic architecture facilitates a multivalent reading that accounts for the complementary functions of structural support, artistic expression, and sociocultural display.

The translation of buttressing-frame systems to other media suggests that artists recognized them as boundary markers. They frequently appeared as parts of architectonic frames or canopies, in both two- and three-dimensional works. Many of these works fall under the classification of microarchitecture—three-dimensional structures of modest size in comparison to buildings yet governed by the same "rhythms of Gothic geometry."[90] Other objects, including sculpture, paintings, and stained glass, frequently employed elaborate architectural ornamentation.[91] As Achim Timmermann has noted, the thirteenth century saw intense experimentation with scale as masons and artisans played with miniaturized and monumental architecture.[92] Reliquaries, baldachins, and sacramental shrines increasingly used gables, pinnacles, and buttresses as their primarily ornamental language, prioritizing nonrepresentational forms over figural ones.[93] These motifs formed part of a shared vocabulary and design process that passed between various media, from architecture to the architectural and back again. The small scale of these objects permitted a sophisticated display of architectural forms that exceeded the structural limitations of macroarchitecture.[94]

Projecting buttress piers and uprights, with and without flyers, are frequent, though not universal, parts of these architectural fantasies. It is noteworthy that buttress piers appear more frequently than flyers, which underscores their visual importance in the linear aesthetic of late medieval architecture. It was not the flyer but the projecting buttress piers that served as the touchstone for the larger system. The Shrine of Saint Gertrude of Nivelles (1272–98, destroyed) exemplifies the use of the buttress motif at a miniaturized scale (fig. 33). This reliquary condensed a French Rayonnant vocabulary onto the boxlike body typical of a twelfth- or early thirteenth-century reliquary casket.[95] The resulting container appeared to be a miniaturized cathedral, even as several of its features—for example, the articulation of the "clerestory" as a line

of repeated narrow lancets—resisted such a mimetic reading. Figures inhabited gabled niches along the shrine's lower register. Buttresses framed these niches, projecting forward from the body of the shrine in a series of powerful vertical piers topped with pinnacles. The alternation of gable and pier resulted in a rhythmic pattern that recalled the lateral façades of Paris Cathedral after the construction of chapels between its buttress piers (see fig. 42). The design of the shrine's buttress piers incorporated aediculae and pinnacles typical of their full-sized counterparts constructed from the 1230s on—for example, at Reims Cathedral (see fig. 61).[96] Their strong verticals provided an organizational logic to the reliquary's façades. Whereas in a built church these verticals would correspond to the bay divisions, in the shrine they marked divisions between the inhabited gabled niches. Their projections, which extended beyond the limits of the niches, also helped construct three-dimensional spaces for the figures. In this example, the buttresses provided an organizational armature to the metal casket. Together with the gables, they defined the privileged spaces of the niches.

Buttress frames also frequently appear in liturgical furnishings that were decorated with microarchitecture. Timmermann's study of sacrament houses, focused particularly on examples from the Holy Roman Empire and eastern Europe, discusses buttressing pyramids as series of nested shells that draw the eye heavenward through architectural glosses on transubstantiation.[97] Comparable buttressing arrangements appear in the baldachins of the jube of Sainte-Madeleine in Troyes, built by Jehan Gailde between 1508 and 1517 (fig. 34).[98] The jube comprises three bays, the middle of which hovers fully unsupported. An elaborate architectural canopy at each end and each bay division covered a figural sculpture (now lost).[99] Each baldachin takes the form of a vertical pyramid of concentric buttresses, some with flyers, culminating in a central pinnacle. This frame of buttressing at once marks the privileged locus of the sculpture below and delineates its boundaries. The

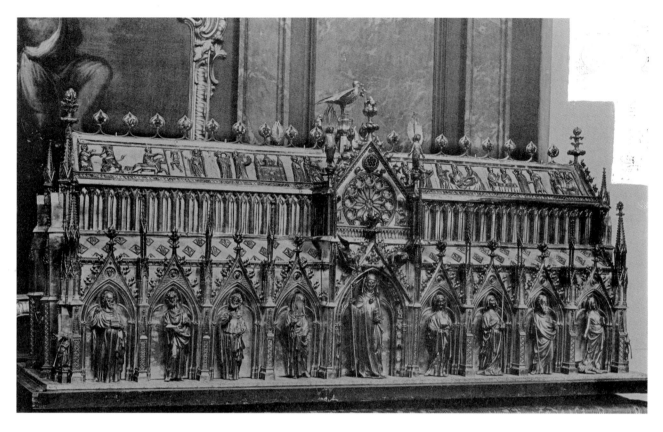

FIGURE 33
Shrine of Saint Gertrude of Nivelles, destroyed in 1940. Photo: Foto Marburg / Art Resource, New York.

FIGURE 34 (OPPOSITE)
Troyes, Sainte-Madeleine, interior, rood screen. Médiathèque de l'architecture et du patrimoine, Charenton-le-Pont, France, inv. LP001242. Photo: Eugène Lefèvre-Pontalis © Ministère de la Culture / Médiathèque du Patrimoine, Dist. RMN-Grand Palais / Art Resource, New York.

vertical lines of the independent buttress piers emphasize the pyramid's ascent. Where flyers are present, they physically link the concentric rings of miniaturized forms.[100]

Not only are buttresses found in three-dimensional microarchitecture and architectural sculpture, but they also frequently appear as part of elaborate frames in two-dimensional and low-relief works. Erwin Panofsky and others have argued that these borders developed from canopies or tabernacles to create a shallow spatial shell for the figure or narrative action.[101] The architectural

frames in manuscript illumination thus function similarly to the buttress piers of the Shrine of Saint Gertrude. Many examples, including the Psalter of Saint Louis, the Psalter of Yolande de Soissons (ca. 1280–99), and a copy of the *Somme le roi* now in London (ca. 1290–1300, Add. MS 28162, originally bound with Yates Thompson MS 11), also share with the destroyed reliquary the motif of the gabled arcade punctuated by pinnacled piers (figs. 35–38). Harvey Stahl links the use of this theme in the Psalter of

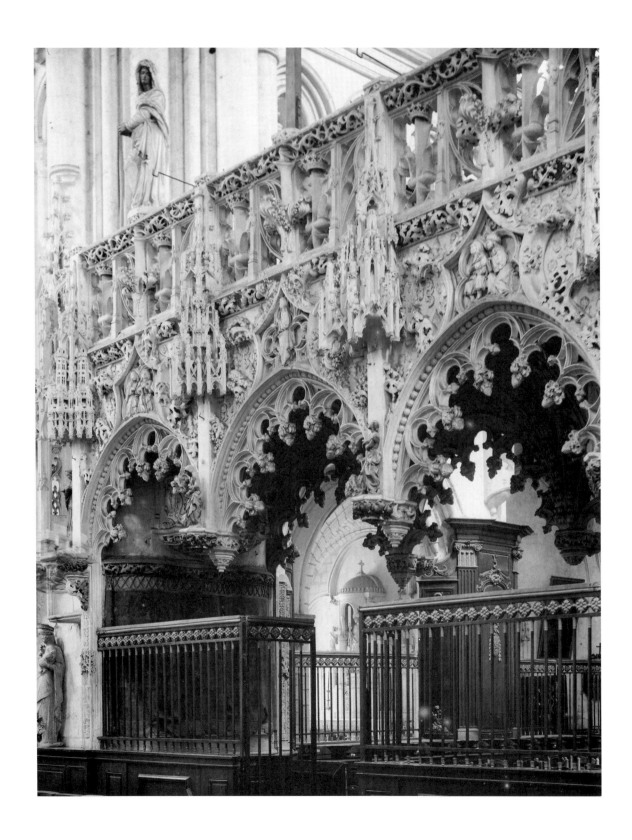

Saint Louis to the façade of Saint-Nicaise in Reims and the transept portals of Notre-Dame in Paris.[102]

The Psalter of Yolande de Soissons makes no formal distinction between piers carrying flyer arches and those that do not.[103] Perhaps pinnacles and buttress piers were interchangeable forms to the illuminator. It is equally possible that the pinnacled pier was shorthand for buttressing-frame systems and that the illuminator omitted the flyer arch, as Villard de Honnecourt did in his drawing of the exterior elevation of Reims Cathedral (see fig. 70). This reading makes particular sense in those cases where the frame depicts a gabled arcade below a clerestory. In Yolande's psalter, flyer arches appear most prominently over the miniature of the Holy Face of Christ (fol. 15r; fig. 35), the most elaborate image in the psalter, and in other illuminations as supports for a centralized tower.[104] This selective use suggests a formal hierarchy of architectural imagery, with the flyer arch indicative of greater embellishment than the buttress pier alone.

In the Psalters of Yolande de Soissons and Saint Louis, the buttresses provide much of the spatial effect of the frame. In Louis IX's manuscript the architectural frame has three major planes, the foregrounded projecting buttresses, the midground of the gabled arches, and the background of the clerestory wall (e.g., fig. 36). The outer two buttress piers establish the outer spatial limits of the fictive space in which the figures act. In Yolande's psalter, buttress piers bound the left and right edges of the central image. The buttress piers of the gabled arcade stand slightly behind the arches. The impression of depth is enhanced in illuminations that include flyer arches, such as the miniature of the Holy Face of Christ. Here the

flying buttresses recede in space until they abut a vertical element set further back from the picture plane.[105]

In the *Somme* manuscript, buttress piers act more as an organizational device, punctuating the vertical divisions between individual arches. For example, the two gables over the depiction of Prudence divide the personified virtue from the group of students she instructs (fig. 37, upper left). Since the artist has omitted the supporting columns of the arch, it is the buttress pier that marks the vertical line between these adjacent spaces. In other miniatures the figures seemingly act outside the organizational system of the frame. For example, the two figures represented in the image of Mercy occupy only the left half of the pictorial space, while a narratively superfluous tree occupies the right (fig. 38, upper left). Nevertheless, Mercy herself stands in the middle of the image, a position emphasized by the buttress pier above. Aden Kumler has also noted how the architectural frames in this manuscript integrate the four quadrants of each full-page illumination, revealing didactic connections between the four scenes.[106] She argues that the spatial continuity created by the fictive architecture encloses the sacred space of the pictorial field, unifying individual quadrants of each register.

The architectural frames in these manuscripts occupy a transitional place between the narrative image and the margins. In all cases the architectural motifs are placed within a subsequent ornamental border.[107] In the Psalter of Saint Louis and the London *Somme le roi*, these borders are rectilinear. In the Psalter of Yolande de Soissons, they take the form of scalloped edges punctuated by shields.[108] This intermediary placement illustrates the layering of framing devices employed by the illuminator, from blank parchment margin to outer border to architectural frame. These various frames mediate the viewer's access to the central image. The familiar architectural motifs possibly operate as an interface between the world of the viewer and the world of the image.[109] The innermost frame, with

FIGURE 35
Psalter of Yolande de Soissons, The Morgan Library & Museum, MS M. 729, purchased in 1927, fol. 15r. Holy Face. Photo: The Morgan Library & Museum.

FIGURE 36
Psalter of Saint Louis, Bibliothèque nationale de France, Paris, MS lat. 10525, fol. 1v. The sacrifices of Cain and Abel. Photo: BnF.

FIGURE 37 (OPPOSITE)
Somme le roi, The British Library, London, Add. MS 28162, fol. 4v. Four cardinal virtues. Photo: The British Library Board.

its architectural motifs, including buttresses, is in the greatest proximity to the sacred, at times even giving space to the holy figures it encloses.

The architectural frames considered above use architectural motifs to represent exterior features, namely lateral façades and portals. In contrast, the tomb of Bishop Evrard de Fouilloy (d. 1222) in Amiens Cathedral presents an architectural frame in the guise of a section (fig. 39).[110]

Here pinnacled buttress uprights support flyer arches that form the lower cusps abutting the upper cusp of a trefoil arch, an imaginary arrangement but nevertheless evocative of the section of the three-aisled basilica-plan church. Evrard's buttresses are fanciful, incorporating crenellations, gables inscribed with trefoil arches, and lacy arch intradoses. Produced near the start of the construction of Amiens, they may have anticipated the tracery flyers

PRVDENCE AT RAM PANCE

FORSE E IUSTICE

FIGURE 38
Somme le roi, The British Library, London, Add.
MS 28162, fol. 9v. Mercy, Avarice, and Abraham
receiving the angels, and the widow pouring oil.
Photo: The British Library Board.

introduced by the cathedral's third master, Renaud de Cormont, around the choir, although nothing so delicate yet existed. The architectural detailing of the buttress piers and flyers creates a canopy over the trefoil arch that delineates the privileged space for the effigy. As in the other examples of microarchitecture and architectural motifs, the buttresses create a hierarchical organization based on the interiority of the image vis-à-vis the frame.

The placement of buttresses in microarchitecture and architecturalized objects and images discussed above is distinct from that typically indicated by the term "marginal" when referencing illuminated manuscripts. Illuminated architectural frames are located interior to the margin proper, often directly outside of the central image. Similarly, in microarchitecture, although buttresses stand on the perimeter of architectural screens, they often do

so for successive layers. At the same time, the selective survey presented above demonstrates that in these objects the motif of buttressing functions as a framing device in an intermediary space between a central element and outer limit, even if it is only one of a series of mediating frames. The pervasiveness of this motif suggests that buttresses were particularly appropriate as devices for demarcating a privileged interior space, a meaning that may well have derived from monumental architecture, where the dramatic projection of flying-buttress systems initially developed. In both the macro and micro examples, buttressing encloses and marks the limits of a privileged, if not sacred, interior space.

CONCLUSIONS

The survey of examples presented in this chapter illustrates a recurring question regarding the definition and articulation of church exteriors through the design of their buttressing. Discussion of the openwork flyer strongly suggests that aesthetic and structural concerns could weigh equally even when designing a structural system. This implication is at odds with the seemingly rigid visualized architectonics so often used to distinguish French Gothic architecture from that of England, Germany, and other geographic regions.[111] Instead, French masons and designers seemingly delighted in the elaborate and playful design of their buttressing, using it—like the complicated tierceron vaults of many English churches—as a platform for expressing their virtuosity. The case of the openwork flyer is especially telling in that it appears in numerous examples where masons sacrificed structural stability for visual effects. Far from being an idiosyncratic feature of Troyes Cathedral, the openwork flyers of Saint-Jean-au-Marché, Saint-Riquier, and Évreux Cathedral reveal the pervasiveness of this mode. Similarly, the unconventional

FIGURE 39
Amiens Cathedral, tomb of Evrard de Fouilloy. Médiathèque de l'architecture et du patrimoine, Charenton-le-Pont, France, inv. MH0191666. Photo: Gérard Franceschi © Ministère de la Culture / Médiathèque du Patrimoine, Dist. RMN-Grand Palais / Art Resource, New York.

designs of the flying buttresses of the porches at Saint-Urbain and the cathedral of Saint-Julien in Le Mans indicate that even when not sacrificing stability, masons still kept an eye on the visual consequences of buttress form.

The long-standing popularity of the openwork flyer and the unusual designs of the buttressing at Saint-Urbain and Saint-Julien support an interpretation of flying buttresses based on their formal characteristics and highlight the interplay between buttresses and the articulation of space. As a three-dimensional object, the church constitutes a massive quasi-sculptural ensemble, and the buttressing-frame system was fundamental in redefining the relationship of that form beginning in the twelfth century. It is possible that masons had greater latitude to engage in creative experimentation with this type of marginalia. However, as part of the zone of "first encounter" between viewer and building, the buttressing also participated in setting expectations for the visitor and filtering many of the initial views of the church. As highly visible frames, buttressing-frame systems, in fact, would have been conceptually important zones for the masons' and patrons' artistic and conceptual expression.

NEGOTIATING BUTTRESS SPACES

IN 1221 THE ARCHBISHOP OF REIMS, Guillaume de Joinville (r. 1219–26), adjudicated a dispute between the chapter and the treasurer concerning jurisdiction over a small piece of land. The area in question lay west of the canon's cloister and north of the cathedral, bounded by the cathedral, the sacristy, and the hôtel-Dieu (fig. 40, just above the word *Trésor*).[1] The treasurer had long held jurisdictional rights to this area, which functioned as his personal garden. Unfortunately for him, construction of a new cathedral (to replace one damaged by fire in 1207) slightly expanded the building's footprint to the north and south.[2] Consequently, a portion of the treasurer's garden was plowed over to make way for the new church wall, which was punctuated by prominently projecting buttress piers. By the date of this adjudication, the relationship between the chapter and the treasurer was already strained. Six years earlier, Guillaume's predecessor, Aubry de Humbert, had authorized the transfer of income away from the treasurer to the subtreasurer, presumably so that the chapter could more closely control oblations and other income intended for the maintenance and repair of the church.[3] The annexation of some of the treasurer's land further diminished the resources under his direct control.

In comparison to the struggle between the church and the bourgeois over the establishment of a commune—which culminated in the flight of the chapter on November 9, 1234, the murder of the archbishop's marshal, a

FIGURE 40
Jean-Gabriel Legendre, *Plan générale de Reims et de ses environs dédié au Roi [...]*, exécuté sur la composition de d'après les desseines du Sieur Le Gendre, Reims, BM, XXXII I F 1, detail. Photo: Bibliothèque municipale de Reims.

short-lived peace, and a second flight by Archbishop Henri de Braine in 1238—the dispute between chapter and treasurer appears rather tame.[4] Nevertheless, it reveals how the chapter further consolidated its authority through the construction of the new cathedral. It also illustrates how church building could impinge upon traditional land rights and the place of buttressing-frame systems within those negotiations.

In reimagining the exterior wall of Reims Cathedral, patron and builder revised not only the cathedral's form but also the interaction between building and audience.

Brigitte Bedos-Rezak has argued that a building's form signifies social process.[5] Rather than the product of a solitary act of planning and building, the exterior structures of the church were built, modified, and rebuilt in response to changing structural and social needs over time. With each iteration the building process required negotiation and reevaluation. Structural necessity provided the immediate catalyst for the undulating envelope of many Gothic churches. Yet, as part of a dense urban environment, what became of this envelope testifies to the rules governing social interaction and the mapping

of those implicit or explicit contracts onto physical space. The area outside the church wall but between the prominent buttress piers enabled a complicated dichotomy of internality and externality—of church and extrachurch—where such negotiations may have been particularly fraught.

Medieval sources reveal a consciousness about the ambiguity of the semipermeable frame created by prominently projecting buttress piers. For example, Guillaume's resolution distinguishes between the interior space of the new church, where the treasurer gave up all rights, and the exterior space, where he retained some jurisdiction. The limitations placed on his rights to the exterior space, however, indicate the transitional nature of this area. They specify that the treasurer's claim could be further diminished should the future building of the church require it. In other words, the treasure's rights were not absolute but moderated by the land's proximity to the cathedral. Perhaps most important, the dispute itself indicates the social and monetary value of the land immediately adjacent to the cathedral, some of which ultimately fell between the buttress piers.

In the 1220s a perimeter punctuated by massive vertical piers, like that constructed at Reims Cathedral, was in keeping with the latest architectural fashion of the region. The worth of the resulting buttress interstices at Reims is underscored by the absence of lateral chapels, which were commonly inserted into these spaces as the thirteenth century progressed. Stephen Murray has suggested that buttress interstices could easily be usurped by individuals for subversive purposes.[6] Murray's attention to these spaces is exceptional in the modern literature, which has otherwise directed very little attention to the activities that occurred in and around buttress interstices before chapel construction. I suggest that while communities co-opted them for nonreligious purposes, as Murray has hypothesized, they did so not through the ad hoc activity of individuals but rather through carefully

regulated commerce. Where buttresses were accessible, they became part of a mixed-use area, one controlled by ecclesiastics but neither exclusively liturgical nor exclusively secular. For example, such a place might have been part of an open cloister, but many also housed markets, residential properties, and cathedral workshops. In this way buttress interstices acted as a buffer, a gradation between the outside world and the church. This intermediary zone where church and extrachurch interlocked could be entered into and experienced as both sacred and profane.

I suggest that the architectural forms of cathedral peripheries—these contested areas within the social dynamic of chapter, town, and bishop—in northern France played a key role in the construction of authority and the assertion of social hierarchy. The exterior space of the church held value, whether it was open and monetized, open but limited and proprietary, or internalized and sacralized. People flowed around and through cathedral districts, making careful control of jurisdictional rights essential to negotiating the relationships among the churchmen and between the clergy and the laity.[7] Privileges granted to the spaces around churches came with economic advantages, which many ecclesiastics capitalized on, often competing with each other and secular lords for profit (as I point out later in this chapter). The deep interstices produced by externalized buttressing disturbed the space immediately around the cathedral (fig. 41). In some instances, outlined below, this exterior space was already imbued with ritual and legal meaning as part of the cloister that held privileges and immunities. The modern understanding of the social use of these spaces has been hampered by the process of *dégagement*—the demolition of subsidiary buildings around a central structure—and the construction of protective grilles during the course of restoration efforts.[8] The medieval use of these external pockets reflected the individual social processes in a given cathedral precinct and, by extension,

FIGURE 41
Chartres Cathedral, view between buttresses on the south side of the nave. Photo: author.

the way in which medieval people experienced and understood the building's frame.

As a consequence of an increasingly externalized support system, sizable buttress interstices (like those visible at Reims Cathedral) were a nearly ubiquitous part of great-church construction in northern France from the mid-twelfth through the mid-thirteenth century. The size of these recesses naturally varied by site and depended on the design of the buttressing system. For example, the twelfth-century buttresses of the turning and straight bays of the chevet of Sens Cathedral measured 2.35 meters and two meters, respectively, whereas the buttress piers along the nave of Paris Cathedral extended out more than

five meters and therefore created comparatively deeper alcoves.[9] Given the function of the buttress piers, which absorb the thrust transferred to them by the flyer arches, it is reasonable to assume that structural concerns largely explain this variation. At the same time, as Jean Bony noted in his discussion of Chartres, the design of the buttress piers also visually manifested the spatial organization of the cathedral. At Chartres the extent of their projection forcefully articulates the vigorous bay divisions seen throughout the building (see fig. 9).[10] Regardless of the motivations behind any given design, even the comparatively shallow niches created by the relatively modest buttress piers at Sens are sizable pockets, the sides of the piers forming walls that divide a series of ready-made compartments.

The jagged perimeter—complete with buttress interstices open to the exterior—resulted from the adoption of buttressing-frame systems. It was thus part and parcel of construction practices as developed from the second half of the twelfth century through the early thirteenth century in northern France. However, the construction of chantry chapels in these spaces reasserted the planar wall at most sites. As Mailan Doquang has demonstrated, the model for these chapels was likely established by the nave chapels constructed at Paris Cathedral during the episcopate of Guillaume d'Auvergne (1228–49; fig. 42).[11] Similar chapels were subsequently inserted between the buttress piers of many other completed churches.[12] However, the later popularity of chapel construction should not overshadow the functionalism of buttress interstices in its absence. Importantly, neither Chartres Cathedral nor Reims Cathedral received a comparable belt of chapels, despite their relative importance as seats of episcopal and archiepiscopal power, respectively.

It is important to note that even in locations where chapels eventually came to fill buttress interstices, they served as open and potentially mixed-use transitional spaces until that point. This phase in the development

FIGURE 42
Paris Cathedral, exterior view of the chapels on the north side of the nave. Photo: author.

of the church's exterior was not a short-lived blip of architectural history; rather, these interstices were major features of many of France's most important monuments for generations. In their own moment, they were ripe with potential. Before the innovation of chantry chapels at Paris, the empty spaces between buttress piers served both as a present reality and as an imagined future—one that could be understood, experienced, and exploited without any expectation that they would someday be converted to interior, liturgical spaces. Even at Paris Cathedral, the voids between the buttress piers were a physical reality for decades,[13] including the almost nine decades it took for the belt of chapels to reach completion after construction on them began. The prolonged presence of the buttress interstices would have been similar at other sites where chapels were appended to completed buildings.

BUTTRESS INTERSTICES AND THE
ACTIVITIES OF CHURCH PERIPHERIES

Since buttress interstices did not have a predetermined use but instead developed their utility as the support system became increasingly externalized, they were eminently adaptable to local circumstances and social practices. Walled on three sides and open in the front, they offered partially protected spaces in which temporary constructions could house any number of activities. Although surviving medieval churches tend to be isolated from surrounding structures, often as a result of nineteenth-century restoration campaigns or the suppression of the local chapter and subsequent destruction of its supporting structures, the original situation differed starkly. Not only did cloistral and episcopal buildings often abut the exterior envelope of medieval churches, but temporary structures could also take advantage of their permanent stone walls. The resulting dense jumble of stone and wooden buildings created a crowded maze where solemn devotion mingled with mundane routine.

Many of the activities that occurred in and around churches during the later twelfth century and first half of the thirteenth were religious in nature, whether part of liturgy or extraliturgical but nonetheless devotional performance, like popular drama staged against the architectural backdrop of church façades.[14] None of these activities seem to have incorporated the buttress interstices. Processions moved both through the cloister and through the courtyard of the bishop's palace, but these spaces acted only as transitions between altars. Some liturgical instructions omit directions for the particular route, perhaps suggesting that it was of minimal importance or so well known as to make repetition unnecessary.[15] Liturgical dramas only rarely took place in the cloister, perhaps so as not to disturb its solemnity.[16] Other religious performances, like the ceremonial washing of the feet on Holy Thursday, occurred in the chapter house and were thus

removed from the undulating edge of church walls.[17] In summary, the evidence suggests that the semi-open spaces between the buttresses played no liturgical role before chapel construction.

In the vicinity of cathedral walls more generally, however, not only sanctified activities but also a number of more secular enterprises were undertaken. These latter were the activities for which buttress interstices were first appropriated.[18] Church surroundings often housed the institution's secular clergy and their servants. This residential use brought with it the performance of quotidian activities necessary to maintain a household. Other subsidiary buildings also stood near the cathedral proper, including administrative spaces and workshops for the construction and maintenance of the church. Likewise, formal and informal markets often appeared on the parvis or in cloisters, almost certainly owing to the immunities and special privileges that these areas enjoyed as part of the religious landscape and to the numerous pilgrims that passed through them.[19]

These uses of interstitial spaces are depicted in medieval and early modern manuscripts, several of which include images of churches with small, impermanent structures leaning against their walls. The Holkham Picture Bible (ca. 1327–35) and the later Breviary of Eleanor of Portugal (ca. 1500) illustrate commercial use of the area immediately adjacent to a church (figs. 43 and 44). The Holkham Picture Bible depicts Christ driving merchants from the temple in an illustration of Matthew 21:12: "And Jesus went into the temple of God, and cast out all them that sold and bought in the temple, and overthrew the tables of the money changers, and the chairs of them that sold doves."[20] Notably, the activity occurs between the temple in the background and a crenellated wall in the foreground—essentially the space that corresponds to the cloister of an urban French cathedral. Eleanor's breviary includes a scene more explicitly related to its late medieval context. The main illumination shows the dedication of a

FIGURE 43
Holkham Picture Bible, The British Library, London, Add. MS 47682, fol. 20r. Photo © The British Library Board.

church, with vendors in their stalls adjoining the church and additional merchants in the lower margin traveling to the celebration. The traveling merchants bring chickens and a young calf, goods comparable to the ducks and cows hawked by the merchants expelled in the Holkham Bible. It is easy to imagine the temporary wooden stalls situated between two buttress piers.[21] While these images differ insofar as one depicts a biblical event and the other illustrates contemporary society, they both reveal the prevalence of mercantilism in church surroundings.

Later in date but more specific in their depiction of identifiable buildings, a number of early modern engravings show wooden structures leaning against church walls. These include Jules Huyot's engraving of the Palais de la Cité (with shops in a ring around the Sainte-Chapelle, fig. 45) and Adrien Dauzat's lithograph of the collegiate church of Notre-Dame-du-Camp in Pamiers for Charles Nodier and Justin Taylor's *Voyages pittoresques* series.[22] Dauzat's lithograph depicts a wooden-framed porch attached to the northern wall of the church. The roof of this porch rises to the height of the side aisle.[23] Perhaps most relevant to the discussion of buttress interstices is A. M. Mallet's image of the Parisian Convent of the Augustinians, which represents stalls placed between its deep buttresses, though these buttress piers do not support flyers (fig. 46). These images demonstrate the widespread functional exploitation of church edges, even if they postdate medieval social patterns.

FIGURE 44 (OPPOSITE)
Breviary of Eleanor of Portugal, The Morgan Library & Museum, MS
M. 52, purchased by J. Pierpont Morgan (1837–1913) in 1905, fol. 578v.
Dedication of a church. Photo: The Morgan Library & Museum.

FIGURE 45
Jules Huyot, *Veuë du Palais en l'Isle, de la saincte Chapelle et de la Cour des Comptes prise de la tour de sainct Barthelemy*. Bibliothèque nationale de France, Paris, Département des Estampes et de la photographie, VA-225 FOL. Photo: BnF.

Commercialism and the Cathedral Cloister in Reims

While graphic evidence provides the most accessible source speaking to the annexation of church envelopes, surviving medieval documents provide even more explicit evidence of the domestic, administrative, and commercial function of religious precincts and buttress interstices. Extant charters show that such activity occurred along church edges before, during, and after their reconstruction with buttressing-frame systems in the later twelfth and early thirteenth centuries. The cathedrals of Chartres

FIGURE 46
A. M. Mallet, *Quai des Augustins*. Bibliothèque nationale de France, Paris, Département des Estampes et de la photographie, VA-262b FOL/ H043772. Photo: BnF.

duties but also in financial and judicial affairs, through which they generated income. Here the clergy made use of their cathedral's buttress interstices for their economic interests. The resulting valuation of these exterior niches demonstrates their integration into the active life of the cloister and helps explain their persistence as exterior spaces within it.

The area immediately surrounding Reims Cathedral was divided into canonical and episcopal jurisdictions. Although many of the claustral buildings were destroyed in the French Revolution, a sense of their layout survives in the three oldest views of the city (e.g., fig. 47) and in Jean-Gabriel Legendre's 1765 map (fig. 40).[25] The bishop's palace and garden occupied the cathedral's southern flank, stretching from a gate paralleling the west façade to the rue du Cloître. The chapter controlled the area adjacent to the northern flank and immediately to the east of the new chevet. The enclosed courtyard of the cloister extended to the north of the northern transept arm and was framed by communal buildings, including the chapel of Saint-Michel. Many of the canonical houses, which numbered at least twenty-five by the late fourteenth century, occupied the northern and easternmost areas of the cloister.[26] The canonical cemetery lay between the cathedral and this residential area, on land that the chapter acquired from the archbishop, possibly as early as 1207.[27] The hôtel-Dieu stood to the northwest of the cathedral, just off the parvis. The buttress interstices were thus part of the cathedral surroundings but were not part of the walled cloister.

Although the cathedral surroundings included many supporting ecclesiastical buildings, they also hosted more-quotidian activities. As identified by Pierre Desportes in his foundational book *Reims et les Rémois*, several key industries of the regional economy had their primary districts in the vicinity of the cathedral. For example, armorers and swordsmiths occupied the area between the rue du Trésor and the chapter's courtyard, locksmiths the small island of buildings overlooking the

and Reims are particularly evocative in this respect. The contentious relationships among the clergy, the bishop, and the town of Reims have become familiar to art historians thanks in large part to the work of Barbara Abou-El-Haj.[24] In the service of a seignorial episcopate, the clergy were particularly well situated to exercise monopolies to their benefit, a level of authority that the burghers violently resisted in the 1230s. At Reims, the clergy's authority was vested not only in their pastoral and liturgical

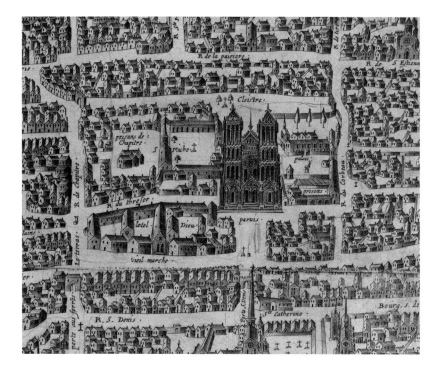

FIGURE 47
J. Cellier, H. Picard, and N. Constant, *Pourtraict de la Ville, Cité et Université de Reims*, Bibliothèque nationale de France, Paris, Département des Cartes et plans, GE BB-246 (IX, 134–35 RES), detail. Photo: BnF.

bishop's courtyard to the south of the parvis, and the *fuseliers* (bobbin and spindle makers) were next to the locksmiths, giving the rue des Fuseliers its name (indicated by "Rue des" in the lower right of fig. 40).[28] Spice merchants and dry-goods shops extended from the north portal of the cloister into the Place Royale.[29] The makers and sellers of these wares hemmed in the sacred district of the cathedral and, especially in the case of the metalsmiths, almost encroached upon it, establishing a dense network of commercial industries on the steps of the cathedral itself.

The mercantilism of the cathedral surrounds extended to the parvis, which housed a small market known as the *Trisandia,* or cloister market, under the exclusive jurisdiction of the treasurer of the cathedral.[30] The treasurer held the right of display for the stalls set up under the portals of the church and on its steps, many of which sold cloth of local manufacture to pilgrims at an inflated price.[31] Later, in 1344, the treasurer's jurisdiction over these stalls came

under dispute with the canons.[32] In his claim, treasurer Reginald cited the aforementioned dispute resolution of 1221 as evidence of his possession and seisin (*saisina*) over the marketplace (*forifaciendium*). The adjudication by a royal court upheld Reginald's claim, ostensibly confirming his jurisdictional rights over the *Trisandia* and the income generated by renting stalls to merchants.

Modern art-historical scholarship has tended to look beyond the specific interests of the treasurer in the marketplace and instead used the 1221 charter as a tool for dating the building campaign of the cathedral. Jean-Pierre Ravaux, who first published the charter, used it to date the eastern bays of the nave, although it now appears that construction of the nave was well underway.[33] Alain Villes, for example, has argued that the document in fact postdates the nave's completion and reflects the treasurer's objections to a wall that had already been built.[34] Dendrochronological and archaeological evidence supports

Villes's proposition that the nave was under construction well before Guillaume issued this resolution.[35] Regardless of the relative chronology of the resolution and construction activities, the very existence of a dispute signals the value of the land to the treasurer—space now subtracted from the treasurer's assets on the exterior of the building through interiorization. The resolution refers explicitly to "*officines*," three small vaulted rooms placed between the buttress piers at bay divisions seven, eight, and nine.[36] Richard Hamann-MacLean has identified these rooms as sacristies.[37] Alternatively, they may have functioned as storage rooms for the cathedral workshop.[38] Whereas the charter grants jurisdiction over the three enclosed buttress interstices to the chapter, the treasurer retained jurisdiction over the other northern buttress interstices, since these were not walled and remained open to the cloister.

While the 1344 adjudication does not specifically mention stalls placed in the northwestern buttress interstices, their likelihood is attested by a third document, from 1384, which explicitly references boutiques placed between the buttress piers of the chevet.[39] The chapter rented out these structures "enfixez entre les pilliers d'icelle" (affixed between [the cathedral's] buttresses) to haberdashers and booksellers for about four livres per year, a substantial rent. The pockets of space between the buttress piers of the nave were larger than those of the chevet, and given the active mercantilism along the rue du Trésor and under the portals of the west front, they were undoubtedly part of the commercial landscape, especially given the fact that the treasurer's jurisdiction extended to this area. The 1221 dispute suggests that the potential economic value of these places generated competition, particularly as the chapter expanded its influence in the area around the cathedral by limiting the treasurer's ability to exercise his traditional claims of authority.

In combination, the three documents reveal that the treasurer and clergy exploited the Reims buttress interstices as part of a terrestrial market instead of a spiritual one. They demonstrate the effect of the rebuilding process on the political geography of the cathedral precinct and the clear distinction between the interior of the cathedral and its surrounding exterior places. The mercantile use of the buttress interstices effectively integrated the religious topography of the church with the earthly needs of its members, forming a transitional zone that mediated between the spiritual and the mundane. Similar commercial activity took place on the exterior of the cathedral of Chartres, producing comparable disputes over space and the control of the outer edge of the church frame.

Commercial Activity in the Cloister at Chartres

Modern scholars have long highlighted the systematic and sustained economic exploitation of the cathedral cloister at Chartres and the role of this exploitation in the local strife between the canons, bishop, and local seignory.[40] At Chartres, ecclesiastics took unusually full advantage of the liberties granted to their cloister, which were reconfirmed on multiple occasions, by bringing tradesmen and serfs to live there as part of their ecclesiastical "family."[41] Once in the cloister, the goods and services procured from these ecclesiastical serfs or *avoués* were no longer subject to the count's taxes. This practice, which preceded construction of the new cathedral, speaks to the value of the cloister for the ecclesiastical community, in terms of both its financial worth and its importance as a means of establishing the ecclesiastical community's authority, a situation comparable to that at Reims. The counts and countesses resisted—sometimes violently—the revenue loss stemming from the chapter's annexation of production and trade.[42] The resulting enmity came to a head in a series of attacks and riots in the cloister between 1210 and 1253, prompting the chapter and bishop to exile themselves until 1258.[43] The canons returned only after securing the authority to build a defensive wall, for an exorbitant one-time payment of

FIGURE 48
Plan de la ville de Chartres en 1750, Bibliothèque nationale de France, Paris, Département des Cartes et plans, GE C-6822, detail. Photo: BnF.

1,000 livres and an additional annual rent of twenty livres. This wall went unrealized until the fourteenth century.[44]

The cloister at Chartres occupied a narrow U-shaped belt of open space to the north, west, and south of the cathedral (fig. 48). The north side of the cloister housed the chapter's administrative buildings, many of which Adolphe Lecocq catalogues in his "Historique du cloître Notre-Dame de Chartres."[45] He notes that it accommodated the houses of the altar boys, the notaries of the chapter, the cathedral works, the cleric of the cathedral works, the wax works (*cirerie*), the *maison de l'horlogeur*, and the *maison des mortiers*. This last, as Lecocq remarks, served as a storehouse for the cathedral works and was

located near the *horlogeur* and next to diverse buildings for the servants of the church. The *maison d'ardoise*, which Jean Laurent locates to the east of the *maison des mortiers*, was also on the north side of the cathedral—according to Lecocq, "at the foot of the old bell tower."[46] The northern cloister thus housed part of the ecclesiastical operations, though many were not liturgical in and of themselves.

The south side of the cloister faced the town and generally catered to the laity. This is where the majority of the commercial enterprises were located. Lecocq describes boutiques festooning canonical houses and the hôtel-Dieu, which lay to the southwest of the cathedral. These shops sold a variety of goods, from butter to charcoal,

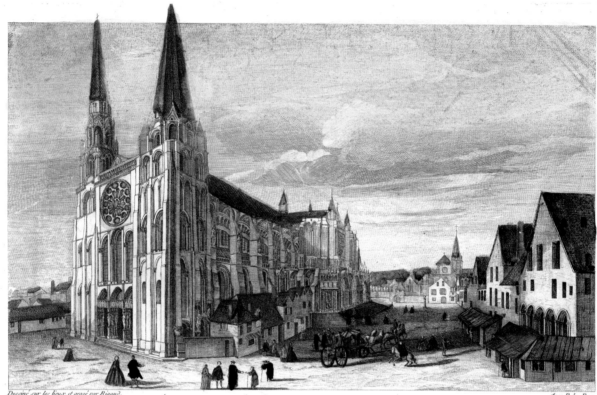

VUE EXTÉRIEURE DE L'ÉGLISE DE NOTRE-DAME DE CHARTRES.
A Paris, chez Rigaud, rue S.t Jacques, vis-à-vis le College du Plesis.

FIGURE 49
J. B. Rigaud, *Vue extérieure de l'église de Notre-Dame de Chartres*, 1760–80. New York Public Library, New York, object. no. 61403. Photo: Print Collection, Miriam and Ira D. Wallach Division of Art, Prints and Photographs, The New York Public Library, Astor, Lenox and Tilden Foundations.

with a particular focus on religious trinkets (presumably aimed at pilgrims).[47] At the beginning of the eighteenth century, the cloister contained thirty-three canonical houses. As described in the sixteenth century by the historian Duparc, these were magnificent stone buildings, each many times larger than those found elsewhere in the city.[48]

Most of the cloistral structures were torn down in the *dégagement* of the cathedral.[49] Fortunately, several etchings and photographs document their relationship to the church before their demolition. For example, a 1730s engraving by J. B. Rigaud depicts a series of houses that abut the south side of the cathedral nave (fig. 49). A short wall running from the south bell tower to the westernmost domicile cuts off this residential area from the activity of the open cloister yard. Similarly, Louis Boudan's 1696 engraving of the cathedral[50] and Nicolas-Marie-Joseph Chapuy's later drawings published in *Vues pittoresques de la cathédrale de Chartres* from 1828 both show a low horizontal building that runs from the north transept

porch to the *pavillon de l'horloge*, presumably the *maison de mortiers* discussed by Lecocq. In their proximity to the cathedral nave, these auxiliary buildings, which support the cathedral and its community, co-opt the exterior buttress interstices. As a consequence, the cathedral and its subsidiary structures connect, forming a bridge between the church and its surroundings. The result is a physical space where the cathedral partially encloses the activities and people necessary for its maintenance.

Although these images form an important record, they do not necessarily reflect the cloister's late medieval reality. To the contrary, they all significantly postdate the fourteenth-century completion of the enclosing wall, which increased the separation of the cloister from the town. Before completion of the wall, the transition from the ecclesiastical to the nonecclesiastical spaces of the town would have been more fluid. A lesser intervention was the construction of the *pavillon de l'horloge*, built around 1520 by Jehan de Beauce just to the west of the *maison des mortiers*.[51] Finally, it is likely that the auxiliary buildings in the cloister, particularly the shops erected by merchants, became increasingly orderly and integrated with the dominant ecclesiastical structure of the cathedral over time.[52] This increasing monumentalization, combined with the ever-diminishing importance of the fairs, transformed the cloister's built environment.[53] Consequently, these images only aid in reconstructing the physical reality of the late medieval cloister to a point. They must be balanced against the documentary evidence, which suggests that temporary structures were likely more numerous in the thirteenth century.

As at Reims, one of the buttress interstices formed part of Chartres's interior from the outset, demonstrating that they were recognized as useful spaces by at least 1200, if not earlier. This space survives today as the Vendôme Chapel, Chartres Cathedral's sole lateral chapel, located on the south side of the nave and two bays west of the crossing (fig. 50). Louis de Bourbon, Count of Vendôme,

FIGURE 50
Chartres Cathedral, Vendôme Chapel exterior. Photo: Sarah Thompson.

founded the chapel in 1413, and mason Geoffroi Sevestre began its construction in 1417.[54] Although the upper parts of the chapel date to the fifteenth century, Sevestre's work rests on an earlier foundation, probably original to the 1194 project and constructed around 1200.[55] Surviving sections of the "first-build" fabric include the chapel's supporting arch and parts of its lower walls.[56] The foundation

document reinforces the inference of a preexisting enclosure between the buttresses. It states that the count had ordered the chapel "constructed anew and founded in the church," implying rebuilding instead of new building of a structure on a blank canvas.[57]

The early thirteenth-century function of this enclosed buttress interstice remains elusive. Jan van der Meulen has proposed that it might have served as a sacristy for the provisional church in use during construction.[58] John James prefers to interpret it as a place for the bellows of the nave organ.[59] As with the "*officines*" at Reims, a dearth of architectural and textual evidence precludes a definitive identification of the chapel's original function. However, it is reasonable to assume that it served a supporting role in the liturgical activities of the cathedral, especially given its position near the pulpit on the canon's side of the church. Van der Meulen dates the present sacristy to the third quarter of the thirteenth century, a date confirmed by its grisaille glass.[60] It is possible that the construction of the new sacristy rendered the earlier space redundant, leaving it available for repurposing as a private chapel in the early fifteenth century.

The income raised by Louis's foundation of the Vendôme Chapel and its associated liturgy was substantial. In all, the canons received seventy-three *livres tournois* per year for the celebration of services in his honor.[61] Although this is by no means the largest gift for the establishment of a chaplaincy in France, it is nonetheless a monumental sum. Louis's gift highlights the powerful financial incentive for establishing chantries and accommodating those Masses with the specialized setting of additional altars placed in lateral chapels. However, at Chartres the canons did not actively pursue the construction of additional spaces for these commemorative liturgies. I suggest that the buttress interstices already provided sufficient value as exterior spaces to offset any enticement for their enclosure. This valuation would have stemmed from their established use for buildings like the *maison des mortiers* and from the exploitation of their inviolability to demonstrate clerical authority against that of the local lord.

The commercialization of the cloister predated construction of the Gothic cathedral and continued until the eighteenth century.[62] Throughout this period it was common practice to establish a stall or shop adjacent to one of the cloister's more permanent structures during the major feasts of the Virgin, which seem to have attracted primarily local pilgrims.[63] An undated entry in the cartulary of Chartres records a charter issued by Pierre de Celle (bishop 1181–83) relating an agreement between the canons of the cathedral and the bishop.[64] It stipulates that merchants could set up stalls under the canopy of a canon's house if the canon did not object. The merchant would assign custody of such a stall to one of the canon's servants for a small fee. The dean's servants took custody of shops located elsewhere and received those payments. For the sake of convenience, merchants could erect their stalls the night before a fair, but canons could seize the goods from stalls set up on any other day. The charter further states that merchants should not block the streets of the cloister and that space had to be left for two men to walk abreast. Again, merchants who did not comply with these regulations could have their goods confiscated.

In addition to income generated by the fairs, the active vending of agricultural surplus in the cloister also benefitted the canons and their servants. For example, in 1195, the archbishop of Sens and his archdeacon, serving as a judge's delegates, adjudicated an agreement between the chapter of the cathedral of Chartres and the countess Alix de Blois regarding the permitted activity of the burghers (*burgenses*), those men and women who served an ecclesiastic.[65] The resolution, copied into the cartulary of Chartres, reaffirms the immunity of the cloister for the canons and their lay servants. It further specifies that the servants could buy and sell food and other provisions (*annonam*) at harvest time, wine during the vintage, and wool made

from the fleece of their sheep in the cloister—and thus escape the burden of the count's taxes. As Jane Welch Williams has discussed, the canons' engagement in the wine trade in the twelfth and thirteenth centuries likely indicates that they were operating a tavern in the cloister by this time, a practice that is explicitly documented only in the early fourteenth century.[66] The degree to which buttress interstices provided usable places to facilitate this commerce is unclear, although it is easy to imagine them as storage areas, workshops, or stalls. Moreover, even if they provided no usable ground, in the context of commercial exploitation, they carried an inherent value as part of the inviolable cloister through which the canons exercised their authority and generated income.

A charter recording the resolution of a dispute of 1224 provides some indication of the location of merchant stalls after the cathedral's rebuilding with its present buttressing-frame system. It reads:

> We decree to each and all, both laypersons and clerics, who have convened for the purpose of electing a Dean, that the stalls of the mercers that used to be [on the porch] (*in capitellis*), shall be located in the cloister, on the southern side, between the stair of the church and the greater tower. We decree this in such a way that all rights of justice over the stalls and the houses in which they are located and the mercers themselves shall belong to the chapter, and he who shall be elected Dean will not be able to claim otherwise; these rights shall be possessed by the chapter in full liberty as they are now, in the place where they are today located, that is, on the plot that used to belong to Archdeacon Milo. Done in the year of the Lord 1224, in the month of May, on the octave of the Ascension of the Lord.[67]

Art historians have used this document to date the south transept arm, arguing that it was necessary to move the stalls from the temporary wooden porch to make way for the construction of the current stone one.[68] However, the charter makes no mention of new construction or building in the area of the *capitella* but rather stresses the chapter's jurisdiction over the stalls. It records the consolidation of the chapter's powers vis-à-vis the dean—the chapter took advantage of Milo's death to further its own agenda—and not the construction of the transept.[69] As dean, Milo would have held jurisdiction over the cloister during fairs and received payment for stalls erected there, except for those located under the eaves of canonical houses. This charter cuts off the future dean from a source of profit derived from those fairs, establishing the chapter as the beneficiary of taxes imposed on the mercers—even after the dean's election. The charter then underscores the value of the cloister by documenting the internal conflict between the dean and the chapter for jurisdiction within it, essentially renegotiating the division outlined by Pierre de Celle in the 1180s.

Although we do not know precisely where Milo's plot was located, the document reports that the stalls would be set up "between the stairs of the church and the great tower" (*inter gradus ecclesie et majorem turrim*), referring to the area between the stairs leading to the south transept porch and the *tour le comte*, now the place Billard.[70] This would include the line of small houses along the south side of the nave, discussed above. Rigaud's tranquil engraving (fig. 49) does not depict any market stalls attached to these houses, although Rigaud does include a line of lean-tos resting against the buildings across the open space of the cathedral close. However, since Pierre's earlier charter specifically stipulated that merchants not block the streets, it is reasonable to extrapolate a density of stalls packed against every possible surface, especially since the practice of establishing stalls under the eaves of houses is well documented.[71]

The area just to the west of the south transept arm, nestled between the stairs, buttress piers of the transept,

and the easternmost house, may have made a particularly desirable place for a shop. As pilgrims entered and exited across the south porch they would have passed by any stall located here. Rigaud's engraving does not provide a clear view of this area, and even so, it may well reflect subsequent changes to the cloister. It is therefore unclear how accessible this area was in the thirteenth century. The possibility finds some circumstantial support in Lecocq's report that the servant of the cathedral works, who lived in a part of the *maison d'ardoise,* was also allowed to sell small religious objects, although this is chronologically distant from the 1224 dispute.[72] It is possible, since this building occupied a similar position on the north side of the cathedral, that jurisdiction over it was comparable to that over the shops near the south transept. Despite the uncertain reach of Milo's jurisdiction, the 1224 resolution reveals that the chapter adjusted the placement of merchant stalls on the eve of the cathedral's completion. In other words, they adapted the traditional commercial exploitation of the cloister to fit its new spatial realities at a politically opportune moment.

The profits derived from stalls in the Chartres cloister could be substantial, and the rents were reliable over the long term (rents are recorded as late as the eighteenth century).[73] Lucien Merlet reports a price of twenty *livres tournois* for a small *logette* under the portals of the church in 1446.[74] In the same year exclusive rights to erect a stall beside the house of the altar boys (*enfans d'aube*) cost six *livres tournois,* and in 1494 rights to place a stall under the portal cost eight *livres tournois.*[75] These prices indicate that such rentals were in high demand, reinforcing the image of intense jockeying for space (conveyed by the 1181–83 regulations) and of internal tensions between chapter and dean (revealed by the 1224 charter). In addition, they provide the most tangible expression of the potential worth of cloistral space, a value that stemmed from its inviolability and proximity to the cathedral, which provided financial benefit and potential patrons.

In summary, the evidence suggests that the chapter was quick to exploit the peripheral spaces around their new cathedral for utility and profit, locating auxiliary structures along its nave and adapting an existing mercantile practice to the reformulated cloister. The area between the buttress piers was entangled with the larger activities of the cathedral district—administrative, residential, and mercantile. In these capacities they likely served as workshops, yards, or storage, as sometimes happened with the rear of plots in commercial districts.[76] Although it is more difficult to fix a value for these spaces, as part of the cloister they received all of its freedoms and rights, and their functionality imbued them with inherent worth. While the potential revenue from lateral chapels was significant—if Louis's gift can be taken as a benchmark for potential chapel-related revenue—it necessitated the loss of space to which the chapter already held rights. Thus, the interiorization of buttress interstices came with a clear opportunity cost. Since the commercial activity of the cloister was deeply entrenched in the history of Chartres (predating the rebuilding of the cloister) and at the heart of the power struggle between bishop, chapter, and count, the value of the exterior space may have been held in particularly high regard by the cathedral clerics. In this case, expansion of the interior does not seem to have been worth the loss of exterior space. The result was the ultimate triumph of the buttressing piers as freestanding structures, the projection of which physically linked cloister to cathedral.

Chartres and Reims exemplify cathedral precincts where commercial exploitation of the holy ground of cathedral flanks imbued buttress interstices with value. Disputes over the jurisdiction rights to this area and co-option of buttress interstices for auxiliary structures demonstrate their careful regulation in the religious landscape. In both cases, lay access to the cloister and cathedral flanks facilitated their secular appropriation. The value of these exterior spaces had limits, however, as shown at the cathedrals of Paris and Laon.

LIMITS TO THE VALUE OF EXTERIOR BUTTRESS INTERSTICES

Paris Cathedral

In contrast to Chartres and Reims, where surviving texts demonstrate an eagerness to accommodate secular activities adjacent to the cathedral's walls, twelfth- and thirteenth-century statutes encouraged the elimination of nonreligious functions from the lateral façades of Paris Cathedral.[77] Instead of regulating an area of mixed use, the surviving documents suggest a greater anxiety over nonclerical access to the cloister, which in turn limited the possible functions of buttress interstices. While the goal of perfect solemnity met some obstacles, it prevented the clergy from establishing a uniform, institutionalized nonreligious use of the cathedral envelope.[78] As a result, by the thirteenth century the buttress interstices had little utility as exterior spaces. Since the clergy had less opportunity to institute their jurisdiction over these spaces through commercial or utilitarian exploitation, they were ripe for repurposing through interiorization.

The buttress interstices of Paris Cathedral formed part of a new sacred topography largely formulated by Maurice de Sully, bishop of Paris, to accompany his project for a new church in the 1160s.[79] This included the creation of the rue Neuve and the construction of a new bishop's palace and hôtel-Dieu (figs. 51 and 52). Following this reconfiguration, the buttress interstices on the north stood along the rue du Cloître, a small alley that followed the cathedral's northern flank, under the exclusive jurisdiction of the chapter. The cloister itself was essentially a loose agglomeration of buildings that extended from the banks of the Seine just about to the plane of Maurice de Sully's façade, laid out by the time of his death, in 1196, and the present rue d'Arcole.[80] It was at least partly walled by the twelfth century, as documented by a charter of 1110, which mentions the "walls of the cloister of the Blessed Virgin."[81] The focal point of the cloister was the chapter building, which stood to the south of the cathedral. It housed the library, chapter room, hall of justice, and other communal spaces.[82] Most of the buildings of the cloister were residences, which totaled thirty-seven in the early fourteenth century. Thirteen additional canonical houses lay outside the cloister proper, but they enjoyed the same rights and protections.[83] The other major ecclesiastical body, the office of the bishop, controlled the buttress interstices on the south side of the cathedral, which faced the episcopal gardens and palace. All of the buttress interstices thus fell within a protected enclave.

The area west of the cathedral seems to have been a vibrant commercial district since the early Middle Ages.[84] However, statutes and other legal agreements governing mercantilism in the cloister and episcopal compound record limits to the commercial exploitation of the immunities these areas enjoyed. For example, in 1222 Philippe II Auguste and Bishop Guillaume de Seignelay (1220–23) concluded an agreement concerning their respective rights within the city, an accord that documents the increased power of the king and bishop.[85] It designated fifteen tradesmen who would remain free from royal taxes due to their indispensability to the bishop. They included a draper, cobbler, mason, carpenter, grocer, baker, and butcher—the butcher distinguished from the others through the designation of his location "on the parvis."[86] Notably, the liberty of these artisans was justified by their service to the bishop, presumably indicating their utility to the church and its pastoral mission. By implication, the market for these wares was the ecclesiastical community, which would benefit from reduced prices. It does not, however, suggest an exploitation of the cloister comparable to that seen at Chartres, where the canons actively engaged in commercial exchange with the laity.

In Paris, commercial activities adjacent to the cathedral that were aimed at a lay audience seem to have been confined to the parvis, which lay outside the cloister and episcopal compounds and therefore away from the

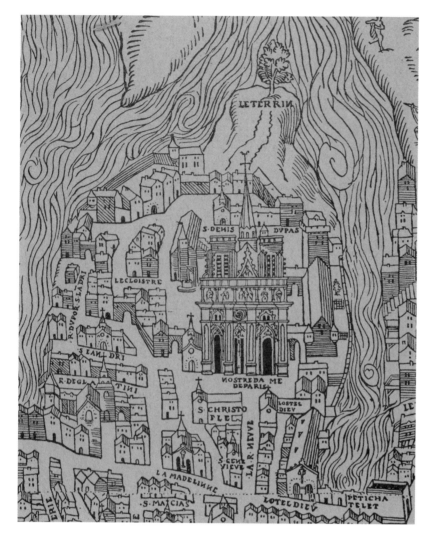

FIGURE 51
Olivier Truschet and Germain Hoyau, *Plan de Paris sous le règne de Henri II*, detail. Photo: Courtesy of the University of Oregon Libraries.

buttress interstices. It accommodated the *foire au jambon*, held during Holy Week; an annual onion market in September; and a weekly Sunday market where bakers sold their waste bread.[87] Despite the proximity of this trade to the cathedral, the extent to which the bishop or the chapter may have profited from it remains unclear. The 1245 "Statutes and Ordinances of the Church," issued not by the chapter or the bishop but rather by a papal legate, outline a number of restrictions on the accessibility and activities of the cloister.[88] Among other things, the statutes

prohibit the sale of candles within the church, an activity likely aimed at a largely lay audience. The purpose of this restriction was to preserve the sanctity of the interior space by removing the taint of commercial transactions to the area outside the church, presumably the parvis. A later document, from 1272, stipulates that candles sold on the parvis could be taxed by either the bishop or the chapter and, further, that neither party could provide stalls for the merchants.[89] Similar limits may have extended to the sale of other goods on the parvis, essentially preventing the

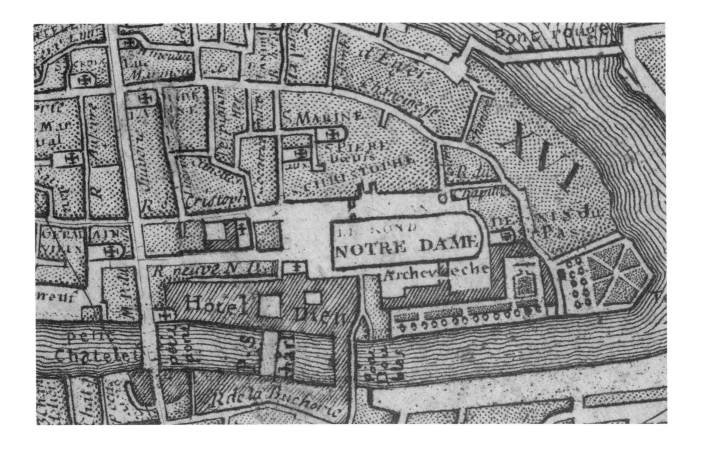

FIGURE 52
Jean Delagrive, Martin Marvie, and Pierre-François Charbonnier, *Plan de Paris divisé en seize quartiers: En execution de l'Ordonnance du Bureau de la Ville du 24. février 1744*, detail. Photo: Courtesy of the University of Oregon Libraries.

ecclesiastical community from profiting from trade in the cathedral precinct.

Beyond restricting the sale of candles, the 1245 statutes essentially codify the rules governing ecclesiastical behavior as outlined at Lateran IV in 1215. They promote clerical celibacy and the decorous pastoral care of women, while they also guard against inappropriate theatrical amusements and—as discussed above—the corrupting

stain of mercantilism within the church. These regulations stemmed from larger reform movements that, among other things, aimed to elevate the clergy by distinguishing them from the laity.[90] The Parisian statutes find parallels with several canons from Lateran IV, including canon 14 (concerning clerical celibacy), canons 15 and 16 (outlining prohibitions against clerical drunkenness and secular entertainments), and canon 65 (against the extraction of money for sacraments).[91] That a deputy of Innocent IV (r. 1243–54), rather than the local Parisian ecclesiastics, instituted these statues may indicate that the canons had been lax in conforming to proper behavior. It also suggests that the upper echelons of the Church hierarchy did not hesitate to intervene in the cathedral's business, perhaps due to its cultural importance as the cathedral of one of

Europe's largest cities and its location in the capital of an increasingly powerful kingdom.

The final clause in the 1245 statutes forbids a number of potentially distracting behaviors, including the keeping of dangerous and entertaining animals (like bears, ravens, and apes) and the establishment of taverns. Prohibitions against taverns and the sale of wine in retail (vs. wholesale) were enacted in 1328 and reenacted in 1411 and 1435, suggesting that this was a commonly transgressed statute.[92] Canons were allowed to sell wine in gross but could not consume it in their houses in any way that resembled drinking in a tavern.[93] These restrictions would have ensured moral behavior within the cloister and around the edges of the cathedral, again suggesting concerns over decorous behavior and perhaps reflecting moralistic preaching like that of Humbert de Romans, a Dominican friar who composed treatises defending Church-reform movements.[94] However, restrictions governing the sale of wine also limited a potential source of income, one that the canons of Chartres seem to have exploited to great success.

The moral stance against drunkenness finds parallels in restrictions against animal entertainments. Canon 15 of Lateran IV prohibits the clerical ownership of animals for the purposes of hunting or fowling, and canon 16 forbids clerics from attending "the performances of mimics and buffoons" as one of its restrictions on secular entertainments.[95] The 1245 statutes against animals likely drew from this model. It is also worth noting that Guillaume d'Auvergne specifically singled out bears as intermediaries for succubi, a type of demon.[96] Moreover, the unnatural actions of performing animals, which were trained to reject their animalistic tendencies, positioned them as just the sort of hybrids that so often illustrated spiritual or moral deformity, suggesting that such shows may have been particularly distasteful to reformers.

Beyond commerce, the lure of scholasticism also drew a large lay audience to the cathedral. In the first part of the twelfth century, masters of the cathedral school lectured within the walls of the cloister and episcopal compound. While the buttress interstices might have made convenient cubicle-like classrooms, the canons and bishop had essentially exiled education from their territory several decades before Maurice undertook construction of the new cathedral. An 1127 dispute resolution between the canons and Bishop Étienne de Senlis banned canons from renting their houses to foreign students (*scolares extranei*) and moved teaching from the cloister to a new enclosure on the southern side of the cathedral, by the bishop's palace.[97] Not only were students (other than those who were also members of the Parisian chapter) now essentially excluded from the cloister, but Étienne also constructed a new building specifically to accommodate the increasingly prevalent activity of teaching. According to the charter, this restriction was made to "confirm peace, and to avoid strife and disturbance."[98] This wording implies that the students disrupted the daily activities of the canons as they went about their pastoral tasks. Parisian preachers complained of students' quarrelsome nature and fixation on temporal gratification.[99] Letters from students and their parents document the former's "dishonorable practices," lending further credibility to the Parisian clergy's stated reasons for expelling them.[100]

The university charter made by Bishop Maurice de Sully in 1160 extended restrictions against student habitation in the cloister by prohibiting canons not only from renting space in their houses to any students but also from offering them any hospitality.[101] In the 1220s the majority of university life occurred on the left bank, with those masters still teaching in the area around the cathedral limiting themselves to the parvis.[102] The 1127 dispute resolution strongly suggests that none of the parties involved wanted the students close to the sanctuary of the cathedral's religious space. As with vending, the elimination of students was tied to morality and the need to preserve the cloister's sanctity. Although it predated construction

of the new cathedral, with projecting buttress piers, the expulsion of students attests to a long-standing practice whereby the clergy maintained authority by distinguishing itself from the laity. Areas to the north, east, and south of the edifice became the exclusive domain of the chapter or bishop, whereas the parvis, separated from the buttressing frame, remained an active site of mixed use, a transitional space where secular and lay activities intertwined.

Admittedly, surviving documents do not provide a clear-cut picture of activity (or lack thereof) at Paris between the substantial protrusions of the buttress piers before the construction of chapels. The 1245 statutes suggest a general state of clerical corruption, and it is delightful to imagine wealthy canons enjoying the spectacle of dancing bears performing in the approximately seventeen-square-meter alcoves around the cathedral's edge. Although this image is likely fanciful, the absence of any surviving dispute resolution or agreement about income generated by activities (like vending) within the cloister perhaps speaks the loudest against any regular or systematic exploitation of the spaces created by the cathedral's exposed support system, especially given the often contentious relationships among the clergy, bishop, and king.[103]

At Paris it was the parvis, and not the cathedral's lateral façades, that served as the major transitional space between the church and its surroundings. Physical barriers to the cloister and episcopal compound and legal barriers to their secular exploitation limited the potential value of buttress interstices as exterior spaces—even as these restrictions productively distinguished ecclesiastical from lay places. I suggest that the absence of value made the buttress interstices at Paris ripe for architectural experimentation, ultimately facilitating their interiorization. With this innovation the clergy risked very little while gaining a new expression of the church's authority in pastoral care, as Mailan Doquang has noted.[104] It was

not their illicit use, but rather the absence of use, that may have expedited their appropriation.

Laon Cathedral

Laon Cathedral is one of many sites where chantry chapels were inserted between the buttress piers following the model established at Paris. I suggest that the buttress interstices of Laon were, like those of Paris, underused before their interiorization.[105] As at the royal capital, barriers to access limited the use of its buttress interstices. The chapter's strict control of the cloister for liturgical and security purposes made them unproductive as exterior spaces. Nevertheless, where the buttress interstices were accessible, the ecclesiastical community quickly transformed them into part of the commercial landscape. Here, for a time, they functioned as a transitional area akin to the more open cloister at Chartres.

The reconstruction of Laon Cathedral, begun around 1155, transformed its immediate surroundings (fig. 53).[106] These changes resulted from the rebuilding of the cathedral's subsidiary structures, including the cloister proper and new hôtel-Dieu, as well as from the reimagining of the cathedral envelope, replete with prominent buttress piers (though originally devoid of flyer arches). Nineteenth-century restorations by Émile Boeswillwald have handicapped attempts by modern scholars to date the appearance of flying buttresses at Laon. Following Eugène Lefèvre-Pontalis's repudiation of flying buttresses before the thirteenth century, scholars have traditionally assigned those at Laon to around 1220, part of a later stabilization project.[107] William Clark and Richard King have subsequently revised this dating to between roughly 1185 and 1195, the time of the fourth construction campaign, which included construction of the western portion of the nave.[108] This modification of the cathedral's existing structural system was minor; builders simply added buttress uprights and flyers to the top of the buttress piers, the form of which had already been established

FIGURE 53
Émile Boeswillwald, floor plan for the ancient cathedral of Laon, with cloisters, March 15, 1847. Médiathèque de l'architecture et du patrimoine, Charenton-le-Pont, France, inv. 04R05864. Photo © Ministère de la Culture / Médiathèque du Patrimoine, Dist. RMN-Grand Palais / Art Resource, New York.

spur buttresses. Their corresponding interstices thus constitute an important link between the use of exterior church walls before adoption of flying buttresses and the use after. Nonetheless, the buttress piers at Laon project markedly from the nave, in line with the well-recognized trend toward more powerful, increasingly externalized buttressing in the mid-twelfth century and with it a more plastic, punctuated wall. The intervening spaces between Laon's buttress piers formed potentially usable spaces, like those at Chartres, Reims, and Paris, even though they did not originally support flyers. Moreover, with the addition of flyers by the end of the twelfth century, Laon featured a buttressing-frame system equivalent to those of Reims, Chartres, and Paris cathedrals.

Following completion of the nave, work began on a small rectangular cloister (figs. 54 and 55). A gallery of eleven vaulted bays, stretching from the southwest corner of the southern transept to the Chapelle des Fonts, enclosed the area immediately adjacent to the south side of the cathedral's nave.[111] The chapter house stood within the cloister such that only a narrow strip of space lay open between it and the cathedral to the north or gallery to the south. Just outside the cloister, next to the south side of the cathedral's west front, was the hôtel-Dieu, later repurposed as storage and assembly hall following the construction of a larger hospital to the north.[112] The canons' residences, built in the twelfth and thirteenth centuries, largely stood beyond these buildings, to the south of the cathedral, on the rue du Cloître and two small alleyways that gave way to the rue Sainte-Geneviève (now the rue Georges Ermant). A wall, punctured with four gates, divided this canonical precinct from the town, although by the fifteenth century the number of houses had increased to the point where the established walls could no longer contain them.[113] The physical arrangement of the cloister meant that the buttress interstices along the south side of the nave were essentially inaccessible to the town, sitting behind both the outer cloister wall and the

in the previous three campaigns. Masons augmented all existing spur buttresses to accommodate these features.[109] The present restored form conforms to that used in the reconstruction of the choir from around 1205–20, effectively erasing their differences as executed as part of two distinct construction phases.[110] The buttress piers at Laon are substantially shallower than those at Paris, probably because they began as comparatively simple

FIGURE 54
Johannes Janssonius, *Laudunum, Vulgo Laon en Picardie*, detail. Bibliothèque nationale de France, Paris, Département des Cartes et plans, GE D-14360. Photo: BnF.

FIGURE 55
Laon, plan of the canonical quarter at the start of the fourteenth century. From Alain Saint-Denis, "Laon," in *Les chanoines dans la ville: Recherches sur la topographie des quartiers canoniaux en France*, ed. Jean-Charles Picard (Paris: De Boccard, 1994), fig. 119.

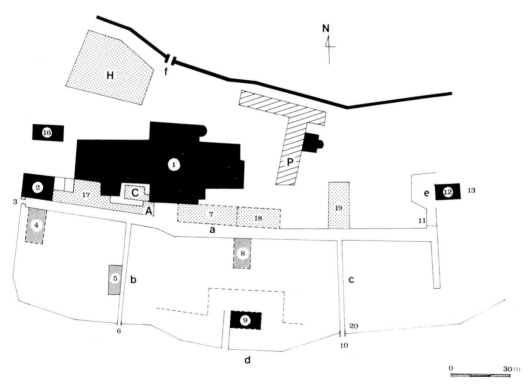

A cloister
C chapter house
H hospital
P episcopal palace

1 cathedral of Notre-Dame
2 church of Saint-Remi-à-la-Porte-du-Cloître
3 cloister gate
4 oven with bakers' houses
5 canonical house
6 gate
7 *cloîtreau*
8 house of Jacques de Troyes
9 collegiate church of Sainte-Geneviève
10 gate
11 gate
12 collegiate church of Saint-Pierre
13 oven with baker's house
16 church of Saint-Martin
17 storeroom, meeting room
18 choir school (*maîtrise*)
19 charter room
20 canonical house

a rue du Cloître
b ruelle à la Vaulte
c ruelle Rouge
d rue Sainte-Geneviève
e place Saint-Pierre.

vaulted gallery. The cramped space of the cloister, largely taken up by the chapter house, further prevented access to their open side.

The buttress interstices of the chevet were equally inaccessible to potential vendors and shoppers. The bishop's palace and chapel stood behind a gated wall (not shown in fig. 55), which extended from the north transept.[114] The northern limit of this episcopal territory lay at the city wall, and the rue du Cloître bounded its southern extent. Consequently, the buttress interstices of the thirteenth-century chevet lay behind the walls enclosing the court, palace, and garden of the bishop. A single fortified entrance on the western side allowed access into the episcopal compound. A history of violence between the bishops and citizens of Laon may explain the presence of defensive fortifications. Guibert de Nogent in his memoirs, vividly describes the assassination of Bishop Gaudry in 1112: "A great crowd of burghers attacked the episcopal palace, armed with rapiers, double-edged swords, bows, and axes, and carrying clubs and lances."[115] Gaudry suffered two mortal blows, and the mob then desecrated his corpse by hacking off its legs, stripping it naked, and throwing it into a corner by the chaplain's house.[116] Tensions between the burghers and Gaudry's successors continued into the thirteenth century.[117] Such a history of violence makes it unlikely that townspeople had easy or regular access to these spaces, and therefore the functionality of the chevet's buttress interstices as exterior-space income generators was probably limited.

The buttress interstices on the north of the nave enjoyed much greater accessibility. Yet it was not the chapter but the castellan who initially controlled this territory. At the beginning of the thirteenth century, the chapter decided to construct an enlarged hôtel-Dieu to the north of the nave (where the Maison des arts et loisirs is now located).[118] The canons' acquisition of land in this area intensified jurisdictional tensions by impinging on the *mansus* of the castellan, which comprised the space between the parvis, the northern rampart, and the episcopal palace.[119] The buttress interstices of the north side of the nave opened onto this same area, and the canons quickly assumed rights over these spaces as well. As at Chartres, the canons constructed houses and small shops between the buttress piers.[120] The castellan, who may have felt hemmed in on both sides, disputed the chapter's rights to this area and organized a series of attacks on the stalls to assert his jurisdiction, first destroying part of a house and then later knocking down all the shops.[121] The settlement required him to pay amends.

The dispute between the clerics and the castellan underscores the marginal status of the buttresses and their interstices, which occupied a gray area between the orbits of clerical and castellan authority. Whereas the canons clearly saw the buttress interstices as their property, the castellan believed them to be under his jurisdiction. The canons' claim demonstrates their status as part of the church, even as the use of the space had no liturgical relevance. Moreover, the episode also illustrates how the chapter's commercialization of these exterior niches increased their power within the larger ecclesiastical district. It is difficult to deny that the canons' use of the buttress interstices coincided with the hôtel-Dieu project and the general dissolution of the castellan's holdings. However, it was only on the north side of the cathedral nave where the buttress interstices stood open to conflicting interpretations. Those along the south side of the nave and chevet were clearly ensconced within physical barriers delineating clerical or episcopal jurisdictions.

Although only some buttress interstices seem to have been transformed into merchant spaces, commercial enterprises were not limited to the cathedral's northern edge. In the thirteenth century, vendors of religious objects, candles, and other merchandise displayed their wares on the parvis, an area controlled by the treasurer.[122] Beyond the parvis butchers and fishmongers flanked the

rue Châtelaine (a western continuation of the rue du Cloître) on its south and north sides, respectively. Even while the clergy benefited from the commercialization of part of their holy precinct, they did not embrace these less decorous shops. From 1158 to 1262, charters repeatedly placed limitations on the siting of fishmonger and butcher stalls near the portals of the cathedral; these restrictions stemmed from the chapter's claim that they were filthy and noisy and produced an unseemly state for the main entrance to the cathedral.[123] The clergy and the bishop also resisted the construction of a permanent marketplace in their vicinity, even if merchants did not always respect imposed ecclesiastical regulations.[124] The proximity of these temporary markets, along with the less odorous retail immediately to the west and north of the cathedral, created a commercial center that extended to the available buttress interstices outside of the cloister.

In summary, before construction of lateral chapels at Laon, the use of its buttress interstices varied substantially. It remains unclear what purpose those of the chevet and those within the cloister may have had, isolated as they were behind walls. Whatever purpose they may have served (if any), it would presumably have been defined by the exclusively ecclesiastical nature of the space. In contrast, where buttress interstices opened onto the town along the north side of the nave, they quickly became part of the commercial district surrounding the western part of the cathedral. In this commercial context they attracted interest from at least two opposing parties, demonstrating their status as valuable real estate and their mixed function as a place where clerical and lay interests met. However, the relative inaccessibility of the interstices within the cloister and beyond the gated wall of the episcopal compound reduced the opportunity cost for their interiorization. It would be easy to understand the seriality of the Parisian model in combination with a desire for symmetry as motivations for including the north side of the nave as part of this augmentation project.[125] Moreover,

while the clergy put the buttress interstices along the north collateral to commercial use, these niches were not fundamental to such exploitation, which continued until the nineteenth century along the updated and newly planar cathedral wall. In other words, it was disuse, rather than nonreligious use, that ultimately facilitated a later architectural intervention.

THE RELATIVE VALUE OF BUTTRESS INTERSTICES AS INTERIOR AND EXTERIOR SPACES

Enclosing the spaces between buttress piers allowed fabric committees to fashion new interior areas for additional altars and thus presumably increase revenue streams through the establishment of chantries at those altars. The economic benefit derived from the founding of chantries provided a powerful incentive for chapel construction, as noted in many studies.[126] Mailan Doquang has also connected the emergence of chantry chapels at Paris, as spaces for the performance of intercessory Masses for the dead, to the codification of purgatory, formulated in part by two of Paris's influential theologians—Pierre le Mangeur, also known as Petrus Comestor (d. ca. 1178), and Peter the Chanter (d. 1197)—and later promoted by Bishop Guillaume, under whose episcopacy the program of nave chapels began. Doquang argues that the construction of these lavish spaces, whose primary function was to house private Masses, bolstered the authority of the church on the path toward salvation.[127] These intertwined motivations of profit and prestige illuminate the social function of the chapel form and distinguish this intensified use of buttress interstices from the more secular, commercial use they had as exterior spaces.

It is also worth noting that Guillaume contributed to the development of parish organization, which pushed the laity away from the cathedral as their primary institution for pastoral care. As Alexander Sturgis has observed,

concomitant with the growth of parishes was the reduction of cathedral involvement in parochial responsibilities and the reduction of their liturgical contact with the laity.[128] The addition of chantry chapels provided a mechanism for the cathedral to reconnect with the wealthiest of the laity in a way that increased the church's authority, bolstered its coffers, and intersected with its mission of salvation. As peripheral spaces, points of first contact between the built church and its flock, buttress interstices were particularly well suited as places for lay donation. Guillaume, with his interest in reform and purgatory, was similarly well positioned to conceive of this reappropriation. The episcopates of Laon, Chartres, and Reims, located in towns significantly smaller than Paris and serving as centerpieces of local commercial life (or even coronations, in the case of Reims), would inevitably have come to see the profitable use of their religious space in radically different ways than Guillaume had.

Along with the systematic clerical exploitation of buttress interstices for the erection of market stalls, Reims and Chartres also have in common an unusually contentious relationship between the town and the clergy. In both cities these hostilities, which stemmed from competition over opportunities to extract income, resulted in violence and the self-imposed exile of the chapter. Since the mobilization of resources necessarily affected the money available for building projects, and since these policies also worked to the detriment of potential patrons, it would be reasonable to assume that the anticlerical mood of these cities alone explains the two cathedrals' lack of chapels between the buttress piers. However, it is worth remembering that Laon, too, suffered from comparable hostilities between town, clergy, and bishop and yet received chapels. It is thus not so clear that such disputes necessarily resulted in the preservation or elimination of exterior buttress interstices.

In Reims, Archbishop Henri de Braine's harsh persecution of suspected usurers, beginning around 1231,

may have driven away potential patrons, especially since moneylending was such a lucrative business in the city.[129] The citizenry's violent response to Henri's measures forced the chapter to flee in 1234. Arbitration between the archbishop and citizens resulted in a financial settlement, which the townspeople later refused to pay in full. Henri fled again in 1238, and he died in exile in 1240. Although the contentious relationship between archbishop and town is well known, it is more difficult to firmly establish that these hostilities alone account for the lack of lateral chapels at Reims.

As Meredith Parsons Lillich has noted, the canons remained in Reims during Henri's second period of exile, which may suggest that the town's sentiments toward archbishop and chapter differed.[130] While the citizens harbored intense resentment toward the archbishop, they may have been more inclined to make donations and establish foundations that would profit the cathedral chapter. In fact, I would argue that there is no evidence that Reims suffered from a scarcity of commemorative Masses. To the contrary, Reims saw an increase in chaplaincies and chaplains comparable to that at cathedrals that appended lateral chapels. Indeed, the canons at Reims complained that "the church of Reims was so weighed down by the number of masses that often it came to celebrate the same mass three or four times a day."[131] In 1272 there were thirty-three chaplains at Reims.[132] In the fourteenth century, Rouen Cathedral (where chantry chapels were constructed in the thirteenth century) had only two more chaplains, and those at Laon numbered only slightly more at fifty-six.[133] Chartres also had chaplains, who, according to Eugène de Lépinois and Lucien Merlet, were part of an independent lower clergy, although their numbers are not certain.[134] In addition, many patrons of chapels and chaplaincies were not laypersons but deacons, canons, bishops, and cardinals. For example, ecclesiastics account for the foundation of all the chapels at Paris

Cathedral that are known to have been financed by individual patrons.[135] Given the social and economic status of medieval ecclesiastics, it is not surprising to find them among the major donors. In sum, Reims's resistance to the construction of lateral chapels cannot be ascribed to a lack of liturgical need.

Richard Hamann-MacLean has proposed another explanation for the resistance to chapels at Reims. He has suggested that the benches formed by the setback in the lower wall would have made convenient viewing areas, especially for coronation celebrations.[136] The construction of chapels, which would have required the destruction of the lower aisle wall, would have eliminated the benches associated with it. The plausibility of this use of the stepped wall cannot be denied, although it alone does not seem a likely reason to forgo chapel construction. Temporary benches or stands could have been constructed for this relatively infrequent event, and the expansion of internal volume would have increased the number of people that the cathedral could have accommodated during the ceremony. In addition, the columns of the nave arcade would have obscured the view from many positions along the stepped wall, making it a less-than-ideal platform for viewing the coronation.

CONCLUSIONS

At Chartres, Reims, and (to a lesser extent) Laon, buttress interstices formed part of the heavily regulated space of a cathedral precinct accessible to clergy and laity alike. Documentary evidence suggests that the clergy quickly found ways to exploit these spaces, drawing on the long-established practices of setting up markets and stalls in the cloister. As a profitable enterprise, this use often drew conflicting claims. Dispute resolutions precisely established jurisdiction over these spaces, which began simply as the natural consequence of a redesigned

support system. The extant documents of these three cathedrals, in combination with graphic evidence of temporary stalls erected along the edges of other churches, suggest that similar practices would have been widespread between buttress piers as a means of supplementing clerical income or generating building funds. Moreover, rather than being seen as areas that threatened the clergy through the possibility of their subversive use, it seems much more likely that, in the majority of cases, buttress interstices were heavily regulated by the ecclesiastical community and that the clergy may have promoted their nonreligious use for financial gain or the assertion of authority.

At Paris, access to buttress interstices seems to have been far more limited. Although it is apparent that some amount of vending occurred on the parvis, it does not seem to have been as free or as systematic as around the other three cathedrals, nor does it seem to have directly profited any ecclesiastical groups for whom the leasing of these spaces would have provided a meaningful income. Thus, rather than monetize the cloister and its buttress interstices as part of a secular market, the clergy at Paris found a way to activate them as part of a spiritual counterpart. The construction of chantry chapels could more clearly be related to the church's role in salvation; the reestablishment of altars and the celebration of commemorative Masses, while still creating a stream of revenue, would not agitate Paris's reform-minded bishop. The model as developed at Paris may then have spread to other sites, like Laon, where local circumstances prevented the wholesale exploitation of buttress interstices. However, at Chartres and Reims, where market stalls appeared throughout the cloisters, the annexation of exterior space for the construction of chapels would have been far less palatable. In other words, their successful nonreligious use made their reappropriation for religious purposes unnecessary, undesirable, or, at the very least, unconsidered.

The various uses developed for buttresses inter-stices—whether as chantry chapels, merchant stalls, or canons' houses—ultimately reveal the contested nature of the cathedral district and especially the cathedral's immediate frame. The income generated through any of these uses surely bolstered the financial reserves of whichever parties controlled the space. More importantly, the statutes established through disputes over such uses clearly defined the jurisdictional rights and authority of the chapter in governing the real estate encompassed by the cathedral, including the extension of the buttress piers (whether such spaces remained external or were eventually internalized). The many disputes over use also demonstrate the initial ambiguity of buttress interstices and their ownership. As partially enclosed niches, buttress interstices occupied an intermediary position, a point of transition between church and nonchurch space. The architectural changes to these spaces, whether resulting in permanent stone structures or temporary wooden ones, made visible the clerical efforts to firmly establish their authority over such liminal spaces. These changes transformed the interstices into functional third spaces under the jurisdiction of the clerical community but serving an ostensibly lay market. Importantly, this process of definition occurred more or less contemporaneously with a larger theological movement aimed at the designation of sacred space and the privileges of consecrated ground. Through an iconographical analysis of buttress decoration, the next chapter explores the relationship of flying buttresses and their supporting piers to this more general concern over the differentiation between the church and society at large.

SCULPTURAL PROGRAMS AND THE ASSERTION OF ECCLESIASTICAL HEGEMONY

SOMETIME AROUND THE YEAR 1200, masons working at Chartres began constructing the buttressing of the cathedral's nave (see fig. 9).[1] These buttresses are remarkable in many respects, not least because a radial arcade connects their two lower arches. This unprecedented characteristic visually links the flyers to the rose window on the cathedral's west front. As discussed in chapter 1, modern scholars have noted the innovation of the Chartres buttresses, and studies of medieval architecture frequently cite them as the first instance in which a master mason fully exploited the possibilities of flying buttresses and aesthetically integrated them into the overall building design.[2] In addition to its visual links to the western rose window, the radial arcade further emphasizes the circulation of light and air in the buttressing frame.[3] An equally innovative but less remarked-on feature of Chartres's buttresses is ts monumental sculptural program, housed in niches of which five possess their early thirteenth-century figures. Like the radial arcade, these niches heighten the buttressing's visual complexity.

The combination of monumental sculpture and buttress upright partly masked the bulk of the structural member while it simultaneously transformed the buttressing into a platform for figural representation. The height of the buttress piers and uprights endowed these sculptures with a visibility beyond that of most portal sculpture, which often required that the viewer

be relatively close to the building.[4] This new location for sculptural embellishment was ideal for presenting key messages to the wide viewership that could see the sculptures from some distance. This sculpture enhanced the building's frame by presenting an image of ecclesiastical hegemony, through the presentation either of church officials or of their pastoral duties—a message that reinforced the distinction of the church, as a place of special privilege, from its surroundings, a distinction that was of increasing concern in the twelfth and thirteenth centuries. However, despite the visibility of these programs and their resulting importance as a means of addressing the public, the study of buttress sculpture remains in its nascence.

To explore the visualization of ecclesiastical hegemony in buttress sculpture, I first present three case studies that exemplify the rich diversity of the genre: the cathedrals of Chartres and Reims and the collegiate church of Saint-Quentin. At these three sites the precise iconography and placement of the sculptures vary. While remaining mindful of this diversity, I suggest that in each instance ecclesiastical authorities used these programs, as representations of ecclesiology and liturgical practice, to assert their authority. Such a subject might seem obvious for any program of cathedral sculpture, yet so too would biblical or hagiographic narratives, points of faith, or Marian cycles, none of which appears in monumental form on the buttresses. The choice of ecclesiology was simultaneously a rejection of these other subjects, perhaps because of the particular appropriateness of the former for buttresses. After considering the themes developed at Chartres, Reims, and Saint-Quentin, I explore their further development in churches at Beauvais, Bayeux, Le Mans, and elsewhere. The chapter concludes by considering buttress sculpture within the context of Church reforms that aimed to increase the power and influence of the Church through its independence from secular authority. I suggest that buttress sculpture's emphasis

on institutional identity had a special significance for the delineation of place and the delimitation of the sacred ground of the church—matters of concern for twelfth- and thirteenth-century theologians. Together, the physical form and sculptural decoration of the buttressing iterate conceptualized disjunctions embedded in topography, specifically distinctions between consecrated and unconsecrated ground. The buttress sculpture visualizes the architectural metaphor of the church supported by its leaders while simultaneously identifying the built structure as a particular locus of sanctity, from which the institution and its administrators draw authority.

THE EARLIEST EXAMPLE: MONUMENTAL BUTTRESS SCULPTURE AT CHARTRES

The monumental standing figures on the outer sides of the flying-buttress piers at Chartres Cathedral ushered in a new form of buttress decoration. Earlier twelfth-century flying-buttress ensembles lack sculptural embellishment or were adorned only with ornamental moldings, architectonic articulations such as columns, or small-scale motifs.[5] For example, chevron moldings ran along the tops of the twelfth-century flyers of Notre-Dame in Paris, and small-scale caryatids adorn the flyer heads at Laon Cathedral (fig. 56).[6] At Chartres Cathedral, each of the five buttress uprights along the north side of the nave contains a niche topped by a trefoil arch, under which stands a figure clad in ecclesiastical regalia (figs. 9 and 57–59). The sculptures likely formed part of the early plans for the building's reconstruction following the fire of 1194, which places them in the first decade of the thirteenth century. They are probably the earliest large-scale sculptures of the post-1194 work, predating the central portal of the north transept.[7] John James dates the upper nave flyers at Chartres to around 1213, providing a likely date for the installation of the sculptures.[8] Of the five figures, the easternmost

FIGURE 56
Laon Cathedral, detail of caryatids. Photo: author.

FIGURE 57
Chartres Cathedral, easternmost bishop figure on the north side of the nave holding a pastoral staff, first decade of the thirteenth century. Photograph before 1909. From Margaret S. Marriage and Ernest Marriage, *The Sculptures of Chartres Cathedral* (Cambridge: Cambridge University Press, 1909), 95, plate 41.

and middle statues are the best preserved, retaining some details of their hands and faces (figs. 57 and 58). The remaining three are heavily worn and are best studied in conjunction with nineteenth-century photographs, which document slightly better states of repair and preserve some now-lost details (fig. 59).[9] The five similar figures on the buttresses of the south side of the nave date to 1865 and were part of a larger restoration effort.[10]

Trefoil niches identical to those along the nave appear on the western sides of the northern and southern transept arms, although these are devoid of sculpture. The uniformity of the nave and western transept niches suggests that the twelfth-century designers planned the sculptural program to run along the exterior of the cathedral, even if this plan never reached fruition. If true, the initial design would have called for an entourage of

FIGURE 58
Chartres Cathedral, bishop figure on the north side of the nave holding a pastoral staff, first decade of the thirteenth century. Photograph before 1909. From Margaret S. Marriage and Ernest Marriage, *The Sculptures of Chartres Cathedral* (Cambridge: Cambridge University Press, 1909), 97, plate 42.

FIGURE 59
Chartres Cathedral, bishop figure on the north side of the nave at bay division 4. Photo: Foto Marburg / Art Resource, New York.

figures that would have surrounded the western portion of the building. In comparison with the tabernacles on the flying buttresses of the east end (ca. 1250), these niches, some of which contain a stout column, generally lighten and refine the pattern of the nave.[11] Given the pattern of the western portions of the cathedral, it is possible that the builders once planned figural sculptures for the tabernacles as well. If so, a ring of sculpted figures

would virtually have circumscribed the upper exterior of the entire cathedral.

An Interpretation of the Chartres Buttress Sculptures
As with most exterior architectural sculpture, the north-buttress figures show their age, and in three cases identifying details are almost completely weathered away. Nevertheless, enough original material and historical

documentation exist to permit some general observations about the program. All of the figures are of a consistent type: a single figure stands erect in each niche, oriented frontally with parallel legs. The bodies are rigid, although the heads tilt slightly down or to the side. Each figure wears ecclesiastical garments (including a miter) and carries a pastoral staff. Although all the figures are similar, the sculptor(s) varied their hand positions and facial features to endow them with limited individuality.

Each figure stands above and behind a *marmoset*, a subsidiary sculpture consisting of one or two small figures. As is true for the arrangement of many of the statue columns of the transept portals, these monstrous consoles likely relate to the central image, although their poor condition makes them difficult to decipher. The marmoset at bay division five once held a moneybag, which is visible in early twentieth-century photographs. Marcel Bulteau interpreted this figure as a symbol of avarice, reading the pair as Judas holding a bag of silver and caressing a demon (fig. 57). Bulteau further suggested that other marmosets also depicted vices, which stood in opposition to the virtues practiced by the bishops.[12] While he did not specify which figures he had in mind, he may have been referring to the squatting and kneeling humanoids that appear at the feet of two other churchmen (fig. 58). The modern grotesques along the south side of the nave depict grimacing or distorted faces. While it is possible that the modern marmosets provide some clue to the badly weathered examples along the north side of the nave, they are decidedly different in character from the supposed avarice pair. While the contorted forms and awkward positions of the monsters and demons in the marmosets evoke malevolent forces and may be physical reflections of spiritual deformity, they do not correspond in number (either in their present arrangement or in the total number of niches) to the traditional seven vices.[13] Nevertheless, even in the absence of specific meanings, they can stand for the triumph of the bishops over evil in general.

The attributes of miters and pastoral staffs indicate the ecclesiastical rank of the monumental buttress figures—signifying their status as bishops or abbots—but their precise identification remains ambiguous. Bulteau saw the figures as donors.[14] This suggestion is problematic, as only two bishops oversaw the late twelfth- and thirteenth-century construction, Renaud de Mouçon (1183–1217) and Gauthier (1218–34). Moreover, it was the cathedral canons, not bishops, who paid for most of the rebuilding.[15] Nevertheless, while the chapter was a formidable political entity, both bishops who reigned during the reconstruction also wielded considerable power and influence. The likelihood that the sculptural program reflects the interests of both groups is bolstered by a parallel in the cathedral's stained-glass program. Jane Welch Williams has argued that the iconographic program of the building memorializes the shifting priorities of both bishops and canons, which ultimately results in what modern scholars identify as apparent incongruities.[16]

It is tempting to understand the figures as illustrious bishops in the history of Chartres, such as Saint Lubin (r. 549–51) and Yves de Chartres (r. 1090–1115). Along with such similarly distinguished figures as Saint Solennis (d. ca. 507) and Fulbert de Chartres (d. 1028/29), these individuals continued to play a role in the institutional memory of the cathedral chapter and in the town more generally. The sculptural and stained-glass programs at Chartres feature at least three of its canonized bishops: Saints Solennis, Lubin, and Caletric (d. 567). The obituaries of the cathedral and nearby abbey of Saint-Père-en-Vallée memorialized deceased bishops of the diocese, ensuring their continued commemoration.[17] Canonized Chartrain bishops also featured prominently in the liturgical calendar. In the thirteenth century, for example, feasts for Saint Lubin were held on March 14 and September 16 to celebrate the anniversaries of his death and his episcopal ordination, respectively.[18] It is possible that the buttress figures represent specific (though now

unidentified) former bishops or possibly bishop saints of Chartres, although this conclusion remains speculative in the absence of inscriptions or identifying attributes. None of the statues are nimbed, which may reflect the diversity of holy statues among the represented figures.[19] In addition, the use of the nimbus was not necessarily as codified as might be expected today, as illustrated by the nimbed figure of Archbishop Henry of France and other noncanonized archbishops in the stained glass at Saint-Remi in Reims.[20]

The rigid stance of the Chartres bishops gives the sculptures an architectonic quality—one that is only enhanced by the body-masking robes with their heavily stylized drapery folds. The repeated vertical lines used to indicate the draping of their albs and chasubles heighten the figures' stability and balance. The erectness and general lack of motion in the statues find parallels with twelfth- and early thirteenth-century statue columns, including those of the nearby Royal Portal (1145–55). In both cases the sculptors transformed the human body into a stable cylindrical form that invites direct comparison to columns. It is even possible that the columns in the tabernacles of the choir buttresses represent a deanthropomorphization of the nave pattern, further emphasizing the statues' visual connection to columns. Both the buttress sculptures and the column statues thus refer to the architectural forms that they decorate, the purpose of which is to sustain and brace the building itself.

The visual parallel drawn between the bishop statues and the bracing elements of the buttressing-frame system echoes biblical metaphors for the Universal Church that describe it as a construction made from "living stones" (*lapidem vivum*) built into a spiritual house (1 Pet. 2:4–6). This metaphor, with some variation, appears in several biblical passages. For example, the Epistle to the Ephesians 2:19–21 relates, "Now therefore you are no more strangers and foreigners; but you are fellow citizens with the saints, and the domestics of God, built upon the foundation of the apostles and prophets, Jesus Christ

himself being the chief cornerstone [*angulari lapide*]: in whom all the building, being framed together, groweth up into a holy temple in the Lord." *Lapis angularis* can also be translated as "keystone." Although keystones and cornerstones have different purposes in architecture, in terms of metaphor the centrality of the stone to the stability of the building is likely the salient point. In both 1 Peter 2:4–6 and Ephesians 2:19–21, members of the Church join with Christ as building components to form the body of a holy temple, but this idea of apostolic support takes a more literal form in Revelation 21:14, where the names of the apostles are placed on the physical supports of the envisioned heavenly city: "The wall of the city had twelve foundations, and in them, the names of the twelve apostles of the Lamb." This passage does not discuss the apostles as people, emphasizing instead the architectonic elements of foundation stones, which are connected to the apostles through their inscribed names.

The fourth-century theologian Jerome linked the passages of Peter and Ephesians, asserting that the Church is composed of the living stones of the faithful held together by the keystone of Christ.[21] This idea became a common metaphor in ecclesiastical writing. For example, Hugh of Saint Victor (d. 1141) makes several references to the Church as the "multitude of the faithful" (*multitudo fidelium*) in his *De sacramentis*.[22] He goes on to say that the Church "is the house of God constructed of living stones, where Christ has been placed as the cornerstone."[23] In this statement the Church is an imagined construction with a figurative relationship to its physical container.[24] In the middle of the eleventh century this relationship changed such that the built church came to symbolize the institutional Church.

Between 1120 and 1290 numerous ecclesiastical authors composed liturgical manuals, many of which employ the allegory of the living Church as a means of explaining relationships and divisions in Christian society.[25] In one of the earliest of these handbooks, *De gemma*

animae (ca. 1120), Honorius of Autun (1080–1154) writes of bishops as the columns that support the building, world leaders as the beams that join it, and soldiers as the roof tiles that protect it.[26] In another of Honorius's works, *Expositio in Cantica canticorum*, he describes the city of God, saying that the columns that support the house of God are the apostles and their successors, the bishops.[27] Bruno di Segni (ca. 1048–1123) similarly writes: "According to this meaning, this church, constructed from wood and stones, refers to the Church itself, which is built from living stones. Its stones are joined and united not with lime but with charity. Its foundation is Christ. Its doors are the apostles. The bishops and doctors are the columns of the Church, on which each stone glows more brightly the more faithful and upright it is."[28] In this passage Bruno, like Honorius, connects the institutional body to its physical structure by equating the building to various members and virtues of the organization. As such, the constructed church functions as a symbol for the collection of people it serves.

The two most widely read and most popular of the liturgical manuals, Jean Beleth's (fl. 1135–82) *Summa de ecclesiasticis officiis* (ca. 1160–64) and Guillaume Durand's (ca. 1230–1296) *Rationale divinorum officiorum* (ca. 1280s), both employ the allegory of living stones.[29] Not much is known about Beleth's life, except that he was in Chartres around 1135, before becoming a disciple of Gilbert de la Porrée in Paris in the 1140s, where he later composed the *Summa*.[30] In chapter 103 Beleth addresses the spiritual and physical aspects of the Church, the one constructed of people, the other of stones. For example, he writes that the pavement of the Church is the poor in spirit, who humble themselves in all things, explicitly connecting part of a generalized physical structure to the members who assemble within. Durand repeats Beleth's allegory of the Church pavement almost verbatim near the beginning of book 1, "On the Church Building and Its Parts." This book provides the most

expansive example of architectural allegory in any of the liturgical handbooks, and it gives a symbolic reading for everything from walls to roof tiles. However, while Durand is the most encyclopedic author in this genre, it is important to remember that his work is the climax of a much longer tradition stretching back more than one hundred years.[31] The architectural metaphor of the institutional Church was already well established by the time he wrote the *Rationale*. Like Beleth, Bruno, and his other predecessors, Durand drew on Ephesians and Peter in his symbolic reading of church architecture. The text relates that "the material church in which the people have come to praise God signifies the holy Church in heaven, constructed of living stones . . . whose foundation is Christ, the cornerstone; the foundation upon whom have been placed the Apostles and Prophets."[32] He also mirrors Honorius's *De gemma* in his description of the columns of the Church as "the bishops or teachers who spiritually hold up the temple of God, just as the Evangelists hold up the throne of God."[33]

This brief account of liturgical manuals is far from exhaustive. In addition to those of Honorius, Hugh, Beleth, and Durand, many similar manuals survive, including the *Manuale de mysteriis ecclesiae* of Pierre de Roissy, chancellor of Chartres in the early thirteenth century.[34] Other authors of Latin liturgical handbooks include Prevostin of Cremona (also known as Praepositinus, ca. 1135–1210) and Lotario dei Conti di Segni (Pope Innocent III, 1161–1216). As is typical for medieval texts, the various manuals rely on each other heavily, often repeating large passages from earlier manuscripts. Thus, while the examples noted here reflect only a small portion of known texts, they demonstrate the pervasiveness of the metaphor of apostolic support. Moreover, these handbooks' frequent equation of the church's physical supports with authoritative figures in Christian society—most frequently bishops, saints, or apostles—finds a meaningful visual parallel in buttress sculpture.[35]

FIGURE 60
Paris, Sainte-Chapelle, view of the upper chapel showing the relationship of a (restored) apostle statue to its column. Photo: Manuel Cohen / Art Resource, New York.

are 180 surviving manuscripts of Beleth's *Summa* and more than 200 extant medieval Latin manuscripts of Durand's *Rationale*, and copies of these two texts circulated as translations in medieval vernaculars and early print editions.[37] Many other manuals also survive in equally impressive numbers of medieval versions.[38] By all accounts, these liturgical handbooks were well known and widely read. In addition, many of the authors of these treatises were associated with schools in cities on the forefront of medieval architectural advancement. Jean Beleth, Pierre de Roissy, and possibly Durand had links to Chartres,[39] while Beleth and Praepositinus have been connected to Paris.[40] Beleth also spent an unspecified amount of time in Amiens.[41]

The wide-reaching effect of the handbooks can be seen not only in their content and number of copies but also in their influence on other kinds of literature. Although the manuals were directed at ecclesiastics and educated audiences, similar allegorical language reappears in later vernacular literature—in both French and English—addressed to the lay populace.[42] For example, in Guillaume de Deguileville's *Le pèlerinage de la vie humaine*, the pilgrim encounters a great ship on which "the mast is the cross of Jesus Christ and the wind is the Holy Spirit, which, as Golden Mouth says, can bring the ship to safe harbor."[43] Similar allegorical passages appear in Langland's *Piers Plowman* and the much later *The Pilgrim's Progress* by John Bunyan, among other works. In addition, Jacobus de Voragine's *Golden Legend* borrowed heavily from the structure and wording of works like Beleth's *Summa*, suggesting that Voragine's text disseminated codified ideas about liturgy and ritual.[44] While the link between scholasticism and medieval architecture remains a matter of some debate, at the very least it is clear that the metaphor of apostolic support circulated in proximity to the construction of many major high medieval building projects.[45]

Most of these liturgical manuals were composed during the later twelfth and thirteenth centuries.[36] The subject's popularity as a genre suggests that their authors and audience were intensely interested in explanations of Church hierarchy and practices in this period. In addition, the most popular texts survive in huge numbers of manuscripts, which further underscores their relevance, accessibility, and widespread appeal. There

Given the popularity of the liturgical manuals and their repetition of architectural metaphor, it is unsurprising that the metaphor of the Universal Church as a construction of living stones appears in a variety of other artistic and architectural contexts. In one of the rare surviving contemporary accounts of medieval architectural construction, Abbot Suger applies this textual metaphor to the two rows of columns in his new apse in the abbey church of Saint-Denis:

> The midst of the edifice, however, was suddenly raised aloft by twelve columns representing the number of the Twelve Apostles and, secondarily, by as many columns in the side-aisles signifying the number of the [minor] Prophets, according to the Apostle who buildeth spiritually. *Now therefore ye are no more strangers and foreigners, says he, but fellow citizens with the saints and of the household of God; and are built upon the foundation of the apostles and prophets, Jesus Christ Himself being the chief cornerstone* which joins one wall to the other; *in Whom all the building—whether spiritual or material— groweth unto one holy temple in the Lord.*[46]

In this passage, Suger draws heavily on the imagery from Ephesians that describes how the building grows from the body of the faithful, with Christ as its cornerstone. Like Jerome (cited above), Suger also integrates the idea of the living Church with that of apostolic support, pointedly connecting the columns to the apostles and noting that the living stones of the faithful rest upon the foundations of the apostles and prophets. Suger's use of the metaphor does not differ much from that of Durand or Bruno, except in that it describes a single, specific, and physical building instead of a generic, abstract church to express ecclesiological ideals. In other words, Suger applies the pervasive architectural metaphor to the object of his patronage.

Although Saint-Denis's apse columns did not feature figural representations of apostles and prophets, such explicit visual representations appear in other buildings, including Chartres, on the central portal of the south porch, where jamb statues of apostles flank a trumeau figure of Christ, and the Sainte-Chapelle, where statues of the apostles decorate the piers of the upper chapel (fig. 60).[47] Peter Low has also argued convincingly that the main portal at Sainte-Marie-Madeleine in Vézelay (1104–32) conflates a representation of Pentecost with Ephesians 2:11–22, visually depicting the architectural metaphors of Christ as keystone and the faithful as constituent members of the Church fabric.[48] Like the Vézelay tympanum and apostle statues at the Sainte-Chapelle, the bishop figures on the buttressing at Chartres physically illustrate the conception of the Church spiritually upheld by its bishops, who derive their authority through apostolic succession. In presenting bishops as part of the building's support system, the buttress sculptures along Chartres's nave work within a larger semiotic field, part of a recurring visual motif representing a common textual metaphor. The Chartres buttress sculptures thus manifest a familiar ecclesiological allegory for the community of the faithful, for whom the building was constructed. In so doing the sculptures stress the connection between the Church as institution and the church as physical structure. At Chartres, however, artists adapted this metaphor, already prominent in the visual arts, to the new structural realities of thirteenth-century architectural practice, placing the bishop figures not only on columns but also on the relatively new forms of the load-bearing buttress uprights. The pattern established at Chartres likely found its successor in the sculpture on the buttress piers at Reims (ca. 1215–ca. 1230).[49] The ensemble at Reims is more elaborate than its predecessor. It not only comprises a greater number of figures but also presents a more sophisticated iconography by representing liturgical performance.

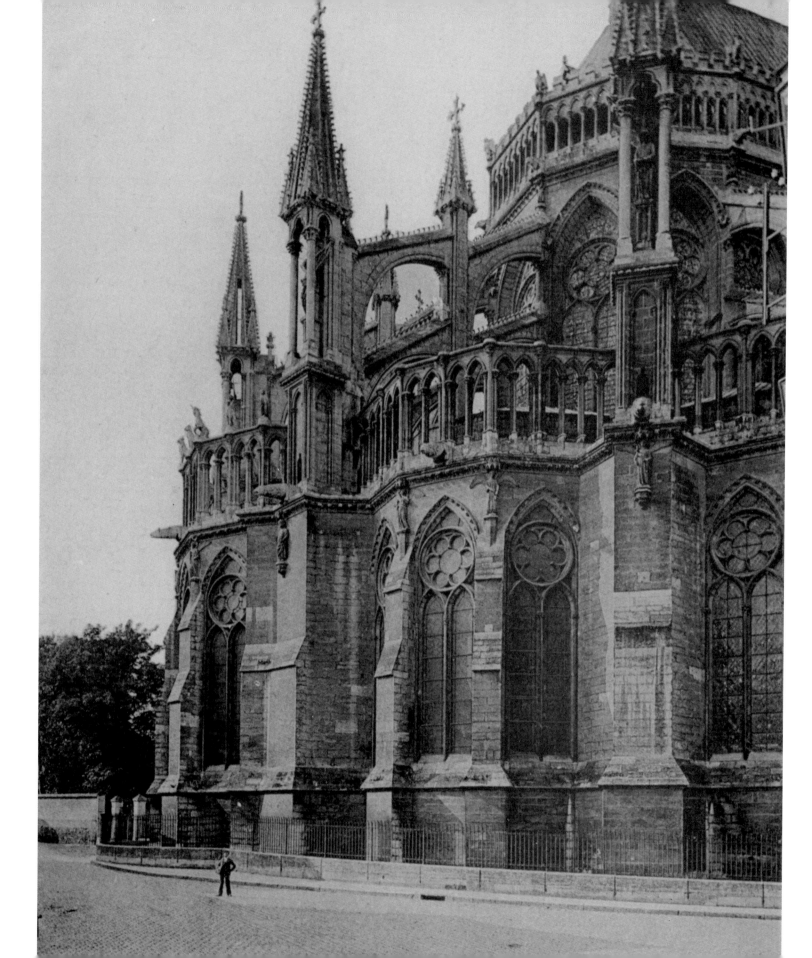

MONUMENTAL BUTTRESS SCULPTURE
AT REIMS AS LITURGY

Although the Reims program was likely inspired by that at Chartres, it differs significantly from this prototype (fig. 61). Instead of representing bishops or possibly bishop saints, the Reims sculptures depict an angelic entourage led by Christ, who is located on a spur buttress of the axial chapel.[50] The central placement of Christ parallels the allegory of Christ as keystone, but the angels, unlike church leaders, are not imagined as supports by Durand and his predecessors. While the iconography of the Reims program differs from the model at Chartres, it nevertheless continues the theme of the living Church, here refocused on ritual life. Instead of emphasizing the person of the bishop, the Reims sculptural program highlights the office's episcopal duties, visualizing their performance as key to the sustenance of the Church as an active community.

In addition to differences in subject matter, the quantity of buttress sculpture is greater at Reims than at Chartres, a distinction in line with the latter's overall luxury. Rather than the single row of figures at Chartres, two levels of sculpture adorn the Reims buttressing. The angelic entourage constitutes a lower series on the buttresses of the radiating chapels. These figures appear both on spur buttresses and on buttress piers supporting flyer arches (figs. 61 and 62). The slightly later upper series (ca. 1230) adorns the top of the buttress uprights and features only angels.[51] The upper angels inhabit aediculae with trefoil arches over their outer openings, perhaps imitating the trefoil niches of the Chartres nave. Also like their predecessors at Chartres, both upper and lower sculptures

present uniformly frontal standing figures. A third register of sculptures atop the heads of the flyer arches comprises atlantes that fictively support the cornice (ca. 1230). Although they may have been inspired by large-scale buttress sculpture or, more likely, by the caryatids of Laon Cathedral, the size, iconography, and relationship of these figures to the architecture distinguish them from the lower rows of angels and call to mind so-called marginal imagery, such as the corbel heads that adorn the cathedral throughout.[52]

The two levels of angel sculptures on the outer faces of the buttresses differ in technique and iconography. The lower series is in high relief, with baldachins integrated into the cornice, whereas the upper series consists of ostensibly freestanding figures set off from the backs of the aediculae. Even though each buttress upright received an aedicula and an angel, only twelve of the sixteen buttresses have a sculpted figure below the chapel cornice; the four southern buttress piers of the chevet do not bear any sculpture at the level of the radiating chapels. The upper program continues along the nave, whereas the lower program exists only on the chevet. In addition, Christ appears only in the lower program; the upper zone consists exclusively of angels on the chevet and nave, with kings in comparable aediculae around the transepts.[53]

Academic interest in the Reims buttress sculptures has generally focused on the lower set of figures (i.e., those on the buttresses of the radiating chapels), which were installed as early as 1215 (figs. 63 and 64).[54] Broadly speaking, most modern scholars agree that the lower series of sculptures represents a procession, although the exact nature of this performance has been the subject of much speculation.[55] Most likely, as William Clark has argued, the program was purposefully multivalent and presents a generalized action whose interpretation was flexible and would change according to the liturgical calendar. This liturgical, or at least quasi-liturgical, reading of the chapel

FIGURE 61
Reims Cathedral, chevet from the northeast. Photograph before 1914. Photo: Foto Marburg / Art Resource, New York.

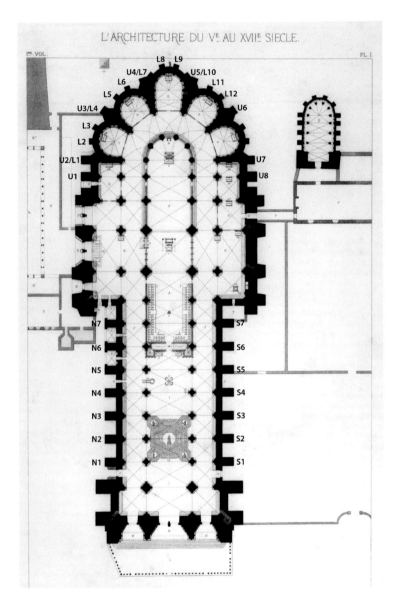

FIGURE 62
Reims Cathedral, plan showing the locations and numbering of the buttress sculptures: N = tabernacle figures on the north side of the nave; S = tabernacle figures on the south side of the nave; U = chevet tabernacle figures; L = figures on the buttresses of the radiating chapels. Plan by Eugène Leblan, from Jules Gailhabaud, *L'architecture du Vᵉ au XVIIᵉ siècle et les arts qui en dépendent: La sculpture, la peinture murale, la peinture sur verre, la mosaïque, la ferronnerie, etc.* (Paris: Gide, 1858), vol. 1, plate 1, with numbering interpolated by author.

buttress sculptures primarily relies on the attributes held by the figures. Christ carries an ornate book, possibly the Gospels. Two of the angels also carry books: one large and open (perhaps the Bible) and the other small and closed (potentially a psalter or ordinary). Three angels swing censers. One of these figures also holds a horn, and the other two carry incense bowls (fig. 63). Of the remaining figures, two angels carry floral maces, one holds a processional cross and scroll, one has a water bucket and aspergillum, and the final two angels hold a gabled tabernacle and a crown, respectively, in their covered hands (fig. 64). The fact that the last two angels hold these objects in cloths and do not touch them directly suggests that they are reliquaries.[56]

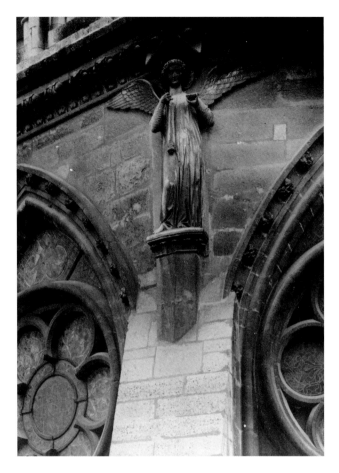

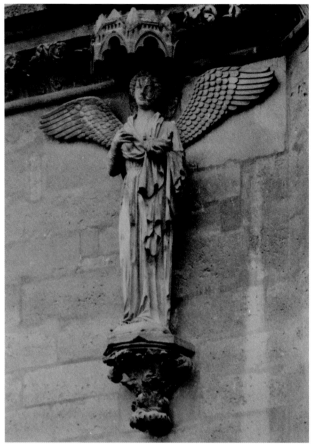

FIGURE 63
Reims Cathedral, figure L9: angel holding a censer and a bowl. Photo:
Foto Marburg / Art Resource, New York.

FIGURE 64
Reims Cathedral, figure L10: angel holding a crown. Photo: Foto
Marburg / Art Resource, New York.

The angels' attributes are the very objects used during many liturgical processions, such as those accompanying consecration ceremonies or (more commonly) the processional entries on festive occasions officiated by the bishop.[57] For example, a consecration ceremony entailed two extramural processions. In the first, the bishop splashed the walls with holy water (bucket and aspergillum), and in the second, relics (gabled reliquary or tabernacle and crown) were processed around the building.[58] It is also likely that these twelve sculptures held

a particular significance for the coronation ceremony, possibly influencing the arrangement of later ordines and reflecting the idea of the king as the angelic forerunner of a messianic king.[59] In other words, rather than represent one particular ceremony, the angelic group may have represented a generalized readiness for liturgical action that could reflect whatever procession happened to pass below them on a given day.

While there is general agreement that the lower series of sculptures on the Reims chevet represents a procession

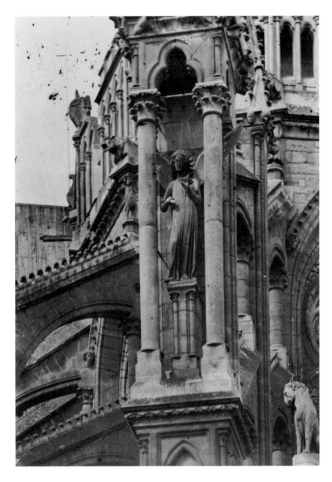

FIGURE 65
Reims Cathedral, figure U5: angel holding a censer and a bowl.
Photograph before 1914. Photo: Foto Marburg / Art Resource, New York.

holding the sun and the moon, which often accompany representations of the Crucifixion. However, these attributes are held by two of the angels in the tabernacles of the buttresses along the south side of the nave—figures that otherwise go unmentioned.[62] Bréhier's discussion of the exterior sculpture thus incorporates details from both levels of angels but attributes them all to the lower figures. This conflation underscores the tension between the general scholarly focus on the sculpture of the chapel buttresses and the iconographic connection between those statues and their brethren in the tabernacles above.

Several scholars have suggested that the upper-level figures represent the guardians of the gates of Heavenly Jerusalem (Rev. 21:2).[63] The upper angels exude a general sense of watchfulness and security simply through their identity as heavenly beings. Nevertheless, the number of tabernacle angels—eight in the choir and an additional seven on each side of the nave—rules out a strictly literal representation of the heavenly guardians as described in John's Apocalypse. No reasonable combination of the Reims angels finds numerical correspondence with the twelve gates of Heavenly Jerusalem as recorded in Revelation.[64] The addition of the lower eleven angels yields a sum of thirty-three, a symbolically important number but one that does not include the figure of Christ, which brings the total to thirty-four.[65] References to the twelve gates also appear in popular literature, like the later Middle English poem *Pearl*, composed in the second half of the fourteenth century. Furthermore, many Latin liturgical treatises, like that of Durand, incorporate numerology and reference theologically significant numbers.[66] Symbolically potent numbers may have played fundamental roles in determining aspects of church plans and elevations.[67] Thus, although the divergence between the number of sculpted angels and John's vision does not necessarily preclude a more general reading of the buttress figures as protective heavenly beings (particularly as viewers may not have counted the sculptures), it suggests

(even if its type remains a matter of debate), this consensus does not extend to the interpretation of the tabernacle angels above.[60] Modern scholars often discuss the two levels of angels separately, implicitly or explicitly proposing that they belong to different iconographic programs. Louis Bréhier's analysis of 1920 provides an especially evocative illustration of the scholarly preference for the lower sculptures.[61] Bréhier suggests that the statues placed on the exterior of the radiating chapels are performing the Divine Liturgy. He refers to the two angels

FIGURE 66
Reims Cathedral, figure N4: angel holding a horn.
Photograph before 1914. Photo: Foto Marburg /
Art Resource, New York.

FIGURE 67
Reims Cathedral, figure S6: angel holding a
vase or vessel; figure S7: angel holding a book.
Photograph by François Rothier, 1852. Photo: Foto
Marburg / Art Resource, New York.

that they are not a straightforward depiction of a biblical passage.[68]

The technical differences between the two levels of angels at Reims mentioned above may have prompted their separation in modern scholarship. However, despite these differences, there are enough similarities between the two registers to encourage an integrated reading. Both levels include frontally facing monumental figures based on the model of Chartres. They also both represent an angelic host. Finally, and perhaps most importantly,

several of the angels in the different levels carry the same attributes. For example, an upper angel in the choir holds a censer and bowl, repeating the utensils borne by two lower figures (figs. 63 and 65). Other shared attributes include horns, banners, and books (figs. 66 and 67, right). Each of three upper angels holds a chalice, a liturgical vessel not carried by any of the figures at the level of the radiating chapels.

Many of the upper angels along the south side of the nave carry objects related to the Passion. One angel holds what have been identified as the bread and sponge, objects that have symbolized Christ's Passion since the Carolingian period.[69] The chalice also frequently appears in images of the Crucifixion, typically held by an angel who uses it to catch the blood that spills from Christ's wounds.[70] The moon and the sun are also among the attributes of the Reims tabernacle angels.[71] These celestial bodies also appear regularly in images of the Crucifixion, reflecting such Gospel accounts as Luke 23:44–45,[72] and, like the instruments of the Passion, symbolize Christ's victory on the cross.[73] As objects closely associated with Christ's suffering (some of which came into direct contact with his body or blood), these objects—especially the chalice and the sponge—are comparable in spirit to the reliquaries held in the hands of some of the lower angels. Thus, if the objects held by the lower sculptures indicate that the group represents a procession, this interpretation should be extended to the upper figures as well.

One might argue that the presence of the sponge and other objects closely associated with the Passion among the attributes of the tabernacle angels imbues the latter with a strong protective message. After all, the *arma Christi* were weapons used in the defense against sin. The presence of the sponge in particular might thus evoke the idea of guardian angels, especially those angels that flank the throne of Christ in some Last Judgment images.[74] However, only some of the attributes of the tabernacle angels represent the Passion objects. Others, including the book and the censer-and-bowl combination, are not typically counted among them. Indeed, even though several angels are now missing their attributes, there is no clear evidence that some of the most commonly depicted Passion instruments (such as the crown of thorns, nails, and scourges) were ever among them. It is also worth noting that the angelic guardians of Heavenly Jerusalem are often shown wielding traditional weapons, which the tabernacle angels do not hold.[75] Moreover, while the instruments of the Passion were frequently depicted in Last Judgment scenes, they were fundamentally linked to the Crucifixion and Christ's sacrifice, which was memorialized in the Eucharistic sacrifice of the Mass. Therefore, it is more likely that, in this context, the sponge and chalice extend the liturgical message of the lower angels through their association with the Crucifixion and thereby amplify the Eucharistic implications of the ensemble.

Given the parallels between the two levels of sculptures, the series at Reims probably constitutes a unified ensemble, in which the upper angels act as an amplification of the lower procession and contribute to a sense of ceremonial richness. In other words, the angels' attributes suggest that they all participate in a shared activity. This interpretation does not negate a possible protective role or detract from the ecclesiological message that asserts the authority of the Church and its prelates. Assuming that the gabled tabernacle and crown indeed represent reliquaries, their inclusion in the program similarly conveys the protections and privileges of this church, which were closely linked to its relics and to its function as a site for the performance of the Eucharistic and other liturgies. The protective role of these objects would have been reinforced by their repeated use in consecration processions, implying that the same power employed in the protection and status of the church's consecration was manifest permanently in its sculpture. In fact, it is possible that the angels reflect a desire to make a more explicit connection to the celestial realm than was possible with

the representation of bishops or bishop saints, as at Chartres. The close iconographic similitude of all thirty-three angels indicates that their significance lies in their totality rather than their individuality.

The idea of processional action reappears in the closely related buttress sculptures at the collegiate church of Saint-Quentin. They demonstrate how the idea of ecclesiastical hegemony could be applied to nonepiscopal buildings.

BUTTRESS SCULPTURE AT THE COLLEGIATE CHURCH OF SAINT-QUENTIN

Like the angelic hosts of Reims Cathedral, the buttress sculptures of Saint-Quentin memorialize extramural religious actions performed at those very sites, here adapted to a collegiate, rather than episcopal, church (figs. 68 and 69).[76] At Reims the presence of Christ is suggestive of the building's episcopal status. Liturgical manuals frequently make comparisons between bishops and Christ, particularly when discussing consecration. For example, Durand writes that "only a bishop can dedicate churches and altars, since he bears the image and figure of the High Priest, that is, Christ."[77] In his discussion of the same ceremony, Honorius of Autun makes this comparison even more explicitly, stating, "The bishop who consecrates [the church] is Christ."[78] It is very likely, therefore, that the Christ on the Reims buttress evoked the episcopal office, at least under certain readings.

A comparable figure is absent at Saint-Quentin, where the buttress sculpture represents angels exclusively. Because Saint-Quentin was a collegiate church rather than a cathedral, the angelic performance would have referred to the pastoral duties of the dean, who exercised his office through liturgy. As administrative officials of the diocese, the deans of Saint-Quentin served ecclesiastical functions roughly comparable to those of bishops,

but without the diocesan responsibilities. They were also ultimately subordinate to the bishop. The exclusive use of angels at Saint-Quentin, in dispensing with the "bishop" figure at Reims, emphasizes local pastoral performance under the authority of the church's own administrative head. The performative emphasis of this program through the depiction of musical accompaniment nevertheless calls to mind the specific duties and jurisdiction of the collegiate church in isolation from the diocesan authority of its bishop, who had his seat in Noyon. The absence of any figure that might carry episcopal connotations is especially striking given the collegiate church's repeated claims of exemption from episcopal control between 1188 and 1228.[79]

The angelic iconography of Saint-Quentin was likely inspired by Reims, with which the collegiate church shares a number of other characteristics, including the use of deep polygonal radiating chapels, but the placement of the figures is different.[80] Instead of adorning the outer edges of buttress piers or uprights, the figures at Saint-Quentin appear on the clerestory wall of the chevet. Each of the six sculptures stands atop a volute at the juncture of a flyer head with the clerestory wall. Although the change in the position of the sculptures at first appears to starkly differentiate the two programs, those at Saint-Quentin have essentially displaced the Reims atlantes. Intriguingly, a sketch of the nave elevation of Reims Cathedral by Villard de Honnecourt depicts a configuration similar to that of the collegiate church (fig. 70). Villard did not include the buttress uprights and therefore could not depict the angels in their tabernacles. Instead, summary sketches of angels with outstretched wings appear in the spandrels between the clerestory windows. Essentially, Villard transposed the upper aediculae angels from the buttress piers to the clerestory wall.[81] The comparable design at Saint-Quentin was most likely fully independent of Villard's efforts but may speak to the nascence of buttress sculpture as a design feature.[82]

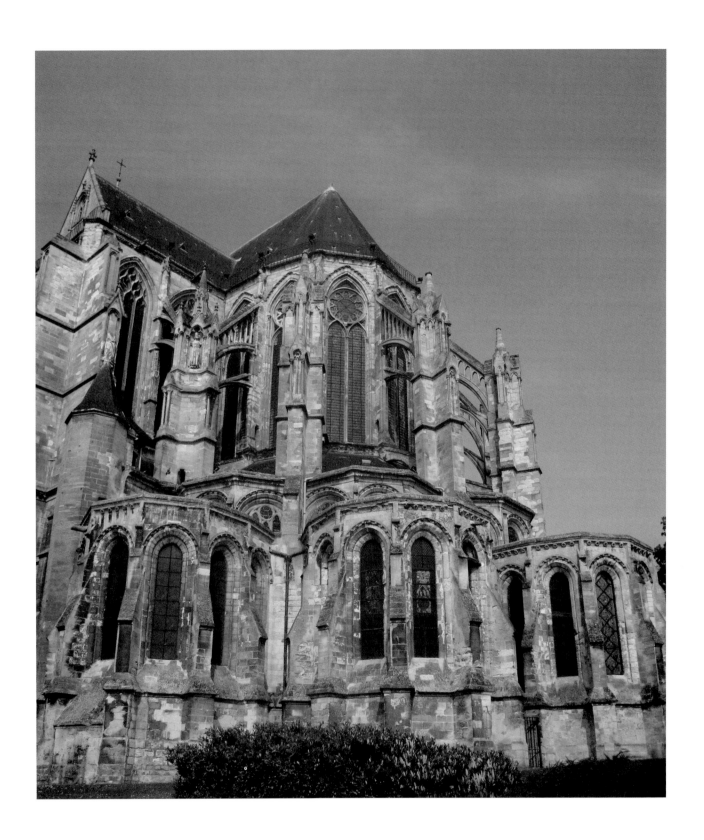

FIGURE 68 (OPPOSITE)
Saint-Quentin, view of the chevet. Photo: author.

FIGURE 69
Saint-Quentin, chevet, detail of angel figures. Photograph before 1920. Médiathèque de l'architecture et du patrimoine, Charenton-le-Pont, France, inv. MH0055514. Photo: Felix Martin-Sabon © Ministère de la Culture / Médiathèque du Patrimoine, Dist. RMN-Grand Palais / Art Resource, New York.

It is possible that Villard and the Saint-Quentin master similarly, perhaps autonomously, conflated the standing angels with the crouching atlantes that surmount the flyer heads at Reims, maybe misremembering the details of the building. Alternatively, they may have erroneously fused the upper and lower levels of the Reims angels in their minds, merging the high position of the upper

series with the lower series' closer association with an outer wall.

The Saint-Quentin figures are in poor condition, but pre-1920 photographs and drawings document some of the sculptures in an earlier and more complete state (figs. 69 and 71). These records present images of three robed figures: one plucks the strings of a small harp; the

FIGURE 70
Villard de Honnecourt, interior and exterior elevations of Reims Cathedral, 1230s. Bibliothèque nationale de France, Paris, MS fr. 19093. Photo © BnF, Dist. RMN-Grand Palais / Art Resource, New York.

survives, and the extant graphic evidence is ambiguous on this point. In one photograph (fig. 71), the figure holding the viol has what might be the stump of a wing, but it is not present in the drawing of the same figure, nor do the documents show a similar vestige on any of the other figures. Nevertheless, in the Middle Ages the depiction of angels was not dependent on the presence of wings.[86] None of the documents yet unearthed shows or discusses a Christ figure at Saint-Quentin, but a description by the seventeenth-century canon Quentin de La Fons notes, "In the turning bays of the choir, outside, below the entablature . . . are large figures of angels and other similar things."[87] This statement suggests that the program may have included saints or other holy beings, although it is frustratingly vague. In addition to the clerestory angels, each of the two buttress uprights at the junction of the choir and transept carries a sculpture of a crowned male, possibly an Old Testament king, on the outer edge. Due to their autonomy from the upper figures, the kings are unlikely to be the "other similar things" observed by de La Fons under the entablature of the clerestory wall. Moreover, because the kings appear only twice and noncontiguously, they are separate from the angel series. It seems more likely that they relate to the kings along the transepts at Reims and even earlier at Chartres.

Interpretation of the Saint-Quentin figures is particularly difficult given their damaged state and the limited quantity of graphic or textual documentation. If the three documented figures are representative of the group as a whole, however, and if the attributes they hold can be understood as indicators of their meaning, as argued for the sculptures at Reims, then it is likely that they, too, represent a procession. I propose that the musical instruments carried by the Saint-Quentin angels draw on the contemporaneous use of musical accompaniment in liturgical and extraliturgical performance.[88] While musical instruments did not play a significant role in interior liturgy during the Middle Ages, jongleurs and musicians

second holds a closed book; and the third carries another stringed instrument, probably a viol or fiddle.[83] The remaining three figures are not shown in these documents. The accompanying caption on one of the photographs identifies the sculptures as "les moines musiciens," or the musician-monks (fig. 69).[84] The representation of monks with musical instruments was extremely rare in thirteenth-century France, and it is more likely that the statues actually represent angels.[85] No trace of wings

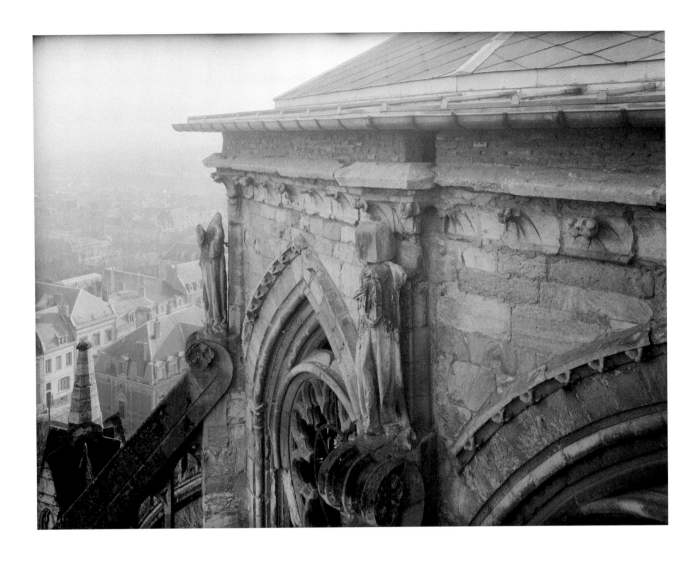

FIGURE 71
Saint-Quentin, view of an upper part of the north apse. Médiathèque de l'architecture et du patrimoine, Charenton-le-Pont, France, inv. MH0110252. Photo: Emmanuel-Louis Mas © Ministère de la Culture / Médiathèque du Patrimoine, Dist. RMN-Grand Palais / Art Resource, New York.

frequently accompanied extramural rituals, particularly processions and mystery plays. Reinhold Hammerstein posits that the procession of angels could imply their song, although he states that such processions occurred only from the fourteenth century on and primarily in Byzantium.[89] The Saint-Quentin buttress sculptures indicate that this motif was more widespread.

Evidence for the liturgical use of musical instruments appears in texts from Saint-Quentin and other churches from the twelfth through the fifteenth centuries. For example, in the *Roman du Mont Saint-Michel* (ca. 1160) by Guillaume de Saint-Pair, which purportedly describes the dedication of the sanctuary by Aubert, bishop of Avranches, the author depicts jongleurs as accompanying

been exceptional instances when liturgy incorporated musical instruments, perhaps especially in popular celebrations.[92] The earliest surviving liturgical book at Saint-Quentin dates to the fifteenth century, but the nineteenth-century antiquarian Dom Grenier's documented fourteenth-century Mardi Gras contests that incorporated instruments.[93] Trumpets and drums signaled the start of the celebrations, which included a *messe en musique*, or a musical Mass; the following day the celebrants entered the church accompanied by trumpets. Although these events were not strictly liturgical, the description clearly notes the use of instruments in celebrations with strong religious components.

Images of processions, such as those depicting King David transporting the Ark of the Covenant to Jerusalem, include participants playing musical instruments, evocative of the description by Guillaume. Just such a scene appears in the Morgan Picture Bible (ca. 1244–54), where the procession is accompanied by trumpeters.[94] Similarly, a *Vita Christi* with illuminations dating to ca. 1190 illustrates musicians playing a harp and a lute,[95] and a fourteenth-century missal and hours pictures King David and several other participants playing various stringed instruments.[96] A later image in the now-destroyed Missel de Jouvenel des Ursins (dated to the fifteenth century) showed musicians accompanying a procession of the Host as it traversed the place de Grève in Paris, providing an example of musical accompaniment in medieval ritual rather than as imagined for past or biblical events (fig. 72).[97]

Descriptions of ceremony and liturgical pomp further suggest that musicians and singers sometimes took on the guise of angels when accompanying major processions or participating in sacred dramas. For example, Jean Froissart (ca. 1337–ca. 1404) writes of musicians dressed as angels surrounding the Trinity in a play enacted above the gates of Saint-Denis on the occasion of Queen Isabella's entry into the city: "A castle had been set up, as at the first gate, and a heaven full of stars with a representation of

FIGURE 72
Procession Through Paris, copy of a fifteenth-century miniature from the Missel de Jouvenel des Ursins showing the Maison des Piliers, place de Grève, and part of the Île de la Cité. Bibliothèque des Arts décoratifs, Paris, France. Photo: Gianni Dagli Orti © DeA Picture Library / Art Resource, New York.

a procession to the abbey church and performing lais (lyrical narrative poems written in octosyllabic couplets) and sonnets with flutes, trumpets, and other instruments.[90] The *roman* describes an eighth-century event, but its description resonates with twelfth-century religious celebrations that involved jongleurs, especially one honoring Saint Michael.[91] Similarly, the Beauvais *Play of Daniel* (second half of the twelfth century), a Feast of Fools, makes several mentions of instrumental musical accompaniment in its prose and rubrics, suggesting that there may have

God the Father, the Son and the Holy Spirit, sitting there in majesty. In this heaven young choir-boys dressed as angels were singing very sweetly. As the Queen passed beneath it in her litter, the gates of paradise opened and two angels came out and began to descend."[98] Musician angels also appear in art, often as part of angelic orchestras in images of sacred events associated with the Virgin. These heavenly ensembles indicated the glory of heaven, even as they were influenced by the instrumentation of processions.[99]

I would argue that the musical angels of the Saint-Quentin choir represent a celestial symphonic ensemble meant to evoke the heavens. As was common, the sculptors drew on earthly models when imagining the celestial world, depicting terrestrial instruments and ceremony. Since musicians frequently took part in processions, the musical instruments held by the two documented Saint-Quentin angels serve a role similar to that of the liturgical instruments carried by the Reims angels and speak to the implied progress of the figures. The program's connection to liturgical performance is further heightened by the inclusion of a book, perhaps representing a psalter or ordinary, which would place the music within a specifically religious context. Thus, the Saint-Quentin program may be read as an abbreviated version of that at Reims, similarly referencing the rituals that sustain the church, here undertaken by the dean.

As at Reims, temporal processions passing beneath the Saint-Quentin buttressing would have found immediate and sustained reflection in the attached sculpture. Both programs thus provide a constant enactment of ecclesiastical ceremony for which the building itself was constructed. Whereas the liturgical commentators see the spiritual Church as the assembly of the faithful, they describe the physical church as the place "in which the divine offices are celebrated."[100] The program at Chartres speaks to the first of these messages; the angelic model

of Reims and its subsequent iteration at Saint-Quentin expound upon the second. However, in representing performance, the sculptures at Reims and Saint-Quentin shift the focus from the stones of the building to the actions of the assembled bodies, once again underscoring the definition of the Church as a collective of the faithful.

BUTTRESS SCULPTURE, STAINED GLASS, AND ARTISTIC INTEGRATION

If buttress sculpture can be interpreted as a representation of ecclesiastical hegemony, as I have suggested, there remains the question of how this theme might relate to the rest of a church's decorative program. In the late twelfth and thirteenth centuries, hemicycle windows in some French churches displayed iconographic representations of the Universal Church comparable to buttress sculpture. An early example of this subject appeared at the church of Saint-Remi in Reims.[101] Although many of the windows have been lost, surviving panels and photographic archives permit a reconstruction of the clerestory program, which in the choir depicted an archbishop below an apostle or patriarch. This arrangement asserts a spiritual hierarchy, but in its representation of the apostles and prophets it also corresponds to the imagery of the Universal Church.[102] As Madeline Caviness has argued, the choir clerestory glass presents an image of Ecclesia as manifested in the images of the apostles and their successors, the archbishops.[103] As representations of the institutional Church, they project a theme similar to that found later on the buttressing of Chartres, Reims, and Saint-Quentin.

A comparable program of stained glass appears in the hemicycle windows of Reims Cathedral, dated to the second quarter of the thirteenth century.[104] The cathedral's axial window presents an image of the Virgin and Child

next to the Crucifixion, above the cathedral and Henri de Braine, archbishop of Reims from 1227 until his death in 1240 (see fig. 31). The other ten windows of the hemicycle depict apostles above the eleven suffragan dioceses, each of which is represented by its bishop, cathedral, or both. There is general agreement among modern historians that the arrangement reflects the order of assembly Henri established at a council held in Saint-Quentin in 1231.[105] As noted by Meredith Parsons Lillich, the horizontal line of bishops and cathedrals speaks to "the cumulative power of the archdiocese," and the vertical juxtaposition of bishops and apostles illustrates apostolic succession and the origins of that power.[106] As with the choir clerestory at Saint-Remi, the hemicycle windows of Reims Cathedral communicate ideas of episcopal authority, especially the power of the archbishop over his representatives and their aggregate control as a diocese. Also like Saint-Remi, the windows allude to the living Church, drawing an even more explicit comparison between the bishop and his building through the image of his physical cathedral. Indeed, there is increasing evidence that the glazed images of buildings drew on contemporary structures.[107] That both the figure of the bishop and the figure of the building served as representations of his see is underscored by the fact that three of the dioceses, Amiens, Arras, and Tournai, are represented only by architecture.[108] Programs similar to those at Saint-Remi and Reims Cathedral in their representation of ecclesiastical authorities and apostles or prophets also appear in the hemicycle windows at Saint-Quentin, Saint-Père (now Saint-Pierre) in Chartres, and Le Mans Cathedral, among other sites, suggesting that it was a prevalent theme in thirteenth-century church decoration that might have been extended to new areas of decoration like buttress sculpture.

The particular iconography of the choir clerestory windows at Reims, with their representation of architecture, deserves special attention in relation to the cathedral's exterior sculpture. One of the most striking

parallels between the two media is the recurring motif of angels. The glazed angels, which appear in seven of the eight images of façades in the chevet windows, are each located on top of a central gable between two flanking towers. This position is visually reminiscent of the tabernacle angels of the chevet and nave buttresses, where the sculptures stand enclosed within a framework of vertical columns. Although the relative chronology of the choir clerestory glass and the chevet tabernacle angels is nebulous, they both date to around the 1230s.[109] At the very least their designs resonate with each other by extending common ideas from exterior to interior or vice versa. Lillich has suggested that the glazed angels might represent the angels of the seven churches of Asia, as discussed in Revelation, which theologians like Cassiodorus and Rupert of Deutz understood as the bishops of these congregations.[110] If true, the windows also underline the connection between apocalyptic and ecclesiological themes, variations of which have been proposed for the upper and lower ranks of Reims's buttress sculpture.

It is possible that the prominence of episcopal authority as a theme in the stained glass of the Reims choir clerestory derived from the patronage of Archbishop Henri de Braine, who may have paid for the axial window that bears his image (fig. 31).[111] While this may be the case, it should also be noted that these windows postdate the sculptures on the buttresses of the radiating chapels, which would have been installed during the episcopates of Aubry de Humbert (1207–18) and Guillaume de Joinville (1219–26), who—like Henri—clashed with the burghers over issues of usury and fought heretics (with whom usurers were often equated). Thus, although Henri's stained glass may bring issues of ecclesiastical authority to the fore, the presence of this theme in earlier buttress sculpture of the radiating chapels may derive from the similar historical circumstances of preceding decades.

While several cathedrals and great churches incorporated glazing programs representing the Universal

Church, Chartres Cathedral is not among them. However, it is worth noting here that the surviving bishop sculptures on the buttresses of Chartres are located only on the south side of the cathedral, the side of the episcopal palace. While it is unclear whether the sculpture planned for other niches was ever completed, the reigning bishop may have had more control over the program on the episcopal side of the cathedral than the side controlled by the canons. Perhaps the apparent independence of the stained glass and buttress sculpture at Chartres reflects the experimental nature of its buttress decoration in the first decades of the thirteenth century.

The episcopal imagery of hemicycle stained-glass windows like those of Reims Cathedral appears at more or less the same height as the buttress sculpture, which most commonly appears on the buttress upright or clerestory wall. In addition, as at Reims, the windows and buttress sculpture were generally executed more or less contemporaneously. These temporal and locational correspondences are provocative in terms of the potential for a unified iconographical program. Were the tabernacle angels at Reims intended as guardians of the gates of Heavenly Jerusalem, it would be possible to understand the sculptures as the celestial protectors of the diocese, as others have argued.[112] However, as a representation of liturgical action, the tabernacle angels can also be read as an image of the pastoral duties of the bishop, which complement the administrative role presented in the glass. Furthermore, the buttress sculpture extends the episcopal imagery from the interior to the exterior. As monumental figures attached to the buttressing frame, the angelic procession achieves a much higher visibility than the stained glass, which is most frequently visible only to those already within the building's walls. In contrast, most ensembles of buttress sculpture can be seen from significant distances, as true today as it was in the Middle Ages. In addition, as part of a motif that stretches across large portions of a church's outer envelope, some portion of the

buttress figures is visible from many different angles and approaches. The permeation of these programs as part of the visual experience of the church exterior makes them particularly potent, and perhaps they prepared visitors for their more condensed representation in the hemicycle glass.

In addition to their subject, the buttress sculptures also share certain compositional aspects with window design. Scholars of stained glass have long noted that clerestory windows tend to feature large single figures, whereas chapel and aisle windows are more frequently constructed from numerous comparatively small narrative panels.[113] It appears that sculptors followed a similar pattern for exterior sculpture, ornamenting the lower portals with complicated scenes composed of numerous figural blocks and decorating the upper zones of the building with isolated monumental figures. In this context it seems significant that the lower and upper registers of buttress sculpture at Reims in fact differ in size, with the upper figures approximately three quarters of a meter larger than those on the buttresses of the radiating chapels.[114] The repetitive nature of the sculptures may also have worked to enhance the lucidity of the program. At Chartres and Reims, and in the documented sculptures at Saint-Quentin, the figures repeatedly represent beings of a type, be it bishop or angel. This repetition may have clarified significant themes and unifying ideas, as has been argued for some stained-glass programs.[115]

Certain aspects of the individual figural compositions also suggest that the artists were keenly aware of visibility issues. William Clark has argued that the stocky chapel sculptures at Reims appear more attenuated when seen from the steep angle of view under which they would most frequently be observed.[116] In many cases, the heads of the figures project forward from the rest of the sculpture and the faces frequently turn downward, making them more perceptible from the ground. Such an outthrust of the neck and head is particularly noticeable in

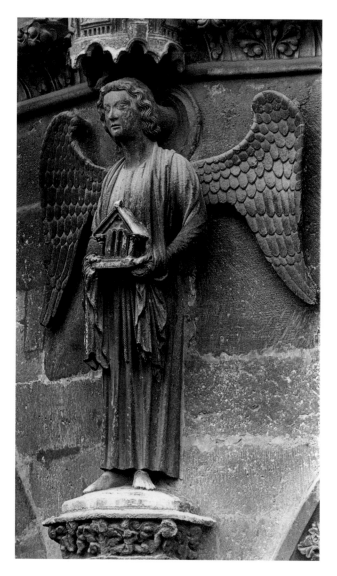

FIGURE 73
Reims Cathedral, figure L3: angel holding reliquary. Pre-1914 photograph by Stoedtner. Photo: Foto Marburg / Art Resource, New York.

the head tips downward. These refinements presumably help viewers close to the cathedral see the faces despite the vertical rise of the cathedral wall and the projection of the body and console. Many of the tabernacle angels at Reims also look downward (fig. 67, left), again presumably enhancing the visibility of their faces. The lowered gaze may be especially noteworthy, as one might well expect the angels, as a celestial ensemble, to gaze heavenward.

Finally, while damage and neglect has significantly limited the available information about many of these buttress figures, at least at Reims it appears that they may have been polychromed. Modern scholarship makes it increasingly clear that exterior polychrome was a common part of the decoration of Gothic portals.[117] It is not unreasonable, therefore, to expect that at least parts of the buttress sculpture would have been highlighted with paint, which would make the sculpture stand out against the background architecture. According to Étienne Moreau-Nélaton and Charles Cerf, parts of the buttress sculptures of the chevet were originally gilded, although the gilding had already disappeared by the twentieth century.[118] The presence of gold in particular would have created a dazzling effect, a metallic shimmer, as the sun moved across the sky and the sculptures moved in and out of the shadows cast by the architecture. Such effects may have been particularly dramatic for the tabernacle angels where their wings extend out beyond their canopies.

BUTTRESS SCULPTURE AT OTHER SITES

Many additional ensembles of buttress sculpture are equally suggestive of the allegorical metaphor of the living Church, with Christ as the foundation stone and saints and bishops as ancillary supports. Although there was clearly some flexibility with this metaphor, figures concerned with the defense and sustenance of the Church were connected to the building's supporting framework.

figure L3 of the lower register at Reims (fig. 73). As seen in a pre-1914 photograph, the sculptor has positioned the head far in front of the chest and filled the gap between head and wall with a cylindrical strut. In other cases, as in the figure of Christ at L9, the halo is set at an angle so that

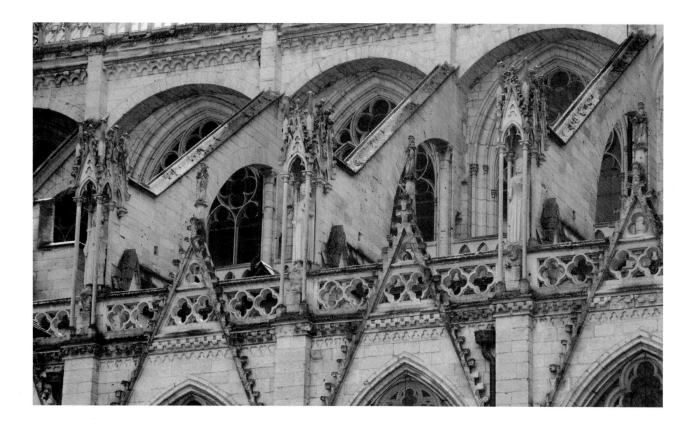

FIGURE 74
Rouen Cathedral, buttress sculpture on the north side of the nave.
Photo: author.

Some later projects follow the liturgical model of Reims. Rouen Cathedral (consecrated 1237) is one such case.[119] Like the angels at Saint-Quentin, the angelic buttress sculptures on the buttress piers of Rouen's south transept were likely influenced by the buttress sculpture at Reims, but they replace the liturgical instruments of the Reims angels with scrolls.[120] Additional buttress sculptures along the nave represent archbishops (reminiscent of the Chartres bishops) and crowned figures, possibly dukes of Normandy (fig. 74).[121] The archbishops, each wearing the pallium, most likely represent local archbishop saints whose cults the cathedral clergy were actively promoting around the time the sculptures were installed.[122] The inclusion of the pallium is significant; its use by archbishops was largely restricted to great feasts, when it symbolized the pastoral care of their metropolitan province.

Other examples of buttress sculpture suggest a closer relationship to the model of Chartres, sometimes combined with liturgical or performative elements. The uniting of structural support and ceremony through buttress sculpture may have been especially clear at Beauvais, if the identification of the sculptures as Saint Lucien and his entourage is correct as reported in early sources.[123] Although the current state of the sculptures does not permit confirmation of these identifications, according to this interpretation they would have combined the liturgical actions of the Reims and Saint-Quentin programs

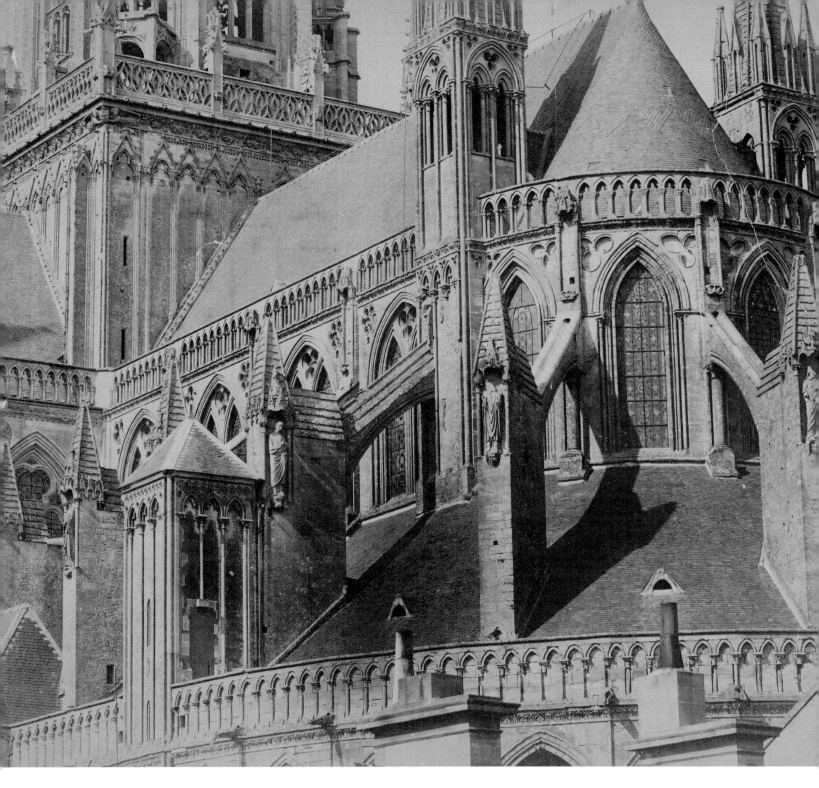

FIGURE 75
Bayeux Cathedral, chevet, ca. 1860. Médiathèque de l'architecture
et du patrimoine. Photo © Ministère de la Culture / Médiathèque du
Patrimoine, Dist. RMN-Grand Palais / Art Resource, New York.

with the representation of bishops as seen at Chartres. The disposition of the Beauvais figures also displays similarities to the arrangement at Saint-Quentin, with the statues placed on the clerestory wall between the heads of the upper and lower flyers, and also to that at Reims, with Saint Lucien at the head of an assemblage (like Christ as the leader of his angelic host). As a synthesis of several previous programs, Beauvais depicts episcopal authority with unusual clarity. Here too the hemicycle glass presents a complementary program of apostles and their saintly successors, with a focus on those of particular significance to the diocese.[124]

Bayeux Cathedral also partially preserves the sculpture of its buttressing-frame system, especially that of the chevet (1230–45; fig. 75).[125] It has two levels of buttress sculpture: one at the top of the buttress uprights and the other surmounting the flyer heads where they meet the clerestory wall. All of the lower sculptures are nineteenth-century replacements based on fragments now housed in the cathedral *dépôt lapidaire*.[126] The only thirteenth-century figure that survives in situ is the sole statue currently on the upper level, above the westernmost flyer of the south side. All of the other upper niches are empty. The Bayeux figures stood on corbels in the form of grotesque faces, comparable to the arrangement at Chartres. Most of the statues were located in shallow recesses between flanking columns and under architectural canopies. The buttress uprights directly behind the stair turrets had statues on either side (instead of on their front), likely because the turrets reduce the available space on the upright's outer edge. Empty corbels and canopies also appear on buttress uprights and clerestory walls on either side of the nave, suggesting that this sculptural program extended to the cathedral's lateral flanks. Some of these niches bear the remnants of heads or halos (fig. 76).

Even though most of the Bayeux sculptures currently installed are modern replacements, their basic iconography predates the restoration work.[127] The

FIGURE 76
Bayeux Cathedral, view of buttresses on the south side of the nave with niches for monumental sculpture; arrow points to surviving halo. Photo: author.

thirteenth-century fragments are generally the lower torsos and upper legs of bishops, identifiable by their garments.[128] As restored, the bishops carry books, chalices, and pastoral staffs. The two figures on either side of the chevet towers wear the galero, or cardinal's hat, and can thus be identified as either cardinals or members of the clergy.[129] One of the heads is preserved in the Musée d'art et d'histoire Baron Gérard in Bayeux (fig. 77). The

FIGURE 77
Head of a cardinal (?) from Bayeux Cathedral chevet buttressing. Collection du Musée d'art et d'histoire Baron Gérard, Bayeux, inv. no. A0773. Photo © MAHB.

FIGURE 78
Bayeux Cathedral, chevet, detail of sole in situ buttress sculpture. Photo: author.

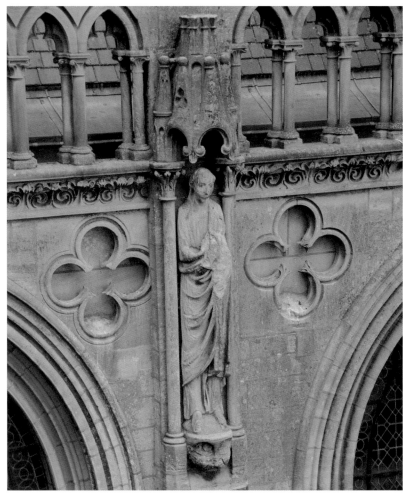

surviving upper-level figure probably represents a saint holding a book (fig. 78); a companion figure is also located in the museum.[130] Finally, the *dépôt lapidaire*, the cathedral's depository for sculptural and architectural fragments, contains several partial sculptures, including two Virgin and Child sculptures that were once located on either side of the axial chapel (fig. 79). The southern Virgin and Child appears in an 1825 engraving representing the cathedral, and a nineteenth-century photograph shows the same statue before the restorations of the 1890s.[131] With the multiple levels of figures, it is tempting

to see the sculptures as a representation of the Church hierarchy, composed of bishops, cardinals, and doctors, but unfortunately their removal and spotty survival do not permit this hypothesis to be tested.

Perhaps the detail that most strongly suggests a representation of the Universal Church in the Bayeux buttress sculpture is the presence of the Virgin and Christ Child at the head of this holy crowd, on the two buttress uprights flanking the axial chapel, in the position of the cornerstone, recalling the often-repeated quotation from Ephesians cited above. A similar arrangement appears on

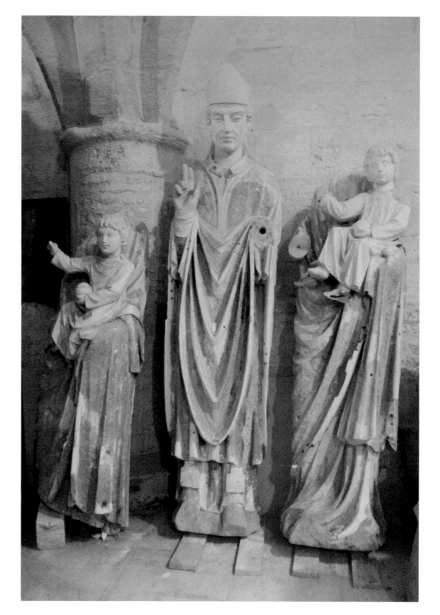

FIGURE 79
Bayeux Cathedral, restored buttress sculptures in
the cathedral *dépôt lapidaire*. Photo: author.

the chevet of Le Mans Cathedral, although the statues run
along the cornice instead of gracing buttress uprights (fig.
80). The poor state of preservation of the statues suggests
that modern intervention on them has been minimal.
Very few are identifiable today, although the statue above
the buttress to the south of the axial chapel is preserved

well enough to show a woman holding an infant, presum-
ably the Virgin and Child. Others appear to hold censers
or other liturgical instruments, similar to the buttress
sculptures of Reims Cathedral.

The examples discussed may help us understand
the programs of numerous churches where buttress

FIGURE 80
Le Mans Cathedral, chevet, detail of buttress sculpture around the axial chapel. Photo: author.

sculptures are missing or were never completed. For example, Pierre Audigier (1659–1744), a canon of Clermont-Ferrand Cathedral, writes that the end of each flying buttress of the chevet had a niche in which was placed a statue of the saint to whom the chapel below was dedicated.[132] As the sculptures have long since gone missing, it is impossible to confirm the identity of the figures. As the choir chapels are dedicated to at least three bishop saints (Saints Austremoine, Bonet, and Arthème), it is likely that at least some of the figures

Audigier speaks of were in episcopal regalia. Nevertheless, it seems unlikely that there would have been such a direct relationship between the chapels' dedicatory saints and the buttress sculpture, as the buttresses appear beside the chapels, not directly above them. Similarly, platforms and gables on the buttress piers between the radiating chapels at Notre-Dame de l'Épine (chapels begun 1509) suggest that monumental figures once inhabited its buttress piers, thus extending the practice well past the thirteenth century.[133]

Where buttress sculptures survive, they generally follow the basic precedent instituted at Chartres, with single standing figures arranged along the exterior wall or outer faces of the supports. The figures stand stiffly with slightly tilted heads that sometimes look down, presumably at the observers below. Usually each figure carries an ecclesiastical attribute or instrument. More often than not, the buttress programs include representations of bishops or archbishops, sometimes interspersed with nonepiscopal saints or holy figures. Within these general rules, however, there is a great deal of variety not only in the types of figures represented (for example, the possible presence of cardinals at Bayeux) but also in the relation of the sculpture to the buttress itself. When attached to the buttress upright, the sculptures are often in niches or tabernacles near its top, but when attached to the clerestory wall, the sculptures might appear below the flyer head (as at Beauvais), above it (as at Bayeux), or in line with the flyer but attached to the cornice or balustrade of the building (as at Le Mans). Variety in the genre of buttress sculpture thus offers a potentially fruitful area for further exploration, despite the poor condition of much of the source material.

BUTTRESSES, BUTTRESS SCULPTURE, AND THE SPECIAL STATUS OF CONSECRATED GROUND

In representing the liturgical and communal performance of the Church, buttress sculpture delineated the metaphysical meaning of the Church as a sacred space dedicated to God. At Reims and Saint-Quentin, where the sculptures depict a coordinated ritualized action, one of the many potential readings is that of the building's consecration, a rite commemorated annually.[134] The attributes held by the lower twelve figures at Reims include instruments that were critical parts of church-dedication processions, particularly the aspergillum, used to bless

the walls of the church, and the relics, from which the building's sanctity ultimately derived. Similarly, the presence of musical instruments at Saint-Quentin may reflect the presence of jongleurs, as described by Guillaume de Saint-Pair for the consecration of Mont Saint-Michel. Even the bishop sculptures at Chartres and Bayeux may reflect the idea of consecration, through the depiction of holy figures triumphing over demons and grotesques, perhaps alluding to the expulsion of demonic forces that was part of any consecration. Moreover, as the only locations where sacrifice might be made to God, churches held a privileged place as sites for ritual performances more generally.[135] Thus, while the buttress sculptures did not necessarily hold a fixed meaning, their presentation of liturgy or religious procession was nonetheless closely tied to the sanctified ground of the church. The development and execution of these buttress programs coincided with an increasing ecclesiastical interest in the delineation of place, specifically in defining hierarchical levels of sanctity and in consolidating their associated privileges, which were key aspects of the reforming movements of the twelfth and thirteenth centuries. I suggest that the sculptures and the buttressing itself reflect this growing concern with compartmentalization, organization, and geographic differentiation. In this way the building edge becomes a signal of the sacred ground it contains.

Latin liturgical manuals highlight the overt twelfth- and thirteenth-century preoccupation with the special nature of the church as consecrated ground. Until the eleventh century, clerics had devoted little energy to the importance of the material place of the church. Heretical attacks on stone churches and a rising interest in liturgical exegesis drew theologians to this point of Christian doctrine.[136] In *De gemma animae*, Honorius stresses the sanctity of the consecrated church and its inherent difference from more quotidian areas. In chapter 169, "Of Certain Locations and Sacrifice," he writes that although God is everywhere in the world, the Church is where he is most

rightly called upon and adored. According to Honorius, the consecration dedicates the church to the faithful and to God, setting it aside as a place for sacrifice.[137] Similarly, Durand writes that the dedication "appropriates the material church and us to God" and cleanses the building of demons or other evils.[138] In both cases the authors specifically single out the consecrated status of a church as the distinguishing feature that marks it as a place of special privilege.

For the authors of the liturgical manuals, the dedication not only appropriates the church building for religious purposes but also reserves it for liturgical use specifically. In this way the consecrated church differs from both secular places and other religious places. In his *Summa*, Beleth distinguishes between three different types of ecclesiastical property: "Among the places dedicated to prayer, some are sacred, some are holy, and some are religious." He goes on to state that sacred places are made so because "by the hand of the bishop they have been duly dedicated to God." He finishes this chapter by explaining that church construction begins by having the bishop or his representative place the foundation stone and sprinkle it with holy water.[139] Like Honorius's *De gemma*, the *Summa* makes explicit the special status of the church, which derives from its dedication. According to both texts, the consecrated church serves a particular role as a place of worship. Beleth's writing, however, further calls attention to lesser ecclesiastical places and also stresses the role of the bishop in constructing the sacred landscape—thereby more forcefully connecting the built environment to its institutional makeup. The tripartite articulation of three levels of ecclesiastical space as expressed in these liturgical manuals parallels a similar division of the interior of the church into the sanctuary, chancel, and nave. Just as the consecration of the church distinguishes it from all other buildings as the most sacred, the consecration of the altar marks the sanctuary as the place of greatest privilege within a church.[140]

In the decades following Beleth's composition of the *Summa*, Sicard of Cremona and Guillaume Durand (among others) repeated the tripartite division of ecclesiastical places.[141] The similarity between the passages in the *Rationale* and the *Summa* suggests that Durand may have copied this passage directly from Beleth or perhaps from an intermediary source like Sicard's *Summa*.[142] As was typical for Durand, he expanded on the earlier work, in this case both adding a much longer description of the various ecclesiastical places and moving Beleth's short section on the dedication to its own chapter, where it receives a much longer explanation of its symbolism and processes. Nevertheless, these differences do not significantly change the message of the text and in fact emphasize the importance of church dedication and the distinction associated with this sanctification.

The stress placed on the special distinction of church ground that appears in Latin liturgical manuscripts was part of the larger reform ideology of the twelfth century and beyond. The very revival of the genre was likely spurred at first by the Investiture Controversy, a conflict between the papacy and the German emperor over who had the right to appoint church officials.[143] In addition, Sicard of Cremona, whose *Mitrale seu de officiis ecclesiasticis summa* was one of Durand's main sources, was a canon lawyer heavily involved in thirteenth-century church reform.[144] Durand himself applied his legal expertise to his liturgical exposition in the *Rationale*. The Gregorian Reforms and related papal reform movements of the eleventh and twelfth centuries, in which Sicard took part, centered on the (re)assertion of Petrine authority and ecclesiastical independence through the rejection of simony (the buying or selling of church offices), lay investiture, and Nicolaitism (clerical marriage).[145]

Generally speaking, many of the reform efforts of the Investiture Controversy emphasized or aimed to increase the purity of the Church such that the clergy could rival the nobility in power and influence. For example,

the proscription against clerical marriage in favor of celibacy can be seen as a means of more clearly distinguishing between the clergy and their lay followers.[146] Popes Nicholas II (ca. 990/995–1061) and Gregory VII (ca. 1020–1085) first championed this particular reform, which Callixtus II (d. 1124) and Innocent II (d. 1143) later codified at the First and Second Lateran Councils of 1123 and 1139, respectively. This legislation forbade presbyters, deacons, subdeacons, and monks from marrying, and it dissolved any existing unions contracted by such persons.[147] In principle, the reformers' proscriptions against clerical marriage created a sharp and recognizable distinction between the clergy and the laity in terms of approved personal relationships and social roles. Similarly, the theological ranking of religious spaces defined their qualitative difference from secular spaces and the mechanism that established this distinction. Although the practical use of religious spaces frequently diverged from those outlined in the manuals, the texts nonetheless present a widely disseminated ecclesiastical ideal that speaks to a medieval conception of the religious landscape as conceptualized by members of its own hierarchy.

CONCLUSIONS

The buttressing-frame system set off and further delineated a boundary between areas of differing degrees of sacredness as described in liturgical treatises. Modern scholars have identified several ways in which church architecture from the eleventh and twelfth centuries forward increasingly marked distinctions between clerical and lay spaces. These included architectural arrangements and physical barriers, like choir screens and walls around cathedral precincts, that compartmentalize, isolate, or focus attention on one area.[148] Such features seem to reflect the gradual transformation of the laity from participants to observers, as suggested by P. S. Barnwell.[149]

Scholars have also suggested that they are related to the idea of the transubstantiation, which had been part of theological discourse since the Carolingian period but was only officially defined at the Fourth Lateran Council in 1215.[150] The intensity of Eucharistic devotion only increased after its codification, as illustrated by the new liturgical feast of Corpus Christi, whose annual celebration was ordered by Pope Urban IV in the bull "Transiturus" (September 8, 1264) and reiterated by Pope Clement V at the General Council of Vienne in 1311–12. The rise in the belief of transubstantiation increasingly limited physical access to the Eucharist to the priest, while the laity took part through the visual experience of the elevation of the Host.

Just as the choir screen and related features demarcate the area reserved for the clergy from the area available to the laity, the dynamic undulation of the buttress piers and flyers, like that of Chartres Cathedral, frames the church and marks its differentiation from the surrounding area (see fig. 9). Like crenellations, the alternation of airshafts and solid masonry generates an ambiguous third space where interior and exterior intertwine in a complex weave of arches, piers, light, and air.[151] Whereas the various constituents of the ecclesiastical community vied for control of the usable space between the boldly projecting buttress piers, the independent rise of the buttress upright and flyer arch prominently signaled the edges of the consecrated ground from a significant distance. According to this reading, the buttressing-frame system becomes part of a multilayered system of boundaries that punctuates the progression from profane to sacred space.

Richard Etlin has proposed that the rib vault, with its thin pier responds, and the flying buttress together visualize the Tent of the Tabernacle and, by extension, the image of the tent created by the wings of two cherubim outstretched over the Ark of the Covenant in Flavius Josephus's *Antiquities of the Jews*[152]—the latter having been represented symbolically in the form of the flying arches

of Constantine's ciborium over Peter's grave in Old Saint Peter's.[153] Etlin argues for an ongoing tradition for the reference to the Constantinian ciborium for Saint Peter, to which he assigns other symbolic meanings and which he maintains persisted across the centuries both in mosaic and painted representations of ribs in cross vaults and in pre-Gothic uses of flying buttresses, as in San Lorenzo in Milan. As a covering for the Ark of the Covenant, the tent itself operated as a protective boundary between the Holiest of Holies and the surrounding court of the Tabernacle. This visual symbolism would have made flying buttresses even more effective as signals for the sanctified ground they encircled.

The sculptures that ornamented buttressing-frame systems, depicting liturgical ceremonies and ecclesiastical authorities, further reinforced the transitional architecture of the buttress zone. Not only did these sculptures form a secondary ring around the building but they also served as visual reminders of the Church's defenders, diocesan heads, and pastoral functions. Thus, as physical objects, this buttressing created a frame, embellished and explained by an iconographic program through sculptures that spoke to its purpose. Buttress interstices negotiated jurisdictional claims between the ecclesiastic and secular communities, while the upper parts of buttressing addressed jurisdictional claims among various members of the ecclesiastic community. Through the combination of all these elements, the church fully integrated its structural supports with contemporary theological and ecclesiological ideas and promoted those ideas to the public at large.

BUTTRESSING-FRAME SYSTEMS AS SIGNS OF SPIRITUAL PROTECTION

VISITORS TO THE CATHEDRAL OF Saint-Just-et-Saint-Pasteur in Narbonne (begun 1272) encounter an unusual buttressing configuration.[1] Buttress uprights rise behind round towers pierced by arrow slits and connected by crenellated parapets supported on round-headed arches (fig. 81). Guardrooms in the buttress piers complete the building's defensive sheathing. These fortified features contrast with the delicate tracery of the cathedral's tall Rayonnant windows. Whereas the battlements, arrow slits, and guardrooms suggest an impenetrable structure, these windows transform the walls into an insubstantial screen. The concentration of Narbonne's fortified features on the buttressing heightens this contradictory juxtaposition of solidity and diaphaneity. The buttressing's inherently intermittent placement makes it an especially poor physical barrier against assault. Thus, while the fortification of Narbonne's buttresses creates visual drama, its protective utility is suspect.

Medieval documents indicate that the church was constructed "in the manner of the noble and magnificent churches of the Kingdom of France."[2] Although only the choir and part of the transept ever came to completion, Narbonne's ground plan, which features aisles, an ambulatory, and radiating chapels, and its three-story elevation confirm this claim of northern inspiration. It is more difficult to pinpoint the stimulus for Narbonne's crenellated buttresses. They do not derive from a northern model, nor are there any clear visual precedents in the Midi.[3]

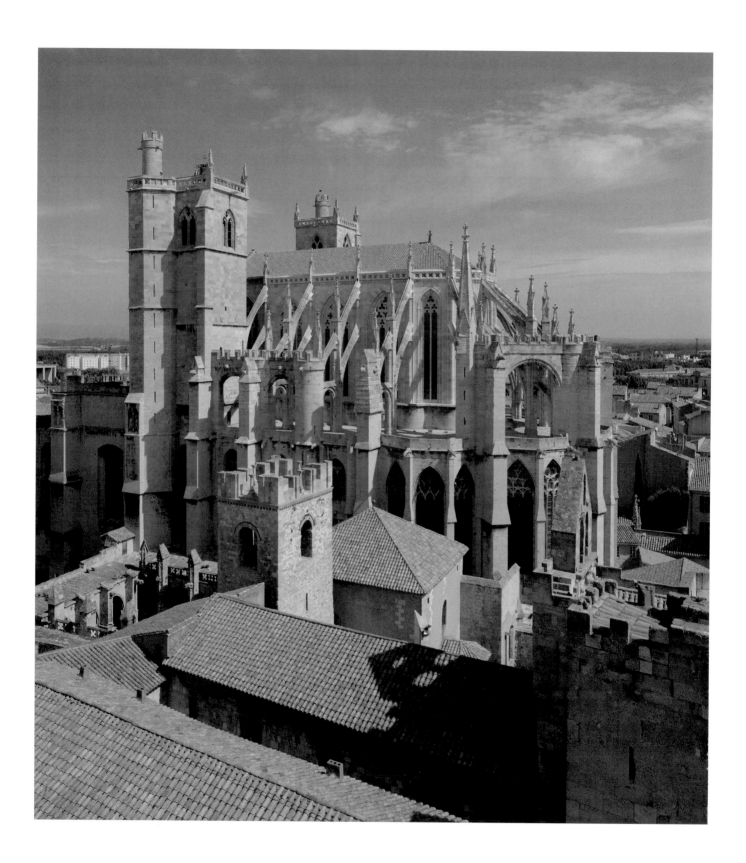

Looking beyond region and style may help better explain these fortified features, insofar as architectural iconography may provide one fruitful avenue for understanding Narbonne's exceptional degree of defensive reinforcement.[4] In the previous chapter I discussed the use of buttress sculpture to amplify the framing of sacred space. In this final chapter, I extend this idea of spatial delineation by first considering the possibility of conceptual links between buttresses and militaristic towers and then examining their presentation of the demonic, potentially apotropaic, forms of gargoyles. Ultimately, I suggest that buttressing-frame systems not only delineate sacred space but also signify the special protections granted by its consecrated status.

Narbonne is something of an outlier in late medieval French architecture. Nonetheless, in it the conceptual link between buttresses and towers takesan unusually literal form. It thus provides a compelling example of the chapter's first argument. Its embattled buttressing capitalizes on the shared systemization of regularly placed towers and buttress piers. By mingling these two different architectural vocabularies, Narbonne embodies the protections provided by consecration. Like a fortified wall, the buttressing signals the boundary between protected and vulnerable places, drawing on the language of physical defense to indicate a spiritual bulwark.

Narbonne Cathedral merges two seemingly oppositional modalities: emblematic markers of contemporary church architecture (flyers and prominently projecting buttress piers) and mechanisms of deterrence common to citadels (turrets, crenellations, arrow slits, and guardrooms). Although modern scholarship typically divides military and ecclesiastical architecture into separate categories, such dualism is largely anachronistic.[5] In the eleventh and twelfth centuries, patrons and master masons worked on buildings of all types without appearing to specialize. For example, ecclesiastics like Benno II. von Osnabrück (ca. 1020–1088) and Gundulf of Rochester (d. 1108) supervised the erection of fortifications and cathedrals, demonstrating that their supervisory skills easily transferred between secular and religious buildings.[6] Stephen Gardner has noted that the Tour Guinette in Étampes uses a particular decorative base that is unique in surviving castle architecture but present in four contemporaneous churches.[7] He argues that this type of evidence suggests that a homogeneous group of designers worked on all royal projects in mid-twelfth-century France.[8] Similarly, the practice of sharing quarries for castle and church construction, as was done at Rochester, illustrates the flow of material and craftsmen between different project types.[9]

The links between military and ecclesiastical architecture extend beyond their builders and materials. Castles, lordly residences, and churches offered physical or symbolic protections, either individually or in combination. Not only could the defensive capacities of these building types overlap, but so too could many of their other features—as seen at Narbonne. Rib vaults and pointed arches, which together with flying buttresses have traditionally been taken as the "essential features" of Gothic buildings, appear in secular and ecclesiastical architecture alike.[10] In contrast, the flying buttress is largely exclusive to church architecture. Thus, while their importance for ecclesiastical architecture is well recognized, their connection to medieval architectural practice more generally is not yet understood. I suggest that while the specific form of the flying buttress was rare on nonchurch buildings, consecrated and unconsecrated buildings both employed curtain walls reinforced by projecting, regularly spaced supports. It is this confluence between the buttressing frame and the defensible curtain wall that Narbonne illustrates with exceptional clarity.

FIGURE 81
Narbonne Cathedral. Photo: Wikimedia Commons (Benh Lieu Song). Licensed under CC BY-SA 3.0.

This overt visual link at Narbonne speaks to the spiritual protection offered by churches, which parallels the material security provided by castles and defensive walls.[11]

After exploring formal and textual connections between buttressing frames and fortifying towers, I turn to a study of small-scale buttress decoration, especially gargoyles. Gargoyles were the most common sculptural ornamentation attached to buttressing-frame systems. They appear much more frequently than the monumental programs discussed in the previous chapter, in large part because of their application to both great churches and small-scale or parish churches. Gargoyles and externalized buttresses have intertwined histories because water evacuation methods exploited the sloping angle of the buttressing arches. Unfortunately, while gargoyles were nearly ubiquitous parts of the Gothic exterior space frame, several obstacles hinder investigations of their meaning. Major restoration projects frequently replaced the original sculptures, and scant medieval documentation makes it challenging to reconstruct original programs, assign agency to their design, or determine their initial reception. While remaining cognizant of these difficulties, I present two case studies, Rouen Cathedral and Notre-Dame in L'Épine, that support apotropaic, protective, or salvific connotations. The case of L'Épine is of particular interest, since its gargoyles visualize the church's eschatological mission and connect directly to the privileged ground of the consecrated church as a place in which stillborn babies could be miraculously revived long enough to receive baptism.[12] Since this miracle required consecrated ground and proximity to relics, the gargoyles of L'Épine, like Narbonne's fortified buttresses, proclaim the spiritual protections afforded by the physical church. The cumulation of this evidence suggests that Gothic buttresses act as a synecdoche for the built church and the privileges granted to it. In this way the buttressing-frame system not only defines the perimeter of the structure to which it is attached but

simultaneously proclaims the significance of that perimeter and defends it from incursion.

THE PRIVILEGES OF CONSECRATED PLACES

Churches offered specific spiritual and physical protections as a benefit of their consecration. These privileges were related to the authority of the Church, through which mankind could achieve salvation. As discussed in the previous chapter, the theological manuals of the twelfth and thirteenth centuries demonstrate an increasing ecclesiastical concern with the delineation of sacred places. A variety of theological and popular texts discuss the immunities associated with sacredness. As the pinnacle of the tripartite hierarchy of ecclesiastical places (which divides spaces for prayer into those that are sacred, holy, or religious), the church offered the greatest privileges. The advantaged status of the church derived from the act of consecration and was linked to the bishop's anointing of the physical church or altar.[13] Narbonne's defensive buttresses, at the furthest extent of the cathedral, mark the limits of that church's protection as an area of the highest sacredness.

This marking of sacred space was especially important for medieval Christians, who saw the temporal world as a place where good and evil coexisted. Texts like Caesarius of Heisterbach's (ca. 1180–ca. 1240) *Dialogue on Miracles* (1220–35) are rife with examples of demons and devils working evil on the earthly plane. According to Caesarius, "so baleful and so poisonous is the nature of demons, that men are often injured by the mere sight of them."[14] He describes several examples where men and women fall into trembling fits after they encounter one.[15] Well-known legends like that of the archdeacon Theophilus of Adana, who sold his soul to the devil to obtain an episcopal office and later repented and sough absolution from the Virgin Mary, similarly recount the ability of benevolent

and maleficent forces to interfere in human endeavors. As Michael Cothren has argued, the depiction of the Theophilus legend in stained glass emphasized its relevance for a thirteenth-century audience by showing the damned cleric executing his ill-gotten power in familiar terms.[16]

Consecration established churches as refuges from the spiritual threat of the devil's power. Guillaume Durand lists five reasons for the dedication of a church in his *Rationale divinorum officiorum*.[17] The first is to expel evil from the building. Bishops began the consecration ceremony with an exorcism and benediction of salt and water.[18] This ritual drove out the devil. Durand underscores this point by repeating a story from Gregory the Great's *Dialogues* in which the reconsecration of an Arian church evicts an evil spirit that had taken the form of a pig. Durand later states, "in consecration [the material church] . . . ceases to be the brothel of demons, as is clearly shown in the consecration of that temple that used to be called the Pantheon"—implying that unconsecrated buildings remained places hospitable to evil forces.[19]

Popular texts also included purification among the purposes of church dedication. For example, Caesarius records that all exorcisms weaken the malice of demons.[20] Jacobus de Voragine comments on the cleansing power of the exorcism in the *Golden Legend*: "The church is sprinkled inside and out with blessed water for three purposes. The first is to drive out the devil, for the blessed water has the particular power to do this. Hence in the rite of exorcism of water are the words, 'Water, be exorcised in order to dispel all the power of the Enemy and to exterminate the devil with his apostate angels.' This holy water is made from four ingredients . . . because there are four principal ways of driving the devil away."[21] Jacobus further interprets the crosses painted on the walls during the consecration as having as their first purpose "to frighten the demons, who, having been driven out of the building, see the sign of the cross and are terrified by it, so that they do not dare enter there again. Chrysostom says of this: 'Wherever the

demons have seen the Lord's sign they take flight, fearing the stick that gave them such a beating.'"[22] The spiritual sanctuary created through consecration provided respite from the lure of temptation. It offered a physical location where the soul was theoretically protected, thereby manifesting the church's role in salvation, as is shown in the practice of taking demoniacs into churches when seeking to cure them, as Caesarius reports about a possessed woman who was taken into the church of Saint Michael the Archangel before she was questioned.[23]

The protective power of the church as a sanctuary extended beyond spiritual safeguards to defense from mundane bodily harm. Durand states that the second purpose of dedication was to make the church into a refuge for those who were fleeing persecution. He again references Gregory as his authority: "Secondly, a church is dedicated so that anyone fleeing to it can be saved, as we read in the canon of Gregory."[24] Similarly, Jacobus writes, "Secondly, the church is consecrated in order that those who take refuge in it may be saved. The lords of the land grant this privilege to some churches after they are consecrated, to protect those fleeing to them from pursuit."[25] The right of asylum was based on the inviolability of the sacred. At first, this privilege was confined to the consecrated church itself, but over time it was extended to peripheral places like church atriums and cloisters. For example, Durand defines holy (*sancta*) places as "those that have immunity or privileges and . . . are assigned to the servants and ministers of churches; places which, lest anyone presume to violate them, or seek a legal remedy or special privilege to violate them, carry the threat of certain punishment."[26] According to Durand, holy places (which include church atriums, some cloisters, and canons' residences) provide protection to anyone fleeing from a crime, even though they are distinguished from sacred places (which are by definition dedicated by a bishop). The extension of this immunity from sacred to holy places does not detract from its application

to consecrated churches, especially since, as part of a graduated sacredness, each successive level contains the characteristics of the previous category. In the words of Durand, "any place that is sacred is also religious, but not the opposite."[27]

Ironically, the best-known example of the right of asylum is one where it failed: the martyrdom of Thomas Becket in Canterbury Cathedral, where Becket had fled for his protection on December 1, 1170. The accounts of this event by Edward Grim (1171–72) and "Garnier" Guernes de Pont-Sainte-Maxence (1174) state that the monks with Becket persuaded him to enter the church in the hope that its sanctity would dissuade his pursuers from injuring or killing him.[28] Garnier writes, "It was not that God wanted [Becket] to be treated so foully; he was testing these wicked men—perhaps they would not dare commit so atrocious a sin within a holy church."[29] En route to the church, the monks carried Becket through the cloister, and Garnier repeatedly references walls and doorways as points of division between the protective, holy church and its surroundings (where Becket would be more vulnerable). The actions of the monks are inverted by the knights, who try to remove Becket from the church before killing him: "Come away with us," says one of the knights, according to Garnier's account, which continues, "He meant to drag him out of the holy church."[30] Garnier, unlike Grim, places more emphasis on Becket's proximity to relics than his being on consecrated ground.[31] However, since the consecration of the church itself was so closely tied to the presence of relics, this distinction is ultimately trivial. Whatever Garnier thought, his report of the actions of both the monks and the knights demonstrates the twelfth-century recognition of the sanctity of the physical church.

Becket's martyrdom and subsequent sainthood resonated powerfully in parts of France, especially Chartres. Chartres Cathedral acquired a relic of Becket's blood within ten years of his death.[32] John of Salisbury, bishop of Chartres from 1176 to 1180, was in Canterbury at the time of Becket's assassination and witnessed it in the church. John actively promoted Becket's cult and composed what may have been the first of ten texts recounting Becket's vita.[33] Becket also features among the martyrs depicted in the rebuilt cathedral of Chartres, which was begun around fifteen years after John's death.[34] At the cathedral, both of the scenes of Becket's murder show the martyrdom within or in front of an arcade. This architectural feature indicates the interiority of the event and the attackers' transgression of consecrated ground, which was a crucial part of Becket's vita.

The right of asylum was not limited to situations of pursuit, as in the case of Becket. With the adoption of the Peace of God (*Pax Dei*) at the Synod of Charroux, in 989, the protection of the physical and spiritual church came to include prohibitions against theft from the church and the poor as well as violence against clergymen.[35] The Peace of God also protected certain vulnerable groups and noncombatants from the violence propagated by warring nobles. In some articulations of this ideology ecclesiastics depicted knights as evil incarnate and the church as the only sanctuary.[36] Among its many proscriptions, the Peace of God explicitly prohibited nobles from invading churches, an offense it made punishable by excommunication. Through the Peace of God movement, churches, many of which actively promoted it, became places removed from the pervasive violence of medieval society.[37]

In sum, churches offered tangible and intangible protections predicated on their sanctity of place. The sacred space of the physical church offered a sanctuary from persecution, a chance at spiritual salvation through the Eucharist, and protection from violence. In the words of Garnier, the church was a place "where misdeeds are made clean and washed away."[38] The example of Thomas Becket illustrates the medieval expectations of these protections, and Caesarius of Heisterbach's *Dialogues*

demonstrates their influence in the medieval imagination. They were linked to the physical building and were demarcated by its walls and buttresses. The use of fortified features, like the crenellations at Narbonne, should be seen in this context. As I argue in the next section, Narbonne's fortifications signaled the spiritual and physical protections offered by the consecrated ground of the church, projecting a type of defense while not necessarily functioning as physical defenses themselves.

FLYING-BUTTRESS SYSTEMS AS SYMBOLIC FORTIFICATION

The fortification of Narbonne is exceptional in its extent, but many churches share features with fortresses. These elements range from moldings to capital types to wall passages. Historians of medieval architecture often speak of wall passages in terms of the diaphanous layered surfaces of Anglo-Norman and northern French Gothic buildings[39]—as seen, for example, at Noyon and Reims Cathedrals. Fortified structures employ similar features to give access to arrow slits, machicolations, and garderobes (a polite term for the medieval toilet—essentially a hole in a small chamber projecting slightly from the wall of a structure, from which human waste would fall into a cesspit below).[40] Stephen Gardner has pointed to a number of precise architectural exchanges between military and ecclesiastical structures built around Paris in the 1130s and 1140s.[41] The similarities between these features illustrate a robust crossover in the administration of building construction, a use of shared materials, and a common vocabulary of forms familiar to designers and builders. In addition, a wide variety of ecclesiastical buildings incorporate features, like crenellations, that derive from a more overtly seignorial context.

Fortified features appear in many different types of ecclesiastical structures throughout France. One of the

FIGURE 82
Reconstruction of the west façade of Saint-Denis as envisaged by Abbot Suger. Drawing by Gregory Robeson from Sumner McKnight Crosby, *The Royal Abbey of Saint-Denis: From Its Beginnings to the Death of Suger, 475–1151,* ed. Pamela Z. Blum (New Haven: Yale University Press, 1987), fig. 72. © Yale University Press.

best-known examples is Abbot Suger's abbey church of Saint-Denis, begun around 1135. Battlements, rebuilt in the fourteenth and nineteenth centuries, crown the full wall of Suger's west façade (fig. 82).[42] A comparable example is the west front of Notre-Dame-du-Fort in Étampes, which received crenellations in the thirteenth

FIGURE 83
Étampes, Notre-Dame-du-Fort, west façade. Photo: Sarah Thompson.

like machicolated arches, crenellations, and crenellated ring walls.[44] Finally, numerous churches received fortifications of some kind during the Hundred Years' War.[45]

While the prevalence of crenellations, machicolations, and other defensive mechanisms on ecclesiastical architecture is indisputable, the protective functionality of those features varied. Their utility certainly differed by location. In some areas, like the Languedoc, the increased anxiety over potential attacks provided a tangible motivating factor for the fortification of churches. Sheila Bonde has argued that the perceived threat of attack by heretics, pirates, and Saracens prompted the construction of defensible churches intended as strongholds, such as the cathedral of Agde (fig. 84).[46] For example, an 1173 diploma of Louis VII states, "We give permission within the same church and city [of Agde], because of fear of the Saracens and because of the frequent incursion of evil men, for the making of towers, fortifications, walls, posterns, and protections of gates, and ditches and whatever you shall have recognized to be helpful to [the defense of] the church and the city itself."[47] Documents like this one link the permission to fortify to an external threat. A comparable utilitarian function seems to have spurred the fortification of several parish churches in the fourteenth and fifteenth centuries, when peasant populations feared an overspill of violence from the conflict between the English and French armies. The French chronicler Jean de Venette (ca. 1307–ca. 1370?) described the fortification of two such churches in his *Chronicle*, reporting that village inhabitants stocked their churches with food and weapons, blocked the windows and doors, and dug ditches around the buildings.[48] One surviving example of the type of fortification described by Jean is the heavily restored church of Sainte-Radegonde in the Aveyron, which features machicolations and an interior well.[49]

Buildings like Agde Cathedral and Sainte-Radegonde may have been intended as strongholds (or at least have incorporated defensive features in response to an external

century, contemporaneous with the creation of its three western portals (fig. 83).[43] In both cases the crenellations boldly project from the top of a façade wall. No stringcourse, molding, or change in plane sets them apart from the rest of the façade. Villard de Honnecourt's drawings of the Reims Cathedral record crenellations along the roof of the nave aisle (fig. 70), both lines of which are much lower than those at Saint-Denis and Étampes. Many twelfth-century churches of the Languedoc are noteworthy for their fortification, which could include features

threat), but medieval narrative accounts document the limited effectiveness of fortified churches. For example, a letter dated 1212 from Guillaume II, abbot of Cluny, to Pope Innocent III relates that the prior of La Charité, Geoffroy de Donzy, hurled stones from his towers when the abbot went to La Charité to return the disobedient abbey to its duty.[50] However, despite the monastery's successful obstruction of Guillaume, it was not able to hold against the Count of Nevers, whom Philippe Auguste eventually enlisted to bring the monastery back to order.

The history of medieval warfare offers numerous instances in which fortified churches fell to hostile armies. For example, Edward III's slaughter of peasants taking refuge in fortified churches on his 1360 advance to Paris during the Hundred Years' War demonstrates the ineffectiveness of churches as defensible structures against a well-armed assault.[51] Jean de Venette relates one instance where, after just such an assault, "of twelve hundred men, women, and children there did not remain three hundred who were not pitiably burned to death" when soldiers torched the fortified church in which they had sought refuge.[52] Likewise, French chronicler Jean Froissart records that the French advisors to the king of Castille placed little value in fortified churches, saying, "When the English ride out, these little fortresses in churches and monasteries will not survive against them, but rather [the English] will be well refreshed and nourished by what they find inside them."[53] In this account, the military advisors not only dismiss fortified churches as inconsequential defenses but even see them as inviting targets that armies could easily pillage.

The qualified protections offered by church fortifications call into question their interpretation as defensive elements given by church patrons and other nonarchitects. Three examples taken from contemporary documents suggest that crenellations and other fortifications were likely built for extramilitary purposes that complemented any defensive function they may have had. Suger's

FIGURE 84
Agde Cathedral. Photo: Wikimedia Commons (Spedona). Licensed under CC-BY-SA-3.0.

De rebus in administratione sua gestis is probably the best-known example in which a patron explains the presence of defensive features on a church. He writes, "We also committed ourselves richly to elaborate the tower[s] and the upper crenellations of the front, both for the beauty [*decorum*] of the church and, should circumstances require it, for practical purposes."[54] Suger's remarks present the battlements as both beautiful and utilitarian features, and most scholars have taken Suger at his word that the crenellations were intended to be defensive.[55] However, as the examples I have presented above demonstrate, their utility would have been finite. Given that Suger was unlikely to have had a sophisticated knowledge of architecture, perhaps it is reasonable to question his authority about the crenellation's practical value.[56]

The cartulary of Chartres Cathedral provides a second example where the crenellation of an ecclesiastical structure (here a cloister, not a church) is described in terms of physical protection. As discussed in chapter 2, the prolonged conflict between ecclesiastical and secular powers in Chartres erupted in a series of attacks against the chapter in 1249, 1252, and 1253. Following these midcentury hostilities, the canons exiled themselves and refused to return to the city until they had secured the rights to construct a crenellated wall around their cloister.[57] According to the 1256 charter documenting the canons' purchase of the right to crenellate, the cloister wall could include crenellations of a moderate height—but not towers, arrow holes, or other means of fortification.[58] The restrictions placed on the type of reinforcement allowed to the chapter reveals the count's anxiety in granting the privilege, although it is less clear whether he feared the militarization of the cathedral close or the granting of seignorial rights. The fact that the cloister's wall was not completed until the fourteenth century calls into question the purported urgency of this barrier for the canons' physical safety.

Narbonne Cathedral offers a third example where a contemporary party portrayed church crenellation as functional defensive architecture. Importantly, however, the master mason disputed this interpretation. A document from April 4, 1349, includes a description and explanation of the buttresses by the master of the works, called to testify as part of a legal battle between the cathedral chapter and the town consuls.[59] This document is one of several records of the conflict over whether the chapter had the right to breach the city's wall, a dispute that lasted from 1345 to 1361. The rampart blocked construction of the cathedral's transept, most immediately the erection of the two portals of the planned north and south transept arms. The April 4 record reflects the consuls' concern over what they perceived as the utilitarian nature of the cathedral's fortified buttressing, which they discuss as

militarized architecture. As recorded in the process of the consuls against the chapter of Saint-Just, the master builder reported that the turreted towers and stone arches were necessary to sustain the fabric of the church.[60] Horizontal buttressing arches are rare in medieval French architecture, but they do appear in a handful of buildings, including in the straight bays of the choir of the basilica of Saint-Quentin, where they were added after the original double-rank system had proved insufficient in the fifteenth century.[61] It remains unclear whether the connecting arches at Narbonne play any significant structural role in supporting the building, as is suggested by the master's recorded testimony.[62]

If the builder understood the arches as braces for the cathedral, he did not describe the fortification of those supports in a comparably utilitarian way. According to the surviving account, the "layered [*melleti*], or even crenellated, pillars were not made or proper for battle or assaults, but were made only for the grace [*decorum*] and the beauty [*pulcritudinem*] of the work of the church."[63] This account underscores the visual role played by buttressing-frame systems and the efforts taken by their designers to maximize their appeal (as discussed in chapter 1). It is possible that the master mason would have seen crenellations as a natural decoration when connected to a ring of projecting vertical piers, given that his testimony denies the crenellations' significance as functional defensive mechanisms. The master's clarification of the crenellations' purpose demonstrates their significance as recognizable markers of defensible architecture and their intentional use in nonfunctional contexts. Moreover, it reveals that experts and nonexperts interpreted the utility of defensive features differently.

To summarize, fortified features on churches do not necessarily indicate the building's usefulness as a physical stronghold. However, the military value of defensive features used in church architecture might not ultimately be the most salient point. Charles Coulson's study of castles

concludes that functional defensibility and the visual suggestion of defensibility possessed equal prestige and were not necessarily differentiated.[64] Even for secular structures, seignorial status—not defensibility—could trigger the use of visible markers of fortification. Symbolism was likely just as strong when those same features appeared in ecclesiastical structures. In this way, while not necessarily practical in a military sense, they carried implications of violence, even if the ecclesiastical overlord never acted on the physical aggression they connoted.

Crenellations at ecclesiastical buildings across France seem to have taken on different symbolic meanings, depending on their location and sociopolitical context. Sumner McKnight Crosby has suggested that Suger's use of crenellations signaled the importance of Saint-Denis as the repository of the royal regalia and oriflamme.[65] It is possible that the crenellations of Narbonne Cathedral similarly played up a connection to the Crown. Vivian Paul has suggested that the desire to construct a cathedral in the manner of the Kingdom of France stemmed from the many royal connections between the archbishops of Narbonne and the kings of France.[66] Moreover, the flesh of Philippe III was entombed in the cathedral following his death, in Perpignan in 1285. Likewise, at Chartres, the purchase of a license to crenellate might have been just as significant as a statement of the chapter's authority in relation to the count as it was as a first step toward providing physical security. The major part of the legal battle between the town consuls of Narbonne and the chapter of Saint-Just revolved around the rights over the town rampart in a similar, if less violent, power struggle. Melissa Jordan Love has argued that features like the crenellations of Narbonne's buttresses, as part of a "castle aesthetic," affirmed the prestige of the chapter.[67]

However, the status of the Church lay not only in its seignorial rights but also in its ability to lead mankind to salvation. Reims Cathedral, where the crenellations were so stunted as to be only slightly better than mere suggestions, aptly illustrates the incorporation of fortifying features without any prospect of military functionality (fig. 70). Therefore, in the context of ecclesiastical architecture, crenellations may also signal the salvific role of the Church in protecting and defending the soul.[68] At least since the early twentieth century, architectural historians have often linked medieval church architecture to biblical archetypes, especially Solomon's Temple and Heavenly Jerusalem, drawing on medieval exegesis and visual or numerical correspondences.[69] For example, Stephen Murray has argued that the geometrical matrix underlying the ground plan of Amiens Cathedral signals the building as a type of New Jerusalem.[70] Solomon's Temple and Heavenly Jerusalem often appear in medieval illuminations with crenellations, and the use of this readily identifiable feature may similarly reference the biblical model of the Temple, from which "the material church take[s] its form," in the words of Guillaume Durand.[71] In this case, the use of crenellations manifests the reverence for the archetype. In addition, whereas in a secular context crenellations or other markers of fortification signaled seignorial status, in the ecclesiastical context they linked the contemporary building to the biblical history of salvation.

BUTTRESS FRAMES AS SYMBOLS OF SPIRITUAL DEFENSE

Consecrated structures shared in the physical and symbolic values of fortifications by appropriating crenellations and other defensive features. In effecting these appropriations, masons transplanted architectural forms from a secular to a religious context but did not necessarily also transfer their utilitarian function. This type of translation was in fact quite common, as Stephen Gardner has argued, and might well be expected, since

medieval masons seem not to have specialized in building types (at least in the twelfth and thirteenth centuries).[72] Buttressing-frame systems stand as an exception to this larger interplay between building types, appearing only infrequently on unconsecrated buildings and even less frequently on structures outside of ecclesiastical purview. How then did the idea of an exterior space frame fit within the larger field of architectural practice, which otherwise exhibited greater fluidity between building types? It stands to reason that if form can transfer in the absence of function, then the reverse should also be true—that function can transfer without form. I suggest that while the buttressing arch remained largely restricted to church architecture, the idea of supporting a wall with regularly spaced projections came to be shared by ecclesiastical and secular buildings. In both, the projecting elements, rather than the wall itself, most forcefully expressed the building's strength.

The system of point support intrinsic to buttressing-frame systems shares several characteristics with fortifications more generally, particularly their similar display of masonry planes, height, and enlivenment of curtain walls. Most of these affinities stem not from the buttressing arch of the flyer but rather from the massive vertical masonry assemblage that supports it—the buttress piers. This bulky support was essential to the buttressing frame and the skeletal appearance of church exteriors in Gothic France. The independent projection of the buttress upright formed a key part of its aesthetic, as is suggested by its decoration with sculpture (discussed in chapter 3). While the structural frame of ecclesiastical architecture differed significantly in appearance from the fortified walls of citadels, castles, and seignorial residences, the two nevertheless shared a general pattern of regularly spaced projecting masonry towers, both of which connoted security. In the ecclesiastical context, the system of turreted (buttressed) curtain walls signaled the security that church ground provided from evil and pursuit.

Buttress-pier supports and defensive towers are visually distinct. Whereas buttress piers and uprights tend to be solid rectilinear masses, defensive towers range widely in shape from rectangular to circular and incorporate vaulted rooms or staircases that could hold defenders. Defensive towers are consequently larger than buttress piers and uprights. Those of Philippe Auguste's fortifications ranged from eight to ten and a half meters in diameter, with walls two to three meters thick.[73] However, the visual differences between buttress piers and towers do not discount a conceptual overlap, and in terms of verticality and projection, the two share limited formal similarities.

Perhaps ironically, the most explicit evidence for a theoretical conflation of buttress piers and defensive towers appears in theological writings that warn against architectural excess, especially Peter the Chanter's (d. 1197) *Verbum abbreviatum* (1191–92). In this text, Peter expresses his anxiety over what he perceives, through the lens of his ascetic and moral concerns, as a lack of architectural decorum. Peter writes that churches and places sacred to God, having been crowned with towers (*ecclesie turrite*), have been encastellated.[74] He focuses his attentions not on the specific mechanisms of fortification but rather on the vanity he perceives in building height and superfluity, in which towers played a significant role. The word *turrita* (meaning "towerlike or towered thing") can be used to refer to a military tower like a donjon. When applied to cathedrals, it can designate a bell tower, but perhaps also any towerlike thing that the new style of architecture incorporated.[75]

The Latin vocabulary of ecclesiastics lagged well behind changes in building dynamics, and classical Latin did not always provide words for expressing architectural morphology precisely.[76] Moreover, while Villard de Honnecourt's sketchbook includes the Latin term *ars boteres*, his text, of the 1220s or 1230s, provides no term for the flyer's pier supports.[77] The word *culée* (signifying the buttress upright)

appears in 1355, but even after this date other terms are also used to designate this same feature.[78] It therefore strikes me as highly unlikely that anyone outside the architectural professions, like Peter, would have used a specialized vocabulary for buttress-pier supports in the late twelfth century, when externalized buttressing was relatively new.

John Baldwin has suggested that Peter directed his criticisms specifically at Paris Cathedral, which was under construction during his composition of *Verbum abbreviatum*.[79] However, the west and crossing towers of the cathedral rose well after Peter's death and so could not have prompted his rebuke and could not be the *turrite* to which he refers.[80] He would have witnessed the construction of the cathedral's hefty buttress piers and uprights, and I think it is plausible that his objections to the project would have encompassed these unfamiliar elements. Consequently, Peter's use of the term *turrite* may refer not only to literal towers but also to the towering piers of the church's outer envelope, which may have brought to mind the defensive towers of secular structures.

Peter is only one of several theologians who criticized the moral excess of France's great cathedrals. Alexander Neckam's (1157–1217) near-contemporaneous *De naturis rerum* (ca. 1190) similarly singles out towers (*turres*) for their vanity of height. Like Peter, Neckam compares these towers to the Tower of Babel.[81] Moreover, Neckam's concern, like Peter's, is not limited to towers in a strict sense but encompasses the general height of buildings and turrets as well. Since buttress uprights and piers participated in the physical and aesthetic verticality of late twelfth-century church building, I find it likely that these forms provoked his ire when he witnessed Notre-Dame's construction during his student days in Paris.[82]

Peter and Neckam propound a negative interpretation of the ecclesiastical use of towers, and while these texts may demonstrate slippage between the Latin terms for buttress piers and flanking towers, they indisputably associate with these structures no positive connotations of spiritual defense. However, such an association may have appeared in other genres of theological texts, insofar as they do connect church towers to protection. For example, Guillaume Durand's liturgical handbook describes church towers (*turres ecclesie*) as the building's "fortification and defense." In this same section Durand, like Peter and Neckam, includes references to pinnacles (*pinnaculum*), which he says represent the mind of the prelate. This clustering of towers and pinnacles may suggest that Durand is generally addressing vertical extensions on church exteriors, which could include buttress piers and uprights—for example, those at Amiens Cathedral, which end in gabled pinnacles (fig. 85). Together, these three texts might suggest a contemporaneous association between buttress piers or uprights and secular towers, despite their formal distinctions regarding size and shape, in the minds of churchmen. They also demonstrate the changing connotations of ecclesiastical towers over time and according to different audiences. What was morally suspicious for Peter and Neckam was virtuous for Durand.

Descriptions of flying buttresses also demonstrate links to fortresses and fortified architecture. For example, the April 4, 1349, document from Narbonne records that what the masters termed pillars and regarded as necessary for building stability, the city consuls regarded as military towers in the construction of an impregnable fortress.[83] Like Peter and Neckam, the consuls of Narbonne did not necessarily distinguish between the buttress piers and military towers, despite their obvious visual distinctions. As part of a politicized debate, these descriptors are colored by the larger conflict but show a semantic slippage between buttress piers and towers in the minds of their viewers. The ambiguity of language, particularly as distinguished between specialists and nonspecialists, reaffirms the likelihood that Peter and Neckam included buttress piers and uprights in their moralistic critique.

The regular masonry of church exteriors also finds parallels with strong walls and fortifications as described

FIGURE 85
Amiens Cathedral, buttressing of the chevet. Photo: author.

in medieval French literary texts.[84] For example, the *Roman d'Énéas*, written by an anonymous Norman author ca. 1160, describes the walls of Carthage as part of the retelling of the story of Aeneas. The author would not have seen the actual city of Carthage, and his careful descriptions likely reflect the buildings he would have known from Normandy. For example, the stones of the walls are "with great skill and cunning . . . placed very regularly; all are marble and adamant. The walls are built with columns, with pillars and with geometrical designs. . . . on the side facing towards the town, the walls were decorated with arcades, arches and canopies, and all were made with great blocks of marble."[85] The decoration of these walls employs an architectural vocabulary more closely suited to ecclesiastical structures than to military ones, particularly the columns, pillars, arches,

and arcades. It also resonates with the French use of well-dressed stone known as ashlar masonry.[86] Over the course of the eleventh and twelfth centuries, ashlar masonry, or *moyen appareil*, came to replace rough stone as standardization and prefabrication became increasingly common.[87] Great churches of the mid-twelfth century depended on well-dressed ashlar blocks for strength and, presumably, visual appeal.[88] In contrast, contemporary defensive structures did not consistently employ this expensive type of material. The uniformity of block size, regularity of coursing, and thinness of the mortar joints of the outer stone of the many castles built by Philippe Auguste contributed to their image of monarchal power distinct to his program of castellation.[89] Similar characteristics appear in church construction already in the eleventh century, as at Saint-Benoît-sur-Loire.[90]

In addition to commenting on the quality of the masonry, the *Roman d'Énéas* also states that Carthage's "walls were thick and high," with "five hundred towers all around."[91] This emphasis on height appears frequently in descriptions of walls and fortifications and finds parallels with the soaring cathedrals of the thirteenth century.[92] Wolfgang van Emden suggests that descriptions emphasizing the great height of a wall correspond to the "wall great and high" from Revelation 21:12.[93] The punctuation of the wall of Carthage with hundreds of towers is comparable to the regular spacing of buttress-pier supports. The document from Narbonne also specifically notes the use of stone in the construction of the flyer arches. Similarly, a document recording a structural appraisal of Saint-Étienne-du-Mont in Paris in 1521 refers to the buttress piers as "pillars of stone" (*pilliers de pierre*). It recommends their enlargement and stipulates that the construction should be in "good masonry" (*bonne maisierre*).[94] Such phrases indicate the quality and regularity of the materials, comparable to the *Roman d'Énéas*'s description of the walls of Carthage.

Any physical similarity shared between buttress piers and towers is part of a more intangible change in which the agency of the wall gradually shifted to periodic points of support. What is of interest here is the marked development of systematic arrangements of flanking towers, which appear in the second half of the twelfth century, and the difference between this arrangement of towers and those of the immediately preceding centuries.[95] Mural towers had long been part of medieval military architecture. This connection is demonstrated by the fragmentary remains of Roman or Visigothic towers at the now heavily restored fortress at Carcassonne.[96] Such towers had clear defensive advantages in their provision of lookouts and tall platforms from which to hurl projectiles. In the first half of the High Middle Ages, mural towers were part of several castles in England and France, but they appeared only on the donjon or on limited stretches of the surrounding wall. For example, at the castle of Gisors, in Normandy, built in stages by English kings from the late eleventh through the thirteenth centuries, three rectangular towers defended the northern stretch of the low wall encircling the donjon (sometimes referred to by the French term *chemise*) constructed in the middle decades of the twelfth century (fig. 86).[97] Only one of these towers survives today.

From the second half of the twelfth century, military architecture began to exhibit a new systematized arrangement of flanking towers such that every section of the wall was protected by defenders on towers to either side of that section, with no portion of the wall remaining unprotected. Comparison of the *chemise* at Gisors with Henry II's building campaign at Dover Castle (begun in the 1180s) illustrates this transformation (fig. 87).[98] In contrast to the irregular placement of the Gisors towers, the curtain walls surrounding the inner bailey (or courtyard) at Dover have fourteen towers placed at regular intervals. The towers are further united by their similar appearance. Each is a projecting square with an open back. Similarly,

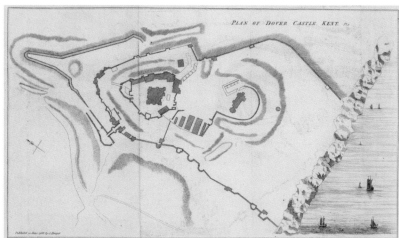

FIGURE 86
Gisors en 1610 d'apres le dessin de Joachim Duviert, detail. Bibliothèque municipale de Rouen, Nmm-165. Photo: BMR.

FIGURE 87
Plan of Dover Castle, Kent. From William Darell, *The History of Dover Castle* (London, 1786), plate XI. The Huntington Library, San Marino, California, call no. 601785. Photo: The Huntington Library.

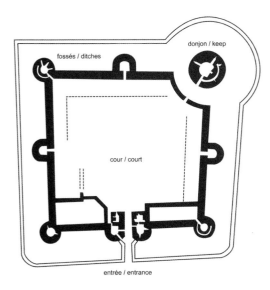

FIGURE 88
Plan of Dourdan Castle. Photo: Wikimedia Commons (Lionel Allorge).
Licensed under CC-BY-SA-3.0.

FIGURE 89
Angers Castle, towered wall. Photo: Wikimedia Commons
(Romainberth). Licensed under CC-BY-SA-3.0.

the outer ring wall at Gisors, under construction from 1161 to the 1180s, came to incorporate a series of towers that extended its entire length. These towers resulted from a series of campaigns, the outcome of which was seemingly inspired by Henry II's work at Dover.[99]

Further refinements in the arrangement and design of mural towers continued in the castles of the last decade of the twelfth century and beginning of the thirteenth. Philippe Auguste is often credited with popularizing a new type of castle featuring geometric plans and circular towers, like that of Dourdan, built in the 1220s (fig. 88). Dourdan was built on a square plan with regularly placed towers, one at each corner—the northern tower is the donjon—and one in the middle of each wall; one wall features a central gate with two flanking towers. Moreover, the distance between the towers of Philippe's castles was regular, measuring between twenty and thirty meters.[100] It is the towered wall of the castle at Angers, however, that perhaps makes the strongest visual statement of this

general trend toward a rhythmic placement of fortifying towers (fig. 89). Built beginning in 1225, during the minority of Louis IX, the banded towers, which once reached a height of around thirty meters, appear at short regular intervals, projecting forcefully from the curtain wall.[101] Although most of the towers have been cut down, the tour du Moulin, on the northern tip of the curtain wall, preserves its original height.

In addition to being more regularly laid out than those of the earlier twelfth century, late twelfth-century and thirteenth-century towers were generally taller, and they included a greater number of features, like arrow holes and machicolations, that could be used to defend the expanse of curtain wall between them. Machicolations may have appeared in medieval France as early as the late twelfth century on the donjon of Château-Gaillard (1190s, dstr. 1599). As reconstructed in a drawing by Viollet-le-Duc, the machicolations sit on the triangular buttresses, which are still visible on the exterior walls of the donjon.[102] This

England between about 1160 and 1220. The primary function of these towers was to enable defenders to protect the integrity of the intermediary wall section. The spacing of the towers, which rarely exceeded thirty meters, allowed defenders perfect coverage of the wall between. In other words, the towers actively maintained the passive obstacle of the curtain by means of the defending army, and the towers, rather than the wall, ultimately signaled its strength. It is the towers' role in upholding the wall that finds a general parallel in buttress-pier supports and may have inspired the conflation of their features by ecclesiastics like Peter the Chanter.

The increasing use of "active defenses"—those elements that allowed a small number of defenders to withstand or prolong an attack until reinforcements could arrive—also finds some parallel in a change in church structure. The heavy stone vaults in French churches of the late eleventh and early twelfth centuries are supported by a combination of thick walls, relieving arches, vaulted galleries, and mildly projecting reinforcements like wall buttresses and corbel tables. Under this stabilizing system, the wall and its various fortifying elements support the load above. In contrast, when the lateral thrust of the vault is transferred to massive buttress piers via flying buttresses, the walls lose much of their previous load-bearing function. They become, as Robert Branner writes, "simple closures wrapped around the skeleton."[104] The massive masonry towers more or less exterior to the wall itself now have primary agency in filling this supportive function. This shift in function from walls to towers is exhibited in Soissons Cathedral, begun ca. 1177. The construction process at Soissons underscores the comparably limited stabilizing purpose of the wall. It appears that the buttresses and engaged columns of the nave rose first, and masons then filled in the wall between them. Construction of the wall lagged behind by a few masonry courses.[105] This means that the supports initially grew independently of the wall.

FIGURE 90
Gustave de Beaucorps, *Donjon du château de Coucy*. Bibliothèque nationale de France, Paris, Département des Estampes et de la photographie, Reserve EI-61-Boîte FOL B-n7. Photo: BnF.

feature appeared on mural towers at least by the 1220s, as is documented by the example of Coucy-le-Château (fig. 90). Illustrations of the towers, destroyed by German troops in the First World War, show that the donjon and the four towers of the keep had stone brackets designed to carry a timber gallery—essentially a system of machicolation that could be put up and taken down at will.[103]

In sum, a system of military architecture in which regularly and systematically placed vertical towers punctuate expanses of curtain walls reemerged in France and

One consequence of the increased size of the piers used in buttressing-frame systems is that the active elements involved in the transmission and absorption of lateral thrust—the flyers and piers—became disentangled from the now passive wall. Simultaneously, in the case of military architecture, the presence of machicolations and arrow holes allowed defenders to engage in combat from the towers themselves. In other words, it is the vertical protuberance from the wall, whether mural tower or buttress pier, that is the principal agent, either by housing defenders or transmitting and resisting lateral force. The wall, in contrast, functions primarily as a physical barrier against the intrusion of people or weather but does not provide a comparable level of reinforcement.

I do not mean to suggest a causal link in the comparison between mural towers and buttress-pier supports. However, the concurrent development of systematically arranged flanking towers in fortifications and externalized buttressing systems of churches provides a larger context for exploring the mechanisms that allowed builders to make innovative conceptual leaps. This comparison between buttressing-frame systems and flanking towers shows a more general movement toward articulating walls by means of projecting vertical elements. Moreover, while the exposed arches of flying buttresses would have been closely associated with church architecture, the parallels between church and military architecture provide a larger visual framework for those buttress piers—one of encircling walls delineating barriers. In this way buttress piers and defensive architecture would have shared a language. The connections between barriers and buttressing-frame systems having already been established, the link proposed here adds yet another layer of meaning to the interpretation of the broken silhouette typical of architecture in medieval France beginning in the mid-twelfth century.

FLYING BUTTRESSES AND ARCHITECTURAL TYPOLOGY

I have argued above that buttress-pier supports signaled a building's protective qualities, the seignorial power of the institution, and the church's connection to the heavenly city. In this section I focus on the independent arches of flying buttresses, which would also have been powerful signifiers. Whereas buttress piers and uprights called to mind the systematic arrangement of defensive towers, flyer arches would have marked places offering spiritual salvation, distinguishing them from secular strongholds. The link between flyers and church architecture in particular was intimate, pervasive, and durable, particularly in medieval and early modern France. They appear only rarely on other building types, including religious buildings like cloisters, dormitories, and episcopal palaces.

The rampant church building of the late twelfth and early thirteenth centuries brought with it the propagation of buttressing-frame systems, which masons exploited for their structural advantages. By the mid-thirteenth century, a considerable portion of northern French churches—and nearly all great-church projects—employed flying buttresses as part of their structural system. The later popularity of simplified churches advocated by the Mendicant orders (sometimes referred to as "preaching barns") offered an alternative church type, but the prominent use of flying buttresses continued in more lavish projects. The adoption of buttressing-frame systems over the second half of the twelfth century made them part of a new standard for church building, a pattern that was sometimes exported to sites outside of the royal domain, such as Narbonne.

As they increasingly developed symbolic capital through their association with sacred buildings, flyer arches came to influence the medieval expression of culturally constituted values in the Île-de-France.[106] This is to say that they participated in a dynamic process

between architecture and the viewer, where buttressing arches as viewed objects were reformulated as conditions changed and as observers responded to these changes.[107] One can imagine that their visually unique structure gradually converged with the demarcation of the sacred space of the church. Over time, flyers encouraged in the viewer an expectation of a sanctified, and therefore protected, place within the spatial field they defined. Their presence supplemented and reinforced the newly reformulated paradigm of church architecture, with large window openings and vertical emphasis. This is not to say that buttressing-frame systems or flying buttresses were always de facto elements of church architecture or that only buildings with an exposed structural framework could have been seen as sacred. Even so, flying-buttress use in numerous new construction projects in the Île-de-France around 1200 made them part of a new and recognizable architectural configuration that was one means of indicating sanctity. In other words, buttressing frames constituted part of the local visual language for sacred architecture and would have operated as an identifier for the built church.[108] By the early thirteenth century, so many major churches in this region had flying buttresses that they became partially defined by them. As a reference to consecrated ground, the flyers would have signaled the special protections afforded by consecration, whereas their supporting piers would have signaled defense more generally.

It is difficult to make broad generalizations about secular buildings in the French royal domain due to their poor survival rates, but I am not aware of any instance of a secular building using flying buttresses in France before the sixteenth century.[109] Presumably, these late examples postdate the convergence between flying buttresses and consecrated ground that had developed over the course of the late twelfth and thirteenth centuries. Since much monumental secular architecture had some defensive function, it should be insignificant that flying buttresses were not employed in lay structures. The technical advantages offered by buttressing-frame systems, particularly their ability to open up the wall, were patently at odds with the defensive function of military architecture, in which openings in the wall introduced vulnerabilities. Large window openings would have been disadvantageous to the safety and security of the building and its inhabitants.

Although the structural advantages of flying buttresses offered no benefit to fortifications, I would suggest that their conspicuous absence from such structures cannot be entirely explained by arguments of structural superfluity. In fact, many French fortifications with spur buttresses had walls thick enough to stand without the external support. In essence, the thickness of any applied buttresses was not great enough in proportion to the height of the building to significantly affect its stability.[110] Nevertheless, many fortifications employed prominently projecting buttress piers. These *contreforts* assumed a wide variety of forms, including rectangular, cylindrical, and prow-like projections. At times they were connected via horizontal arches attached to the side of the building, which usually functioned as machicolations, as at Clansayes in southern France (fig. 91). The presence and variety of wall buttresses seem to have had at least as much to do with architectural fashion as with structure. Their role is almost entirely decorative, deriving from the wall buttresses used in religious architecture.[111] The use of projecting buttress piers on castles further demonstrates the connection between towers and buttresses and shows how secular architecture participated in the trend of exposed Gothic buttressing.

If flying buttresses did come to signal consecrated ground over the course of the twelfth century, it seems likely that this meaning remained stable throughout the rest of the medieval period. The contested and problematic separation between sacred and profane, as defined in Durand's liturgical manual and reinforced

through architecture and liturgical ceremonies, proved so ingrained in religious practice that it not only continued throughout the Middle Ages but even survived the Protestant Reformation. Burial practices and seating arrangements in the post-Reformation era demonstrate a continuity in the perception of sacred place, and the Council of Trent renewed the emphasis on gendered divisions. Protestants even developed their own practice of consecration, which was firmly established by 1700.[112] The desire to distinguish the sacred and profane may never have been fully successful in dividing the use of space, but it nevertheless continued to influence architectural and liturgical design. It is important to see repeated attempts to define sacred space as part of a long-standing process, albeit one that gained momentum over the course of the Middle Ages.

As a means of marking differences along the sacred/profane continuum, buttressing-frame systems exemplified the continuing concern with hierarchical spatial divisions through their very longevity. If flying buttresses came to represent for a medieval French viewer the presence of a great church, then by extension any structure with flying buttresses came to be defined as sacred space. In churches of the sixteenth and seventeenth centuries, such as Saint-Eustache in Paris, the retained "medieval" elements generally carried symbolic significance (fig. 92). This is the case with the cruciform ground plan, a manifestation of the cross, and the transept façades, a deliberate copy of Notre-Dame intended to evoke the twelfth-century prosperity of the capital city.[113] The scale of Saint-Eustache is also an important symbol of affluence and success, although size in itself does not necessitate the use of flying buttresses.[114] Most importantly, the flyers are extremely prominent, arguably even more so than those of the cathedral. The continued use of flying buttresses in sixteenth-century churches was common in France; other significant examples include Saint-Pantaléon in Troyes, Saint-Étienne-du-Mont in Paris, and Sainte-Madeleine

FIGURE 91
Clansayes, view of the keep. Médiathèque de l'architecture et du patrimoine, Charenton-le-Pont, France, inv. MH0110252. Photo © Ministère de la Culture / Médiathèque du Patrimoine, Dist. RMN-Grand Palais / Art Resource, New York.

in Montargis (fig. 8).[115] At Montargis and in many of the other examples, the use of flyers continued despite a more general trend toward Italianate neo-antique articulation. While the expression of sanctity would have been only one possible justification for employing flyers, by the sixteenth and seventeenth centuries they would have been part of an easily recognizable church typology as developed in and around the Île-de-France. In sum, if buttress-pier supports transcended typologies, flyers denoted architectural distinctions. The buttressing-frame systems

FIGURE 92
Paris, Saint-Eustache, chevet. Photo: author.

capitalized on the defensive associations of fortified walls while simultaneously indicating the particular spiritual protections afforded by consecration.

BUTTRESSING FRAMES AND GARGOYLES

Buttress decoration frequently reinforced the message of sanctified ground. As discussed above, the fortification of the Narbonne buttresses exploited the parallel symbolism of spiritual and physical protection. Monumental sculpture (the subject of chapter 3), like that at Chartres, Reims, and Saint-Quentin, also drew parallels between the physical and spiritual in its manifestation of ecclesiastical authority and hierarchy. However, this kind of monumental sculpture was only part of the decoration that ornamented buttressing systems. Gargoyles and other small creatures adorned pinnacles and formed an equally important part of their embellishment. In exploring the iconography of gargoyles, I ultimately argue that their protective symbolism amplified the defensive associations of buttressing-frame systems.

Medieval gargoyles were often located on the piers or uprights of buttressing-frame systems. In fact, the method of water evacuation that developed over the course of the Middle Ages exploited the downward slope of the flyers themselves. The carved forms of the gargoyles were thus an integral part of mature flying-buttress systems. Modern scholars have posed a variety of interpretations of the demonic and monstrous forms of medieval gargoyles, which likely held several parallel meanings. Whatever else they may have referenced, their varied forms frequently drew on hellish visions of malevolent forces. Such imagery contrasts sharply with the holy figures of angels, bishops, and saints that inhabited buttress piers. However, it is likely that both types of sculpture—the deformed and the perfected—spoke to the sanctity and privileges of the building they surrounded. Gargoyles could function apotropaically, as wardens of the consecrated space beyond them, and were ingrained as part of the social practice governing the purification and symbolic defense of the medieval landscape.[116]

One of the pervasive obstacles facing the study of gargoyles is their frequent replacement during medieval and modern restoration campaigns. For example, visitors to Paris Cathedral are greeted with a vast array of nineteenth-century sculpture that enlivens its exterior walls. These fantastic and grotesque creatures have become part of the cathedral's identity—despite the fact that their relationship to their medieval predecessors is ambiguous at best. The role of Notre-Dame's gargoyles in the modern imagination is exemplified by Victor Hugo's *Notre-Dame de Paris*, which prominently features them.[117] Hugo describes the novel's main character, Quasimodo, as a reincarnation of the sculptures: "[The cathedral] was peopled by marble figures, kings, saints, and bishops, who at least did not burst out laughing in his face, but only stared down at him quietly and kindly. The other statues, the ones of monsters and demons, felt no hatred for Quasimodo. He resembled them too closely for that."[118]

Toward the end of the book, Hugo, observing that the gargoyles "bristle on Gothic buildings," presents them as a pervasive and prominent aspect of the church's exterior character.[119] Yet the army of stone fiends that populate the upper reaches of Quasimodo's cathedral no longer existed when Hugo penned the hunchback into existence. Indeed, if anything, Hugo's fantastical stone creatures provided models for the restorers' later sculptural additions to the balustrade, towers, and buttresses.[120] The present sculptures are the product of the building's restoration beginning in the 1840s under Eugène-Emmanuel Viollet-le-Duc and Jean-Baptiste-Antoine Lassus.

Viollet-le-Duc's fearsome menagerie comprises two different types of monstrous addenda: chimeras and gargoyles. The two groups divide based on their purpose: the former are nonfunctional decorative sculptures, while the latter are defined by their utilitarian use as drainpipes. Whereas the very presence of chimeras at Notre-Dame in the Middle Ages is debatable,[121] there is no question that the medieval cathedral used gargoyles in its system of water evacuation. These medieval gargoyles were gradually removed during the eighteenth century and replaced by lead pipes. Viollet-le-Duc's restoration included the dismounting of the few extant medieval examples, which were used as models for their replacements. Although the gargoyles and chimeras of Paris Cathedral are modern counterfeits, gargoyles were nevertheless highly visible works of art that played a significant role in medieval ecclesiastical architecture, both in terms of the functioning of buildings and, as I argue, in their symbolism.

The Unity of Buttresses and Gargoyles

"Gargoyle" is a term often applied to all manner of fantastical carvings decorating architectural monuments. However, the meaning of the French term *gargouille* as throat or gullet makes clear that it refers to a feature through which liquid might pass. The first known use of this word (*gargoule*) dates to 1294.[122] If not properly channeled,

FIGURE 93
Autun Cathedral, gargoyle. Photo: author.

buttress that postdates the sculpture itself. However, Autun did not have flying buttresses originally, a fact that demonstrates the initial independence of these two architectural elements.

In his *Dictionnaire raisonné*, Viollet-le-Duc states that architects had integrated gargoyles and flying buttresses into a new method of water drainage by 1225. He cites the nave of Amiens Cathedral as the earliest example of this new system, in which water flows from the roof, down a gutter inserted into the top of a flyer, and finally out through the gargoyle.[124] This combination logically exploits the typical form of the flying buttress, with its diagonally placed coping enhancing the efficacy of another critical piece of infrastructure.[125] Assuming that Amiens represents the first example of the new water-drainage system, somewhere between half and three-quarters of a century separates the emergence of the flying buttress and its integration with the new gutter system. This combination of the flyer, water channel, and gargoyle remained the standard method of water drainage on churches for hundreds of years, surviving even into the Renaissance (fig. 8). One might understand this unity of gargoyle and buttressing as a synergetic system, in which the combination of elements works together to greater efficiency than would be possible if they were decoupled.

Interpreting Gargoyles

If the history of gargoyle development is fairly straightforward, their interpretation has proved trickier. Modern scholars have interpreted gargoyles in a variety of ways: as fantastical ornaments born from the free imagining of their sculptors,[126] remnants of a remote pagan history,[127] purveyors of moralizing lessons,[128] and guardians that protect against or expel evil from the church.[129] Part of the difficulty in establishing a universal meaning for gargoyles is that medieval audiences were open to and enjoyed multivalence. For example, the dress of column figures on Gothic portals supports multiple interpretations of

water could pool on roofs or along masonry seams, slowly penetrating the stonework and leaking into the interior, causing erosion. Gargoyles, like flying buttresses, thus had a real utilitarian function. However, also like flying buttresses, their value was not limited to this utility, a point underscored by the fantastical forms that gargoyles took in the Middle Ages.

Gargoyles and buttressing frames had different geneses. The earliest known gargoyle survives at Saint-Lazare at Autun (ca. 1120; fig. 93). It is a singular medieval survival among a host of modern replacements designed by Viollet-le-Duc. It demonstrates the cleverness of medieval sculptors in relating bodies to a gargoyle's utilitarian function. Whereas in most cases water exits the gargoyle through its mouth, in this case the sculptor has arranged the figure so that the water leaves by a different orifice, simulating a rather unhealthy defecation.[123] Today the Autun gargoyle sprouts from the upright of a flying

the figures' rank and status.[130] Another is that gargoyles appear on so many and such a variety of buildings. It is unlikely that gargoyles on fifteenth-century bourgeois châteaux had precisely the same meaning as those on thirteenth-century cathedrals. In addition, very few medieval texts provide contemporary textual evidence that could support a modern interpretation. Finally, in many cases the original gargoyles are lost, having been replaced by later, often nineteenth-century, examples. As at Paris Cathedral, it is always difficult to know how closely the replacements follow the model. Nevertheless, the study of buttressing-frame systems, as the immediate architectural context for gargoyles on many churches, must consider these elusive creatures. The dearth of source material will continue to obscure the medieval reality, but the following exploration examines a variety of textual and visual evidence, which in total supports the idea that gargoyles functioned protectively and amplified the defensive connotations of buttressing frames.

Despite the destruction of numerous medieval examples, those gargoyles that survive suggest that many took their form from the medieval visual language of demons and devils. For example, the early thirteenth-century gargoyles from Laon Cathedral, illustrated by Viollet-le-Duc, show particular affinity with medieval visualizations of the hell mouth (fig. 94).[131] The hell mouth frequently appeared on sculpted Romanesque tympana featuring images of the Last Judgment—for example, that of the cathedral of Saint-Lazare in Autun (fig. 95). In this twelfth-century tympanum, the medieval sculptor represented the mouth of hell as an open-mouthed canine of ambiguous, or perhaps composite, nature. Similar images appeared in many other French portal ensembles as well as in other types of public art, including wall paintings, historiated capitals, and altarpieces, possibly reflecting imagery of the Leviathan from Job 41: "Who can go into the midst of his mouth? Who can open the doors of his face? His teeth are terrible round about. His body is like

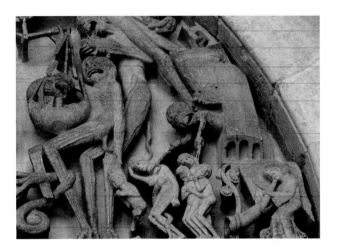

FIGURE 94
Gargoyle of Laon Cathedral. From Eugène-Emmanuel Viollet-le-Duc, *Dictionnaire raisonné de l'architecture française du XIᵉ au XVIᵉ siècle*, vol. 6 (Paris: A. Morel, 1875), 21. Photo courtesy of the University of Oregon Libraries.

FIGURE 95
Autun Cathedral, tympanum, detail of the hell mouth. Photo: author.

molten shields."[132] The gaping mouth and protruding snout, which result in a hound-like appearance, form the primary visual similarities between gargoyles and representations of hell mouths. On the tympanum above the main entrance of the abbey church of Sainte-Foy, in Conques, the beast's forelegs, which resemble those of the Laon gargoyle, are visible. The open mouth of the beast acts as the doorway to hell as it consumes the damned, but the wolflike head itself projects forward

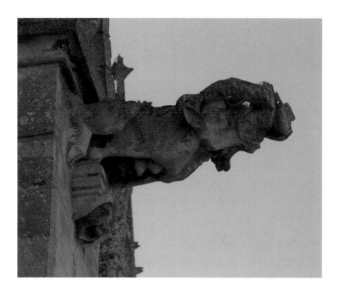

FIGURE 96
L'Épine, Notre-Dame, chevet gargoyle. Photo: author.

from a doorway, already mingling the monstrous image with an architectural setting. Moreover, visual similarities between gargoyles and the hell mouth in apocalyptic imagery suggest that the form invoked similar qualities of spatial guardianship. While the hell mouth drew upon a fantastic beast to connote a gateway to a fiery world of eternal damnation, the gargoyle, as a similar bestial form, demarcated a hard but permeable border for the sanctified church within.

The hell mouth from Conques gnashes on a second figure: the lower legs and feet of the Leviathan's most recent victim protrude from its maw. Like the hell mouth itself, this nested composition has visual parallels in composite gargoyles, such as that showing a beast swallowing a woman at Notre-Dame de l'Épine (fig. 96). The other demons in the Last Judgment tympanum grimace, bare their teeth, or otherwise contort their faces into fearsome expressions similar to those commonly represented on gargoyles. Although the functional use of the waterspouts certainly helps explain such expressions, it nevertheless

also connects the appearance of gargoyles to images of demonic creatures and differentiates them from the serene faces of the blessed or divine, represented in the trumeaux or buttresses (as discussed in chapter 3).

Of course, not all gargoyles represent open-mawed beasts. The defecating man at Autun (fig. 93) embodies another common subject for gargoyles, namely, scatological or otherwise obscene figures that confront the viewer with images of genitalia or bodily discharge. Misshapen anatomy, crippled bodies, and distorted faces represent a third category of imagery. As with the monstrous, these subjects similarly transcend any one medium and can be found in manuscript painting, architectural sculpture, and liturgical furnishings. Similarly, no firm and universal meaning is yet identified for the obscene or deformed. However, several scholars have suggested that they too acted apotropaically.[133]

Literary sources provide additional evidence that supports a protective interpretation of gargoyles.[134] The few surviving medieval accounts that explicitly mention gargoyles include the *Roman d'Abladane*, composed around 1260 in Amiens. This text purports to be a French translation of a Latin chronicle destroyed in the 1258 fire of the cathedral.[135] The story is essentially a fantastical history of Amiens (Abladane) in the time of Caesar. It presents the town as a rival to Rome, due in large part to the work of the powerful necromancer Flocars. As part of his embellishment of Abladane, Flocars attaches a series of three protective statues above one of the gates in the city's walls. This series comprises two gargoyles that flank a sculpture of a woman. The two gargoyles act as gatekeepers, allowing certain people to enter but not others: they pour deadly venom on the city's enemies but rain down gold and silver on its lord.[136] The material they expel indicates the granting or withholding of permission to enter. In other words, they function as defenses, like arrow slits, which can spew harmful projectiles against external threats.

The Dominican friar Étienne de Bourbon (ca. 1190/95–1261) provides a similar account of gargoyles actively defending a space in his *Tractatus de diversis materiis praedicabilibus*. According to Étienne, when a certain usurer in Dijon attempted to enter the church of Notre-Dame with his bride on his wedding day, a sculpture of a usurer mounted on the façade of the church, above the door, threw his coin purse at the man's head and killed him.[137] Étienne's account does not use the term "gargoyle," although it almost certainly refers to a representation of a usurer among the three horizontal registers of gargoyles that ornament the façade.[138] According to the friar, following the death of the bridegroom, the other usurers in Dijon organized the destruction of the façade's gargoyles, which were replaced in the 1880s. Like the gargoyles in the *Roman d'Abladane*, the Dijon sculpture is not itself evil but rather protects the purity of a circumscribed place by repelling a would-be intruder.

In both texts gargoyles work to protect a walled space from external malevolence. In both, the defensive function of gargoyles, which in the physical realm prevent rainwater from infiltrating the building and eroding its stonework, has been extended to the metaphysical realm, where the gargoyles protect against sin or malice. These descriptions, which position gargoyles near gateways, reinforce the understanding of buttresses, with which gargoyles are ordinarily associated in church architecture, as a frame or point of transition.[139] Moreover, in projecting a liquid, Flocars's gargoyles are linked to those with the more prosaic function. These accounts recall other types of magical objects and automata that recognize rightful lords or guard locations.[140] The authors adapted this existing literary trope to their contemporary architectural landscape by assigning supernatural roles to the gargoyles that populated monumental architecture. At least in these two accounts, the interpretation of gargoyles as protective emblems gains credence, especially since the gargoyle at Dijon was part of an actual, rather than fictive, building. In other words,

Étienne's exemplum invested a gargoyle from a known building with a miraculous power to ward its church.

In the end, whatever else gargoyles may have meant, analysis of the limited visual and textual evidence identifies one thread running through the medieval responses to them: their function as custodians and doorkeepers. In general, the form of gargoyles shared more with images of demons than with images of saints, angels, other holy figures, or even images of lower-class society engaged in productive labor. Many gargoyles are humorous to modern spectators, and they may well have been humorous to medieval viewers as well, but the similarity of many gargoyles' visual characteristics likely also conjured thoughts of sin, evil, or hell. In addition, at least two medieval authors explicitly linked gargoyles to a clear protective function. Of course, these statements cannot be applied unilaterally to all gargoyles throughout the Middle Ages, especially since so many have been lost. Local circumstances almost certainly had an impact on the form and interpretation of the gargoyles at any given site. Nevertheless, as the following case studies of Rouen Cathedral and Notre-Dame de l'Épine elucidate, custodial value can carry through, even if layered with other specific, local meanings.

GARGOYLES AT ROUEN CATHEDRAL AND NOTRE-DAME DE L'ÉPINE

As previously mentioned, the limited survival of medieval gargoyles hampers our ability to understand their meaning. However, Rouen and Notre-Dame de l'Épine stand as unusual cases in which surviving textual (Rouen) or physical (L'Épine) evidence allows for an evaluation of the hypothesis that gargoyles operated apotropaically within the medieval landscape and in concert with contemporaneous religious practices that occurred in or around the church.

In 1930 the scholar and gargoyle authority Lester Bridaham wrote that the "events of daily life influenced carvers in the choice of grotesque motifs."[141] Bridaham was referring to popular dramas and public festivities like that observing the Privilege of Saint Romanus in Rouen, a right recorded as far back as 1210. This festival, begun the week before Ascension, celebrated Archbishop Romanus's victory over a huge dragon that lived in the Seine (to the detriment of the town and its population). According to the legend, a prisoner assisted Romanus in subduing the monster. The tale was used, and possibly created, to justify the privilege itself, which granted the cathedral chapter the right to pardon one prisoner each year on Ascension Day. As part of the celebrations, the newly freed prisoner paraded through the streets of Rouen along with musicians, clergy from all of the nearby churches, many other prominent members of the town, and a large statue of the defeated dragon.[142]

The most direct connection between the Saint Romanus festivities and gargoyles is the use of the term *gargouille* (gargoyle) to refer to the Seine monster. The saint's vitas refer to the beast as a *dragon/draglon* or *serpent*, but *gargouille* was a popular local nickname for the creature.[143] The proceedings of the chapter indicate that the term *gargouille* was used interchangeably to refer to both the legendary dragon and carved waterspouts. For example, in 1467 the proceedings record the removal of gargoyles from the tour de Saint-Romain, and in 1476 they document the chapter's acceptance of a *gargouille* statue that had been used in a Saint Romanus play.[144]

At least two theories have been proposed to explain how *gargouille* came to be applied to the monster.[145] Amable Floquet, the author of an old but still definitive work on the privilege, ascribes the convergence of terminology to "the resemblance between those monstrous figures [gargoyles] and those that were carried in processions [dragons/serpents]."[146] Various campaigns of restoration have repaired and replaced the gargoyles at Rouen

Cathedral, but the dragon sculpture may well have shared at least some passing likeness to its gargoyles, particularly if the medieval carvings had the elongated bodies of those currently visible along the nave's north and south sides.[147] Louis de Sacy instead sees the story as a distortion of Romanus's miracle of turning back the Seine. According to de Sacy, the eruption of water (*gargoville*) became *hydra* in Latin, where it was mistaken for a monster.[148] Although de Sacy was apparently not aware that flooding waters, like dragons, were symbolic of paganism,[149] his account is intriguing, as it relies on a shared reference to the gurgling of water that would occur both in a flood and in the evacuation of water through a spout.

Within the context of Rouen itself, the linguistic slippage between the Seine monster and the gargoyles of the cathedral linked the two elements. In this circumstance, it is easy to see how the fearsome power of the legendary beast might be associated with the grotesque sculptures along the edges of major monuments, either as reminders of Romanus's victory over evil or perhaps as apotropaic carvings meant to scare away potential threats. This association would have been particularly strong when the wooden dragon (or *gargouille*) was processed around Rouen against the background of its ecclesiastical buildings, with their gargoyles, permitting not only the mental recollection of linguistic similarity but also a direct and immediate visual comparison.

Rouen was by no means the only town that celebrated a dragon-slaying local saint with a procession of images of the defeated monster. Dragon-slaying bishops were fairly common and were frequently the patron saints of cities or dioceses, as Saint Marcellus was for Paris.[150] In many cases these defeated dragons likely acted as metaphorical stand-ins for paganism.[151] Dragons also appeared in processions in numerous towns across medieval France, including Amiens, Paris, Chartres, Noyon, and Bayeux. One surviving example is that of La Grand'Goule from Poitiers, which has an open mouth, reminiscent of

gargoyles (fig. 97).[152] These beasts represent the forces of evil, which Christ defeats.[153] Their demonic symbolism appears in theological treatises like those of Jean Beleth and Guillaume Durand.[154] Prevostin of Cremona and Jacobus de Voragine describe the visualization of Christ's triumph through the shortening of the dragon's tail.[155] The carved representations of dragons, which were part of both liturgical and popular performance, thus represented not the fearsome terror of the devil but rather the triumph of Christ and the saints as protectors of the faithful.

These links between the beast of Rouen known as the *gargouille* and gargoyles themselves are familiar to art and architectural historians. I would like to make one addition here, particularly in terms of a processed *gargouille*'s mechanical and magical qualities, by highlighting the intersection of these liturgical performances with the *Roman d'Abladane*. Many of the dragon simulacra used in town had moving parts. An example from Amiens had mechanisms for moving the mouth, which were operated by men hidden inside the object.[156] The mechanical aspect of some of these beasts recalls the automata crafted by Flocars, which would rain venom or precious metals down upon visitors. In both cases the beast appears to act of its own will. Gargoyles, like Flocars's automata, are similarly enlivened by their aqueous discharge, which often flows from one of the creature's orifices as if it were a bodily fluid, as at Autun (fig. 93). The comparable animation of the processional props and waterspouts reinforces the linguistic relationship between Rouen's legendary monster and the cathedral's carved grotesques and suggests an analogous symbolism of the Church's victory over evil. As with monumental buttress sculpture, the similarities between the dragon marionettes and gargoyles would have been particularly strong as the procession passed by the building, which occurred multiple times in a year, usually on Rogation days.

Finally, while Bridaham and many of those who have repeated his claims imply that dragon-related

FIGURE 97
Jean Gargot, La Grand'Goule, 1677. Collection des musées de Poitiers. Photo © Musées de Poitiers / Christian Vignaud.

performances and associated props were the sources of gargoyle imagery, at least for Rouen, the direction of influence is not so clear. As Felice Lifshitz has noted, no source from the seventh through twelfth centuries makes any reference to Romanus's victory over the dragon or to the associated privilege. Instead, the idea of the privilege was born around 1210, and the legend may well have been invented as an explanation for the privilege after it had already been instituted.[157] Amable Floquet dates the first mention of the *gargouille* to 1394, well after much of the cathedral and its gargoyles were completed.[158] It is certainly possible that similar festivals in other towns influenced the medieval gargoyles at Rouen, but it is much more likely that the story of Romanus and the *gargouille* developed concurrently with the gargoyles that sprout from the cathedral. In fact, the direction of influence may even have operated in reverse, with the fearsome nature of the gargoyles contributing to the power of the legend but not necessarily diminishing the resonance between the two.

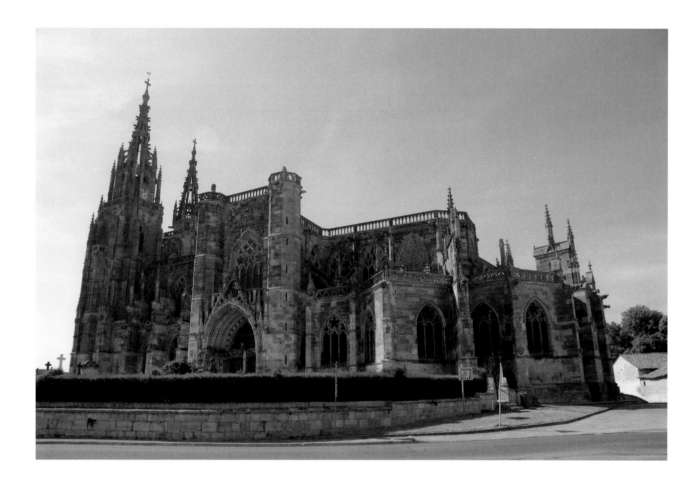

FIGURE 98
L'Épine, Notre-Dame, view from the southeast. Photo: author.

At Rouen Cathedral, thirteenth-century gargoyles, possibly carved in keeping with the protective connotations witnessed by the Amiens and Dijon accounts, came to mirror the beast of the vita and privilege of Saint Romanus, forming a symbiosis between civic performance and architectural background. Unfortunately, a close analysis of the gargoyles at Rouen is impractical because so many are modern replacements. While many scholars of gargoyles assume that restorers worked "in the spirit of their medieval predecessors,"[159] the sensitivity of restorers to original material varied dramatically. Indeed, we know that nineteenth-century restorers all too frequently altered original designs drastically, even introducing representations of animals whose physiognomy was foreign to the medieval West, such as a gargoyle of a rhinoceros at Laon.[160]

Unusually, the chevet of the church of Notre-Dame de l'Épine did not undergo the typical replacement of its gargoyles (fig. 98).[161] It too has been restored, but these interventions are at least well documented. In addition, the construction history of L'Épine is well known, and the extant gargoyles can thus be dated with reasonable

certainty.[162] Consequently, it serves as a viable test case for examining the meaning of medieval gargoyle ensembles and ultimately demonstrates their protective associations. This protective message takes on particular importance at L'Épine, which functioned as a site of miraculous baptisms.

Notre-Dame de l'Épine is modeled on the nearby cathedral of Reims: the similarities visible between these two monuments include the flying buttresses.[163] Construction of the church began around 1400–1410 and was largely complete by about 1530.[164] Completion of the nave preceded that of the chevet by approximately a half century. The gargoyles of the nave generally follow the thirteenth-century type described by Viollet-le-Duc. Although the nave gargoyles bore the brunt of restoration interventions, their form is preserved in the two examples that escaped restoration.[165] One depicts a cow, and the other a squatting hooded humanoid with the hairy body of a wild man (fig. 99, compare to fig. 94).[166] Each consists of a single forcefully projecting figure whose feet are visible. The gargoyle is supported by a corbel. The restored gargoyles generally conform to early nineteenth-century descriptions by Étienne-François-Xavier Povillon-Piérard and were in form likely similar to the surviving medieval originals.[167]

The gargoyles of the chevet are more elaborate in their form and dramatic in their subject matter. Unusually for a medieval building, they are attributed to a single workshop, that of Guichart Anthoine, who (along with his son-in-law) replaced the former master mason Rémi Goureau in 1515.[168] Construction of the chevet was completed around 1527, indicating that the chevet gargoyles were completed within the span of just over a decade.[169] The attribution and short period of construction suggest that they are a unified program.

It is possible to interpret L'Épine's chevet gargoyles in the general custodial manner proposed earlier. For example, a gargoyle in the form of a female beast devouring a woman shares features with the image of the hell mouth on the tympanum of the central portal of the church (figs.

FIGURE 99
L'Épine, Notre-Dame, chevet gargoyle. Photo: author.

96 and 100).[170] Pierre-Olivier Dittmar and Jean-Pierre Ravaux have proposed two compelling interpretations of L'Épine's chevet gargoyles that permit a more specific understanding of the ensemble, accounting for the narrative quality of many of the individual sculptures. The first reading follows an anthropological interpretation in which the deformed and obscene become negative models for reinforcing social norms and behaviors.[171] The second interpretation understands the entire program narratively as an installation that viewers would experience temporally as they circumambulated around the

FIGURE 100
L'Épine, Notre-Dame, detail of the hell mouth from the lintel of the west façade's central portal. Photo: author.

chevet from south to north. This analysis has the great benefit of examining the gargoyles within their specific architectural context and viewing conditions. Dittmar and Ravaux argue that the gargoyles represent a descent into hell, successively depicting temptation (gargoyles representing the margins of society, like acrobats and fools), sin (gargoyles representing humans secreting bodily fluids), and ultimately punishment (gargoyles representing creatures holding human figures in their claws) in a counterclockwise arrangement.[172] They further argue that the eschatological reading of the gargoyles resonates with L'Épine's portal sculpture, its relic cult, and the ritual of respite (*répit*) practiced in its sanctuary.[173]

The convincing interpretation offered by Dittmar and Ravaux derives from a close study of the gargoyles themselves, their arrangement, and a deep knowledge of the church. In terms of the protective connotations of the gargoyles, I would like to highlight two aspects of the L'Épine program. The first point revolves around the

building as a sanctuary of respite, a place where parents could take their stillborn infants in an attempt to save their souls through a ritual that would grant temporary viability.[174] According to Christian practice, corpses cannot be baptized, meaning that the souls of stillborn children cannot enter heaven. From at least the fourteenth century, parents would bring stillborn babies to a sanctuary of respite in the hopes that prayer and proximity to relics would result in a miraculous, if transient, return of life.[175] In this brief moment of vitality, the infant could be baptized, and its soul would be saved. The sheer number of sites that functioned as such sanctuaries—more than 270 have been identified in France alone—points to the popularity of this practice.[176] The importance of the child's proximity to relics underscores the ritual's dependence on the consecrated ground of the church and the special protections that it offered.

As Dittmar and Ravaux argue, the eschatological message of the gargoyles resonates with the ritual of respite as a means of ensuring the salvation of stillborn infants. The physical form of the gargoyles, which repeatedly represents liquids and abducted souls, intensifies this connection. Two of the gargoyles on the north side of the chevet of Notre-Dame de l'Épine depict a monster carrying away a small nude human figure (figs. 101 and 102).[177] These likely represent demons carrying off condemned souls, imagery that would have resonated powerfully with distraught mothers, particularly given the medieval practice of depicting souls in a diminutive scale, and sometimes as adolescents or infants.[178] The parental association may have been particularly strong for the figure in the grips of a beast with prominent, possibly lactating, breasts (fig. 101). Another gargoyle on the south side has traditionally been identified as a fool with a doll, imagery that parodies the parent-child relationship (fig. 103).[179] Other gargoyles show men with bowls or other vessels for pouring liquid (fig. 104).[180] These gargoyles either present an image of the helpless child's soul or refer to its salvation

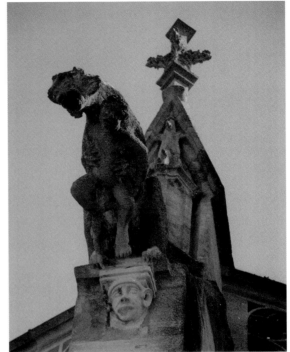

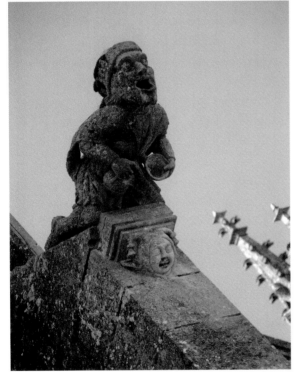

CLOCKWISE FROM TOP LEFT

FIGURES 101–104

L'Épine, Notre-Dame, chevet gargoyles. Photos: author.

the salvation offered through baptism, which in the case of stillborn infants was thought to only be possible by miracles that occurred within the walls of the consecrated church.

The Church's position regarding sanctuaries of respite was ambivalent at best. It condemned the ritualized animation of stillborn infants several times, first at the Synod of Langres in 1452. Bishops issued additional repudiations in 1524, 1577, 1592, and 1656.[182] The necessity of the repeated condemnations ironically indicates the prevalence of the practice. At the same time, the historian Jacques Gélis has noted that the Church was not unified in its position on this practice. The personality of an individual bishop determined his level of tolerance, and even where bishops condemned it, parish priests were often sympathetic to the popular desire for the ritual.[183] L'Épine functioned as a sanctuary of respite from at least 1441/42 until at least 1788.[184] The earliest known mention of the practice, from 1441/42, echoes other episcopal condemnations and records the fines paid by the priest and churchwarden involved. However, Ravaux has detailed a subsequent document, from 1537/38, in which the hôtel-Dieu de Châlons, an organization at that time controlled by the cathedral chapter, awarded payment to two women who carried a stillborn infant to L'Épine for the incapacitated mother.[185] Since the officializing agency was under the control of the cathedral chapter, this document might suggest greater local tolerance in the first half of the sixteenth century, perhaps further contextualizing the gargoyle imagery and its emphasis on salvation and baptism.

A second point about the program at L'Épine concerns the representation of animals playing musical instruments. Four sculptures that decorate the top of the buttress piers in the chevet represent this subject: a pig playing a lyre, a monkey playing bagpipes, a bear playing a tambourine, and an unrecognizable fourth creature (fig. 105). Dittmar and Ravaux discuss these examples in

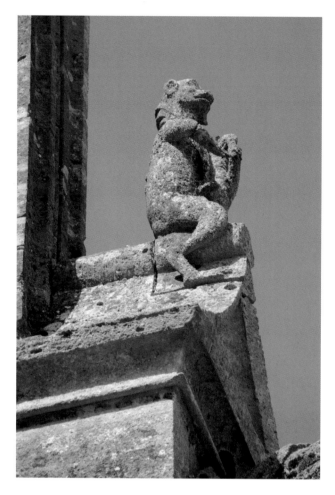

FIGURE 105
L'Épine, Notre-Dame, animal musician of the chevet. Photo: author.

through the flowing liquid. In other words, the gargoyles visualize the fate that awaits those unable to enter heaven and the protections afforded to the infant's soul via the baptism, which was only made possible through the holy ground of the church. This connection between the protections offered by consecrated ground and baptismal waters is attested further by Durand, who writes that "this water, by whose aspersion the church is consecrated, signifies Baptism, since in a certain manner, the church itself is baptized."[181] Thus, the program of L'Épine references

terms of inversion, as presentations of anthropomorphic imagery that violates the natural order.[186] I would further suggest that it is also important to see the imagery in the context of buttress decoration more generally. In particular, the chimeras evoke the figural sculpture that often decorated thirteenth-century buttresses (discussed in the previous chapter). Each projects vertically from the top of a buttress pier, against the face of the buttress upright, in a position similar to those of the upper angels at Reims Cathedral. The presence of musical instruments likewise brings to mind the musician angels from Saint-Quentin, itself closely related to Reims. It thus appears that Guichart Anthoine may have collapsed the imagery of monumental and marginal buttress sculpture. Anthoine's mingling of different sculptural modes can also be seen as a type of inversion, here literally aping a divine procession.

The case of the gargoyles of L'Épine underscores the pervasive interpretation of gargoyles as protective entities, yet it also links that interpretation firmly to the local character of the site. At this church, not only did gargoyles proclaim its sanctity and attendant protections, but—at least in the chevet—they did so by referencing the site's importance in the salvation of the souls of stillborn infants. Moreover, the presence of the musician animals demonstrates the close connection between what a church too often divided into "high" and "low" sculpture and between sculpture and the architectural feature that serves as its support.

CONCLUSIONS

The visual and textual evidence presented here offers two cases where gargoyles performed protective functions, from which I have argued for a more generalized guardian role. I do not, however, suggest that gargoyles were used exclusively in this way or that their interpretation was so limited as to exclude all other meanings. Instead, it seems much more likely, particularly given the medieval practice of combining decoration and function, that gargoyles represented guardianship in a manner that was simultaneously humorous, grotesque, frightening, and visually engaging. The sources referred to here, however, nonetheless indicate a real connection between gargoyles and the defense of boundaries. To dismiss gargoyles as impenetrable or irrevocably lost ignores a captivating and pervasive aspect of medieval material production.

In particular, it is the close association between this type of marginalia and Gothic buttressing that connected the latter to larger ideas about the defensive qualities of sacred places, as seen in the integration of the flyer and the gargoyle as a means of water evacuation. The degree to which these elements were coupled makes buttressing frames appropriate zones for the imagery adopted by the gargoyle, at the very least. It is even possible that the initial architectural strangeness of flying buttresses themselves made them particularly attractive as sites of typically marginal figures such as grotesques, hybrids, and contorted humans. Lying at the outermost edges of the building, forming a weblike cage of stone around the church, buttressing-frame systems might similarly have been seen as a composite architectural form, especially in their early decades of use in the Île-de-France. Like the hybrid monsters of the medieval imagination, Gothic buttressing borrowed from existing architectural elements, explicitly arches and piers, cutting them up and sewing them back together in new arrangements. The ultimate product was something new and unfamiliar. This novel support system surrounds the church at its margins, edges being the typical territory of deviant imagery. As discussed by Michael Camille and others, the marginal images in medieval manuscripts often present perversions of social order as a means of "reinstat[ing] the very modes they oppose."[187] Seen in this way, the very shape of buttressing-frame systems parallels that of protective imagery, engaging with the theme of inversion as a defensive shield.

Whether or not the form of flying buttresses warded off demons, it helped visualize, conjure, and constitute the division between the outside world (which had not been purified, dedicated, and given to God) and the interior world of the church (which had). The assumption, expressed in contemporary texts, was that the consecration of the church protected its space from the influence of demons, the devil, and even terrestrial violence. Buttressing-frame systems, and indeed their encircling presence, participated in the protection of the interior of the church, first by making up part of the boundary area between sacred and profane and then by presenting surfaces to which protective images were often attached. Furthermore, their relationship with defensive structures, as noted above, enhanced the association between Gothic buttresses and protection. The strong vertical thrust of buttress piers and buttress uprights, comparable to that of flanking fortification towers—where defensive functions were prominently displayed in the use of crenellations, arrow slits, and machicolations—emphasized the protective association with military architecture. In this way, buttressing-frame systems indicated the presence of sanctified space and, by association, the protections it offered from physical and spiritual harm. The monstrous imagery of many gargoyles reflected this protective message while simultaneously conforming to the architectural setting and rituals of individual structures.

CONCLUSIONS

THE EXTERNALIZED BUTTRESSING SYSTEMS OF independent arches and towerlike piers that developed in medieval France over the course of the twelfth century had a profound effect on the construction, appearance, and social use of the churches that employed them. The structural advantages offered by flying buttresses, in combination with other technologies, catalyzed the construction of the soaring glass-filled cathedrals of the thirteenth century. In addition to this vital utilitarian function, a buttressing-frame system was intimately connected to the visual program of the larger structure, the daily life of the church surrounds, and the institution's expression of self.

The visual prominence of flying buttresses and their supporting piers made them a critical component of the exterior massing of the buildings to which they were attached. As the point of juncture between the church and its surrounds, a buttressing-frame system framed the church as one of the places of initial contact between the building and its audience. The physicality, design, and decoration of buttressing-frame systems had the potential to influence the mechanism of that interaction and to present the building according to the aspirations of its patrons and builders. The messages conveyed by that presentation took many forms and addressed numerous concerns, from architectural design to jurisdictional rights, ecclesiastical authority, and the privileges of consecration. Medieval material culture provides numerous examples in other media where elaboration of the margins explains,

authorizes, or otherwise upholds the message of the central image. Although the nature of these objects differs and the meaning of these margins need not necessarily equate, buttressing-frame systems, as an extension of the church into its own margin, occupied a comparable space with an analogous relationship between periphery and center.

From the first decades of flying-buttress use to the end of the Middle Ages, French master masons and architects applied various approaches to their designs, resulting in a dramatic diversity of types. Comparison of the porch buttressing at Saint-Urbain in Troyes (figs. 20–21) to that of the cathedral of Saint-Julien in Le Mans (fig. 24) highlights the distinct aesthetic outcomes possible through formal modifications. Whereas the Saint-Urbain flyers frankly and openly display their unadorned architectonics, the bifurcated system at Le Mans results in a visual cacophony that overwhelms the eye and masks the spatial relationships of one part to another. The possibilities available to buttress designers were virtually endless. The importance of structure in this design process should not be minimized, yet the case of the openwork flyer, and particularly its continued used in the face of known structural failings, is an equally powerful statement of the weight placed on a desired look. While this example is particularly telling given the structural risks of openwork flyers, it may also help answer the perennial question of why the most efficient of all buttressing-frame systems, that used in the chevet of Bourges Cathedral, was never replicated (fig. 7). As Marvin Trachtenberg has suggested, perhaps this design simply did not suit the aesthetic tastes of its mid-thirteenth-century audience.[1]

Buttressing-frame systems influenced not only the appearance of church exteriors but also their physical reality. The dramatically protruding piers that supported flyers, and even those without flyers, created pockets of usable space around the exterior of the church. Although it has been suggested that these buttress interstices could be appropriated for subversive purposes, in actuality ecclesiastical communities tightly controlled access to and jurisdiction over these spaces. At Chartres, Reims, and (to a more limited degree) Laon, cathedral canons actively appropriated buttress interstices and may subsequently have leased them out as stalls to merchants. This practice followed from the active commercial activity of many cathedral precincts. At Paris, where restrictions prevented the bishop and chapter from profiting off of commercial activity of the cloister, the buttress interstices, absent exploitation, consequently held less value as external places. Although most early thirteenth-century cathedrals would eventually follow the model of Paris by constructing chapels in between buttress piers, this was not the case at Chartres or Reims, where exterior buttress interstices held economic and social value that was worth preserving.

As major components of the churches to which they were attached, buttressing-frame systems served the needs of the institutionalized Church. This connection appears most explicitly in the monumental sculptural programs attached to buttresses, beginning at Chartres Cathedral around the turn of the twelfth century and repeated shortly thereafter at Reims Cathedral and numerous other sites. In many cases minimal conservation efforts and extended exposure to the elements has obliterated attributes, facial features, and other aspects that would have aided in the interpretation of these programs. Nevertheless, it is possible to identify the most common types of figures as bishops, angels, and saints—that is, figures described by theological texts as the metaphorical supports for the Universal Church. Although the point of attachment differs by site, the sculptures are always arranged with one frontally facing figure per buttress, most typically attached to the buttress pier but sometimes rising above the upper cornice. In the cases where identification is still possible, figure attributes, whether liturgical or musical instruments, suggest

procession, as would frequently occur below the buttresses in accordance with the liturgical calendar. These processions, and most especially the one commemorating the dedication, delineated the consecrated space of the church. As reflections of such action, the sculptures concretized this separation of sacred space from its surrounds at a time when reform movements and reform-minded clerics increasingly emphasized the distinctions between religious and secular society. Moreover, as a sculptural program paid for by the cathedral chapter, this assertion of special status for church ground affirmed the chapter's jurisdiction over that space while simultaneously projecting the Church's role in salvation through liturgical performance.

The distinction between unconsecrated and consecrated ground not only spoke to the authority of the Church and its various communities but also provided physical and spiritual protection from a host of earthly and demonic threats. The form of the buttressing and its smaller-scale sculpture referenced the protective privileges of churches. Scholars have long recognized that secular and ecclesiastical architecture have common features, although the function of those features need not translate from one context to another. In their shared function but changing form, buttress piers and uprights participate in this larger shared architectural language. The moralizing treatises of Peter the Chanter and his contemporaries suggest that lay viewers easily conflated defensive towers with the towerlike assemblages of flying-buttress ensembles, demonstrating how these seemingly distinctive features recalled each other in their height, use of ashlar masonry, and systematic placement at a building edge. The flying buttresses of Narbonne Cathedral visualize a similar conflation by incorporating arrow slits, crenellations, and other more overtly defensive features. In this way flying buttresses become a signal of spiritual protection, analogues to the defensive towers of military architecture, behind which one might seek shelter from physical harm.

Like buttress towers, the demonic faces so popular in the sculpting of gargoyles reinforce the idea of protection. Although sources on gargoyles are sparse, those that do exist place them as guardians of city or church gates, preventing malicious or sinful people from passing through a door. Thus, just as towers defend a wall, gargoyles defend a perimeter, which is exactly the type of marginal space Gothic buttresses inhabit.

In his *Philosophy of Structures*, Eduardo Torroja argues that medieval masons "hid behind stained glass windows the flying buttresses necessary to sustain the vaults," like structural props.[2] When one sees buttressing frames as expressions of aesthetic, social, and religious messages, the absurdity of such a statement becomes clear. To be sure, the interior of a soaring Gothic cathedral, seemingly sustained by the divine will of God, powerfully visualizes the authority of the Church and divine grace. However, it was the exterior of the church that most people saw most of the time, and it too visualized an image of the Church as an instrument of God. The physical mass of buttressing-frame systems was not hidden but rather exhibited along church flanks and around chevets, embellished by sculpture, and replicated in all manner of nonarchitectural arts, including stained glass, manuscript illumination, and ivory carving. Moreover, even on the interior of the building, it is often possible to make out the shapes of the flyer arches, whose shadows pass over the stained-glass windows as the sun moves across the sky and subtly changes the lighting conditions of the building interior.

While microarchitecture and manuscript illumination speak powerfully of the importance of buttressing-frame systems in the visual landscape, an equally formidable mechanism for understanding their place in society is the very longevity of these exterior space frames. Although flying buttresses are most often described as triumphs of medieval engineering, they continued to be prominent features of church exteriors well into the sixteenth century—for example, at the church of Saint-Eustache

in Paris, begun in 1532 (fig. 92). By this time, buttressing-frame systems had nearly four hundred years of history, and their use at Saint-Eustache could certainly have drawn on this extended architectural past. The dramatic and unapologetic use of the flyer provides the exterior of the building with a sense of drama and excitement, much as it does at Paris Cathedral, where the long flyers of the choir form the primary focus of the chevet exterior. The aesthetic success of the flying buttresses at Saint-Eustache, where the elliptical supporting arches mirror the classically inspired tracery and elongated clerestory windows, stems from a desire for a unified exterior design, seen throughout the entire history of flying-buttress use.

Nor did buttressing-frame systems disappear with the return to the more rule-based classicism of the late French Renaissance and neoclassical periods. The twentieth century saw the use of the flying buttress on all kinds of secular edifices, from skyscrapers to lighthouses. While these buttresses have been secularized and are differentiated from the religious meanings that I have argued for in the medieval context, they nonetheless speak to a continued interest in the sweeping form of semi-independent arches and the dramatic spatial effects that those independent projections create. Although historians must always be wary of introducing anachronisms to their work, it is difficult to imagine that such forms would have struck medieval viewers less than they do us today.

NOTES

ABBREVIATIONS

AB	*Art Bulletin*
BM	*Bulletin monumental*
BnF	Bibliothèque nationale de France

JSAH	*Journal of the Society of Architectural Historians*
MAP	Médiathèque de l'architecture et du patrimoine

PL	*Patrologia Latina*. Edited by J.-P. Migne. Paris: Garnier, 1844–55, 1862–65

INTRODUCTION

1. This comparison has been made for other buildings but is equally apt for Paris Cathedral. "There is an old church I know of down near Les Halles [Saint-Eustache], a black foliated building with flying buttresses spread out like the legs of a spider." Power, *Conversations with James Joyce*, 92. See also Deuchler, *Gothic Art*, 20, citing Peter Meyer, *Europäische Kunstgeschichte* (1947).

2. Flying buttresses can also brace against the wind. Mark, *Experiments in Gothic Structure*, 22–24; Mark and Jonash, "Wind Loading on Gothic Structure"; Fitchen, "Upper Flying Buttresses."

3. Murray, "Notre-Dame of Paris," 229.

4. Ibid., 248.

5. Trachtenberg, "Desedimenting Time"; Trachtenberg, "Suger's Miracles"; Trachtenberg, "Gothic/Italian 'Gothic.'" For responses to Trachtenberg's idea of medieval modernism, see Binski, "Heroic Age of Gothic"; Bruzelius, "Rose by Any Other Name"; and Fernie, "Medieval Modernism."

6. Trachtenberg, "Desedimenting Time," 22.

7. A similar statement appears in Tallon, "Structure in Gothic": "The flying buttress is similarly multilingual, assessed as much for its ability to provide structural support as for its look; it is an instrument by which the decorative and spatial treatment hitherto proper to the interior might equally be extended to the exterior—transforming what was before a continuous, self-contained massing into an ever-changing and indistinct zone of shadow and light."

8. Hutterer, "When Old Meets New."

9. James, "Evidence for Flying Buttresses Before 1180," 279; Tallon, "Experiments in Early Gothic Structure," 100–122. Bony, *French Gothic Architecture*, 185, dates the flying buttresses of Mantes-la-Jolie to ca. 1185.

10. Tallon, "Experiments in Early Gothic Structure," 115.

11. On the dating of the buttressing of Saint-Remi, as well as that of Notre-Dame-en-Vaux, see Prache, "Rapports architecturaux." Notre-Dame-en-Vaux in Châlons-en-Champagne and Notre-Dame in Mouzon closely copy the Saint-Remi flying buttresses. On Mouzon, see Souchal, *Abbatiale de Mouzon*, 115, and Prache, *Saint-Remi de Reims*, 115.

12. Murray, "Notre-Dame of Paris," 236. Murray notes that the buttress piers of the choir did not project out quite as far but were slightly thicker. Tallon, "Experiments in Early Gothic Structure," 144–206, has reassessed the traditional narrative of Paris Cathedral's influence on buttress design.

13. Doquang, "Lateral Chapels," 144–50.

14. On the construction chronology of Saint-Eustache, see Sankovitch, *Church of Saint-Eustache*, 45–133.

15. I borrow the term "great church" from Christopher Wilson as a means of referring to architecturally and aesthetically ambitious churches of cruciform plan, whether they be monastic, collegiate, or episcopal buildings. Wilson, *Gothic Cathedral*, 7.

16. Murray, "Notre-Dame of Paris," 248. Minimizing buttress piers entailed practices like embedding them within chapel walls (as was eventually done at Paris Cathedral)

or reducing the height of the buttress uprights (as seen in the sixteenth-century work of Martin Chambiges at Saint-Étienne in Beauvais).

17. Lefèvre-Pontalis, "Origine des arcs-boutants," 395. For a concise historiography on the origin of the flying buttress up to 1919, see Philippe Plagnieux, "Réhabilitation des arcs-boutants du XII^e siècle," 102–6.

18. Prache, "Arcs-boutants au XII^e siècle," followed shortly by Henriet, "Saint-Martin d'Étampes." The best recent survey of twelfth-century flying buttresses is Tallon, "Experiments in Early Gothic Structure." Tallon offers a critical analysis of many of the studies cited below, along with revelations based on laser-scanned measurements and the models created from those measurements. See also his "Rethinking Medieval Structure," "Nouveau regard," "Équilibre expérimentale," and "Technologie 3D au service de Notre-Dame."

19. Henriet, "Cathédrale Saint-Étienne de Sens," 127–40; James, "Evidence for Flying Buttresses Before 1180," 264–66; Tallon, "Experiments in Early Gothic Structure," 99–143.

20. Prache, "Arcs-boutants au XII^e siècle," 37–38. Henriet, "Cathédrale Saint-Étienne de Sens," 156; James, "Evidence for Flying Buttresses Before 1180," 267; Plagnieux, "Saint-Germain-des-Prés," 71–74; Tallon, "Experiments in Early Gothic Structure," 122–38. For a contrary view see Clark, "Spatial Innovations," 363-65.

21. Plagnieux, "Arcs-boutants du XII^e siècle de l'église de Domont"; James, "Evidence for Flying Buttresses Before 1180," 271–74; Tallon, "Experiments in Early Gothic Structure," 138–41.

22. Henriet, "Saint-Martin d'Étampes"; Tallon, "Nouveau regard," 75–83. See also James ("Evidence for Flying Buttresses Before 1180," 287), who "does not believe that the evidence is firm enough to prove that flyers were intended" at Saint-Martin.

23. Timbert, "Choeur de l'église Saint-Maclou de Pontoise," 121.

24. Prache, "Arcs-boutants au XII^e siècle," 36; Everett, "Role of the Abbey Church," 269–72; Wu, "Cathédrale de Langres," 264–67.

25. Plagnieux, "Madeleine de Châteaudun." Earlier scholarship proposed that the flying buttresses dated to the thirteenth century; see, for example, Grant, "Aspects of the Twelfth-Century Design," 31 and 32 n. 32. Other proposed twelfth-century examples include Notre-Dame in Voulton, Saint-Quiriace in Provins, Saint-Remi in Reims, Senlis Cathedral, and Laon Cathedral. But this list of early French flying buttresses is not exhaustive.

26. Fitchen, *Construction of Gothic Cathedrals*, app. L; Wilson, *Gothic Cathedral*, 41–43; Stanley, "Original Buttressing of Abbot Suger's Chevet." See also the responses to Stanley's article by Andrew Tallon and Robert Mark (*JSAH* 66, no. 1 [2007], 136–38) and Rowland Mainstone (*JSAH* 67, no. 1 [2008], 161–62). Tallon also presented an argument against flying buttresses at Suger's chevet in a talk, "The Superstructure of Suger's Chevet at Saint-Denis," on February 10, 2015, at a colloquium in honor of William W. Clark, which I was not able to attend.

27. Timbert, "Arcs-boutants de la nef," 34.

28. Timbert, "Abbatiale de Cluny III"; Conant, *Carolingian and Romanesque Architecture*, 218–19. Conant repeated this assertion in many of his subsequent publications.

29. Tallon, "Experiments in Early Gothic Structure," 27–35; Baud, *Cluny*, 161–62.

30. See, for example, Etlin, "On the Symbolism of Rib Vaults," and Wilson, *Gothic Cathedral*, 41.

31. Tallon and Timbert, "Bâtiment gothique relevé par laser"; Timbert, "Chevet de l'église Saint-Sulpice de Chars."

32. Tallon, "Experiments in Early Gothic Structure," 207–8.

33. Tallon, "Équilibre expérimentale," 173.

34. Mark, *Experiments in Gothic Structure*, 52–56; Heyman, *Stone Skeleton*, 91–105; Nikolinakou, Tallon, and Ochsendorf, "Structure and Form"; Nikolinakou and

Tallon, "Early Gothic Flying Buttresses"; Mainstone, "Springs of Structural Invention"; Mainstone, "Springs of Invention Revisited."

35. Murray, "Notre-Dame of Paris." Murray was the first to establish that the current flying buttresses of Paris Cathedral take a form similar to that of the original buttressing. His argument has been confirmed by subsequent work by Tallon. See Tallon, "Équilibre expérimentale"; Tallon, "Technologie 3D au service de Notre-Dame."

36. See, for example, Onians, *Bearers of Meaning*; Jung, *Gothic Screen*; Lheure, *Triforium*; Huitson, *Stairway to Heaven*.

37. Several authors have argued for the primacy of flying buttresses as an essential characteristic of Gothic architecture. For example, Anthyme Saint-Paul ("Transition," 476) describes flying buttresses as "la meilleure expression matérielle d'un principe, le principe d'équilibre, spécialement consacré par l'architecture gothique." Marvin Trachtenberg ("Desedimenting Time," 21) expresses a similar sentiment: "With the advent of the flying buttress, the exterior of the cathedral rapidly became the purest and most powerful modernist aspect of the entire building."

38. Paul Frankl writes of "stylistic function" and "function in terms of statics" regarding flying buttresses. Frankl, *Gothic Architecture*, 87. Tallon has similarly stated that in some cases flying buttresses may have been added to buildings for their look. Tallon, "Structure in Gothic."

39. On the economics of cathedral building, see Kraus, *Gold Was the Mortar*.

40. Abou-El-Haj, "Urban Setting"; Williams, *Bread, Wine, and Money*.

41. McGinn, "Admirable Tabernacle," 52.

42. Whitehead, *Castles of the Mind*, 49–60.

43. Zerner, *Renaissance Art in France*, 25.

44. This disparity has been discussed by Sandron, "Cathedral Façade," 35.

45. Elmes, *Life and Works of Sir Christopher Wren*, app. 120, quoted in Frankl, *Gothic*, 368.

46. Viollet-le-Duc, *Foundations of Architecture*, 232.

47. Viollet-le-Duc, *Dictionnaire raisonné*, 1:61. Andrew Tallon has explored the historiography of the "invention" of the flying buttress as an extension of the architectural section in greater depth. See Tallon, "Experiments in Early Gothic Structure," 7–15.

48. Viollet-le-Duc, *Dictionnaire raisonné*, 1:60. My translation, as are all subsequent translations unless otherwise noted.

49. As discussed in Paul Crossley's introduction to the revised edition; see Frankl, *Gothic Architecture*, 10.

50. Ibid., 87.

51. Ibid., 86 and 87.

52. Bony, *French Gothic Architecture*, 197. In his discussions of individual buildings, Bony sensitively relates the design of individual buttressing systems to the larger building design.

53. Ibid., 232.

54. Ibid., 202–20.

55. Bork, Mark, and Murray, "Openwork."

56. Ibid., 482–83. On the flying buttresses of Auxerre, see also Titus, "Auxerre Cathedral," 51–55; Coste, *Architecture gothique*, 194–97; and Sapin, *Saint-Étienne d'Auxerre*, 171–72. For Saint-Quentin, see Shortell, "Choir of Saint-Quentin," 231–33, and Héliot, *Saint-Quentin*, 36.

57. Bork, Mark, and Murray, "Openwork," 492.

58. Viollet-le-Duc, *Dictionnaire raisonné*, 4:300.

59. For example, Timmermann, *Real Presence*; *Représentations architecturales dans les vitraux*, 9; Kumler, *Translating Truth*, 182–85. See also the discussion of microarchitecture and architectural frames in chapter 1.

60. My thanks to Robert Bork for this helpful analogy.

61. Bony, *French Gothic Architecture*, 197.

62. On the linguistic difficulties of terminology, see also Murray, "Notre-Dame of Paris," 229. On the history of flying-buttress terminology, see Tallon, "Experiments in Early Gothic Structure," 2–3.

63. *Arc-boutant* derives from the medieval French *ars boteres* / *ars buteret*, appearing in Villard de Honnecourt's thirteenth-century portfolio. Paris, BnF, MS fr. 19093, fols. 14v and 31v. See also Barnes, *Portfolio of Villard de Honnecourt*, 91-94 and 198–200, plates 31 and 65.

64. *Culée* appears as early as 1355, although this same feature is also referred to as a *pillier* (pillar), as in an expert report regarding the stability of Saint-Étienne-du-Mont in Paris made in 1521. Imbs, *Trésor de la langue française*, s.v. culée 2; Bos, *Églises flamboyantes*, 155.

65. A similar comparison appears in Dehio and Bezold, *Kirchliche Baukunst des Abendlandes*, 2:74.

66. Etlin, "On the Symbolism of Rib Vaults."

67. On Domont and the aesthetics of buttressing, see Tallon, "Experiments in Early Gothic Structure," 141. On Chartres, see Frankl, *Gothic Architecture*, 79; von Simson, *Gothic Cathedral*, 204; Henderson, *Chartres*, 111; and Bony, *French Gothic Architecture*, 235.

68. Baldwin, *Government of Philip Augustus*, 64–73.

69. Evergates, *Aristocracy in the County of Champagne*, 11.

70. Henry had died ten years earlier, when Jeanne was only one year old. She succeeded her father under the regency of her mother, Blanche.

71. Baldwin, *Government of Philip Augustus*, 246–48.

72. See, for example, Paul, "Projecting Triforium at Narbonne," 27. On Narbonne Cathedral and the Capetian monarchy, see also Freigang, *Imitare ecclesias nobiles*. In his review of Freigang's *Imitare*, Michael Davis (*JSAH* 54, no. 3 [1995]: 373) notes that "while local motivations may have stimulated the Narbonne project . . . the cathedral celebrated the monarchy in its

liturgy, received royal foundations, and was the site of the tomb of Philip III."

73. Trachtenberg, "Suger's Miracles," 202; Hutterer, "Architectural Design," 288–90.

CHAPTER 1

1. Bony, *French Gothic Architecture*, 27–28.

2. Villard's drawing of the flying buttresses at Reims appears on folio 32v of his sketchbook (Paris, BnF, MS fr. 19093). *Ars boteres* appears in reference to Cambrai Cathedral on folio 14v. *Ars buteret*, in reference to Reims Cathedral, appears on folio 31v as an addition by an anonymous later hand in the 1240s or 1250s. Murray, *Plotting Gothic*, 38–39; Barnes, *Portfolio of Villard de Honnecourt*, 92, 198–200; Quicherat, "Notice sur l'album de Villard de Honnecourt," pt. 5; Frankl, *The Gothic*, 46–47; Godefroy, *Dictionnaire de l'ancienne langue française*, 1:712b–c; Wiener, "Etymology of Buttress"; Rothwell, "Glanures lexicologiques," 221–23.

3. Grant, "Naming of Parts," 51. Grant suggests that the need for technical and specialized vocabulary hindered an author's ability to produce detailed architectural description. Want of technical knowledge of architecture may also have played a role, as suggested in Kidson, "Panofsky, Suger, and St. Denis," 2.

4. Inglis, "Gothic Architecture and a Scholastic," 73. Inglis notes that Gervase of Canterbury, the chronicler of the building campaign at Canterbury Cathedral, is highly unusual in that he compares master mason William of Sens's twelfth-century reconstruction of the choir to the previous building, specifically noting changes in the column capitals and vaults. Gervase does not mention Canterbury's use of flying buttresses, which, although new to the site, are admittedly small and hesitant in comparison to contemporaneous French examples.

5. One such example is the expertise of 1362 for Troyes Cathedral, which is transcribed and translated in Murray, *Building Troyes Cathedral*, 120–21.

6. Frankl, *Gothic Architecture*, 87; Simson, *Gothic Cathedral*, 203–4; Henderson, *Chartres*, 111; Barnes, "Cathedral of Chartres," 72; Ball, *Universe of Stone*, 225.

7. Bony, *French Gothic Architecture*, 235.

8. On the buttressing of Saint-Jean-au-Marché, see Piétresson de Saint-Aubin, "Arcs-boutants du choeur."

9. On the invention, development, and structure of openwork flyers, see Bork, Mark, and Murray, "Openwork."

10. Ibid., 486–89.

11. The choir flyers of the cathedral were completely replaced in the nineteenth century, but the original form is preserved in the similar units of the transept. On the choir of Troyes Cathedral, see Bongartz, *Die frühen Bauteile der Kathedrale in Troyes*.

12. Murray, *Building Troyes Cathedral*, 14.

13. Bongartz, *Die frühen Bauteile der Kathedrale in Troyes*, 142–51, 231–46.

14. Bork, Mark, and Murray, "Openwork," 482.

15. Murray, *Building Troyes Cathedral*, 30–31.

16. Ibid., 31–32, 120–21; Bongartz, *Die frühen Bauteile der Kathedrale in Troyes*, 148.

17. Murray, *Building Troyes Cathedral*, 32.

18. Ibid., 31–32, 120–21.

19. On Garnache's work on the flying buttresses, see ibid., 77–82.

20. Ibid., 78.

21. Piétresson de Saint-Aubin, "Église Saint-Jean-au-Marché de Troyes," 91.

22. Ibid., 87; Murray, *Building Troyes Cathedral*, 90, 108–9, 177–79. Murray notes that Gailde, along with another mason from the cathedral works, Jehan Bailly, played an important role in the inception of work at Saint-Jean (ibid., 108).

23. Piétresson de Saint-Aubin, "Arcs-boutants du choeur," 182.

24. Piétresson de Saint-Aubin, "Église Saint-Jean-au-Marché de Troyes," 91,

compares the Saint-Jean flyers to those of the cathedral's nave.

25. Piétresson de Saint-Aubin, "Arcs-boutants du choeur," 182.

26. Ibid., 182–83.

27. Ibid., 183–85.

28. Isnard, "Travaux," 107.

29. The flying buttresses of Saint-Vulfran may also have served as a model for Saint-Riquier. Ibid., 100. The Saint-Vulfran flyers were totally replaced in the nineteenth century.

30. Bork, Mark, and Murray, "Openwork," 490–91.

31. On the restoration of the flyers, see Isnard, "Travaux," 93–95.

32. Gallet, *Cathédrale d'Évreux*, 230–33.

33. Gosse-Kischinewski and Gatouillat, *Cathédrale d'Évreux*, 23; Gallet, *Cathédrale d'Évreux*, 83.

34. Denifle, *Désolation des églises, monastères, hôpitaux*, 1:82; Gallet, *Cathédrale d'Évreux*, 84.

35. Gallet, *Cathédrale d'Évreux*, 197–200.

36. Bork, Mark, and Murray, "Openwork," 489–91.

37. Cf. Bony, *French Gothic Architecture*, 197.

38. Bork, Mark, and Murray, "Openwork," 482–83.

39. Murray, *Cathedral of Amiens*, 82–86.

40. On the construction chronology of Saint-Urbain, see Davis, "Saint-Urbain"; Bruzelius, "Second Campaign at Saint-Urbain"; and Davis and Neagley, "Mechanics and Meaning," 164–65, 167–69.

41. Davis and Neagley, "Mechanics and Meaning," 164–65, 167–69.

42. Davis, "Saint-Urbain," 853, 875–77. See also Bruzelius, "Second Campaign at Saint-Urbain," 635, 639.

43. Davis, "Saint-Urbain," 855, 872–75.

44. Ibid., 853–75.

45. Ibid., 878–79.

46. At Noirlac the low-level flying buttress supports the northwest corner of the cellar. The flying buttresses of the south side of the abbey church were not at ground level, but viewers had a particularly good view of them from the second level of the

cloister walk. On those at Auxerre Cathedral, see Titus, "Auxerre Cathedral," 53, and Sapin, *Saint-Étienne d'Auxerre*, 171–72.

47. In England a parallel example is the Lincoln chapter house, completed before 1235. Kidson, "Architectural History," 36-37.

48. Titus, "Auxerre Cathedral," 53.

49. On the church of Saint-Eusèbe, see Vallery-Radot, "Église Saint-Eusèbe d'Auxerre."

50. Seymour, *Notre-Dame of Noyon*, 71.

51. Charles Seymour dates the original completion of the west ensemble, including porches, to ca. 1235. He further argues that much of the damage to the north tower and the porch in the 1293 fire was due to the bells in the north tower, which presumably fell and damaged the vaults. Chapter accounts suggest that the repairs were mostly completed by 1333. Ibid., 65–71.

52. On the chronology of Le Mans Cathedral, see Herschman, "Norman Ambulatory of Le Mans," 325, and Bouttier, *Cathédrale du Mans*, 50–76.

53. Bouttier, *Cathédrale du Mans*, 72–76.

54. This arrangement is similar to those in the east ends of buildings like the abbey church of Notre-Dame in Fontgombault (ca. 1124–41) and Saint-Hilaire in Poitiers (second half of the eleventh century).

55. Bouttier, *Cathédrale du Mans*, 58–59.

56. On the relationship between Bourges and Le Mans, see, for example, Bork, "Holy Toledo," and Branner, *Cathedral of Bourges*, 183–89.

57. Bouttier, *Cathédrale du Mans*, 62–70.

58. Branner, *Cathedral of Bourges*, 66. On the conception of Bourges's chevet flyers, see ibid., 87–92.

59. *Grandes Chroniques de France*, illuminated by Jean Fouquet, Tours, ca. 1455–60. Paris, BnF, Département des manuscrits, MS fr. 6465, fol. 223r.

60. Branner called the Saint-Martin buttressing "an innovation that simplified the system of Bourges." Branner, *Cathedral of Bourges*, 180.

61. M[aury] Wolfe and R[obert] Mark have argued that because the chevet of

the cathedral at Coutances is relatively small, the technological innovations of the Bourges chevet could have had little influence. Whether or not the buttressing ensemble at Coutances functions as efficiently as the ensemble at Bourges, the former nonetheless visually recalls the latter. It may be that the master of Coutances was influenced by the design at Bourges but failed to implement all of its structural lessons either because of a lack of understanding or by necessity. Wolfe and Mark, "Gothic Cathedral Buttressing," 23.

62. Bouttier, *Cathédrale du Mans*, 59.

63. On the originality of the apse chapels at Bourges, see Kidson, "Bourges After Branner," 150-53.

64. While today the chevet of Saint-Martin in Étamps displays a series of flying buttresses, most of these flyers, added only in the thirteenth century, postdate its initial construction. It is possible that one flyer on the southern flank of the chevet was intended from the outset, today indicated only by the stump of what may have been its buttress upright, although the evidence remains inconclusive. See Tallon, "Nouveau regard," 75–83. Nevertheless, the pattern of buttress piers flanked by windows could still have served as a model for Le Mans, even if the flyers had not been added by this date.

65. Bouttier, *Cathédrale du Mans*, 72.

66. On Toledo Cathedral, see Nickson, *Toledo Cathedral*.

67. Cf. Murray, "Notre-Dame of Paris," 229.

68. Claudine Lautier has examined several such images that appear in thirteenth-century stained glass. Lautier, "Édifices religieux." Iconographically similar images also appear in manuscript illumination—for example, on folio 50v of Vienna Codex 2554, a moralized Bible from around 1220. Other similar images appear in New York, Morgan Library & Museum, MS M 536, fol. 21v, and Princeton Library, MS Princeton 116, fol. 79r.

69. A similar panel, dedicated to the masons from Rouen Cathedral, also clearly displays the building's buttressing. See Lautier, "Édifices religieux," 44. Jane Welch Williams, in *Bread, Wine, and Money*, has suggested that the donor panels at Chartres in fact represent an ecclesiastical ideal of Christian society.

70. On flying buttresses as signs of modernity in the Middle Ages, especially in microarchitecture, see Guérin, "Meaningful Spectacles," 58.

71. Lautier, "Édifices religieux," 44.

72. In an image from Laon Cathedral (window 1, panel 16) each of the three represented flyers meets the clerestory wall at a different height. In another example from Sens (window 23, panel 9) the number of flyers per buttress pier is not consistent— the westernmost pier has only a top flyer, and the easternmost pier has only a lower flyer.

73. Lautier has singled out a panel from the Saint Martin window at Auxerre that clearly depicts the straight diagonal line that defines the upper edge of the flyer. See Lautier, "Édifices religieux," 44.

74. Tallon, "Experiments in Early Gothic Structure," 191–92.

75. Viollet-le-Duc, *Dictionnaire raisonné*, 4:300.

76. For example, Frodl-Kraft, "Kirchenschaubildern."

77. Kurmann, "Architecture, vitrail et orfèvrerie."

78. Lillich, *Gothic Stained Glass of Reims Cathedral*, 138–43. Lillich proposes that the recycled panels of window 118 date to around 1220.

79. Ibid., 87. On the construction chronology of Beauvais Cathedral, see Murray, *Beauvais Cathedral*, 51–60.

80. Kurmann, "Architecture, vitrail et orfèvrerie," 35–36.

81. Smith, "Margin," 31.

82. Camille, *Image on the Edge*, 77.

83. On marginal sculpture, see Kenaan-Kedar, *Marginal Sculpture in Medieval France*. The phrase "betwixt and between" references Victor Turner's work on liminality, specifically his 1967 essay "Betwixt and Between: The Liminal Period in Rites of Passage," published in *The Forest of Symbols*.

84. Sandler, "Study of Marginal Imagery," 1.

85. Smith, "Margin," 30.

86. For example, Émile Mâle (*Gothic Image*, 58) has called them "gay invention or good-humored raillery." For more-current views, see, for example, Sandler, "Study of Marginal Imagery," and Smith, "Margin." Other groundbreaking works on the study of marginalia include Camille, *Image on the Edge*; Kenaan-Kedar, *Marginal Sculpture in Medieval France*; and Randall, *Images in the Margins*.

87. Caviness, "Marginally Correct," 143; Sandler, "Study of Marginal Imagery," 36.

88. Smith, "Chivalric Narratives and Devotional Experience"; Smith, "Book, Body and the Construction of the Self."

89. Smith, "Margin," 30.

90. François Bucher, "Micro-Architecture," 82.

91. Nancy Wu has drawn attention to the difference between microarchitecture and architectural objects in her paper "Reconsidering 'Micro-Architecture' in the Late Middle Ages," presented at the annual conference of the Society of Architectural Historians, June 7–11, 2017, in Glasgow, Scotland.

92. Timmermann, *Real Presence*, 13.

93. Kavaler, *Renaissance Gothic*, 166.

94. Bucher, "Micro-architecture," 71, 74.

95. Kurmann, "Miniaturkathedrale oder monumentales Reliquiar?," 135.

96. Cf. ibid., 135–38. On the connection of the shrine to Reims and Paris, see Lestocquoy, "Reliquary of St. Gertrude at Nivelles."

97. Timmermann, *Real Presence*, 64.

98. Kavaler, *Renaissance Gothic*, 186. See also Collet, "Jehan Gailde," and idem, "Compagnons de Jehan Gailde."

99. Another French example would be the Montjoies set up to mark the resting points of Philippe III as he carried the

body of his father, Louis IX, from Paris to Saint-Denis. On images of these objects, see Evans, "Prototype of the Eleanor Crosses"; Branner, "Montjoies of Saint Louis"; and Zukowsky, "Montjoies and Eleanor Crosses Reconsidered."

100. Timmermann, *Real Presence*, 40–43, 178–83.

101. Panofsky, *Early Netherlandish Painting*, 1:15–16; Birkmeyer, "Arch Motif in Netherlandish Painting"; Pächt, *Book Illumination in the Middle Ages*, 148–49, 190–94; Bunim, *Space in Medieval Painting*, 109–12.

102. Stahl, *Picturing Kingship*, 85–86.

103. See, for example, the buttress piers/ pinnacles on 232v and 286v.

104. Barnes, "Cross-Media Design Motifs," 38, 39.

105. The use of buttress piers as an integral part of the space-delimiting frame is perhaps best illustrated by the miniatures in the *Life of Saint Denis* (Paris, BnF, MS fr. 2090–2092), where the diagonal placements of the buttress piers provide the shallow spatial frame for the picture.

106. Kumler, *Translating Truth*, 182–85.

107. Pächt, *Book Illumination in the Middle Ages*, 148, notes that sometimes the upper border is omitted from the outer decorative frame.

108. Carl F. Barnes has argued that this motif derives from the portals of the west façade of Amiens Cathedral. Barnes, *Portfolio of Villard de Honnecourt*, 38.

109. Stahl, *Picturing Kingship*, 88–89.

110. Ibid., 87, distinguishes between frames depicting exterior architectural forms and frames made from cutaway views.

111. See, for example, Draper, *Formation of English Gothic*, and Nussbaum, *German Gothic Church Architecture*.

CHAPTER 2

1. Ravaux, "Campagnes de construction," 10 and 60–61 n. 33; Prache, "Début de la construction," 44, 48.

2. The traditional start date of 1211 for the reconstruction of Reims Cathedral comes from the *Annales Sancti Nicassi Remenses*, published in the *Monumenta Germaniae Historica: Scriptores* (Hanover, 1881), 13:85. The revised start date was first proposed in Prache, "Début de la construction." Feltman, introduction to *North Transept of Reims Cathedral*, 5–9, provides a concise account of the revised chronology.

3. Branner, "Historical Aspects," 29–30; Pierre Varin, *Archives administratives*, 1:495–98.

4. Desportes, *Reims et les Rémois*, 155–67. On the relationship between this conflict and the project at Reims, see, for example, Abou-El-Haj, "Urban Setting"; Abou-El-Haj, "Program and Power"; Branner, "Historical Aspects"; Lillich, *Gothic Stained Glass of Reims Cathedral*, 8–11 and chap. 3; Demouy, "Être achevêque de Reims"; and Desportes, "Chapitre et sa cathédrale."

5. Bedos-Rezak, "Form as Social Process."

6. Murray, "Notre-Dame of Paris," 249 n. 19.

7. For a description of the various activities that took place around cathedrals, see Temko, *Notre-Dame of Paris*, 249. Temko probably exaggerates, but the description is evocative nonetheless. An alternative interpretation appears in Davis, "Canonical Views," 107–8.

8. For example, at Chartres the demolition of buildings attached to the cathedral occurred between 1865 and 1906. Meulen, "Angrenzende Bauwerke der Kathedrale von Chartres," 7 n. 3. On the establishment of the grille at Chartres, see Paris, Archives nationales, F19 7680.

9. Henriet, "Cathédrale Saint-Étienne de Sens," 133; Murray, "Notre-Dame of Paris," 242.

10. Bony, *French Gothic Architecture*, 232.

11. Doquang, "Lateral Chapels," 150–52.

12. Recent work on chantry chapels in France is that of Mailan Doquang: "Rayonnant Chantry Chapels," "Lateral Chapels," "Status and the Soul." See also Baron,

"Effigies sculptées"; Davis, "Splendor and Peril"; Sandron, "Fondation"; Sankovitch, "Intercession, Commemoration, and Display"; Stanford, "Body at the Funeral"; Viollet-le-Duc, *Dictionnaire raisonné*, 2:289–92; and Freigang, "Chapelles latérales privées."

13. The flying buttresses of the choir were in place by 1177. Tallon, "Technologie 3D au service de Notre-Dame," 160. Caroline Bruzelius has argued that construction of the nave at Paris Cathedral began while the upper levels of the choir were under construction, around 1170. Bruzelius, "Construction of Notre-Dame in Paris," 555–61. On the projecting buttress piers as part of the original twelfth-century project, see Murray, "Notre-Dame of Paris," 246. On the dating of the nave chantry chapels of Paris to shortly after 1228, see Doquang, "Lateral Chapels," 147.

14. See, for example, the locations and instructions for religious dramas in Tydeman, *Medieval European Stage*, such as the description of a play that took place in a graveyard (181).

15. Baltzer, "Geography of the Liturgy," 52.

16. C. M. Wright, *Music and Ceremony*, 29–30.

17. Ibid., 53–54.

18. See, for example, Hicks, *Religious Life in Normandy*; Hayes, *Body and Sacred Place*; and Smith, "Chivalric Narratives and Devotional Experience."

19. Hayes, *Body and Sacred Place*, 17–24.

20. All biblical translations are from the Douay-Rheims Bible at www.drbo.org.

21. Perhaps stalls similar to those depicted in the *Pontifical of Sens*, Paris, BnF, MS lat. 962, fol. 264r.

22. Charles Nodier and Justin Taylor, *Voyages pittoresque et romantiques dans l'ancienne France*, vol. 2, 1bis, *Alet, Mirepoix, Pamiers, Foix, Muret, Valcabrère, St Bertrand de Comminges; les Pyrénées* (Paris: Didot, 1833), n.p. Shops around the Sainte-Chapelle also appear in Étienne Martellange, *Palais de la Cité, View of the Cour du Mai*, Oxford, Ashmolean Museum, CL II 117.

23. This porch was in place at least until 1911, as is documented by a photograph of that date, MAP, photograph MH0194127.

24. For example, Abou-El-Haj, "Urban Setting." See also Lillich, *Gothic Stained Glass of Reims Cathedral*, 1–11.

25. Branner, "North Transept," 224–35. Walter Berry has suggested that the south walk of the canon's cloister was rebuilt to accommodate construction of the cathedral's north transept façade. W. Berry, "North Portals of Reims Cathedral," 22–25.

26. Varin, *Archives administratives*, 3:576.

27. Prache, "Début de la construction," 44.

28. Desportes, *Reims et les Rémois*, 354.

29. Ibid., 361.

30. Niermeyer, van de Kieft, and Lake-Schoonebeek, *Mediae Latinitatis Lexicon Minus*, gives *Trisantia* as cloister. Desportes, *Reims et les Rémois*, 374 n. 30, gives the local variant, *Trisande*.

31. Desportes, *Reims et les Rémois*, 374–75.

32. Ibid., 374–75 n. 31; Varin, *Archives administratives*, 2:917–19.

33. Ravaux, "Campagnes de construction," 10, 60–61 n. 33.

34. Villes, *Cathédrale Notre-Dame de Reims*, 234. Jennifer M. Feltman similarly suggests that "all of the interior units were laid out and built up to a certain level, perhaps the top of the piers, before the revolts of the 1230s." Feltman, introduction to *North Transept of Reims Cathedral*, 9. See also Berné, "Sources de la construction," 77.

35. Dendrochronological findings were first used to revise the construction chronology in Prache, "Début de la construction." For Villes's chronology of construction campaigns, see Villes, *Cathédrale Notre-Dame de Reims*, 423–28. A summary of the literature appears in Feltman, introduction to *North Transept of Reims Cathedral*, 7–9.

36. Villes argues that these rooms were likely constructed before the 1221 resolution was issued. Given the exceptional nature of these "*officines*" along the nave, I remain open to the possibility that a continuing dispute between the chapter and treasurer

may have delayed their construction even if the nave was well under way. While Guillaume's 1221 agreement confirms a resolution made by Aubry de Humbert in 1215, I understand this primarily as the affirmation of a predecessor's ruling and not as indicative of an earlier agreement over the treasurer's garden.

37. Hamann-MacLean, "Zur Baugeschichte der Kathedrale von Reims," 228; Ravaux, "Campagnes de construction," 10.

38. Prache, "Début de la construction," 48.

39. Varin, *Archives administratives*, 3:577; Desportes, *Reims et les Rémois*, 375.

40. For a bibliography up to 1989 on the history of Chartres to 1260, see Meulen, Hoyer, and Cole, *Chartres: Sources and Literary Interpretation*, 402–37. On the relationship between social conflict and the cathedral project post-1194, see especially Williams, *Bread, Wine, and Money*, 19–35; Hayes, *Body and Sacred Place*, 27–31; and Abou-El-Haj, "Artistic Integration Inside the Cathedral Precinct."

41. Williams, *Bread, Wine, and Money*, 22–25; Lépinois, *Histoire de Chartres*, 1:117; Chédeville, *Histoire de Chartres*, 491.

42. Williams, *Bread, Wine, and Money*, 22.

43. The documents relating to these uprisings are published in Lépinois and Merlet, *Cartulaire de Notre-Dame de Chartres*, 2:56–62 (no. 203, 1210–11), 77–78 (no. 218, 1215), 140–42 (no. 294, 1249), 157–59 (no. 316, 1254), 165–66 (no. 324, 1257).

44. Lecocq, "Historique du cloître," 131; Lépinois, *Histoire de Chartres*, 1:142.

45. Lecocq, "Historique du cloître," 149. See also Laurent, "Chartres: Le cloître Notre-Dame," and Nicot, "Cloître Notre-Dame de Chartres." On the division of the cloister into areas with distinct audiences and functions, see Hollengreen, "Medieval Sacred Place," 96.

46. Lecocq, "Historique du cloître," 157; Laurent, "Chartres: Le cloître Notre-Dame," 7.

47. Lecocq, "Historique du cloître," 149; Merlet, "Boutiques au cloître Notre-Dame." Surviving documents refer to *mercerii*,

which modern scholars have interpreted both as money changers and haberdashers. It is possible that money changing took place in the cloister during the four pilgrimage fairs, although I think it is more likely that *mercerii* most frequently refers to vendors of religious baubles. On the translation of this term, see Williams, *Bread, Wine, and Money*, 111–12.

48. Lecocq, "Historique du cloître," 141.

49. See note 8 above.

50. Paris, BnF, Estampes, VA-28 (4).

51. Lecocq, "Horloges," 308.

52. Meulen, "Angrenzende Bauwerke der Kathedrale von Chartres," 7; Merlet, "Boutiques au cloître Notre-Dame," 81.

53. Merlet, "Boutiques au cloître Notre-Dame," 81; Billot, *Chartres à la fin du Moyen Âge*, 135.

54. Prache, "Chapelle de Vendôme," 569–70.

55. Meulen, "Histoire de la construction," 103–4.

56. Prache, "Chapelle de Vendôme," 575.

57. Transcribed in Billot, "Chartres, xive siècle–xve siècle," 797: "construire de nouvel et fonder en ladicte eglise."

58. Meulen, "Histoire de la construction," 103–4.

59. James, *Contractors of Chartres*, 1:87 n. 12.

60. Meulen, "Angrenzende Bauwerke der Kathedrale von Chartres," 16–22; Delaporte, *Chartres*, 1, 18, 137; Lillich, "Grisaille Windows of Chartres Cathedral," 14.

61. Billot, "Chartres, xive siècle–xve siècle," 797.

62. Merlet, "Boutiques au cloître Notre-Dame," 88.

63. Chédeville, *Chartres et ses campagnes*, 458, 523–34.

64. Lépinois and Merlet, *Cartulaire de Notre-Dame de Chartres*, 1:203–5. A summary of the charter appears in Hayes, *Body and Sacred Place*, 60.

65. Lépinois and Merlet, *Cartulaire de Notre-Dame de Chartres*, 1:244–45; Livingstone, *Out of Love for My Kin*, 237.

66. Williams, *Bread, Wine, and Money*, 77–80.

67. Lépinois and Merlet, *Cartulaire de Notre-Dame de Chartres*, 2:103. Translation from "Three Disputes Involving the Cathedral Chapter of Notre-Dame of Chartres, 1215–1224," trans. Richard Barton, Internet Medieval Source Book (Fordham University, 1998), http://origin.web.fordham.edu/Halsall/source/1224chartres.asp. I have modified Barton's translation by replacing "among the columns" with "on the porch," following Lefèvre-Pontalis, "Architectes," 113.

68. See, for example, Lefèvre-Pontalis, "Architectes," 113, and Grodecki, "Transept Portals of Chartres Cathedral," 157.

69. Sauerländer, *Gothic Sculpture in France*, 434–35. Sauerländer's interpretation of this document allowed for a slight shift in the dating of the porch from ca. 1225 to 1230–40.

70. Lecocq, "Recerces sur les enseignes," 209 n. 1.

71. Ibid., 208.

72. Lecocq includes this information on page 37 of a version of his "Esquisse historique du cloître Notre-Dame de Chartres" published in Chartres by Imprimerie de Garnier in 1857, but not in the version published a year later by *Mémoires de la Société archéologique d'Eure-et-Loir*.

73. Merlet, "Boutiques au cloître Notre-Dame."

74. Ibid., 80.

75. Ibid., 81–82.

76. Dyer, *Making a Living in the Middle Ages*, 197.

77. On the clerical exclusivity of the Paris Cathedral cloister, see Davis, "Canonical Views," 107-08. The immunity of the cloister was confirmed in 1119 and 1200. See Guérard, *Cartulaire de l'église Notre-Dame*, 1:264–65 (no. 283).

78. See, for example, reports of theft in the cloister: Guérard, *Cartulaire de l'église Notre-Dame*, 3:346–38.

79. Erlande-Brandenburg, *Notre-Dame de Paris*, 42–48; Davis, "Canonical Views," 106–10.

80. Des Graviers, "'Messeigneurs du Chapitre,'" 196. On the date of the west façade, see Bruzelius, "Construction of Notre-Dame in Paris," 562–64.

81. Guérard, *Cartulaire de l'église Notre-Dame*, 1:253: "ad muros claustri Beate Maria." Another mention of the cloister walls appears in a charter of 1225. Ibid., 2:529: "juxta muros claustri nostri" (next to the walls of our cloister).

82. Erlande-Brandenburg, *Notre-Dame de Paris*, 47; Erlande-Brandenburg and Dectot, "Cloître Notre-Dame," 116-17.

83. Guérard, *Cartulaire de l'église Notre-Dame*, 1:cix–cxii.

84. Martineau, *Halles de Paris*, 15.

85. Lombard-Jourdan, *Aux origines de Paris*, 85–89, 127–29. On the relative power of the king and bishop of Paris, see, for example, Cohen, *Sainte-Chapelle*, chap. 1.

86. Lombard-Jourdan, *Aux origines de Paris*, 86, 128.

87. Martineau, *Halles de Paris*, 43, 131, 241–42. Martineau cites the origin of the *foire au jambon* to a 1222 charter of concession by Philippe Auguste, maybe referring to the 1222 agreement between Philippe and Guillaume cited above. If so, I am skeptical of his linking the agreement to the fair's genesis, since the 1222 agreement refers to a single butcher. Boileau, *Métiers et corporations*, v.

88. Guérard, *Cartulaire de l'église Notre-Dame*, 1:cx–cxi and 2:404–6.

89. Ibid., 3:246–47; Timbal and Metman, "Évêque de Paris et Chapitre," 122 n. 36.

90. See, for example, Beaudette, "Clerical Celibacy."

91. Schroeder, *Disciplinary Decrees of the General Councils*, 236–96.

92. Graviers, "'Messeigneurs du Chapitre,'" 200; Guérard, *Cartulaire de l'église Notre-Dame*, 3:421.

93. Graviers, "'Messeigneurs du Chapitre,'" 199.

94. Camille, *Image on the Edge*, 91.

95. Schroeder, *Disciplinary Decrees of the General Councils*, 256–57.

96. See, for example, Uebel, "Foreigner Within," 98. Guillaume's discussion of bears and succubi appears in book 3, chapter 25, of *De universo*.

97. Guérard, *Cartulaire de l'église Notre-Dame*, 1:338–40; Gabriel, "Écoles de la cathédrale," 145–46.

98. Guérard, *Cartulaire de l'église Notre-Dame*, 1:339: "pro pace confirmanda, et lite et inquietatione evitanda."

99. Haskins, *Rise of Universities*, 83.

100. Quoted in Haskins, "Life of Medieval Students," 214.

101. Gabriel, "Écoles de la cathédrale," 146.

102. Ibid., 147.

103. Timbal and Metman, "Évêque de Paris et Chapitre," 115–16.

104. Doquang, "Lateral Chapels," 150–51.

105. Scholars have traditionally dated chapel construction at Laon to the later thirteenth and fourteenth centuries. See, for example, Clark and King, *Laon Cathedral*, 1:51.

106. On the chronology of the construction of Laon, see ibid., 28–54.

107. Broche, *Cathédrale de Laon*, 46–47; Bony, *French Gothic Architecture*, 128.

108. Clark and King, *Laon Cathedral*, 1:54 and 2:50.

109. Ibid., 2:70 n. 8.

110. Ibid., 2:51, 62, 72 n. 8.

111. Ibid., 1:47.

112. This wall is indicated in Erlande-Brandenburg, *Cathedral*, fig. 157, and is mentioned in Saint-Denis, *Laon et le Laonnois*, 341.

113. Erlande-Brandenburg, *Cathedral*, 346–47.

114. Ibid., 323, 327.

115. Guibert, *Self and Society in Medieval France*, 174.

116. Ibid., 176.

117. Abou-El-Haj, "Artistic Integration Inside the Cathedral Precinct," 218–19; Luchaire, *Social France*, 412–13.

118. Erlande-Brandenburg, *Cathedral*, 345–47.

119. Saint-Denis, *Laon et le Laonnois*, 472.

120. Ibid., 353.

121. Ibid., 472. Laon, Archives départementales de l'Aisne, G 1850 (1226), fol. 138v; Paris, BnF, MS lat. 9227, fol. 8r.

122. Saint-Denis, *Laon et le Laonnois*, 353, 361.

123. Clark and King, *Laon Cathedral*, 1:23.

124. Saint-Denis, *Laon et le Laonnois*, 361–62.

125. On seriality as a characteristic of the lateral chapels of Paris Cathedral, see Doquang, "Lateral Chapels," 138.

126. For example, Viollet-le-Duc, *Dictionnaire raisonné*, 2:296–97; Davis, "Splendor and Peril," 36; Doquang, "Lateral Chapels," 148.

127. Doquang, "Lateral Chapels," 148–52. For later examples of similar processes in England, see Rosenthal, *Purchase of Paradise*.

128. Sturgis, "Liturgy," 54–55.

129. Demouy, "Franchises urbaines et liberté," 57. See also Lillich, *Gothic Stained Glass of Reims Cathedral*, 8–11; Abou-El-Haj, "Urban Setting," 20–23.

130. Lillich, *Gothic Stained Glass of Reims Cathedral*, 9.

131. Ravaux, "Campagnes de construction," 59–60; translation in Sturgis, "Liturgy," 70.

132. Ravaux, "Campagnes de construction," 59–60.

133. Doquang, "Lateral Chapels," 159 n. 80. Doquang further notes that the number of chaplains at Noyon was thirty-nine, also very similar to the number at Reims. Some institutions had more. By the fourteenth century there were one hundred chaplains at Paris Cathedral and sixty at Amiens Cathedral. On the dating of the Rouen chapels, see Doquang, "Status and the Soul," 100 n. 19.

134. Lépinois and Merlet, *Cartulaire de Notre-Dame de Chartres*, 1:lxxxvi–lxxxviii.

135. Doquang, "Status and the Soul," 101–2. Doquang identifies six such chapels. Bishop Simon Matifas de Bucy paid for the construction of three of them. Canons

Gilbert de Saana and Eudes de Sens and Cardinal Michel du Bec each financed one of the remaining three.

136. Hamann-MacLean and Schüssler, *Kathedrale von Reims*, 1:47.

CHAPTER 3

1. The chronology of Chartres Cathedral has been much debated. A sample of the relevant literature includes Lautier, "Restaurations récentes"; Tallon, "Structure de la cathédrale de Chartres"; Kurmann-Schwarz and Kurmann, *Chartres: La cathédrale*, 119–22; Prache, "Observations sur la construction"; James, *Contractors of Chartres*; Meulen, "Histoire de la construction"; Frankl, "Chronology of the Stained Glass"; Frankl, "Reconsiderations on the Chronology"; and Frankl, "Chronology of Chartres Cathedral."

2. See note 5 to chapter 1.

3. Bony, *French Gothic Architecture*, 235.

4. Sandron, "Cathedral Façade," 35.

5. The fourteenth-century choir of Verdun is an exception in that its buttresses were decorated with reused twelfth-century reliefs (now stored in the cloister), although this use as buttress decoration probably does not reflect the sculpture's original location and cannot be taken as a model for Chartres. See Müller-Dietrich, *Romanische Skulptur in Lothringen*, 54; Williamson, *Gothic Sculpture*, 72 n. 27; and Hutterer, "Lofty Sculpture," 197–98.

6. Murray, "Notre-Dame of Paris," 244–45. Kasarska, *Sculpture de la façade*, 167–69.

7. Frankl, "Chronology of Chartres Cathedral," 34; Frankl, "Reconsiderations on the Chronology," 57; Aubert, *Notre-Dame de Paris*, 85; Grodecki, "À propos de la sculpture," 125–26. Frankl, in his "Reconsiderations on the Chronology," has suggested that masons planned the niches from the outset and that the sculptures were prepared and stored until their installation in 1210–16.

8. James, "Construction Timetables."

9. Charenton-le-Pont, MAP, photothèque: photographs MH0062939, 43LE03784, MH0013718. See also Marriage and Marriage, *Sculptures of Chartres Cathedral*, 40–42. The difference in the wear among the northern sculptures may result from the incursion of water in three of the northern buttresses, noted by Boeswillwald in 1860. Paris, Archives nationales, F19 7680.

10. Bulteau, *Monographie de la cathédrale de Chartres*, 1:268–69. For documents relating to the restorations of 1865, including records of payment to Fromanger and Chenillon for their new sculptures, see Paris, Archives nationales, F19 7680, and Chartres, Archives départementales d'Eure-et-Loir, V55.

11. Frankl has suggested that the designs of the tabernacles and the niches both date to ca. 1196, whatever their date of construction. If true, the contemporaneity of their designs would lend weight to the idea that the designers intended to place sculptures within the tabernacles as well. Frankl, "Chronology of Chartres Cathedral," 34.

12. Bulteau, *Monographie de la cathédrale de Chartres*, 1:133. Bulteau's claim was repeated by numerous other scholars, including Marcel Aubert (*Sculpture française*, 85).

13. The virtues and vices quatrefoils on the west façade of Amiens Cathedral depict a total of twelve vices, so the number of niches does not necessarily preclude Bulteau's interpretation. Additionally, Bulteau (*Monographie de la cathédrale de Chartres*, 1:133) did not insist that all the subsidiary figures represented particular vices, but claimed that "souvent ces sculptures placées aux pieds des statues sont de simples jeux d'imagination comme s'en permettent souvent les artistes" (often these sculptures placed at the feet of the statues are simple fantasies like those artists often permit themselves). It seems strange, however, that the sculptures would alternately carry prescribed iconographic messages and be under the total control of the sculptors.

Aubert (*Sculpture française*, 85) implies that each of the grotesques represents an individual vice. On the use of monsters in ecclesiastical decoration, see Dale, "Monsters, Corporeal Deformities, and Phantasms," 403. Finally, each side of the nave has five buttresses, with an additional two buttresses on the western side of each transept arm. Thus, it is possible that each of the seven vices was to appear twice, once along the north side and once along the south side, although this interpretation leaves the buttressing of the choir unaccounted for and presumes that a separate visual program was imagined for the choir at a very early date.

14. Bulteau, *Monographie de la cathédrale de Chartres*, 1:133.

15. Williams, *Bread, Wine, and Money*, 32–36. On the wealth and economic influence of the canons in the thirteenth century and construction of the cathedral, see Chédeville, *Chartres et ses campagnes*, 491–91, 509–19. In contradistinction to the rising prosperity of the canons, the bishops received a more or less fixed income. Luchaire, *Social France*, 156. Gautier's significant personal debt further underscores the disparity between the financial means of the two parties. Lépinois and Merlet, *Cartulaire de Notre-Dame de Chartres*, 2:127–29 (no. 278, 1234).

16. Williams, *Bread, Wine, and Money*, 35–36.

17. Molinier and Longnon, *Obituaires de la province de Sens*.

18. Chartres, Bibliothèque municipale, MS 1058, ca. 1230, published as Delaporte, *Ordinaire chartrain*. Several canonized bishops of Chartres had feast days celebrated in the town. For example, Saint Solennis's feast was celebrated September 24, Saint Caletric's on October 7, and Saint Anianus's on December 7.

19. French and O'Connor, *York Minster*, 15.

20. Grodecki, Brisac, and Lautier, *Vitrail roman*, 138; Caviness, *Sumptuous Arts*, 59.

21. Jerome, *Commentariorum in Epistolam ad Ephesios*, cols. 475B–477A.

22. Hugh of Saint-Victor, *De sacramentis Christiane fidei*, II:2:ii and II:5:i. English translation in Hugh of Saint-Victor, *Sacraments of the Christian Faith*, 255 and 279.

23. Hugh of Saint-Victor, *De sacramentis Christiane fidei*, II:5:i. English translation from Hugh of Saint-Victor, *Sacraments of the Christian Faith*, 279.

24. Iogna-Prat, *Order and Exclusion*, 162.

25. Whitehead, *Castles of the Mind*, 55. See also Whitehead, "Symbolic Translation."

26. "Columnae, quae domum fulciunt, sunt episcopi, qui machinam Ecclesiae vitae rectitudine in alta suspendunt. *Trabes,* quae domum conjungunt, sunt saeculi principes, qui ecclesiam continendo muniunt. *Tegulae* tecti, quae imbrem a domo repellunt, sunt milites, qui Ecclesiam a paganis et hostibus protegunt." Honorius of Autun, *Gemma animae*, col. 586B.

27. Honorius of Autun, *Expositio in Cantica canticorum*, col. 407D.

28. "Secundum hanc igitur significationem, haec ecclesia ex lignis, lapidibusque constructa, eam Ecclesiam designat, quae ex vivis lapidibus aedificatur; cujus lapides non calce, sed charitate junguntur et uniuntur; cujus fundamentum Christus est; cujus portae apostoli sunt; cujus columnae episcopi sunt et doctores, in quo unusquisque lapis tanto amplius rutilat, quanto fidelior et melior est." Bruno Astensis, *De sacramentis ecclesiae*, col. 1092B. My translation alters the structure of the final clauses so as to maintain the agreement of *quo* with *ecclesia*.

29. For English translations of the latter, see Durand, *Rationale* (2007), and Durand, *On the Clergy and Their Vestments*.

30. Masini, "'Magister' Johannes Beleth"; Oury, "Jean Beleth," col. 286.

31. Whitehead, *Castles of the Mind*, 51.

32. Durand, Rationale (2007), 14.

33. Ibid., 19.

34. Pierre de Roissy writes that "the columns of the building represent the doctors of the church; the towers, the prelates and preachers." Kennedy, "Handbook of Master Peter," 7. See also Mortet and Deschamps, *Recueil de textes*, 2:186.

35. Christiania Whitehead (*Castles of the Mind*, 56) argues that the twelfth- and thirteenth-century liturgical handbooks differ from earlier ecclesiological exegeses of the temple and tabernacle by relating sacred architecture to the laity instead of to the ecclesiastical hierarchy. While the authors do integrate the laity as she suggests, they continue to refer to ecclesiastical roles as well.

36. There are a few such manuals from the late eleventh and early twelfth centuries as well as less allegorical liturgical expositions from the Carolingian era and earlier—for example, Amalarius of Metz, *De ecclesiasticis officiis libri quatuor*. In addition, the genre did not die out in the late thirteenth and fourteenth centuries, although few new treatises were composed during this period. Macy, "Commentaries on the Mass," 25; Whitehead, *Castles of the Mind*, 51.

37. Beleth, *Summa de ecclesiasticis officiis*, 1:33; Durand, *On the Clergy and Their Vestments*, xxii. On vernacular translations of Durand's *Rationale*, see Ménard, "William Durand's *Rationale divinorum officiorum*."

38. In addition to the approximately 120 known manuscripts of Beleth's *Summa*, there are at least 60 of the liturgical commentary of Richardus Praemonstratensis and 194 of that of Lotario dei Conti di Segni. D. F. Wright, "Medieval Commentary on the Mass," 56; Macy, "Commentaries on the Mass," 27.

39. On Durand as a canon of Chartres, see Fassler, "Liturgy and Sacred History," 502.

40. Oury, "Jean Beleth," col. 286.

41. Ibid.

42. It is possible that Beleth wrote *Summa* for his students at the university. Maurel, "Jean Beleth et la 'Summa.'" The observation that liturgical manuals influenced vernacular literature was made as early as the mid-nineteenth century. See Hill, *Ancient Poem of Guillaume de Guileville*, 25. In the first lines of book 1 Guillaume specifically addresses his *Le pèlerinage de la vie humaine* to "men and women, rich and poor, wise

and foolish, kings and queens." Guillaume de Deguileville, *Pilgrimage of Human Life*, 3.

43. Guillaume de Deguileville, *Pilgrimage of Human Life*, 172.

44. Collomb, "Éléments liturgiques."

45. On the connection between medieval scholasticism and artistic practice, see Semper, *Stil in den technischen und tektonischen Künsten*, xx; Dehio and Bezold, *Kirchliche Baukunst des Abendlandes*, 2:15; Panofsky, *Gothic Architecture and Scholasticism*; Mâle, *Art religieux*, 75–93; Katzenellenbogen, *Sculptural Programs of Chartres Cathedral*; Holly, *Panofsky and the Foundations of Art History*; Radding and Clark, *Medieval Architecture, Medieval Learning*; and Liefferinge, "Hemicycle of Notre-Dame of Paris." For historiography on Gothic architecture and scholasticism, see Frankl, *Gothic Architecture*, 295–97, and Inglis, "Gothic Architecture and a Scholastic," 73–74.

46. Abbot Suger, *Abbey Church of St.-Denis*, 105.

47. For a discussion of apostles and columns in medieval churches, see Onians, *Bearers of Meaning*, 74–90.

48. Low, "Enlivening Scripture." On this theme see also Thunø, "'Living Stones' of Jerusalem," 228–30; Thunø, *Image and Relic*, 65–70; Kessler and Zacharias, *Rome 1300*, 114; Deshman, "Imagery of the Living Ecclesia"; Tallon, "Architecture of Perfection."

49. John James's analysis of the construction timetables at Reims suggests that the upper walls of the radiating chapels were completed around 1222, placing these sculptures about a decade after those in the buttress uprights at Chartres. James, "Construction Timetables," 15.

50. For a summary of the restoration history of these sculptures, see Caillet, "Typologie des contreforts gothiques," 59–63. Some of the original angels from the aediculae in the buttress uprights are now on view at the Palais du Tau.

51. Sauerländer, *Gothic Sculpture in France*, 485.

52. Kasarska, *Sculpture de la façade*, 167–69.

53. The kings appear in aediculae set into large buttresses that do not support flyers.

54. Bréhier, *Cathédrale de Reims*, 111–12; Frisch, "Twelve Choir Statues"; Hinkle, *Portal of the Saints*, 50–52; Hamann-MacLean, "Kathedrale von Reims: Bildwelt und Stilbildung"; Demouy, *Notre-Dame de Reims*, 80; Demouy, *Reims: La cathédrale*, 212–14; Sadler, *Reverse Façade*, 37–39; Clark, "Reading Reims, I"; Clark, "Teachers, Preachers, and the Good Shepherd"; Clark, "Christ et les anges."

55. Peter Kurmann has argued that all thirty-three angels represent the guardians of Heavenly Jerusalem. Kurmann, "Couronnement de la Vierge," 97–98.

56. For identification of the lower angels' attributes, see Clark, "Reading Reims, I," 137. It is possible that the crown might be connected to Heavenly Jerusalem, as are the objects held by the angels in the spandrels of the blind arcade at the Sainte-Chapelle, although in the palace chapel the angels do not cover their hands.

57. On entrance ceremonies, see Fassler, "Liturgy and Sacred History."

58. On consecration rites, see Iogna-Prat, *Maison Dieu*, and Dalmais, *Principles of the Liturgy*.

59. Clark, "Reading Reims, I," 140–41; Sadler, *Reverse Façade*, 38. Clark also points to a possible relationship between the buttress figures and the miraculous consecration of Saint-Denis by Christ.

60. See Clark, "Teachers, Preachers, and the Good Shepherd," 163.

61. Bréhier, *Cathédrale de Reims*, 111–12.

62. William Clark ("Reading Reims, I," 137) notes that the sun and the moon are not among the attributes of the sculptures on the buttresses of the radiating chapels, but he makes no comment about their presence among the tabernacle angels.

63. Kurmann and Kurmann-Schwarz, "Sculpture," 216; Clark, "Teachers, Preachers, and the Good Shepherd," 163; Clark, "Reading Reims, I," 139; Sauerländer,

"Integrated Fragments," 157; Hamann-MacLean, "Kathedrale von Reims: Bildwelt und Stilbildung," 44; Demouy, *Notre-Dame de Reims*, 44, 80, 95; Demouy, *Reims: La cathédrale*, 212–14; Sauerländer, "Cathédrale de Reims," 12–16. Patrick Demouy sees the two programs as related through the image of Heavenly Jerusalem, but he does not explicitly extend the idea of procession to the upper angels, which he views as protectors. Peter Kurmann offers an alternative hypothesis in which both levels of angels represent a heavenly guard.

64. Manuscript illustrations of the Heavenly Jerusalem demonstrate that the number of gates varied, although twelve is by far the most common. For example, Moralized Bible MS M. 240, fol. 5v, depicts the celestial city with six gates, and the *Apocalypse* of Margaret of York (MS M. 484), fol. 113r, shows the city with thirteen gates. Both manuscripts are in the collection of the Morgan Library & Museum, New York.

65. Clark, "Reading Reims, I," 139.

66. "Moreover, while there might be several columns in the church, nonetheless we say there are seven, according to what is written: *Wisdom has built herself a house; she has hewn seven column* [Prov. 91]; and, since the bishops ought to be filled with the sevenfold grace of the Holy Spirit, James and John, as the Apostle says, were seen as columns." Durand, *Rationale divinorum officiorum*, I:I:1:xxvii. Translation from Durand, *Rationale* (2007), 19.

67. The literature on this topic is extensive. See, for example, Murray, *Cathedral of Amiens*, 42–43; Davis and Neagley, "Mechanics and Meaning"; and Hiscock, *Symbol at Your Door*.

68. Cf. the representation of sixteen apostles in the clerestory hemicycle at Saint-Père (now Saint-Pierre) in Chartres. Lillich, *Gothic Stained Glass of Reims Cathedral*, 95–98.

69. For identification of objects, see the notes on Foto Marburg photograph LA 783/11, www.bildindex.de/document /obj20794078. On the symbolism and

history of the instruments of the Passion, see Schiller, *Iconography of Christian Art*, 2:184–98.

70. For example, the chalice appears among the instruments of the Passion in the Hours of the Life of Saint Marguerite (Troyes, Bibliothèque municipale, MS 1905, fol. 207v) and in the initial *D* in a book of hours of about 1470 (Morgan Library & Museum, MS 152, fol. 12r). See also Schiller, *Iconography of Christian Art*, 2:188.

71. Peter Kurmann and Brigitte Kurmann-Schwarz ("Sculpture," 213) have identified the "moon" as a sundial.

72. "And it was almost the sixth hour; and there was darkness over all the earth until the ninth hour. And the sun was darkened, and the veil of the temple was rent in the midst."

73. Schiller, *Iconography of Christian Art*, 2:109.

74. This motif dates back at least to the sixth century, as documented by the apse mosaic of the church of San Michele in Africisco in Ravenna, dated 545/46, now part of the Skulpturensammlung und Museum für Byzantinische Kunst of the Staatliche Museen zu Berlin. Ibid., 186.

75. An example is Morgan Library & Museum, MS M. 1038, fol. 1v, *Pèlerinage de la vie humaine* (second quarter of fourteenth century), where the guardian angel wields a sword.

76. On Saint-Quentin, see Héliot, *Saint-Quentin*, and Shortell, "Choir of Saint-Quentin."

77. Durand, *Rationale* (2007), 61.

78. Honorius of Autun, *Gemma animae*, col. 590D.

79. Shortell, "Dismembering Saint Quentin," 37.

80. On the relationship of the Saint-Quentin choir to other high Gothic churches, see Héliot, *Saint-Quentin*, 58–62, and Shortell, "Choir of Saint-Quentin," 175–235.

81. Richard Hamann-MacLean has argued that the Villard drawing represents an earlier design of the nave elevation. In

contrast, William Clark suggests that the drawing represents Villard's impression of the building, adjusted from reality according to his experience and interests. Hamann-MacLean and Schüssler, *Kathedrale von Reims*, 1:1, 146–77; Clark, "Reims Cathedral in the Portfolio," 30.

82. Some scholars have attributed the choir of Saint-Quentin to Villard. Bénard, *Collégiale de Saint-Quentin*, 1–18; Hahnloser, *Villard de Honnecourt*, 73–76, 234–37. More-recent scholarship suggests that Villard was not a practicing architect but rather an architecture enthusiast. See Ackerman, "Villard de Honnecourt's Drawings," 42; Barnes, "Villard de Honnecourt"; Bechmann, "Villard de Honnecourt"; Branner, "Villard de Honnecourt"; and Clark, "Reims Cathedral in the Portfolio," 50.

83. Charenton-le-Pont, MAP, Plans d'édifice de l'Ainse, Saint-Quentin, Louis-François Bruyerre, vue de la partie haute du chevet.

84. In his nineteenth-century description Ferdinand Guilhermy identified each of the figures as an angel. Paris, BnF, MS nouv. acq. fr. 6108, Papiers archéologiques du baron de Guilhermy, Notes sur diverses localités de la France, fol. 313r.

85. Examples of the depiction of monks with instruments include images of Anthony Abbot the Great, whose attributes include bells, and marginal images depicting monks that generally invert social norms and are thus very different from the monumental sculpture of the Saint-Quentin chevet.

86. Wingless musician angels appear, for example, in Stockholm Nationalmuseum, MS B2286 (1290–99), col. 42v; the Death of the Virgin Triptych housed at the Bibliothèque de la Ville in Amiens (1315–30); and Morgan Library & Museum, MS M. 1000 (ca. 1420), fol. 148v, and Hours of Claude Molé, MS M. 356 (ca. 1500), fol. 64v. Earlier examples of wingless angels (not carrying instruments) include two on the tympanum of the main portal of the church of Montceaux-l'Étoile (dated to the twelfth

century) and a statue currently housed at the Victoria and Albert Museum in London, A.20-1929 (second half of the twelfth century).

87. De La Fons, *Extraits originaux*, 1:44. "À l'entour du chœur, en-dehors, au-dessous de l'entablement qui fait cette galerie, sont de grandes figures d'anges et d'autres choses semblables." La Fons's description is at odds with that of Guilhermy, who states that all six figures are angels, although he, noting that the sculptures were missing their arms, presumably viewed them in a worse state of repair. Paris, BnF, MS nouv. acq. fr. 6108, fol. 313r.

88. Huck, "Music of the Angels."

89. Hammerstein, *Musik der Engel*, 203–4; 193–257 for images of musical angels more generally.

90. "Cil jugleor la ou il vunt, / Tuit lor vieles traites unt: / Laiz et sonnez vunt vielant. / . . . / Cors et boisines et fresteals, / Et fleütes et chalemeals." Guillaume de Saint-Pair, *Roman du Mont Saint-Michel*, lines 767–69, 781–82.

91. Labande, "Pèlerinages au Mont Saint-Michel," 242.

92. M. Harris, *Sacred Folly*, 117–18, 161–62. For alternate interpretations, see Fassler, "Feast of Fools," 96 and C. M. Wright, *Music and Ceremony*, 34.

93. Paris, BnF, Collection Picardie 14, fol. 79r. I thank Ellen Shortell for making me aware of this source.

94. New York, Morgan Library & Museum, MS M. 638, fol. 39v.

95. Los Angeles, J. Paul Getty Center, MS 101, fol. 14r.

96. Paris, BnF, Département des manuscrits, MS lat. 757, fol. 147r.

97. Comparable examples that show a contemporary procession with musicians are the scene of the translation of relics on the tomb of Peter Martyr in the church of S. Eustorgio, Milan, 1339, and the procession of Charles VIII of France in the Cronaca della Napoli Aragonese, New York, Morgan Library & Museum, MS M. 801, fol. 113r.

98. Froissart, *Oeuvres de Froissart*, 14:9. Translation from Froissart and Brereton, *Chronicles*, 353. On the distinction between the use of instruments in liturgical drama and their use in open-air mystery plays, see Smoldon, "Medieval Church Drama."

99. Winternitz, "On Angel Concerts," 458.

100. Durand, *Rationale* (2007), 11. See also Beleth, *Summa de ecclesiasticis officiis*, 2:103b.

101. Caviness, *Sumptuous Arts*, 58–64.

102. Grodecki, Brisac, and Lautier, *Vitrail roman*, 228.

103. Caviness, *Sumptuous Arts*, 64.

104. Meredith Lillich argues that the axial window (bay 100) dates to 1227–31, that the program for the rest of the hemicycle dates to after 1231 and Henri de Braine's first provincial council, and that the straight bays of the choir were completed after 1237. This dating of the windows does not necessarily accord with the various chronologies proposed for the architecture. Lillich, *Gothic Stained Glass of Reims Cathedral*, 61–103. For a sampling of proposed architectural chronologies, see Kurmann, *Façade de la cathédrale de Reims*, 1:65–68; Ravaux, "Campagnes de construction," 8–9, 59 n. 16; and Kimpel and Suckale, *Architecture gothique en France*, 288–90.

105. Branner, "Historical Aspects," 26 n. 15; Lillich, *Gothic Stained Glass of Reims Cathedral*, 68; Clark, "Teachers, Preachers, and the Good Shepherd," 156.

106. Lillich, *Gothic Stained Glass of Reims Cathedral*, 68.

107. Kurmann, "Architecture, vitrail et orfèvrerie."

108. The "façade" of Amiens (bay 105) is labeled and is paired in the neighboring lancet with a representation of the bishop of Senlis. Bay 107 depicts the bishop of Thérouanne and an unlabeled façade, probably Arras. Bay 106 depicts the "façade" of Tournai and an unlabeled bishop, probably the bishop of Cambrai. See Lillich, *Gothic Stained Glass of Reims Cathedral*, 69.

109. On the dating of the clerestory lancets, see ibid., 61–67.

110. Ibid., 73. Lillich further states that the fact that six angels blow trumpets signals the particular idea of the avenging angels mentioned in Revelation 8, 9, and 11. However, she earlier argues for flexibility in terms of numbers, especially with regard to the number of apostles represented in the choir, where they number twenty instead of twelve. It seems strange that the number of trumpets would have to be so precise when the number of apostles was clearly not rigidly fixed.

111. Ibid., 66.

112. See note 63 above.

113. Raguin, *Stained Glass*, 68, 86; Raguin, "Visual Designer," 30–39. This pattern of placing large-scale figures in the clerestory and narrative images in the chapels and aisles occurred as early as Canterbury Cathedral.

114. Clark, "Reims Cathedral in the Portfolio," 30 n. 14. The upper angel sculptures stand approximately 3.25 meters and the lower figures approximately 2.5 meters.

115. Kemp, *Narratives of Gothic Stained Glass*; Jordan, *Visualizing Kingship*, 17–24. Jordan identifies this practice with the concept of *amplificatio* (amplification) as practiced by authors like Matthew of Vendôme, Geoffrey of Vinsauf, and John of Garland.

116. Clark, "Teachers, Preachers, and the Good Shepherd," 156.

117. See, for example, Callet et al., "Natural Lighting"; Chataignère, "Étude technique de la polychromie"; Katz, "Architectural Polychromy"; Verret and Steyaert, *Couleur et la pierre*; and Weeks, "'Portail de la Mere Dieu.'"

118. Cerf, *Notre-Dame de Reims*, 86; Moreau-Nélaton, *Cathédrale de Reims*, 99.

119. Only four statues survived the late fourteenth-century Rayonnant modifications.

120. Kurmann, "'Et angeli tui custodiant muros eius,'" 115–16.

121. The Rouen figures were added in the thirteenth century, at the same time as the nave chapels. Schlicht, *Cathédrale de Rouen vers 1300*, 341–45.

122. Ibid., 341.

123. Murray, *Beauvais Cathedral*, 58; Cothren, *Picturing the Celestial City*, 111 and 233 n. 65, citing A. P. M. Gilbert, *Notice historique et descriptive de l'église cathédrale de Saint-Pierre de Beauvais* (Beauvais: Moisant et Dupont-Diot, 1829), 9, and Gustave Desjardins, *Histoire de la cathédrale de Beauvais* (Beauvais: V. Pineau, 1865), 6.

124. Cothren, *Picturing the Celestial City*, 111–12.

125. The nested V-folds of the surviving fragments, now in the *dépôt lapidaire* at Bayeux, suggest a thirteenth-century date. Thirion, "Cathédrale de Bayeux," 274.

126. In many cases the restorers reconstructed the damaged sculptures with plaster additions and used the resulting composite figures as models for new stone copies.

127. Victor Ruprich-Robert mentioned the sculptures in a report of 1849, stating that "les contreforts dans les pinnacles, et les murs au droit des arcs-boutants étaient ornée des statues de grandeur naturelle qu'ont disparu presqu'entièrement, dans le chevet il on rest encore quelques unes admirablement sculpté et d'autant plus précieuses qu'elles sont devenues rares." Paris, Archives nationales, F 19 7628. The restoration of the chevet came only several decades after this report. A "Devis estimatif des travaux" (estimate of work) for 1893 notes the restoration of the sculptures of the eighth and ninth buttress piers of the north side of the chevet, including the replacement of their heads, carried out by J. A. Corbel. Paris, Archives nationales, F 19 7631.

128. One of the figures holds a scroll and might be a prophet, although it is worth noting that one of the angels at Reims also holds a scroll, as do the angels on the buttress piers of Rouen. In the absence of other prophet figures, I am hesitant to confirm this identification. Thirion, "Cathédrale de Bayeux," 272.

129. The galero has been in use for more than a thousand years. Although typically associated today with cardinals, other members of the ecclesiastical hierarchy, including priests and prelates, may use this type of headgear in colors appropriate to their rank. Pope Innocent IV first granted cardinals the red galero at the First Council of Lyons, in 1245. Noonan, *Church Visible*, 191.

130. Bayeux, Musée d'art et d'histoire Baron Gérard, Inv. no. A0772.

131. Nicholas Marie Joseph Chapuy, *Vue extérieure de la cathédrale*, engraving, Paris, BnF, Estampes, VA-14, tome 1a, in microfilm H113603; Charenton-le-Pont, MAP, photograph 3033, anonymous, chevet of Bayeux Cathedral, ca. 1880.

132. Pierre Audigier, *Histoire de la ville de Clermont en Auvergne*, Paris, BnF, Département des manuscrits, Fonds français, MS 11485, fol. 108v. Audigier relates that the flyers "des arcs-boutants qui repoussent les voûtes travaillees avec beaucoup de soin surtout aux extremites où ils presentent des niches dans lesquelles on a placé la statue du saint auquel est dediée la chapelle qui est au dessous." My thanks to Michael Davis for alerting me to this source.

133. Benoist, *Notre-Dame de l'Épine*, 63. L'Épine and Reims Cathedral have many similarities, and the placement of the sculptures on the lower portion of the buttress piers of the radiating chapels at L'Épine may look back to the lower level of sculptures on the Reims chevet. In several cases nineteenth-century sculptures fill buttress niches, like those in the fifteenth-century buttresses along the south side of the nave of Notre-Dame in Louviers. Verdier, "Église paroissiale Notre-Dame de Louviers," 26.

134. The consecration procession is one among many interpretations offered for the lower Reims sculptures. See Clark, "Reading Reims, I," 139; Clark, "Teachers, Preachers, and the Good Shepherd," 156.

135. On the development of the medieval idea of sacred space, see Iogna-Prat, *Order and Exclusion*, 164–81.

136. Ibid., 164–65.

137. Honorius of Autun, "De certo loco et sacrificio," in *Gemma animae*, col. 596B.

138. Durand, *On the Clergy and Their Vestments*, 63.

139. Beleth, *Summa de ecclesiasticis officiis*, 2:5–7, chap. 2, sects. c and g.

140. Pierre de Roissy and Honorius of Autun divide the church into only two sections, chancel and nave. The bipartite division probably indicates that Pierre was using a Romanesque basilica as his model, unlike many of his contemporaries, who used the Gothic cathedral. Nevertheless, the division has a significant history in the mapping of sanctity. See also Hayes, *Body and Sacred Place*, 52, and Iogna-Prat, *Order and Exclusion*, 162–64.

141. Sicard of Cremona, *Mitralis de officiis*, 1:4:269–73; Durand, *Rationale divinorum officiorum*, 57.

142. On Durand's sources, see Thibodeau, "Sources du *Rationale*," and Durand, *Rationale divinorum officiorum*, xviii–xxii.

143. Thibodeau, "Influence of Canon Law."

144. One of the best sources on Sicard's work and life remains Brocchieri, "Sicardo di Cremona."

145. On the reform movement, see Constable, *Reformation of the Twelfth Century*.

146. Elliott, *Fallen Bodies*. See also the work of Uta-Renate Blumenthal and H. E. J. Cowdrey.

147. Beaudette, "Clerical Celibacy," 23–24.

148. See, for example, Parker, "Architecture as Liturgical Setting," and Hamilton and Spicer, "Defining the Holy," 14–15. On choir screens, Jung, *Gothic Screen*, 71–103; Jung, "Beyond the Barrier," 626–27; Chédozeau, *Chœur clos, chœur ouvert*, 16–24; and Brooke, "Religious Sentiment and Church Design," 166. Erlande-Brandenburg, *Cathedral*, 323, links the increasing "fortification" of cathedral precincts to growing civil unrest and to conflicts between the clerics and their towns.

149. Barnwell, "Laity, the Clergy, and the Divine Presence," 52–57.

150. For example, Gillerman, *Clôture*, 158.

151. Arnheim, *Dynamics of Architectural Form*, 228.

152. Josephus, *AJ* 8:10.

153. Etlin, "On the Symbolism of Rib Vaults." Etlin presented a version of this paper at the symposium "Épures d'histoire, un processus pragmatique: Perspectives pour l'histoire de l'architecture et de la construction en hommage à Joël Sakarovitch," Colloque international avec le soutien de l'Académie de l'architecture, du Centre Alexandre Koyré, du Centre de théorie et analyse du droit, du Centre Jean Pépin et du Laboratoire de médiévistique occidentale de Paris, Académie d'architecture, Place des Vosges, October 13–14, 2015. On biblical symbolism in Old Saint Peters, see Bannister, "Constantinian Basilica of Saint Peter at Rome."

CHAPTER 4

1. On Narbonne Cathedral, see Freigang, *Imitare ecclesias nobiles*; Paul, "Projecting Triforium at Narbonne"; and Nichols, Paul, and Nichols, "Vaulting of Narbonne Cathedral."

2. Sigal, "Histoire de la cathédrale Saint-Just," 51: "in faciendo, imitare ecclesias nobiles et magnifice operatas et opera ecclesiarum que in regno Francie construuntur et sunt in preterito jam constructe." Translation from Paul, "Projecting Triforium at Narbonne," 27. Paul (38, n.8) points out that this remark has often been misattributed to Clement IV. On the significance of the use of a northern French design in Narbonne, see Freigang, *Imitare ecclesias nobiles*, 239–96; Kurmann, "Late Gothic Architecture," 162; and Love, "Creation of the Bastides," 84–87.

3. Some churches in the Languedoc use buttresses with arrow slits. The crenellated balustrades linking buttress piers are unique, as far as I am aware.

4. Krautheimer, "Introduction to an 'Iconography.'"

5. Several scholars have noted the artificiality of this partition, yet it persists. See, for example, Bonde, *Fortress-Churches of Languedoc*, 1, and Coulson, *Castles in Medieval Society*, 153. In ibid., 153 n. 238, Coulson notes a handful of studies that address both ecclesiastical and military architecture, to which could be added Stalley, *Early Medieval Architecture*.

6. Bonde, "Castle and Church Building," 84–93.

7. Gardner, "Influence of Castle Building," 104.

8. Ibid., 114.

9. Worssam and Ashbee, "Building Stones of Rochester."

10. See, for example, Saint-Paul, "Transition," 476, and Lefèvre-Pontalis, "Origine des arcs-boutants," 367.

11. On the symbolism of Narbonne's fortifications, see also Love, "Creation of the Bastides," 174–75.

12. Dittmar and Ravaux, "Significations et valeur," 59–64.

13. The stones used to build a church remained sacred and could not be repurposed for use in a secular building. Hayes, *Body and Sacred Place*, 44 n. 58.

14. Caesarius of Heisterbach, *Dialogue on Miracles*, 1:355.

15. Ibid., 355–64.

16. Cothren, "Iconography of Theophilus Windows," 327.

17. Durand, *Rationale* (2007), 60–63.

18. Iogna-Prat, *Maison Dieu*, 482.

19. Durand, *Rationale* (2007), 63.

20. Caesarius of Heisterbach, *Dialogue on Miracles*, 1:331.

21. Jacobus de Voragine, *Golden Legend*, 2:391.

22. Ibid., 1:392.

23. Caesarius of Heisterbach, *Dialogue on Miracles*, 1:333. As an example of an image in which a demoniac is exorcised, see roundel 10 (Guthlac heals a demoniac) from *The Guthlac Roll* (1175–1215), London, British Library and Museum, Harley Roll Y 6.

24. Durand, *Rationale* (2007), 62.

25. Jacobus de Voragine, *Golden Legend*, 2:387. Durand similarly writes, "Finally, it should be noted that those fleeing from bloody crimes to a consecrated church—so long as they did not commit them inside or outside the church—are defended by it, lest a life or limb be lost. As so we read that Joab fled into the Tabernacle and was seized at the corner of the altar. The same privilege applies in an unconsecrated church in which the Divine Offices are celebrated." Durand, *Rationale* (2007), 24.

26. Durand, *Rationale* (2007), 54. Cf. Richter and Friedberg, *Corpus iuris canonici*, 1:816.

27. Durand, *Rationale* (2007), 55. See also Hayes, *Body and Sacred Place*, 17.

28. Grim, "Murder of Thomas Becket"; Guernes de Pont-Maxence, *Garnier's Becket*, 144–45.

29. Guernes de Pont-Maxence, *Garnier's Becket*, 147.

30. Ibid., 146.

31. Hayes, *Body and Sacred Place*, 21.

32. Ibid., 207.

33. Duggan, "John of Salisbury and Thomas Becket," 428; Staunton, *Thomas Becket and His Biographers*, 4–5.

34. Hayes, *Body and Sacred Place*, 216.

35. On the Peace of God, see Head and Landes, *Peace of God*.

36. Duby, *Three Orders*, 155–57.

37. For example, the powerful Benedictine monastery of Cluny, a reform community itself, promoted the Peace of God and the Truce of God among the feudatories of France to remove from the laity the potential for sin through violence, theft, and oppression of the poor. Cowdrey, *Cluniacs and the Gregorian Reform*, 135, 183–84.

38. Guernes de Pont-Maxence, *Garnier's Becket*, 149.

39. For example, Jantzen, *High Gothic*, 76; Bony, *French Gothic Architecture*, 166–68.

40. Bonde, "Castle and Church Building," 80; Gardner, "Influence of Castle Building," 109.

41. Gardner, "Influence of Castle Building," 104–14.

42. Crosby, *Royal Abbey of Saint-Denis*, 179–213.

43. Saint-Paul, "Notre-Dame d'Étampes," 216; Thompson, "Adaptation and Audience," 62; Baillieul, "Notre-Dame d'Étampes," 1:77; Lefèvre-Pontalis, "Notre-Dame d'Étampes," 29.

44. Bonde, *Fortress-Churches of Languedoc*, 160–72.

45. N. Wright, *Knights and Peasants*, 102–16.

46. Bonde, *Fortress-Churches of Languedoc*, 54–56.

47. Cartulaire de l'évêché d'Agde, Paris, BnF, MS lat. 9999, no. 3, transcribed and translated in ibid., app. 24.

48. Jean de Venette, *Chonicle*, 99–100.

49. Gauléjac, "Sainte-Radegonde."

50. Luchaire, *Social France*, 239.

51. N. Wright, *Knights and Peasants*, 112.

52. Jean de Venette, *Chonicle*, 100.

53. Froissart, *Chroniques*, 12:321–22.

54. Abbot Suger, *Abbey Church of St.-Denis*, 47.

55. On the defensibility of Suger's west façade, see Crosby, *Royal Abbey of Saint-Denis*, 201, 282; Simson, *Gothic Cathedral*, 108–10; and Gardner, "Influence of Castle Building," 113.

56. On Suger's architectural knowledge, see, for example, Kidson, "Panofsky, Suger, and St. Denis," 1-2.

57. Williams, *Bread, Wine, and Money*, 28–29; Lecocq, "Historique du cloître," 131; Lépinois and Merlet, *Cartulaire de Notre-Dame de Chartres*, 2:165–66 (no. 324, 1257). Williams has also argued that Chartres Cathedral was designed with a system of elevated passageways intended for defense. On these passageways, see also James, *Contractors of Chartres*, 1:202–7; Meulen, "Angrenzende Bauwerke der Kathedrale von Chartres"; and Hayes, *Body and Sacred Place*, 28.

58. "Concesserunt quod ipsi in clausura seu firmatura claustri sui Carnotensis, sive in portis et portallis ejusdem claustri, in quibus clausura et portis seu portallis querenellos altitudinis moderate facient seu

facere porerunt, turres aliquas seu archerias vel balisterias, non facient nec facere porterunt, nec aliquod aliud quod as forteliciam se extendat." Lecocq, "Historique du cloître," 131 n. 2, citing Lépinois, *Histoire de Chartres*, 1:142.

59. Freigang, *Imitare ecclesias nobiles*, 372–73, giving partial transcription of the *Procedure des Consuls contre le chapitre St. Just*, fols. 82r–84v.

60. "R(esp)u(n)det q(uod) om(n)ia pilaria que pars c(ontra)ria apellat turres et om(n)ia alia op(er)a et hedifficia que sunt supra eccl(es)iam facta fuerunt et sunt necessaria ad sustinendum testudinem dicti capit(is)." Ibid., 372–73.

61. Héliot, *Saint-Quentin*, 66.

62. Nichols, Paul, and Nichols, "Vaulting of Narbonne Cathedral."

63. Freigang, *Imitare ecclesias nobiles*, 373: "supra dicta pilaria melleti seu crenelli non sunt ad pugnandum vel inpugnandum facti v(e)l apti sed solum facti fuerunt ad decorem et pulc(ri)tudinem op(er)is eccl(es)ie sup(ra) dicte."

64. Coulson, *Castles in Medieval Society*, 77, 205–11. See also the *Castle Studies Group Journal*, vols. 20–23, which include several articles debating the interpretation and significance of licenses to crenellate.

65. Crosby, *Royal Abbey of Saint-Denis*, 201.

66. Paul, "Projecting Triforium at Narbonne," 35–36.

67. Love, "Creation of the Bastides," 174.

68. Just such a connection between crenellations on churches and Heavenly Jerusalem appears in Kurmann, "Couronnement de la Vierge," 97–98. See also Crosby, *Royal Abbey of Saint-Denis*, 282.

69. The literature on Heavenly Jerusalem and the Temple of Solomon as inspirations for church architecture is extensive. As a sample, see Davis and Neagley, "Mechanics and Meaning"; Hiscock, *Symbol at Your Door*, 191–98; Gutmann, *Temple of Solomon*; and Šedinová, "Precious Stones of Heavenly Jeruslaem." For a contrasting view, see

Schlink, "Gothic Cathedral as Heavenly Jerusalem."

70. Murray, *Cathedral of Amiens*, 42–43.

71. Durand, *Rationale* (2007), 13.

72. Gardner, "Influence of Castle Building," 105–9.

73. Chatelain, "Châteaux de Philippe Auguste," 139.

74. Baldwin, *Masters, Princes, and Merchants*, 2:48 n. 25.

75. I would like to thank Jonathan Newman for helping me to understand Peter's use of this term.

76. Mantello and Rigg, *Medieval Latin*, 436; Grant, "Naming of Parts," 51–52. Cf. Barnes, *Portfolio of Villard de Honnecourt*, 19.

77. Murray, *Plotting Gothic*, 38–39. On the dating of the inscription, see Barnes, *Portfolio of Villard de Honnecourt*, 12.

78. See note 64 to the introduction.

79. Baldwin, *Masters, Princes, and Merchants*, 1:68.

80. Baldwin has suggested that since Notre-Dame's towers postdated Peter's death, he was specifically referring to those towers used on Romanesque structures. Since his criticism seems particularly attuned to the increased size of late twelfth-century buildings, he is more likely responding to the projecting buttress uprights of the new structural system. Ibid.

81. Neckam, *De naturis rerum*, 34, 281–83, 351.

82. Neckam studied in Paris from about 1175 to 1182. Zahora, *Tropological Universe of Alexander Neckam*, 21.

83. Sigal, "Histoire de la cathédrale Saint-Just," 52–53.

84. Emden, "Representations of City and Other Walls."

85. Translation from ibid., 558. Salverda de Grave, *Eneas: Roman du XIIᵉ siècle*, 1:407–47.

86. Emden, "Representations of City and Other Walls," 558.

87. Prigent, "Evolution de la construction médiévale," 22–28.

88. Fitchen, *Construction of Gothic Cathedrals*, 63–66.

89. Jean Mesqui reports that the heights of stones in Philip's fortifications in Paris range between 0.25 and 0.40 meters, a range that signifies a royal workshop. Maurice Berry adds to this that the mortar joints are extremely thin and perfectly horizontal except for a small portion of the wall where they follow the curvature of the terrain. Mesqui, "Construire une enceinte urbaine," 76–78; M. Berry, "Connaissance du mur," 128. See also Cohen, *Sainte-Chapelle*, 20.

90. Vergnolle, "Pierre de taille dans l'architecture religieuse," 231.

91. Emden, "Representations of City and Other Walls," 558.

92. Another particularly evocative example comes from the Middle English *Sir Orfeo* (ca. 1300), which in lines 353–63 describes a wondrously high castle with one hundred towers, golden buttresses, and beasts carved onto its façade. On this description, see Whitaker, "Otherworld Castles," 394.

93. Emden, "Representations of City and Other Walls," 552.

94. Paris, Archives nationales, S 3327, "Raport d'experts"; partial transcription in Bos, *Églises flamboyantes*, 155.

95. Mesqui, *Châteaux et enceintes*, 1:258–63.

96. Viollet-le-Duc, *Cité de Carcassone*, 2; Bruand, "Cité de Carcassonne," 496–500.

97. Mesqui and Toussaint, "Gisors," 271.

98. Coad, *Book of Dover Castle*, 33; Renn, *Norman Castles in Britain*, 169–73.

99. Mesqui and Toussaint, "Gisors," 293.

100. Héliot, "Genèse des châteaux"; Mesqui, *Châteaux et enceintes*, 1:263; Chatelain, "Châteaux de Philippe Auguste," 138.

101. Finó, *Forteresses de la France médiévale*, 311.

102. Viollet-le-Duc, *Military Architecture of the Middle Ages*, 88–91; Toy, *History of Fortification*, 131.

103. J. Harris, "Machicolation: History and Significance," 197–98.

104. Branner, *St. Louis and the Court Style*, 13.

105. Ancien, *Cathédrale de Soissons*, 36–37.

106. This is akin to Pierre Bourdieu's theory of the cultural capital. Bourdieu, *Outline of a Theory of Practice*, esp. 72–95.

107. This could be termed an "aesthetic response" as defined by Wolfgang Iser, in that flying buttresses generated meaning for observers as they participated in the act of viewing. Iser, *Implied Reader*, 50; Iser, *Act of Reading*, x. In the case of the flying buttress, Iser's relationship between text and reader parallels that between architecture and viewer.

108. Cf. Cohen, *Sainte-Chapelle*, 63.

109. Flying buttresses appear as part of elaborate window decoration in a handful of late châteaux, such as the Parlement de Normandie in Rouen, which dates to the early sixteenth century. In these cases they act more as decorative motifs, as in microarchitecture, than as structural supports. A comparable example is the Charles Bridge in Prague, where flying buttresses appear in the form of blind tracery against the tower wall.

110. Mesqui, *Châteaux et enceintes*, 1:195.

111. Ibid.

112. Hamilton and Spicer, "Defining the Holy," 19–21.

113. Sankovitch, *Church of Saint-Eustache*, 35–40.

114. Trachtenberg, "Desedimenting Time," 21.

115. Hutterer, "When Old Meets New," 303–11.

116. Mellinkoff, "Break a Leg!"

117. Camille, *Gargoyles of Notre-Dame*, 71–113.

118. Hugo, *Notre-Dame of Paris*, 166.

119. Ibid., 486.

120. Camille, *Gargoyles of Notre-Dame*, 77.

121. Ibid., 7–12.

122. Baldinger et al., *Dictionnaire étymologique de l'ancien français*, G.2:258.

123. Sheridan and Ross, *Gargoyles and Grotesques*, 66.

124. Viollet-le-Duc, *Dictionnaire raisonné*, 1:64–65, 3:220–22. See also Caillet, "Typologie des contreforts gothiques," 90–92.

125. This arrangement was not without its problems, especially in resolving the flow of water from the roof down into the channel on the top of the flyer. Lasteyrie, *Architecture religieuse*, 367.

126. Mâle, *Religious Art in France*, 58.

127. Sheridan and Ross, *Gargoyles and Grotesques*.

128. Benton, "Gargoyles," 157–58.

129. One of the first modern scholars to make this claim was the abbot Charles-Auguste Auber. It has been repeated in various forms by numerous scholars subsequently. Auber, *Histoire et théorie du symbolisme religieux*, 3:256–59.

130. Snyder, *Early Gothic Column-Figure Sculpture*, 17. The thirteenth-century text *Manières des vilains* similarly demonstrates this multivalence, as it describes a pickpocket who identifies figures from the gallery of kings at Paris Cathedral, which represents the kings of Judah, as Pepin and Charlemagne. Faral, *"Des vilains,"* 254. I thank Johanna Seasonwein for making me aware of this text.

131. The depiction of the gates of hell as the mouth of a monstrous beast developed in Anglo-Saxon England in the tenth century. Galpern, "Shape of Hell"; Schmidt, *Iconography of the Mouth of Hell*.

132. Sheingorn, "Iconography of Hell Mouth." Job 41:4–6. The full description occupies the whole of Job 41. Other public examples include capital 23 from the crypt of the abbey church of Saint-Denis and the Passion window from Bourges Cathedral (window 6, panel 27).

133. For example, Dittmar and Ravaux, "Significations et valeur," 49–51; Mellinkoff, "Break a Leg!," 242.

134. Both of the following texts are cited in Dittmar and Ravaux, "Significations et valeur," 43–44.

135. Link, "Roman d'Abladane"; Flutre, "Roman d'Abladane"; Palumbo, *Roman d'Abladane*.

136. Palumbo, *Roman d'Abladane*, 78–79, vv. 23–28.

137. Stephen of Bourbon, *Stephani de Borbone Tractatus*, 1:280. See also the translation of a variant in Berlioz, *Rire du prédicateur*, 100.

138. Dittmar and Ravaux, "Significations et valeur," 43.

139. Ibid., 44.

140. On medieval automata, see Truitt, *Medieval Robots*.

141. Bridaham, *Gargoyles*, ix.

142. Lifshitz, "Privilege of St. Romanus," 161–62. See also Lifshitz, "Dossier of Romanus."

143. For *serpent* and *dragon*, see the various accounts of the life of Saint Romain as transcribed in Floquet, *Histoire du privilège de Saint Romain*, 1:11–65. For *gargouille*, see Imbs, *Trésor de la langue française*, 8: s.v. *gargouille*.

144. Darnétal, Archives départementales de Seine-Maritime, G2137, entry for November 14, 1467, and G2139, entry for August 9, 1476. See also Campbell, "Cathedral Chapter and Town Council," 105–6.

145. Lifshitz, "Privilege of St. Romanus," 161–62.

146. Floquet, *Histoire du privilège de Saint Romain*, 1:45.

147. The major nineteenth-century restorations occurred between 1850 and 1857. Paris, Archives nationales, F19 7852–63.

148. Sacy, *Recueil de memoires, factums et harangues*, 1:42–46. Dragons were also used as metaphors of pre-Christian or heterodox beliefs as well as symbols of lust and sin. Riches, "Encountering the Monstrous."

149. Lifshitz, "Privilege of St. Romanus," 162–63.

150. Le Goff, *Time, Work, and Culture*, 160–61.

151. Lifshitz, "Privilege of St. Romanus," 162. Interestingly, Guillaume Durand notes that "the roof tiles, which repel the rain from the Lord's house, are the soldiers who protect the church from pagans and other enemies." Durand, *Rationale* (2007), 21. Dittmar and Ravaux, "Significations et valeur," 44 n. 14, have suggested that Durand was equating rain with paganism.

152. On the ubiquity and meaning of dragons in liturgical processions, see Le Goff, *Time, Work, and Culture*, 159–88.

153. C. M. Wright, "Palm Sunday Procession in Medieval Chartres," 351–52.

154. Durand, *Rationale divinorum officiorum*, III:VI:102; Beleth, *Summa de ecclesiasticis officiis*, 2:233.

155. Jacobus de Voragine, *Golden Legend*, 1:288; Praepositinus Cremonensis, *Tractatus de officiis*, 198.

156. Bridaham, *Gargoyles*, x. Bridaham reports that it would take the hats off of men as it passed them in the street, suggesting that his example is postmedieval (he gives no date or citation), although the procession itself likely dates to the Middle Ages.

157. Lifshitz, "Privilege of St. Romanus," 161, 166.

158. Floquet, *Histoire du privilège de Saint Romain*, 10. Jenson Salvart transformed the choir clerestory windows from 1398 to 1447, and Guillaume Pontifs worked on the top of the tour de Saint-Romain between 1468 and 1478. In addition, the foundation stone of the tour de Beurre was laid in 1485, and work on the tower continued until the 1520s. Additions were also made to the west façade into the sixteenth century.

159. Benton, "Gargoyles," 150.

160. The rhinoceros, also known as the monoceros and sometimes conflated with the unicorn, appears in medieval bestiaries as a fantastical beast but shares little in common with the African mammal physiologically. See, for example, London, British Library, Harley MS 3244, fol. 42v. European artists did not have access to rhinoceroses until the arrival of one in Lisbon in the sixteenth century. The rhinoceros gargoyles of Lisbon's Belém Tower may have provided the model for those at Laon. Clarke, *Rhinoceros from Dürer to Stubbs*, esp. chap. 1, "The First Lisbon or 'Dürer Rhinoceros' of 1515."

161. A recent study of the gargoyles of L'Épine is that by Pierre-Olivier Dittmar and Jean-Pierre Ravaux. The following owes much to their work. Dittmar and Ravaux, "Significations et valeur."

162. On the construction history of L'Épine, see Villes, "Programme de construction."

163. Benoist, *Notre-Dame de l'Épine*, 30 and 61.

164. For a summary of the building chronology, see Villes, "Programme de construction," 199–200.

165. For a summary of restorations, see Dittmar and Ravaux, "Significations et valeur," 79–80.

166. Étienne-François-Xavier Povillon-Piérard (*Description historique de l'église*) described this figure as a demon or satyr. His identification was later repeated by Jean-Marie Berland (*Épine en Champagne*). A catalogue of L'Épine's gargoyles appears in Dittmar and Ravaux, "Significations et valeur," 68–79.

167. Povillon-Piérard, *Description historique de l'église*, 21, 23.

168. Dittmar and Ravaux, "Significations et valeur," 41.

169. Demaison, *Documents inédits sur l'église*; Grignon, "Achèvement de l'église"; Villes, "Programme de construction," 163.

170. Dittmar and Ravaux, "Significations et valeur," 62. Dittmar and Ravaux offer apotropaic and moralizing readings of the gargoyles of L'Épine, which they argue could be found at other buildings of the same period. Ibid., 43–58.

171. The medieval use of the negative model appears in many other studies, including Camille, *Image on the Edge*, and Schmitt, *Raison des gestes dans l'Occident médiéval*.

172. Dittmar and Ravaux, "Significations et valeur," 59–64.

173. Ibid., 63–64.

174. Gélis, *Enfants des limbes*, 8. Gélis attributes the term *répit* (respite) to Pierre Saintyves, "Les résurrections d'enfants morts-nés (sic) et les sanctuaires à répit," *Revue d'ethnographie et de sociologie*, n.s., 2 (1911): 65–74. For a bibliography on this ritual, see Gélis's 2006 monograph. Dittmar and Ravaux, "Significations et valeur," 64.

175. On the importance of relics and venerable images in the ritual, see Gélis, *Enfants des limbes*, 135–66.

176. Ibid., 12–13.

177. Dittmar and Ravaux, "Significations et valeur," nos. 12 and 13.

178. Barasch, "Departing Soul," 18–19.

179. Dittmar and Ravaux, "Significations et valeur," no. 24.

180. Ibid., nos. 25 and 78, respectively.

181. Durand, *Rationale* (2007), 63.

182. Gélis, *Enfants des limbes*, 183.

183. Ibid., 183, 186–90.

184. Barat, *Notre-Dame de l'Épine et son pélerinage*; Ravaux, "Notre-Dame de l'Épine," 53.

185. Ravaux, "Notre-Dame de l'Épine," 53–54.

186. Dittmar and Ravaux, "Significations et valeur," 54.

187. Camille, *Image on the Edge*, 30. For an updated response to Camille, see Smith, "Margin."

CONCLUSIONS

1. Trachtenberg, "Suger's Miracles," 202.

2. Torroja, *Philosophy of Structures*, 169.

BIBLIOGRAPHY

UNPUBLISHED SOURCES

Charenton-le-Pont
 MAP
 Archives photographiques: Amiens,
 Bayeux, Bourges, Chartres, Laon,
 Saint-Quentin, Troyes
 Planothèque: Plans d'édifice de
 l'Ainse, Saint-Quentin
Chartres
 Archives départementales d'Eure-et-
 Loir: V55
 Bibliothèque municipale: MS 1058
Darnétal
 Archives départementales de
 Seine-Maritime: G2137, G2139
Laon
 Archives départementales de l'Aisne:
 G 1850
London
 The British Library and Museum:
 Add. MS 28162, Add. MS 47682
Los Angeles
 J. Paul Getty Center: MS 101
New York
 Morgan Library and Museum: MS M.
 52, MS M. 638, MS M. 729, MS M.
 801
Paris
 Archives nationales: F 19 7628, 7631,
 7680, 7852–63; S 3327
 BnF, Département des Cartes et
 plans: GE BB-246, GE C-6822, GE
 D-14360

BnF, Département des manuscrits: MS
 fr. 11485; MS lat. 757; MS lat. 920;
 MS lat. 9227; MS lat. 9999, no. 3; MS
 lat. 10525; MS nouv. acq. fr. 6108;
 Collection Picardie 14
BnF, Estampes: UB-9; VA-14, tome 1a;
 VA-28; VA-225 FOL; VA-262b FOL
Reims
 Bibliothèque municipale: XXXII I F 1

PRINTED PRIMARY SOURCES

Abbot Suger. *Abbot Suger on the Abbey*
Church of St.-Denis and Its Art
Treasures. Edited by Erwin Panofsky
and Gerda Panofsky-Soergel. 2nd
ed. Princeton: Princeton University
Press, 1979.
Amalarius of Metz. *De ecclesiasticis officiis*
libri quatuor. Edited by J.-P. Migne.
In *PL* 105, cols. 985–1242. Paris:
Garnier, 1851.
Beleth, Jean. *Summa de ecclesiasticis officiis.*
Edited by Herbert Douteil. 2 vols.
Corpus Christianorum Continua-
tio Mediaevalis 41, 41a. Turnhout:
Brepols, 1976.
Berlioz, Jacques, ed. *Le rire du prédicateur:*
Récits facétieux du Moyen Âge. Trans-
lated by Albert Lecoy de La Marche.
Turnhout: Brepols, 1992.
Bruno Astensis. *De sacramentis ecclesiae,*
mysteriis atque ecclesiasticis ritibus.

Edited by J.-P. Migne. In *PL* 165, cols.
1089–110. Paris: Garnier, 1854.
Caesarius of Heisterbach. *The Dialogue*
on Miracles. Translated by Henry
von Essen Scott and C. C. Swinton
Bland. 2 vols. London: G. Routledge
& Sons, 1929.
Delaporte, Yves. *L'ordinaire chartrain du*
XIIIᵉ siècle: Publié d'après le man-
uscrit original. Chartres: Société
archéologique d'Eure-et-Loir, 1953.
Demaison, Louis. *Documents inédits sur*
l'église Notre-Dame de l'Épine. Reims:
Imprimerie de l'Académie, 1895.
Durand, Guillaume. *On the Clergy and*
Their Vestments: A New Translation
of Books 2 and 3 of the Rationale
divinorum officiorum. Translated by
Timothy M. Thibodeau. Scranton:
University of Scranton Press, 2010.
———. *Rationale divinorum officiorum.*
Edited by Anselmus Davril, Timothy
M. Thibodeau and Bertrand G.
Guyot. 3 vols. Corpus Christiano-
rum Continuatio Mediaevalis 140,
140A, 140B. Turnhout: Brepols,
1995–2000.
———. *The Rationale divinorum officiorum*
of William Durand of Mende: A New
Translation of the Prologue and Book
One. Translated by Timothy M.
Thibodeau. New York: Columbia
University Press, 2007.

Faral, Edmond. *"Des vilains" ou "Des XXIII manières de vilains."* Paris: E. Champion, 1922.

Froissart, Jean. *Chroniques de J. Froissart, publiées pour la Société de l'histoire de France par Siméon Luce.* Edited by Siméon Luce, Gaston Raynaud, Léon Mirot, and Albert Mirot. 15 vols. Paris: Mme. Ve. J. Renouard, 1869–.

———. *Oeuvres de Froissart.* Edited by Kervyn de Lettenhove. 25 vols. Osnabrück: Biblio Verlag, 1967.

Froissart, Jean, and Geoffrey Brereton. *Chronicles.* Harmondsworth, U.K.: Penguin, 1978.

Grim, Edward. "The Murder of Thomas Becket." Translated by Dawn Marie Hayes. Fordham University. https://sourcebooks.fordham.edu/source/Grim-becket.asp.

Guérard, B., ed. *Cartulaire de l'église Notre-Dame de Paris.* 4 vols. Paris: Imprimerie de Crapelet, 1850.

Guernes de Pont-Maxence. *Garnier's Becket: Translated from the 12th-Century "Vie saint Thomas le martyr de Cantorbire" of Garnier of Pont-Sainte-Maxence.* Translated by Janet Shirley. London: Phillimore, 1975.

Guibert, abbot of Nogent-sous-Coucy. *Self and Society in Medieval France: The Memoirs of Abbot Guibert of Nogent (1064?–c. 1125).* Translated by C. C. Swinton Bland, revised by John F. Benton. New York: Harper & Row, 1970.

Guillaume de Deguileville. *The Pilgrimage of Human Life.* Translated by Eugene Clasby. New York: Garland, 1992.

Guillaume de Saint-Pair. *Le roman du Mont Saint-Michel, XII^e siècle.* Edited by Catherine Bougy. Caen: Presses universitaires de Caen, 2009.

The Holy Bible, with Revisions and Footnotes by Bishop Richard Challoner. Baltimore: Murphy, 1899.

Honorius of Autun. *Expositio in Cantica canticorum.* Edited by J.-P. Migne. In *PL* 172, cols. 347–496. Paris: Garnier, 1854.

———. *Gemma animae.* Edited by J.-P. Migne. In *PL* 172, cols. 541–738. Paris: Garnier, 1854.

Hugh of Saint Victor [Hugonis de Sancto Victore]. *De sacramentis Christiane fidei.* Edited by Rainer Berndt. Corpus Victorinum: Textus historici 1. Monasterii Westfalorum: Aschendorff, 2008.

———. *On the Sacraments of the Christian Faith (De sacramentis).* Translated by Roy J. Deferrari. Cambridge, Mass.: Mediaeval Academy of America, 1951.

Hugo, Victor. *Notre-Dame of Paris.* Translated by John Sturrock. New York: Penguin, 1978.

Jacobus de Voragine. *The Golden Legend: Readings on the Saints.* Translated by William Granger Ryan. 2 vols. Princeton: Princeton University Press, 1993.

Jean de Venette. *The Chronicle of Jean de Venette.* Translated by Jean Birdsall. Edited by Richard A. Newhall. New York: Columbia University Press, 1953.

Jerome [Hieronymus Stridonensis]. *Commentariorum in Epistolam ad Ephesios.* Edited by J.-P. Migne. In *PL* 26, cols. 439–554. Paris: Garnier, 1845.

Lépinois, E. de Buchère de, and Lucien Merlet, eds. *Cartulaire de Notre-Dame de Chartres.* 3 vols. Chartres: Garnier, 1861–65.

Molinier, Auguste, and Auguste Longnon, eds. *Obituaires de la province de Sens,* vol. 2, *Diocèse de Chartres.* Paris: Imprimerie nationale, 1906.

Neckam, Alexander [Alexandri Neckam]. *"De naturis rerum," libri duo, with the poem of the same author, "De laudibus divinae sapientiae."* Edited by Thomas Wright. Rerum Britannicarum medii aevi scriptores 34. London: Longman, Green, Roberts, and Green, 1863.

Palumbo, Giovanni, ed. *Le roman d'Abladane.* Paris: H. Champion, 2011.

Peter the Chanter [Petri Cantoris]. *Verbum abbreviatum.* Edited by J.-P. Migne. In *PL* 205, cols. 21–554. Paris: Garnier, 1855.

Praepositinus Cremonensis. *Praepositini Cremonensis Tractatus de officiis.* Edited by James A. Corbett. Publications in Medieval Studies 21. Notre Dame: University of Notre Dame Press, 1969.

Richter, Aemilius Ludwig, and Emil Friedberg, eds. *Corpus iuris canonici.* 2 vols. Leipzig: Bernard Tauchnitz, 1879. Reprint, Graz: Akademische Druck- u. Verlagsanstalt, 1959.

Salverda de Grave, Jean-Jacques, ed. *Eneas: Roman du XII^e siècle.* 2 vols. 1925–29. Paris: H. Champion, 1964–68.

Schroeder, Henry Joseph. *Disciplinary Decrees of the General Councils: Text, Translation, and Commentary.* St. Louis: B. Herder, 1937.

Sicard of Cremona [Sicardus Cremonensis]. *Mitralis de officiis.* Edited by Gábor Sarbak and Lorenz Weinrich. Corpus Christianorum Continuatio Mediaevalis 228. Turnhout: Brepols, 2008.

Stephen of Bourbon [Stephanus]. *Stephani de Borbone Tractatus de diversis materiis predicabilibus.* Edited by Jacques Berlioz and Jean-Luc Eichenlaub. Vol. 1. Corpus Christianorum Continuatio Mediaevalis 124. Turnhout: Brepols, 2002.

Varin, Pierre. *Archives administratives de la ville de Reims; collection de pièces inédites pouvant servir à l'histoire des institutions dans l'intérieur de la cité.* Documents inédits sur l'histoire de la France. 3 vols. Paris: Imprimerie de Crapelet, 1839–48.

SECONDARY SOURCES

Abou-El-Haj, Barbara. "Artistic Integration Inside the Cathedral Precinct: Social Consensus Outside?" In *Artistic Integration in Gothic Buildings*, edited by Virginia Chieffo Raguin, Kathryn Brush, and Peter Draper, 214–35. Toronto: University of Toronto Press, 1995.

———. "Program and Power in the Glass of Reims." In *Radical Art History: Internationale anthologie; Subject, O. K. Werckmeister*, edited by Wolfgang Kersten, 23–33. Zurich: ZIP, 1997.

———. "The Urban Setting for Late Medieval Church Building: Reims and Its Cathedral Between 1210 and 1240." *Art History* 11, no. 1 (1988): 17–41.

Ackerman, James S. "Villard de Honnecourt's Drawings of Reims Cathedral: A Study in Architectural Representation." *Artibus et Historiae* 18, no. 35 (1997): 41–49.

Ancien, Jean. *Contribution à l'étude archéologique: Architecture de la cathédrale de Soissons*. Soissons: J. Ancien, 1984.

Arnheim, Rudolf. *The Dynamics of Architectural Form: Based on the 1975 Mary Duke Biddle Lectures at the Cooper Union*. Berkeley: University of California Press, 1977.

Auber, Charles-Auguste. *Histoire et théorie du symbolisme religieux avant et depuis le christianisme*. 4 vols. Paris: Franck, 1870–72.

Aubert, Marcel. *Notre-Dame de Paris; architecture et sculpture*. Paris: A. Morancé, 1928.

———. *La sculpture française au début de l'époque gothique, 1140–1225*. Florence: Pantheon, 1929.

Baillieul, Elise. "L'ancienne collègiale Notre-Dame d'Étampes, un monument du premier art gothique." 2 vols. Ph.D. diss., Université Charles-de-Gaulle—Lille 3, 2012.

Baldinger, Kurt, Jean-Denis Gendron, Georges Straka, and Frankwalt Möhren. *Dictionnaire étymologique de l'ancien français*. Paris: Klincksieck, 1974–.

Baldwin, John W. *The Government of Philip Augustus: Foundations of French Royal Power in the Middle Ages*. Berkeley: University of California Press, 1986.

———. *Masters, Princes, and Merchants: The Social Views of Peter the Chanter and His Circle*. 2 vols. Princeton: Princeton University Press, 1970.

Ball, Philip. *Universe of Stone: A Biography of Chartres Cathedral*. New York: Harper, 2008.

Baltzer, Rebecca A. "The Geography of the Liturgy at Notre-Dame of Paris." In *Plainsong in the Age of Polyphony*, edited by Thomas Forrest Kelly, 45–64. Cambridge: Cambridge University Press, 1992.

Bannister, Turpin C. "The Constantinian Basilica of Saint Peter at Rome." *JSAH* 27, no. 1 (1968): 3–32.

Barasch, Moshe. "The Departing Soul: The Long Life of a Medieval Creation." *Artibus et Historiae* 26, no. 52 (2005): 13–28.

Barat, J.-A. *Notre-Dame de l'Épine et son pélerinage*. Châlons: Dortu-Deullin, 1860.

Barnes, Carl F., Jr. "The Cathedral of Chartres and the Architect of Soissons." *JSAH* 22, no. 2 (1963): 63–74.

———. "Cross-Media Design Motifs in XIIIth-Century France: Architectural Motifs in the Psalter and Hours of Yolande de Soissons and in the Cathedral of Notre-Dame at Amiens." *Gesta* 17, no. 2 (1978): 37–40.

———. *The Portfolio of Villard de Honnecourt (Paris, Bibliothèque nationale de France, MS Fr 19093): A New Critical Edition and Color Facsimile*. Farnham, U.K.: Ashgate, 2009.

———. "Villard de Honnecourt." In *The Dictionary of Art*, edited by Jane Turner, 32:569–71. London: Grove's Dictionaries, 2009.

Barnwell, P. S. "The Laity, the Clergy, and the Divine Presence: The Use of Space in Smaller Churches of the Eleventh and Twelfth Centuries." *Journal of the British Archaeological Association* 157 (2004): 41–60.

Baron, Françoise. "Effigies sculptées à Notre-Dame de Paris aux XIVᵉ et XVᵉ siècles." In *Pierre, lumière, couleur: Études d'histoire de l'art du Moyen Âge en l'honneur d'Anne Prache*, edited by Fabienne Joubert and Dany Sandron, 327–40. Paris: Presses de l'Université de Paris-Sorbonne, 1999.

Baud, Anne. *Cluny, un grand chantier médiéval au coeur de l'Europe*. Paris: Picard, 2003.

Beaudette, Paul. "'In the World but Not of It': Clerical Celibacy as a Symbol of the Medieval Church." In *Medieval Purity and Piety: Essays on Medieval Clerical Celibacy and Religious Reform*, edited by Michael Frassetto, 23–46. New York: Garland, 1998.

Bechmann, Roland. "Villard de Honnecourt." In *Dictionnaire encyclopédique du Moyen Âge*, edited by André Vauchez and Catherine Vincent, 2:1589–90. Paris: Éditions du Cerf, 1997.

Bedos-Rezak, Brigitte. "Form as Social Process." In *Artistic Integration in Gothic Buildings*, edited by Virginia Chieffo Raguin, Kathryn Brush, and Peter Draper, 236–48. Toronto: University of Toronto Press, 1995.

Bénard, Pierre. *Collégiale de Saint-Quentin: Renseignements pour servir a l'histoire de cette église, comprenant . . . une recherche sur la patrie et les travaux de Vilard [sic] d'Honnecourt. . . .* Paris: Librairie centrale d'architecture, 1867.

Benoist, Luc. *Notre-Dame de l'Épine*. Paris: H. Laurens, 1933.

Benton, Janetta Rebold. "Gargoyles: Animal Imagery and Artistic Individuality in Medieval Art." In *Animals in the Middle Ages*, edited by Nona C. Flores, 147–65. London: Routledge, 1996.

Berland, Jean-Marie. *L'Épine en Champagne*. Colmar-Ingersheim: S.A.E.P., 1972.

Berné, Damien. "Les sources de la construction de la cathédrale de Reims au XIIIe siècle." In *La cathédrale de Reims*, edited by Patrick Demouy, 73–80. Paris: Presses de l'Université de Paris-Sorbonne, 2017.

Berry, Maurice. "La connaissance du mur." In *L'enceinte et le Louvre de Philippe Auguste*, edited by Maurice Berry and Michel Fleury, 119–36. Paris: La Délégation, 1988.

Berry, Walter. "The North Portals of Reims Cathedral: The Evidence Below Ground." In *The North Transept of Reims Cathedral: Design, Construction, and Visual Programs*, edited by Jennifer M. Feltman, 15–37. New York: Routledge, 2016.

Billot, Claudine. "Chartres, XIVe siècle–XVe siècle: Une ville et son plat pays." Ph.D. diss., University of Paris VIII, 1980.

———. *Chartres à la fin du Moyen Âge*. Paris: École des hautes études en sciences sociales, 1987.

Binski, Paul. "The Heroic Age of Gothic and the Metaphors of Modernism." *Gesta* 52, no. 1 (2013): 3–19.

Birkmeyer, Karl M. "The Arch Motif in Netherlandish Painting of the Fifteenth Century: Part One." *AB* 43, no. 1 (1961): 1–20.

Boileau, Étienne. *Les métiers et corporations de la ville de Paris: XIIIe siècle*. Paris: Imprimerie nationale, 1879.

Bonde, Sheila. "Castle and Church Building at the Time of the Norman Conquest." In *The Medieval Castle: Romance and Reality*, edited by Kathryn Reyerson and Faye Powe, 79–96. Dubuque: Kendall/Hunt, 1984.

———. *Fortress-Churches of Languedoc: Architecture, Religion, and Conflict in the High Middle Ages*. New York: Cambridge University Press, 1994.

Bongartz, Norbert. *Die frühen Bauteile der Kathedrale in Troyes: Architekturgeschichtliche Monographie*. Stuttgart: Hochschul-Verlag, 1979.

Bony, Jean. *French Gothic Architecture of the 12th and 13th Centuries*. Berkeley: University of California Press, 1983.

Bork, Robert. "Holy Toledo: Art-Historical Taxonomy and the Morphology of Toledo Cathedral." *AVISTA Forum Journal* 10, no. 2 (1998): 31–37.

Bork, Robert, Robert Mark, and Stephen Murray. "The Openwork Flying Buttresses of Amiens Cathedral: 'Postmodern Gothic' and the Limits of Structural Rationalism." *JSAH* 56, no. 4 (1997): 478–93.

Bos, Agnès. *Les églises flamboyantes de Paris, XVe–XVIe siècles*. Paris: Picard, 2003.

Bourdieu, Pierre. *Outline of a Theory of Practice*. Translated by Richard Nice. New York: Cambridge University Press, 1977.

Bouttier, Michel. *La cathédrale du Mans*. Le Mans: Éditions de la Reinette, 2000.

Branner, Robert. *The Cathedral of Bourges and Its Place in Gothic Architecture*. Edited by Shirley Prager Branner. Cambridge, Mass.: MIT Press, 1989.

———. "Historical Aspects of the Reconstruction of Reims Cathedral, 1210–1241." *Speculum* 36, no. 1 (1961): 23–37.

———. "The Montjoies of Saint Louis." In *Essays in the History of Architecture Presented to Rudolf Wittkower*, edited by Douglas Fraser, Howard Hibbard, and Milton J. Lewine, 13–16. London: Phaidon, 1967.

———. "The North Transept and the First West Façades of Reims Cathedral." *Zeitschrift für Kunstgeschichte* 24, nos. 3–4 (1961): 220–41.

———. *St. Louis and the Court Style in Gothic Architecture*. London: A. Zwemmer, 1965.

———. "Villard de Honnecourt, Reims, and the Origin of Gothic Architectural Drawing." *Gazette des beaux-arts*, ser. 6, 61 (1963): 129–46.

Bréhier, Louis. *La cathédrale de Reims: Une oeuvre française*. Paris: H. Laurens, 1916.

Bridaham, Lester Burbank. *Gargoyles, Chimères, and the Grotesque in French Gothic Sculpture*. 2nd ed. New York: Da Capo Press, 1969.

Brocchieri, Ercole. "Sicardo di Cremona e la sua opera letteraria." *Annali della Biblioteca governativa e libreria civica di Cremona* 11 (1958): 1–115.

Broche, Lucien. *La cathédrale de Laon*. 3rd ed. Paris: H. Laurens, 1961.

Brooke, Christopher. "Religious Sentiment and Church Design in the Later Middle Ages." In *Medieval Church and Society: Collected Essays*, 162–82. New York: New York University Press, 1972.

Bruand, Yves. "La Cité de Carcassonne: Les enceintes fortifiées." *Congrès archéologique de France* 131 (1973): 496–515.

Bruzelius, Caroline. "The Construction of Notre-Dame in Paris." *AB* 69, no. 4 (1987): 540–69.

———. "A Rose by Any Other Name: The 'Not Gothic Enough' Architecture of Italy (Again)." In *Reading Gothic Architecture*, edited by Matthew M. Reeve, 93–109. Turnhout: Brepols, 2008.

———. "The Second Campaign at Saint-Urbain at Troyes." *Speculum* 62, no. 3 (1987): 635–40.

Bucher, François. "Micro-architecture as the 'Idea' of Gothic Theory and Style." *Gesta* 15, nos. 1–2 (1976): 71–89.

Bulteau, Marcel Joseph. *Monographie de la cathédrale de Chartres*. 2nd ed. 3 vols. Chartres: R. Selleret, 1887–92.

Bunim, Miriam Schild. *Space in Medieval Painting and the Forerunners of*

Perspective. 1940. Reprint, New York: AMS Press, 1970.

Caillet, Josiane. "Typologie des contreforts gothiques: La place de Notre-Dame de Reims." Ph.D. diss., University of Montreal, 2001.

Callet, P., S. Dumazet, C. Leclercq, and C. Politi. "Natural Lighting, Gilts, and Polychromy of Notre-Dame de Paris Cathedral." In *VAST 2010: The 11th International Symposium on Virtual Reality, Archaeology, and Cultural Heritage*, edited by A. Artusi, M. Joly-Parvez, G. Lucet, A. Ribes, and D. Pitzalis, 63–70. Goslar, Germany: Eurographics Association, 2010.

Camille, Michael. *The Gargoyles of Notre-Dame: Medievalism and the Monsters of Modernity*. Chicago: University of Chicago Press, 2009.

———. *The Gothic Idol: Ideology and Image-Making in Medieval Art*. Cambridge: Cambridge University Press, 1989.

———. *Image on the Edge: The Margins of Medieval Art*. Cambridge, Mass.: Harvard University Press, 1992.

Campbell, Thomas P. "Cathedral Chapter and Town Council: Cooperative Ceremony and Drama in Medieval Rouen." *Comparative Drama* 27, no. 1 (1993): 100–113.

Caviness, Madeline Harrison. "Marginally Correct." In *Tributes to Lucy Freeman Sandler: Studies in Illuminated Manuscripts*, edited by Kathryn A. Smith and Carol H. Krinsky, 141–56. London: Harvey Miller, 2007.

———. *Sumptuous Arts at the Royal Abbeys in Reims and Braine: Ornatus Elegantiae, Varietate Stupendes*. Princeton: Princeton University Press, 1990.

Cerf, Charles, with the collaboration of Pierre Charles Hannesse. *Histoire et description de Notre-Dame de Reims*. 2 vols. Reims: Pierre Dubois, 1861.

Chataignère, Myriam. "Étude technique de la polychromie." In *Les sculptures de Notre-Dame de Paris au Musée de Cluny*, edited by Alain Erlande-Brandenburg and Dominique Thibaudat, 121–31. Paris: Éditions de la Réunion des musées nationaux, 1982.

Chatelain, André. "Recherche sur les châteaux de Philippe Auguste." *Archéologie médiévale* 21 (1991): 115–61.

Chédeville, André. *Chartres et ses campagnes (XIᵉ–XIIIᵉ s.)*. Paris: Klincksieck, 1973.

———. *Histoire de Chartres et du pays chartrain*. Toulouse: Privat, 1983.

Chédozeau, Bernard. *Chœur clos, chœur ouvert: De l'église médiévale à l'église tridentine (France, XVIIᵉ–XVIIIᵉ siècle)*. Paris: Cerf, 1998.

Clark, William W. "Le Christ et les anges autour des chapelles rayonnantes de la cathédrale de Reims." In *La cathédrale de Reims*, edited by Patrick Demouy, 341–57. Paris: Presses de l'Université de Paris-Sorbonne, 2017.

———. "Reading Reims, I: The Sculptures on the Chapel Buttresses." *Gesta* 39, no. 2 (2000): 135–45.

———. "Reims Cathedral in the Portfolio of Villard de Honnecourt." In *Villard's Legacy: Studies in Medieval Technology, Science, and Art in Memory of Jean Gimpel*, edited by Marie-Thérèse Zenner, 23–51. Burlington, Vt.: Ashgate, 2004

———. Spatial Innovations in the Chevet of Saint-Germain-des-Prés." *JSAH* 38, no. 4 (1979): 348–65..

———. "Teachers, Preachers, and the Good Shepherd at Reims Cathedral: Another Look at the Radiating Chapel Sculptures." In *Arts of the Medieval Cathedrals: Studies on Architecture, Stained Glass, and Sculpture in Honor of Anne Prache*, edited by Kathleen Nolan and Dany Sandron, 151–64. AVISTA Studies in the History of Medieval Technology, Science, and Art. Burlington, Vt.: Ashgate, 2015.

Clark, William W., and Richard King. *Laon Cathedral*. 2 vols. London: Harvey Millar, 1983–87.

Clarke, T. H. *The Rhinoceros from Dürer to Stubbs, 1515–1799*. London: Sotheby's Publications, 1986.

Coad, J. G. *Book of Dover Castle and the Defences of Dover*. London: B. T. Batsford; English Heritage, 1995.

Cohen, Meredith. *The Sainte-Chapelle and the Construction of Sacral Monarchy: Royal Architecture in Thirteenth-Century Paris*. New York: Cambridge University Press, 2015.

Collet, Brice. "Les compagnons de Jehan Gailde au jubé de la Madeleine." *La vie en Champagne* 380 (1987): 9–13.

———. "Jehan Gailde, maître d'oeuvre du jubé da la Madeleine." *La vie en Champagne* 379 (1987): 13–20.

Collin, Hubert. "La cathédrale Notre-Dame de Verdun." *Congrès archéologique de France* 149 (1991): 403–29.

Collomb, Pascal. "Les éléments liturgiques de la *Légende dorée*: Tradition et innovations." In *De la sainteté a l'hagiographie: Genèse et usage de la "Legende dorée,"* edited by Barbara Fleith and Franco Morenzoni, 97–122. Geneva: Droz, 2001.

Conant, Kenneth John. *Carolingian and Romanesque Architecture, 800 to 1200*. Baltimore: Penguin, 1959.

Constable, Giles. *The Reformation of the Twelfth Century*. Cambridge: Cambridge University Press, 1996.

Coste, Anne. *L'architecture gothique: Lectures et interprétations d'un modèle*. Saint-Étienne: Publications de l'Université de Saint-Étienne, 1997.

Cothren, Michael W. "The Iconography of Theophilus Windows in the First Half of the Thirteenth Century." *Speculum* 59, no. 2 (1984): 308–41.

———. *Picturing the Celestial City: The Medieval Stained Glass of Beauvais Cathedral*. Princeton: Princeton University Press, 2006.

Coulson, Charles. *Castles in Medieval Society: Fortresses in England, France, and Ireland in the Central Middle*

Ages. New York: Oxford University Press, 2003.

Cowdrey, H. E. J. *The Cluniacs and the Gregorian Reform.* Oxford: Clarendon Press, 1970.

Crosby, Sumner McKnight. *The Royal Abbey of Saint-Denis: From Its Beginnings to the Death of Suger, 475–1151.* Edited by Pamela Z. Blum. New Haven: Yale University Press, 1987.

Dale, Thomas E. A. "Monsters, Corporeal Deformities, and Phantasms in the Cloister of St-Michel-de-Cuxa." *AB* 83, no. 3 (2001): 402–36.

Dalmais, Irénée Henri. *Principles of the Liturgy.* Translated by Matthew J. O'Connell. Collegeville, Minn.: Liturgical Press, 1987.

Davis, Michael T. "Canonical Views: The Theophilus Story and the Choir Reliefs at Notre-Dame, Paris." In *Reading Medieval Images: The Art Historian and the Object,* edited by Elizabeth Sears and Thelma K. Thomas, 102–16. Ann Arbor: University of Michigan Press, 2002.

———. "On the Threshold of the Flamboyant: The Second Campaign of Construction of Saint-Urbain, Troyes." *Speculum* 59, no. 4 (1984): 847–84.

———. "Splendor and Peril: The Cathedral of Paris, 1290–1350." *AB* 80, no. 1 (1998): 34–66.

Davis, Michael T., and Linda Elaine Neagley. "Mechanics and Meaning: Plan Design at Saint-Urbain, Troyes and Saint-Ouen, Rouen." *Gesta* 39, no. 2 (2000): 161–82.

Dehio, Georg, and Gustav von Bezold. *Die kirchliche Baukunst des Abendlandes.* 2 vols. Stuttgart: J. G. Cotta, 1887–1901.

Delaporte, Yves. *Les vitraux de la cathédrale de Chartres.* Vol. 1. Chartres: Houvet, 1926.

Demouy, Patrick. "Être achevêque de Reims au XIIIe siècle." In *La cathédrale de Reims,* edited by Patrick Demouy, 39–51. Paris: Presses de l'Université de Paris-Sorbonne, 2017.

———. "Franchises urbaines et liberté de l'Église à Reims au XIIe siècle: Les relations entre les laïcs et l'archêveque-comte." In *Les laïcs dans les villes de la France du Nord au XIIe siècle,* edited by Patrick Demouy, 43–57. Turnhout: Brepols, 2008.

———. *Notre-Dame de Reims: La cathédrale royale.* Paris: Centurion, 1986.

———. *Reims: La cathédrale.* Saint-Léger-Vauban: Zodiaque, 2000.

Denifle, Heinrich. *La désolation des églises, monastères, hôpitaux en France vers le milieu du XVe siècle.* 2 vols. Mâcon: Protat frères, 1897.

Deshman, Robert. "The Imagery of the Living Ecclesia and the English Monastic Reform." In *Sources of Anglo-Saxon Culture,* edited by Paul E. Szarmach, 261–82. Kalamazoo, Mich.: Medieval Institute Publications, 1986.

Desportes, Pierre. "Le chapitre et sa cathédrale." In *La cathédrale de Reims,* edited by Patrick Demouy, 53–58. Paris: Presses de l'Université de Paris-Sorbonne, 2017.

———. *Reims et les Rémois aux XIIIe et XIVe siècles.* Paris: A. & J. Picard, 1979.

Deuchler, Florens. *Gothic Art.* New York: Universe Books, 1973.

Dittmar, Pierre-Olivier, and Jean-Pierre Ravaux. "Significations et valeur d'usage des gargouilles: Le cas de Notre-Dame de l'Épine." In *Notre-Dame de l'Épine, 1406–2006: Actes du colloque international, L'Épine-Châlons-en-Champagne, 13–14 septembre 2006,* edited by Christine Abélé and Jean-Pierre Ravaux, vol. 2, Études marnaises 123, 38–80. Châlons-en-Champagne: Société d'agriculture, commerce, sciences et arts du département de la Marne, 2008.

Doquang, Mailan S. "The Lateral Chapels of Notre-Dame in Context." *Gesta* 50, no. 2 (2011): 137–61.

———. "Rayonnant Chantry Chapels in Context." Ph.D. diss., New York University, 2009.

———. "Status and the Soul: Commemoration and Intercession in the Rayonnant Chapels of Northern France in the Thirteenth and Fourteenth Centuries." In *Memory and Commemoration in Medieval Culture,* edited by Elma Brenner, Meredith Cohen, and Mary Franklin-Brown, 93–118. Burlington, Vt.: Ashgate, 2013.

Draper, Peter. *The Formation of English Gothic: Architecture and Identity.* New Haven: Yale University Press, 2006.

Duby, Georges. *The Three Orders: Feudal Society Imagined.* Translated by Arthur Goldhammer. Chicago: University of Chicago Press, 1980.

Duggan, Anne. "John of Salisbury and Thomas Becket." In *The World of John of Salisbury,* edited by Michael Wilks, Studies in Church History, Subsidia 3, 427–38. Oxford: Blackwell, 1984.

Dyer, Christopher. *Making a Living in the Middle Ages: The People of Britain, 850–1520.* New Haven: Yale University Press, 2002.

Elliott, Dyan. *Fallen Bodies: Pollution, Sexuality, and Demonology in the Middle Ages.* Philadelphia: University of Pennsylvania Press, 1998.

Elmes, James. *Memoirs of the Life and Works of Sir Christopher Wren.* London: Priestley & Weale, 1823.

Emden, Wolfgang van. "Medieval French Representations of City and Other Walls." In *City Walls: The Urban Enceinte in Global Perspective,* edited by James D. Tracy, 530–72. Cambridge: Cambridge University Press, 2000.

Erlande-Brandenburg, Alain. *The Cathedral: The Social and Architectural Dynamics of Construction.* New York: Cambridge University Press, 1994.

———. *Notre-Dame de Paris.* Translated by John Goodman. New York: Abrams, 1998.

Erlande-Brandenburg, Alain, and Xavier Dectot. "Le cloître Notre-Dame." In *Autour de Notre-Dame*, edited by Alain Erlande-Brandenburg, Jean-Michel Leniaud, François Loyer, and Christian Michel, 116–19. Paris: Action artistique de la ville de Paris, 2003.

Etlin, Richard. "On the Symbolism of Rib Vaults and Flying Buttresses." Forthcoming.

Evans, Joan. "A Prototype of the Eleanor Crosses." *Burlington Magazine* 91, no. 553 (1949): 96–99.

Everett, George Eldric. "The Role of the Abbey Church of Saint-Lomer-de-Blois in the Evolution of Early Gothic Architecture." Ph.D. diss., Harvard University, 1975.

Evergates, Theodore. *The Aristocracy in the County of Champagne, 1100–1300*. Philadelphia: University of Pennsylvania Press, 2007.

Fassler, Margot. "The Feast of Fools and *Danielis ludus*: Popular Tradition in a Medieval Cathedral Play." In *Plainsong in the Age of Polyphony*, edited by Thomas Forrest Kelly, 65–99. Cambridge: Cambridge University Press, 1992.

———. "Liturgy and Sacred History in the Twelfth-Century Tympana at Chartres." *AB* 75, no. 3 (1993): 499–520.

Feltman, Jennifer M. Introduction to *The North Transept of Reims Cathedral: Design, Construction, and Visual Programs*, edited by Jennifer M. Feltman, 1–11. New York: Routledge, 2016.

Fernie, Eric. "Medieval Modernism and the Origins of Gothic." In *Reading Gothic Architecture*, edited by Matthew M. Reeve, 11–24. Turnhout: Brepols, 2008.

Finó, José Federico. *Forteresses de la France médiévale: Construction—attaque—défense*. Paris: Picard, 1967.

Fitchen, John. "A Comment on the Function of the Upper Flying Buttresses in French Gothic Architecture." *Gazette des beaux-Arts*, ser. 6, 45 (1955): 69–90.

———. *The Construction of Gothic Cathedrals: A Study of Medieval Vault Erection*. Oxford: Clarendon Press, 1961.

Floquet, Amable. *Histoire du privilège de Saint Romain, en vertu duquel le chapitre de la cathédrale de Rouen délivrait anciennement un meurtrier tous les ans, le jour de l'ascension*. 2 vols. Rouen: Libraire de l'Académie et du collége royal, 1833.

Flutre, L.-F. "Le roman d'Abladane." *Romania* 92 (1971): 458–506.

Frankl, Paul. "The Chronology of Chartres Cathedral." *AB* 39, no. 1 (1957): 33–47.

———. "The Chronology of the Stained Glass in Chartres Cathedral." *AB* 45, no. 4 (1963): 301–22.

———. *Gothic Architecture*. Translated by Dieter Pevsner, revised by Paul Crossley. New Haven: Yale University Press, 2000.

———. *The Gothic: Literary Sources and Interpretations Through Eight Centuries*. Princeton: Princeton University Press, 1960.

———. "Reconsiderations on the Chronology of Chartres Cathedral." *AB* 43, no. 1 (1961): 51–58.

Freigang, Christian. "Chapelles latérales privées: Origines, fonctions, financement; Le cas de Notre-Dame de Paris." In *Art, cérémonial et liturgie au Moyen Âge: Actes du Colloque de 3ᵉ cycle romand de lettres, Lausanne-Fribourg, 24–25 mars, 14–15 avril, 12–13 mai 2000*, edited by Nicholas Bock and Peter Kurmann, 525–44. Rome: Viella, 2002.

———. *Imitare ecclesias nobiles: Die Kathedralen von Narbonne, Toulouse und Rodez und die nordfranzösische Rayonnantgotik im Languedoc*. Worms: Wernersche Verlagsgesellschaft, 1992.

French, Thomas, and David Elgar O'Connor. *York Minster: A Catalogue of Medieval Stained Glass*. Corpus Vitrearum Medii Aevi, Great Britain 3. Oxford: Oxford University Press, 1987.

Frisch, Teresa G. "The Twelve Choir Statues of the Cathedral at Reims: Their Stylistic and Chronological Relation to the Sculpture of the North Transept and of the West Façade." *AB* 42, no. 1 (1960): 1–24.

Frodl-Kraft, Eva. "Zu den Kirchenschaubildern in den Hochchorfenstern von Reims: Abbildung und Abstraktion." *Wiener Jahrbuch für Kunstgeschichte* 25 (1972): 53–86.

Gabriel, A. L. "Les écoles de la cathédrale de Notre-Dame et le commencement de l'université de Paris." In *Huitième centenaire de Notre-Dame de Paris (Congrès des 30 mai–3 juin 1964): Recueil de travaux sur l'histoire de la cathédrale et de l'église de Paris*, 141–66. Paris: J. Vrin, 1967.

Gallet, Yves. *La cathédrale d'Évreux et l'architecture rayonnante, XIIIᵉ–XIVᵉ siècles*. Besançon: Presses universitaires de Franche-Comté, 2014.

Galpern, Joyce Ruth Manheimer. "The Shape of Hell in Anglo-Saxon England." Ph.D. diss., University of California, Berkeley, 1977.

Gardner, Stephen. "The Influence of Castle Building on Ecclesiastical Architecture in the Paris Region, 1130–1150." In *The Medieval Castle: Romance and Reality*, edited by Kathryn Reyerson and Faye Powe, 97–123. Dubuque: Kendall/Hunt, 1984.

Gauléjac, B. de. "Sainte-Radegonde." *Congrès archéologique de France* 100 (1938): 401–7.

Gélis, Jacques. *Les enfants des limbes: Mort-nés et parents dans l'Europe chrétienne*. Paris: Louis Audibert, 2006.

Gillerman, Dorothy. *The Clôture of Notre-Dame and Its Role in the Fourteenth Century Choir Program*. New York: Garland, 1977.

Godefroy, Frédéric. *Dictionnaire de l'ancienne langue française, et de tous ses dialectes du ixe au XVᵉ siècle, composé d'après le dépouillement de tous les plus importants documents, manuscrits ou imprimés, qui se trouvent dans les grands bibliothèques de la France et de l'Europe, et dans les principales archives départementales, municipales, hospitalières ou privées.* 10 vols. Paris: F. Vieweg, 1881–1902.

Gosse-Kischinewski, Annick, and Françoise Gatouillat. *La cathédrale d'Évreux.* Évreux: Les Colporteurs, 1997.

Grant, Lindy. "Aspects of the Twelfth-Century Design of La Madeleine at Châteaudun." *Journal of the British Archaeological Association* 135 (1982): 23–34.

———. "Naming of Parts: Describing Architecture in the High Middle Ages." In *Architecture and Language: Constructing Identity in European Architecture, c. 1000–c. 1650*, edited by Georgia Clarke and Paul Crossley, 46–57. Cambridge: Cambridge University Press, 2000.

Graviers, J. Emmanuel des. "'Messeigneurs du Chapitre' de l'église de Paris à l'époque de la Guerre de Cent Ans." In *Huitième centenaire de Notre-Dame de Paris (Congrès des 30 mai–3 juin 1964): Recueil de travaux sur l'histoire de la cathédrale et de l'église de Paris*, 185–222. Paris: J. Vrin, 1967.

Grignon, L. "L'achèvement de l'église Notre-Dame de l'Épine un XVIᵉ siècle." *Semaine religieuse*, 1 May 1886, 494–96.

Grodecki, Louis. "À propos de la sculpture française autour de 1200." *BM* 115 (1957): 119–26.

———. "The Transept Portals of Chartres Cathedral: The Date of Their Construction According to Archaeological Data." *AB* 33, no. 3 (1951): 156–64.

Grodecki, Louis, Catherine Brisac, and Claudine Lautier. *Le vitrail roman.* Fribourg: Office du livre, 1977.

Guérin, Sarah M. "Meaningful Spectacles: Gothic Ivories Staging the Divine." *AB* 95, no. 1 (2013): 53–77.

Gutmann, Joseph. *The Temple of Solomon: Archaeological Fact and Medieval Tradition in Christian, Islamic, and Jewish Art.* Missoula: Scholars Press for American Academy of Religion, 1976.

Hahnloser, Hans R. *Villard de Honnecourt: Kritische Gesamtausgabe des Bauhüttenbuches ms. fr. 19093 der Pariser Nationalbibliothek.* Vienna: A. Schroll, 1935.

Hamann-MacLean, Richard. "Die Kathedrale von Reims: Bildwelt und Stilbildung." *Marburger Jahrbuch für Kunstwissenschaft* 20 (1981): 21–54.

———. "Zur Baugeschichte der Kathedrale von Reims." In *Gedenkschrift Ernst Gall*, edited by Margarete Kühn and Louis Grodecki, 195–234. Berlin: Deutscher Kunstverlag, 1965.

Hamann-MacLean, Richard, and Ise Schüssler. *Die Kathedrale von Reims.* Pt. 1, *Die Architektur.* 3 vols. Stuttgart: Steiner, 1993.

Hamilton, Sarah, and Andrew Spicer. "Defining the Holy: The Delineation of Sacred Space." In *Defining the Holy: Sacred Space in Medieval and Early Modern Europe*, edited by Andrew Spicer and Sarah Hamilton, 1–26. Burlington, Vt.: Ashgate, 2005.

Hammerstein, Reinhold. *Die Musik der Engel: Untersuchungen zur Musikanschauung des Mittelalters.* Bern: Francke, 1962.

Harris, John. "Machicolation: History and Significance." *Castle Studies Group Journal* 23 (2009–10): 191–214.

Harris, Max. *Sacred Folly: A New History of the Feast of Fools.* Ithaca: Cornell University Press, 2011.

Haskins, Charles H. "The Life of Medieval Students as Illustrated by Their Letters." *American Historical Review* 3, no. 2 (1898): 203–29.

———. *The Rise of Universities.* New York: Henry Holt, 1923.

Hayes, Dawn Marie. *Body and Sacred Place in Medieval Europe, 1100–1389.* New York: Routledge, 2003.

Head, Thomas, and Richard Landes, eds. *The Peace of God: Social Violence and Religious Response in France Around the Year 1000.* Ithaca: Cornell University Press, 1992.

Héliot, Pierre M. L. *La basilique de Saint-Quentin et l'architecture du Moyen Âge.* Paris: A. & J. Picard, 1967.

———. "La genèse des châteaux de plan quadrangulaire en France et en Angleterre." *Bulletin de la Société nationale des antiquaires de France* (1965): 238–57.

Henderson, George. *Chartres.* Harmondsworth, U.K.: Penguin, 1968.

Henriet, Jacques. "La cathédrale Saint-Étienne de Sens: Le parti du premier maître et les campagnes du XIIᵉ siècle." *BM* 140 (1982): 81–174.

———. "Recherches sur les premiers arcs-boutants, un jalon: Saint-Martin d'Étampes." *BM* 136 (1978): 309–23.

Herschman, Joel. "The Norman Ambulatory of Le Mans Cathedral and the Chevet of the Cathedral of Coutances." *Gesta* 20, no. 2 (1981): 323–32.

Heyman, Jacques. *The Stone Skeleton: Structural Engineering of Masonry Architecture.* New York: Cambridge University Press, 1995.

Hicks, Leonie V. *Religious Life in Normandy, 1050–1300: Space, Gender, and Social Pressure.* Rochester, N.Y.: Boydell & Brewer, 2007.

Hill, Nathaniel. *The Ancient Poem of Guillaume de Guileville, Entitled "Le pèlerinage de l'homme," Compared with the "Pilgrim's Progress" of John Bunyan.* Edited by Katherine Isabella Cust. London: Basil Montagu Pickering, 1858.

Hinkle, William M. *The Portal of the Saints of Reims Cathedral: A Study in Mediaeval Iconography*. New York: College Art Association of America in conjunction with the Art Bulletin, 1965.

Hiscock, Nigel. *The Symbol at Your Door: Number and Geometry in Religious Architecture of the Greek and Latin Middle Ages*. Burlington, Vt.: Ashgate, 2007.

Hollengreen, Laura H. "From Medieval Sacred Place to Modern Secular Space: Changing Perspectives on the Cathedral and Town of Chartres." In *Architecture as Experience: Radical Change in Spatial Practice*, edited by Dana Arnold and Andrew Ballantyne, 81–108. New York: Routledge, 2004.

Holly, Michael Ann. *Panofsky and the Foundations of Art History*. Ithaca: Cornell University Press, 1984.

Huck, Oliver. "The Music of the Angels in Fourteenth- and Early Fifteenth-Century Music." *Musica disciplina* 53 (2003): 99–119.

Huitson, Toby. *Stairway to Heaven: The Functions of Medieval Upper Spaces*. Oxford: Oxbow Books, 2014.

Hutterer, Maile. "Architectural Design as an Expression of Religious Tolerance: The Case of Sainte-Madeleine in Montargis." *JSAH* 76, no. 3 (2017): 281–301.

———. "Lofty Sculpture: Flying Buttress Decoration and Ecclesiastical Authority." *Gesta* 54, no. 2 (2015): 195–218.

———. "When Old Meets New: Classicizing Columns in Northern French Flying Buttress Systems." *Journal of Medieval and Early Modern Studies* 44, no. 2 (2014): 281–320.

Imbs, Paul, ed. *Trésor de la langue française: Dictionnaire de la langue du XIXᵉ et du XXᵉ siècle (1789–1960)*. 16 vols. Paris: Éditions du Centre national de la recherche scientifique, 1971–94.

Inglis, Erik. "Gothic Architecture and a Scholastic: Jean de Jandun's *Tractatus de laudibus Parisius* (1323)." *Gesta* 42, no. 1 (2003): 63–85.

Iogna-Prat, Dominique. *La maison Dieu: Une histoire monumentale de l'Église au Moyen-Âge (v. 800–v. 1200)*. Paris: Seuil, 2006.

———. *Order and Exclusion: Cluny and Christendom Face Heresy, Judaism, and Islam, 1000–1150*. Translated by Graham Robert Edwards. Ithaca: Cornell University Press, 2002.

Iser, Wolfgang. *The Act of Reading: A Theory of Aesthetic Response*. Baltimore: Johns Hopkins University Press, 1978.

———. *The Implied Reader: Patterns of Communication in Prose Fiction from Bunyan to Beckett*. Baltimore: Johns Hopkins University Press, 1974.

Isnard, Isabelle. "Les travaux de la fin du Moyen Âge (l'âge flamboyant)." In *Saint-Riquier: Une grande abbaye bénédictine*, edited by Aline Magnien, 93–108. Paris: Picard, 2009.

James, John. "Construction Timetables." *ICMA Master Carvers Series*, no. 8 (2011): 1–18. http://www.johnjames.com.au/pdf/08 construction timetables.pdf.

———. *The Contractors of Chartres*. Limited ed. 2 vols. Dooralong, N.S.W.: Mandorla, 1979–81.

———. "Evidence for Flying Buttresses Before 1180." *JSAH* 51, no. 3 (1992): 261–87.

Jantzen, Hans. *High Gothic: The Classic Cathedrals of Chartres, Reims, Amiens*. Translated by James Palmes. New York: Minerva Press, 1962.

Jordan, Alyce A. *Visualizing Kingship in the Windows of the Sainte-Chapelle*. Turnhout: Brepols, 2002.

Jung, Jacqueline E. "Beyond the Barrier: The Unifying Role of the Choir Screen in Gothic Churches." *AB* 82, no. 4 (2000): 622–57.

———. *The Gothic Screen: Space, Sculpture, and Community in the Cathedrals of France and Germany, ca. 1200–1400*. Cambridge: Cambridge University Press, 2012.

Kasarska, Iliana. *La sculpture de la façade de la cathédrale de Laon: Eschatologie et humanisme*. Paris: Picard, 2008.

Katz, Melissa R. "Architectural Polychromy and the Painters' Trade in Medieval Spain." *Gesta* 41, no. 1 (2002): 3–14.

Katzenellenbogen, Adolf. *The Sculptural Programs of Chartres Cathedral: Christ, Mary, Ecclesia*. Baltimore: John Hopkins University Press, 1959.

Kavaler, Ethan Matt. *Renaissance Gothic: Architecture and the Arts in Northern Europe, 1470–1540*. New Haven: Yale University Press, 2012.

Kemp, Wolfgang. *The Narratives of Gothic Stained Glass*. Translated by Caroline Dobson Saltzwedel. Cambridge: Cambridge University Press, 1997.

Kenaan-Kedar, Nurith. *Marginal Sculpture in Medieval France: Towards the Deciphering of an Enigmatic Pictorial Language*. Brookfield, Vt.: Scolar Press, 1995.

Kennedy, V. L. "The Handbook of Master Peter Chancellor of Chartres." *Medieval Studies* 5 (1943): 1–38.

Kessler, Herbert L., and Johanna Zacharias. *Rome 1300: On the Path of the Pilgrim*. New Haven: Yale University Press, 2000.

Kidson, Peter. "Architectural History." In *A History of Lincoln Minster*, edited by Dorothy Owen, 14–46. Cambridge: Cambridge University Press, 1994.

———. "Bourges After Branner." *Gesta* 39, no. 2 (2000): 147–56.

———. "Panofsky, Suger, and St. Denis." *Journal of the Warburg and Courtauld Institutes* 50 (1987): 1–17.

Kimpel, Dieter, and Robert Suckale. *L'architecture gothique en France: 1130–1270*. Translated by Françoise Neu. Paris: Flammarion, 1990.

Kraus, Henry. *Gold Was the Mortar: The Economics of Cathedral Building*. Boston: Routledge & Kegan Paul, 1979.

Krautheimer, Richard. "Introduction to an 'Iconography of Mediaeval Architecture.'" *Journal of the Warburg and Courtauld Institutes* 5 (1942): 1–33.

Kumler, Aden. *Translating Truth: Ambitious Images and Religious Knowledge in Late Medieval France and England*. New Haven: Yale University Press, 2011.

Kurmann, Peter. "Architecture, vitrail et orfèvrerie: À propos de premiers dessins d'édifices gothiques." In *Représentations architecturales dans les vitraux*, 32–41.

———. "Le Couronnement de la Vierge du grand portail de Reims: Clef du système iconographique de la cathédrale des sacres." In *De l'art comme mystagogie: Iconographie du Jugement dernier et des fins dernières à l'époque gothique; Actes du Colloque de la Fondation Hardt tenu à Genève du 13 au 16 février 1994*, edited by Yves Christe, 95–104. Poitiers: Universitié de Poitiers, 1996.

———. "'Et angeli tui custodiant muros eius': Un cycle de statues méconnu au transept sud de Notre-Dame de Rouen; Modèle ou reflet du cortège des anges de Reims?" In *"Tout le temps du veneour est sanz oyseuseté": Mélanges offerts à Yves Christe pour son 65^ème anniversaire par ses amis, ses collègues, ses élèves*, edited by Christine Hediger, 113–24. Turnhout: Brepols, 2005.

———. *La façade de la cathédrale de Reims: Architecture et sculpture des portails; Étude archéologique et stylistique*. Translated by Françoise Monfrin. 2 vols. Paris: Éditions du Centre national de la recherche scientifique, 1987.

———. "Late Gothic Architecture in France and the Netherlands." In *The Art of Gothic: Architecture, Sculpture, Painting*, edited by Rolf Toman, 156–86. Cologne: Ullmann & Könemann, 1999.

———. "Miniaturkathedrale oder monumentales Reliquiar? Zur Architektur des Gertrudenschreins." In *Schatz aus den Trümmern: Der Silberschrein von Nivelles und die europäische Hochgotik*, edited by Hiltrud Westermann-Angerhausen, Gudrun Sporbeck, Marion Opitz, and Silke Eberhardt, 135–53. Regensburg: Schnell & Steiner, 1995.

Kurmann, Peter, and Brigitte Kurmann-Schwarz. "La sculpture: Le triomphe de l'église de Reims." In *Reims*, edited by Thierry Jordan, 175–229. Strasbourg: Nuée bleue, 2010.

Kurmann-Schwarz, Brigitte, and Peter Kurmann. *Chartres: La cathédrale*. Translated by Thomas de Kayser. Saint-Léger-Vauban: Zodiaque, 2001.

Labande, Edmond-René. "Les pèlerinages au Mont Saint-Michel pendant le Moyen Âge." In *Millénaire monastique du Mont Saint-Michel*, vol. 3, *Culte de Saint Michel et pèlerinages au Mont*, edited by Marcel Baudot, 237–50. Paris: Lethielleux, 1971.

La Fons, Quentin de. *Extraits originaux d'un manuscrit de Quentin de La Fons intitulé "Histoire particulière de l'église de Saint-Quentin."* Edited by Charles Gomart. 2 vols. Paris: Didron, 1854.

Lasteyrie, Robert de. *L'architecture religieuse en France à l'époque gothique*. Edited by Marcel Aubert. 2 vols. Paris: A. Picard, 1926–27.

Laurent, Jean. "Chartres: Le cloître Notre-Dame; Observations archéologiques." *Bulletin de la Société archéologique d'Eure-et-Loir*, n.s., 14 (1987): 5–12.

Lautier, Claudine. "Les édifices religieux et leur construction dans les vitraux narratifs de la première moitié du XII^e siècle en France." In *Représentations architecturales dans les vitraux*, 43–52.

———. "Restaurations récentes à la cathédrale de Chartres et nouvelles recherches." *BM* 169 (2011): 3–11.

Lecocq, Adolphe. "Historique du cloître Notre-Dame de Chartres." *Mémoires de la Société archéologique d'Eure-et-Loir* 1 (1858): 125–58.

———. "Notice historique et archéologique sur les horloges de l'église Notre-Dame de Chartres." *Mémoires de la Société archéologique d'Eure-et-Loir* 4 (1867): 284–340.

———. "Recherces sur les enseignes de pèlerinages et les chemisettes de Notre-Dame-de-Chartres." *Mémoires de la Société archéologique d'Eure-et-Loir* 6 (1876):194–242.

Lefèvre-Pontalis, Eugène. "Les architectes et la construction des cathédrales de Chartres." *Mémoires de la Société nationale des antiquaires de France* 64 (1905): 69–136.

———. "Les campagnes de construction de Notre-Dame d'Étampes." *BM* 73 (1909): 5–31.

———. "L'origine des arcs-boutants." *Congrès archéologique de France* 82 (1920): 367–96.

Le Goff, Jacques. *Time, Work, and Culture in the Middle Ages*. Translated by Arthur Goldhammer. Chicago: University of Chicago Press, 1980.

Lépinois, Ernest de Buchère de. *Histoire de Chartres*. 2 vols. Chartres: Garnier, 1854–58.

Lestocquoy, Jean. "The Reliquary of St. Gertrude at Nivelles." *Burlington Magazine for Connoisseurs* 77, no. 452 (1940): 163–64.

Lheure, Michel. *Le triforium: Construction et fonctions, XI^e–XVI^e siècle*. Paris: Lheure, 2012. Distributed by Picard.

Liefferinge, Stefaan Van. "The Hemicycle of Notre-Dame of Paris: Gothic Design and Geometrical Knowledge in the Twelfth Century." *JSAH* 69, no. 4 (2010): 490–507.

Lifshitz, Felice. "The Dossier of Romanus of Rouen: The Political Uses of

Hagiographical Texts." Ph.D. diss, Columbia University, 1988.

———. "The Privilege of St. Romanus: Provincial Independence and Hagiographical Legends at Rouen." *Analecta Bollandiana* 107 (1989): 161–70.

Lillich, Meredith P. *The Gothic Stained Glass of Reims Cathedral*. University Park: Pennsylvania State University Press, 2011.

———. "A Redating of the Thirteenth-Century Grisaille Windows of Chartres Cathedral." *Gesta* 11, no. 1 (1972): 11–18.

Link, Th. "Der Roman d'Abladane." *Zeitschrift für romanische Philologie* 17 (1893): 215–32.

Livingstone, Amy. *Out of Love for My Kin: Aristocratic Family Life in the Lands of the Loire, 1000–1200*. Ithaca: Cornell University Press, 2010.

Lombard-Jourdan, Anne. *Aux origines de Paris: La genèse de la rive droite jusqu'en 1223*. New ed., rev. and augmented. Paris: Éditions du Centre national de la recherche scientifique, 1985.

Love, Melissa Jordan. "'On Earth as It Is in Heaven?': The Creation of the Bastides of Southwest France." Ph.D. diss., Columbia University, 2012.

Low, Peter. "'You Who Once Were Far Off': Enlivening Scripture in the Main Portal at Vézelay." *AB* 85, no. 3 (2003): 469–89.

Luchaire, Achille. *Social France at the Time of Philip Augustus*. Translated by Edward B. Krehbiel. New York: H. Holt, 1912.

Macy, Gary. "Commentaries on the Mass During the Early Scholastic Period." In *Medieval Liturgy: A Book of Essays*, edited by Lizette Larson-Miller, 25–59. New York: Garland, 1997.

Mainstone, Rowland J. "Intuition and the Springs of Structural Invention." In *Structures Implicit and Explicit*, edited by James Bryan and Rolf Sauer,

42–67. Philadelphia: University of Pennsylvania, 1973.

———. "The Springs of Invention Revisited." *Structural Engineer* 73, no. 22 (1995): 392–99.

Mâle, Émile. *L' art religieux au XIII^e siècle en France*. 1898. Reprint, Paris: Colin, 1948.

———. *The Gothic Image: Religious Art in France of the Thirteenth Century*. Translated by Dora Nussey. New York: Harper & Row, 1972.

———. *Religious Art in France, XIII Century: A Study in Mediaeval Iconography and Its Sources of Inspiration*. Translated by Dora Nussey. New York: E. P. Dutton, 1913. New York: Dover, 2000.

Mantello, Frank Anthony Carl, and A. G. Rigg, eds. *Medieval Latin: An Introduction and Bibliographical Guide*. Washington, D.C.: Catholic University of America Press, 1996.

Mark, Robert. *Experiments in Gothic Structure*. Cambridge, Mass.: MIT Press, 1982.

Mark, Robert, and Ronald S. Jonash. "Wind Loading on Gothic Structure." *JSAH* 29, no. 3 (1970): 222–30.

Marriage, Margaret S., and Ernest Marriage. *The Sculptures of Chartres Cathedral*. Cambridge: Cambridge University Press, 1909.

Martineau, Jean. *Les Halles de Paris, des origines à 1789: Evolution matérielle, juridique et économique*. Paris: Éditions Montchrestien, 1960.

Masini, Paolo. "'Magister' Johannes Beleth: Ipotesi di una traccia biografica." *Ephemerides Liturgicae* 107 (1993): 248–59.

Maurel, Jean-François. "Jean Beleth et la 'Summa de ecclesiasticis officiis.'" *Positions des thèses de l'École des chartes* (1953): 77–80.

McGinn, Bernard. "From Admirable Tabernacle to the House of God: Some Theological Reflections on Medieval Architectural Integration." In *Artistic*

Integration in Gothic Buildings, edited by Virginia Chieffo Raguin, Kathryn Brush, and Peter Draper, 41–56. Toronto: University of Toronto Press, 1995.

Mellinkoff, Ruth. "Break a Leg!" In *Tributes to Jonathan J. G. Alexander: The Making and Meaning of Illuminated Medieval and Renaissance Manuscripts, Art, and Architecture*, edited by Susan L'Engle and Gerald B. Guest, 233–47. Turnhout: Brepols, 2006.

Ménard, Clarence Cecil. "William Durand's *Rationale divinorum officiorum*: Preliminaries to a New Critical Edition." Ph.D. diss., Pontifical Gregorian University, 1967.

Merlet, Lucien. "Boutiques au cloître Notre-Dame." *Mémoires de la Société archéologique d'Eure-et-Loir* 1 (1858): 79–89.

Mesqui, Jean. *Châteaux et enceintes de la France médiévale: De la défense à la résidence*. 2 vols. Paris: Picard, 1991–93.

———. "Construire une enceinte urbaine au temps de Philippe Auguste." In *L'enceinte et le Louvre de Philippe Auguste*, edited by Maurice Berry and Michel Fleury, 75–86. Paris: La Délégation, 1988.

Mesqui, Jean, and Patrick Toussaint. "Le château de Gisors aux XII^e et XIII^e siècles." *Archéologie médiévale* 20 (1990): 253–317.

Meulen, Jan van der. "Angrenzende Bauwerke der Kathedrale von Chartres." *Jahrbuch der Berliner Museen* 16 (1974): 5–45.

———. "Histoire de la construction de la cathédrale Notre-Dame de Chartres après 1194." *Bulletin de la Société archéologique d'Eure-et-Loir* 23 (1965): 79–126.

Meulen, Jan van der, Rüdiger Hoyer, and Deborah Cole. *Chartres: Sources and Literary Interpretation; A Critical Bibliography*. Boston: G. K. Hall, 1989.

Moreau-Nélaton, Étienne. *La cathédrale de Reims*. Paris: Librairie centrale des beaux-arts, 1915.

Mortet, Victor, and Paul Deschamps, eds. *Recueil de textes relatifs à l'histoire de l'architecture et à la condition des architectes en France au Moyen Âge, XI*^e*–XII*^e *siecles*. 2 vols. 1911–29. Paris: Éditions du Comité des travaux historiques et scientifiques, 1995.

Müller-Dietrich, Norbert. *Die romanische Skulptur in Lothringen*. Munich: Deutscher Kunstverlag, 1968.

Murray, Stephen. *Beauvais Cathedral: Architecture of Transcendence*. Princeton: Princeton University Press, 1989.

———. *Building Troyes Cathedral: The Late Gothic Campaigns*. Bloomington: Indiana University Press, 1987.

———. *Notre-Dame, Cathedral of Amiens: The Power of Change in Gothic*. Cambridge: Cambridge University Press, 1995.

———. "Notre-Dame of Paris and the Anticipation of Gothic." *AB* 80, no. 2 (1998): 229–53.

———. *Plotting Gothic*. Chicago: University of Chicago Press, 2014.

Nichols, Anne B., Vivian L. Paul, and John M. Nichols. "Vaulting of Narbonne Cathedral." In *Proceedings of the 11th North American Masonry Conference: Transforming Traditions, June 5–8, 2011*, n.p. Minneapolis: North American Masonry Conference, 2011. CD-ROM.

Nickson, Tom. *Toledo Cathedral: Building Histories in Medieval Castile*. University Park: Pennsylvania State University Press, 2017.

Nicot, Guy. "Le cloître Notre-Dame de Chartres." *La voix de Notre-Dame de Chartres: Journal religieux dédié à la Vierge de la Crypte* 27 (1976): 4–16.

Niermeyer, Jan F., C. van de Kieft, and G. S. M. M. Lake-Schoonebeek. *Mediae Latinitatis Lexicon Minus*. 2 vols. Leiden: E. J. Brill, 1976.

Nikolinakou, Maria A., and Andrew J. Tallon. "New Research in Early Gothic Flying Buttresses." In *Proceedings of the Second International Congress on Construction History, Queen's College, Cambridge University, 29th March–2nd April 2006*, edited by Malcolm Dunkeld, 3:2347–61. Ascot, U.K.: Construction History Society, 2006.

Nikolinakou, Maria-Katerina, Andrew J. Tallon, and John A. Ochsendorf. "Structure and Form of Early Gothic Flying Buttresses." *Revue européenne de génie civil* 9, nos. 9–10 (2005): 1191–217.

Noonan, James-Charles. *The Church Visible: The Ceremonial Life and Protocol of the Roman Catholic Church*. New York: Viking, 1996.

Nussbaum, Norbert. *German Gothic Church Architecture*. Translated by Scott Kleager. New Haven: Yale University Press, 2000.

Onians, John. *Bearers of Meaning: The Classical Orders in Antiquity, the Middle Ages, and the Renaissance*. Princeton: Princeton University Press, 1988.

Oury, Guy. "Jean Beleth." In *Dictionnaire de spiritualité: Ascétique et mystique, doctrine et histoire*, edited by Marcel Viller, Charles Baumgartner, and André Rayez, vol. 8, cols. 285–86. Paris: G. Beauchesne et ses fils, 1972.

Pächt, Otto. *Book Illumination in the Middle Ages: An Introduction*. New York: Oxford University Press, 1986.

Panofsky, Erwin. *Early Netherlandish Painting: Its Origins and Character*. 2 vols. Cambridge, Mass.: Harvard University Press, 1953.

———. *Gothic Architecture and Scholasticism*. Latrobe, Pa.: Archabbey Press, 1951.

Parker, Elizabeth C. "Architecture as Liturgical Setting." In *The Liturgy of the Medieval Church*, edited by Thomas J. Heffernan and E. Ann Matter, 273–327. Kalamazoo, Mich.: Medieval Institute Publications, 2001.

Paul, Vivian. "The Projecting Triforium at Narbonne Cathedral: Meaning, Structure, or Form?" *Gesta* 30, no. 1 (1991): 27–40.

Piétresson de Saint-Aubin, Pierre. "L'église Saint-Jean-au-Marché de Troyes." *Congrès archéologique de France* 113 (1955): 85–95.

———. "Note sur les arcs-boutants du choeur de Saint-Jean-au-Marché de Troyes." *Bulletin archéologique du Comité des travaux historiques et scientifiques* 43 (1927): 179–85.

Plagnieux, Philippe. "L'abbatiale de Saint-Germain-des-Prés et les débuts de l'architecture gothique." *BM* 158, no. 1 (2000): 6–88.

———. "Les arcs-boutants du XII^e siècle de l'église de Domont." *BM* 150, no. 3 (1992): 209–22.

———. "Une étude de cas: La réhabilitation des arcs-boutants du XII^e siècle au révélateur des dossiers de restauration du XIX^e siècle." *Livraisons de l'histoire de l'architecture* 21 (2011): 101–14.

———. "La Madeleine de Châteaudun: La nef du milieu du XII^e siècle; L'échec d'une architecture gothique réalisée par un maître d'oeuvre issu du monde roman." In *Pierre, lumière, couleur: Études d'histoire de l'art du Moyen Âge en l'honneur d'Anne Prache*, edited by Fabienne Joubert and Dany Sandron, 39–50. Paris: Presses de l'Université de Paris-Sorbonne, 1999.

Povillon-Piérard, Étienne-François-Xavier. *Description historique de l'église de Notre-Dame de l'Épine, près de Châlons-sur-Marne*. Châlons: Impr. de Boniez-Lambert, 1825.

Power, Arthur. *Conversations with James Joyce*. Edited by Clive Hart. Chicago: University of Chicago Press, 1975.

Prache, Anne. "Les arcs-boutants au XII^e siècle." *Gesta* 15, nos. 1–2 (1976): 31–42.

———. "La chapelle de Vendôme à la cathédrale de Chartres et l'art

flamboyant en Île-de-France." *Wiener Jahrbuch für Kunstgeschichte* 46–47, no. 2 (1994): 569–75.

———. "Le début de la construction de la cathédrale de Reims au XIIIe siècle: L'apport de l'archéologie et de la dendrochronologie." In *Nouveaux regards sur la cathédrale de Reims: Actes du colloque international des 1er et 2 octobre 2004*, edited by Bruno Decrock and Patrick Demouy, 41–52. Langres: Guéniot, 2008.

———. "Observations sur la construction de la cathédrale de Chartres au XIIIe siècle." *Bulletin de la Société nationale des antiquaires de France* (1990): 327–34.

———. "Les rapports architecturaux des églises Saint-Remi de Reims et Notre-Dame-en-Vaux de Châlons dans la deuxième moitié du XIIe siècle." In *Actes du 95e Congrès national des sociétés savantes, Reims, 1970, archéologie et d'histoire de l'art*, 251–62. Paris: Bibliothèque nationale, 1975.

———. *Saint-Remi de Reims: L'œuvre de Pierre de Celle et sa place dans l'architecture gothique*. Geneva: Droz, 1978.

Prigent, Daniel. "Evolution de la construction médiévale en pierre en Anjou et Touraine." In *Anjou: Medieval Art, Architecture, and Archaeology*, edited by John McNeill and Daniel Prigent, 14–33. Leeds: British Archaeological Association and Maney Publishing, 2003.

Quicherat, Jules-Étienne-Joseph. "Notice sur l'album de Villard de Honnecourt, architecte du XIIIe siècle." *Revue archéologique* 6 (1849): 65–80, 164–88, 209–26.

Radding, Charles M., and William W. Clark. *Medieval Architecture, Medieval Learning: Builders and Masters in the Age of Romanesque and Gothic*. New Haven: Yale University Press, 1992.

Raguin, Virginia Chieffo. *Stained Glass: From Its Origins to the Present*. New York: Abrams, 2003.

———. "The Visual Designer in the Middle Ages: The Case for Stained Glass." *Journal of Glass Studies* 28 (1986): 30–39.

Randall, Lilian M. C. *Images in the Margins of Gothic Manuscripts*. Berkeley: University of California Press, 1966.

Ravaux, Jean-Pierre. "Les campagnes de construction de la cathédrale de Reims au XIIIe siècle." *BM* 137, no. 1 (1979): 7–66.

———. "Notre-Dame de l'Épine: À la recherché des origines." In *Notre-Dame de l'Épine, 1406–2006: Actes du colloque international, L'Épine-Châlons-en-Champagne, 13–14 septembre 2006*, edited by Christine Abelé and Jean-Pierre Ravaux, vol. 1, Études marnaises 122, 13–72. Châlons-en-Champagne: Société d'agriculture, commerce, sciences et arts du département de la Marne, 2007.

Renn, D. F. *Norman Castles in Britain*. New York: Humanities Press, 1968.

Représentations architecturales dans les vitraux: Colloque international, Bruxelles, Palais des Académies, 22–27 août 2002. Edited by Robert Tollet. Liège: Commission royale des monuments, sites et fouilles de la région Wallone, 2002.

Riches, Samantha J. E. . "Encountering the Monstrous: Saints and Dragons in Medieval Thought." In *The Monstrous Middle Ages*, edited by Bettina Bildhauer and Robert Mills, 196–218. Toronto: University of Toronto Press, 2003.

Rosenthal, Joel Thomas. *The Purchase of Paradise: Gift Giving and the Aristocracy, 1307–1485*. London: Routledge, 1972.

Rothwell, William. "Glanures lexicologiques dans des documents des 14e et 15e siècles provenant de l'évêché de Durham." *Zeitschrift für romanische Philologie* 116, no. 2 (2000): 213–36.

Sacy, Louis-Silvestre de. *Recueil de memoires, factums et harangues*. 2 vols. Paris, 1724.

Sadler, Donna L. *Reading the Reverse Façade of Reims Cathedral: Royalty and Ritual in 13th-Century France*. Burlington, Vt.: Ashgate, 2012.

Saint-Denis, Alain. *Apogée d'une cité: Laon et le Laonnois aux XIIe et XIIIe siècles*. Nancy: Presses universitaires de Nancy, 1994.

Saint-Paul, Anthyme. "Notre-Dame d'Étampes." *Gazette archéologique* 9 (1884): 211–23.

———. "La transition." *Revue de l'art chrétien*, 5th ser., 5 (1894): 470–82.

Sandler, Lucy Freeman. "The Study of Marginal Imagery: Past, Present, and Future." *Studies in Iconography* 18 (1997): 1–49.

Sandron, Dany. "The Cathedral Façade: Monumental Sculpture in Context from the Twelfth to the Sixteenth Centuries." In *Gothic Art and Thought in the Later Medieval Period*, edited by Colum Hourihane, 35–54. The Index of Christian Art Occasional Papers. University Park: Pennsylvania State University Press, 2011.

———. "La fondation par le cardinal Jean de la Grange de deux chapelles à la cathédrale d'Amiens: Une tradition épiscopale devenue manifeste politique à la gloire de roi Charles V." In *L'artiste et le clerc: Commandes artistiques des grands ecclésiastiques à la fin du Moyen Âge (XIVe–XVIe siècles)*, edited by Fabienne Joubert, 155–70. Paris: Presses de l'Université Paris-Sorbonne, 2006.

Sankovitch, Anne-Marie. *The Church of Saint-Eustache in the Early French Renaissance*. Turnhout: Brepols, 2015.

———. "Intercession, Commemoration, and Display: The Parish Church as Archive in Late Medieval Paris." In *Demeures d'éternité: Églises et chapelles funéraires aux XVe et XVIe siècles; Actes du colloque tenu à Tours du 11 au 14 juin 1996*, edited by Jean Guillaume, 247–67. Paris: Picard, 2005.

Sapin, Christian, ed. *Saint-Étienne d'Aux-erre: La seconde vie d'une cathédrale.* Paris: Picard, 2011.

Sauerländer, Willibald. "Le cathédrale de Reims: Lieu de mémoire et cité céleste." Introduction to *La cathédrale de Reims*, edited by Patrick Demouy, 9–35. Paris: Presses de l'Université de Paris-Sorbonne, 2017.

———. *Gothic Sculpture in France, 1140–1270.* Translated by Janet Sondheimer. New York: Abrams, 1973.

———. "Integrated Fragments and the Unintegrated Whole: Scattered Examples from Reims, Strasbourg, Chartres, and Naumburg." In *Artistic Integration in Gothic Buildings*, edited by Virginia Chieffo Raguin, Kathryn Brush, and Peter Draper, 153–66. Toronto: University of Toronto Press, 1995.

Schiller, Gertrud. *Iconography of Christian Art.* Translated by Janet Seligman. Vol. 2, *The Passion of Christ.* Greenwich, Conn.: New York Graphic Society, 1972.

Schlicht, Markus. *La cathédrale de Rouen vers 1300: Portail des libraires, portail de la Calende, chapelle de la Vièrge; Un chantier majeur de la fin du Moyen Âge.* Caen: Société des antiquaires de Normandie, 2005.

Schlink, Wilhelm. "The Gothic Cathedral as Heavenly Jerusalem: A Fiction in German Art History." In *The Real and Ideal Jerusalem in Jewish, Christian, and Islamic Art: Studies in Honor of Bezalel Narkiss on the Occasion of His Seventieth Birthday*, edited by Bianca Kühnel, 275–85. Jerusalem: Hebrew University, 1998.

Schmidt, Gary D. *The Iconography of the Mouth of Hell: Eighth-Century Britain to the Fifteenth Century.* Selinsgrove: Susquehanna University Press, 1995.

Schmitt, Jean-Claude. *La raison des gestes dans l'Occident médiéval.* Paris: Gallimard, 1990.

Šedinová, Hana. "The Precious Stones of Heavenly Jerusalem in the Medieval Book Illustration and Their Comparison with the Wall Incrustation in St. Wenceslas Chapel." *Artibus et Historiae* 21, no. 41 (2000): 31–47.

Semper, Gottfried. *Der Stil in den technischen und tektonischen Künsten; oder, Praktische Ästhetik: Ein Handbuch für Techniker, Künstler und Kunstfreunde.* 2nd ed. 2 vols. Munich: F. Bruckmann, 1878–79.

Seymour, Charles. *Notre-Dame of Noyon in the Twelfth Century: A Study in the Early Development of Gothic Architecture.* New York: W. W. Norton, 1968.

Sheingorn, Pamela. "'Who Can Open the Doors of His Face?': The Iconography of Hell Mouth." In *The Iconography of Hell*, edited by Clifford Davidson and Thomas H. Seiler, 1–19. Kalamazoo, Mich.: Medieval Institute Publications, 1992.

Sheridan, Ronald, and Anne Ross. *Gargoyles and Grotesques: Paganism in the Medieval Church.* Boston: New York Graphic Society, 1975.

Shortell, Ellen M. "The Choir of Saint-Quentin: Gothic Structure, Power, and Cult." Ph.D. diss., Columbia University, 2000.

———. "Dismembering Saint Quentin: Gothic Architecture and the Display of Relics." *Gesta* 36, no. 1 (1997): 32–47.

Sigal, Louis. "Contribution à l'histoire de la cathédrale Saint-Just de Narbonne." *Bulletin de la Commission archéologique de Narbonne* 15 (1921): 11–153.

Simson, Otto Georg von. *The Gothic Cathedral: Origins of Gothic Architecture and the Medieval Concept of Order.* New York: Pantheon Books, 1956.

Smith, Kathryn A. "Book, Body, and the Construction of the Self in the Taymouth Hours." In *Negotiating Community and Difference in Medieval Europe: Gender, Power, Patronage, and the Authority of Religion in Latin Christendom*, edited by Katherine Allen Smith and Scott Wells, 173–204. Leiden: Brill, 2009.

———. "Chivalric Narratives and Devotional Experience in the Taymouth Hours." In *Negotiating Secular and Sacred in Medieval Art: Christian, Islamic, and Buddhist*, edited by Alicia Walker and Amanda Luyster, 17–54. Farnham, U.K.: Ashgate, 2009.

———. "Margin." *Studies in Iconography* 33 (2012): 29–44.

Smoldon, W. L. "Medieval Church Drama and the Use of Musical Instruments." *Musical Times* 103, no. 1438 (1962): 836–40.

Snyder, Janet Ellen. *Early Gothic Column-Figure Sculpture in France: Appearance, Materials, and Significance.* Burlington, Vt.: Ashgate, 2011.

Souchal, François. *L'abbatiale de Mouzon.* Charleville-Mézières: Éditions de la Société d'études ardennaises, 1967.

Stahl, Harvey. *Picturing Kingship: History and Painting in the Psalter of Saint Louis.* University Park: Pennsylvania State University Press, 2008.

Stalley, Roger A. *Early Medieval Architecture.* New York: Oxford University Press, 1999.

Stanford, Charlotte A. "The Body at the Funeral: Imagery and Commemoration at Notre-Dame, Paris, About 1304–18." *AB* 89, no. 4 (2007): 657–73.

Stanley, David J. "The Original Buttressing of Abbot Suger's Chevet at the Abbey of Saint-Denis." *JSAH* 65, no. 3 (2006): 334–55.

Staunton, Michael. *Thomas Becket and His Biographers.* Woodbridge, U.K.: Boydell, 2006.

Sturgis, Alexander J. "The Liturgy and Its Relation to Gothic Cathedral Design and Ornamentation in Late Twelfth and Early Thirteenth Century France." Ph.D. diss., Courtauld Institute, 1990.

Tallon, Andrew. "An Architecture of Perfection." *JSAH* 72, no. 4 (2013): 530–54.

———. "L'équilibre expérimentale de la prieurale de Saint-Leu-d'Esserent." In *Saint-Leu-d'Esserent et l'implantation monastique dans la basse vallée de l'Oise*, edited by Delphine Hanquiez and Anthony Petit, 173–93. Amiens: Centre d'archéologie et d'histoire médiévales des établissements religieux, 2012.

———. "Experiments in Early Gothic Structure: The Flying Buttress." Ph.D. diss., Columbia University, 2007.

———. "Nouveau regard sur les arcs-boutants des églises d'Étampes." In *Art et architecture à Étampes au Moyen Âge: Journée d'études internationale, 20 décembre 2008, Étampes*, edited by Elise Baillieul, 67–83. Chamarande: Société historique et archéologique de l'Essonne et du Hurepoix, 2010.

———. "Rethinking Medieval Structure." In *New Approaches to Medieval Architecture*, edited by Robert Bork, William W. Clark, and Abby McGehee, 209–17. Farnham, U.K.: Ashgate, 2011.

———. "La structure de la cathédrale de Chartres." In *Chartres: Construire et restaurer la cathédrale, XIᵉ–XXIᵉ s.*, edited by Arnaud Timbert, 239–57. Villeneuve d'Ascq: Presses universitaires du Septentrion, 2014.

———. "Structure in Gothic." In *The Cambridge History of Religious Architecture*, edited by Stephen Murray and Richard Etlin. Cambridge: Cambridge University Press, forthcoming.

———. "La technologie 3D au service de Notre-Dame." In *Notre-Dame de Paris*, edited by Cardinal André Vingt-Trois, 158–60. Strasbourg: Nuée bleue, 2012.

Tallon, Andrew, and Arnaud Timbert. "Le bâtiment gothique relevé par laser: Le cas de la cathédrale Notre-Dame de Noyon et la question de son contrebutement; Première approche." In *Arch-I-Tech 2010: Actes du colloque Cluny, 17–19 novembre 2010*, edited by Christian Père and Juliette Rollier-Hanselmann, 63–69. Bordeaux: Ausonius, 2011.

Temko, Allan. *Notre-Dame of Paris.* New York: Viking Press, 1955.

Thibodeau, Timothy M. "The Influence of Canon Law on Liturgical Exposition c. 1100–1300." *Sacris Erudiri* 37 (1997): 185–202.

———. "Les sources du *Rationale* de Guillaume Durand." In *Guillaume Durand: Évêque de Mende (v. 1230–1296); Canoniste, liturgiste et homme politique*, edited by Pierre-Marie Gym 143–53. Paris: Institut de recherche et d'histoire des textes, 1992.

Thirion, Jacques. "La cathédrale de Bayeux." *Congrès archéologique de France* 132 (1974): 240–85.

Thompson, Sarah. "Adaptation and Audience: Remodeling Notre-Dame d'Étampes in the Thirteenth Century." *AVISTA Forum Journal* 22, nos. 1–2 (2012): 57–70.

Thunø, Erik. *Image and Relic: Mediating the Sacred in Early Medieval Rome.* Rome: Erma di Bretschneider, 2002.

———. "'Living Stones' of Jerusalem: The Triumphal Arch Mosaic of Santa Prassede in Rome." In *Visual Constructs of Jerusalem*, edited by Bianca Kühnel, Galit Noga-Banai, and Hanna Vorholt, 222–30. Turnhout: Brepols, 2014.

Timbal, Pierre-Clément, and Josette Metman. "Évêque de Paris et Chapitre de Notre-Dame: La juridiction dans la cathédrale au Moyen Âge." In *Huitième centenaire de Notre-Dame de Paris (Congrès des 30 mai–3 juin 1964): Recueil de travaux sur l'histoire de la cathédrale et de l'église de Paris*, 115–40. Paris: J. Vrin, 1967.

Timbert, Arnaud. "L'abbatiale de Cluny III et l'architecture gothique: Hypothèse sur l'accident de 1126." *Annales de Bourgogne* 78, no. 3 (2006): 255–76.

———. "Les arcs-boutants de la nef de l'église abbatiale Sainte-Marie-Madeleine de Vézelay." *Annales de Bourgogne* 74 (2002): 25–38.

———. "Le chevet de l'église Saint-Sulpice de Chars: Un effet de style?" In *Ex Quadris Lapidibus: La pierre et sa mise en oeuvre dans l'art médiévale; Mélanges d'histoire de l'art offerts à Elaine Vergnolle*, edited by Yves Gallet, 255–64. Turnhout: Brepols, 2011.

———. "Le choeur de l'église Saint-Maclou de Pontoise." *Mémoires de la Société historique et archéologique de Pontoise du Val-d'Oise et du Véxin* 79 (1996): 95–155.

Timmermann, Achim. *Real Presence: Sacrament Houses and the Body of Christ, c. 1270–1600.* Turnhout: Brepols, 2009.

Titus, Harry B. "The Auxerre Cathedral Chevet and Burgundian Gothic Architecture." *JSAH* 47, no. 1 (1988): 45–56.

Torroja, Eduardo. *Philosophy of Structures.* Translated by J. J. Polivka and Milos Polivka. Berkeley: University of California Press, 1958.

Toy, Sidney. *A History of Fortification from 3000 B.C. to A.D. 1700.* London: Heinemann, 1955.

Trachtenberg, Marvin. "Desedimenting Time: Gothic Column/Paradigm Shifter." *RES: Anthropology and Aesthetics* 40 (2001): 5–28.

———. "Gothic/Italian 'Gothic': Toward a Redefinition." *JSAH* 50, no. 1 (1991): 22–37.

———. "Suger's Miracles, Branner's Bourges: Reflections on 'Gothic Architecture' as Medieval Modernism." *Gesta* 39, no. 2 (2000): 183–205.

Truitt, Elly Rachel. *Medieval Robots: Mechanism, Magic, Nature, and Art.* Philadelphia: University of Pennsylvania Press, 2015.

Tydeman, William, ed. *The Medieval European Stage, 500–1550*. New York: Cambridge University Press, 2001.

Uebel, Michael. "The Foreigner Within: The Subject of Abjection in Sir Gowther." In *Meeting the Foreign in the Middle Ages*, edited by Albrecht Classen, 96–117. New York: Routledge, 2002.

Vallery-Radot, Jean. "L'église Saint-Eusèbe d'Auxerre." *Congrès archéologique de France* 116 (1958): 87–96.

Verdier, François. "L'église paroissiale Notre-Dame de Louviers." *Congrès archéologique de France* 138 (1980): 9–28.

Vergnolle, Éliane. "La pierre de taille dans l'architecture religieuse de la première moitié du XIᵉ siècle." *BM* 154, no. 3 (1996): 229–34.

Verret, Denis, and Delphine Steyaert, eds. *La couleur et la pierre: Polychromie des portails gothiques; Actes du colloque, Amiens, 12–14 octobre 2000*. Paris: Picard, 2002.

Villes, Alain. *La cathédrale Notre-Dame de Reims: Chronologie et campagnes de travaux*. Joue les Tours: La Simarre Éditions, 2009.

———. "Le programme de construction et la chronologie de Notre-Dame de l'Épine." In *Notre-Dame de l'Épine, 1406–2006: Actes du colloque international, L'Épine-Châlons-en-Champagne, 13–14 septembre 2006*, edited by Christine Abelé and Jean-Pierre Ravaux, vol. 1, Études marnaises 122, 135–204. Châlons-en-Champagne: Société d'agriculture, commerce, sciences et arts du département de la Marne, 2007.

Viollet-le-Duc, Eugène-Emmanuel. *La cité de Carcassonne*. Paris: Morel, 1888.

———. *Dictionnaire raisonné de l'architecture française du XIᵉ au XVIᵉ siècle*. 10 vols. Paris: Bance, 1854. [Also Paris: A. Morel, 1875–82.]

———. *An Essay on the Military Architecture of the Middle Ages*. Translated by M. Macdermott. Westport, Conn.: Greenwood Press, 1977.

———. *The Foundations of Architecture: Selections from the "Dictionnaire raisonné."* Translated by Kenneth D. Whitehead. New York: George Braziller, 1990.

Weeks, Christopher. "The 'Portail de la Mere Dieu' of Amiens Cathedral: Its Polychromy and Conservation." *Studies in Conservation* 43, no. 2 (1998): 101–8.

Whitaker, Muriel A. "Otherworld Castles in Middle English Arthurian Romance." In *Late Medieval Castles*, edited by Robert Liddiard, 393–408. Woodbridge, Suffolk, U.K.: Boydell & Brewer, 2016.

Whitehead, Christiania. *Castles of the Mind: A Study of Medieval Architectural Allegory*. Cardiff: University of Wales Press, 2003.

———. "*Columnae . . . sunt episcopi. Pavimentum . . . est vulgus*: The Symbolic Translation of Ecclesiastical Architecture in Latin Liturgical Handbooks of the Twelfth and Thirteenth Centuries." *Medieval Translator* 8 (2003): 29–37.

Wiener, L. "The Etymology of Buttress." *Modern Language Notes* 14, no. 1 (1899): 16.

Williams, Jane Welch. *Bread, Wine, and Money: The Windows of the Trades at Chartres Cathedral*. Chicago: University of Chicago Press, 1993.

Williamson, Paul. *Gothic Sculpture, 1140–1300*. New Haven: Yale University Press, 1995.

Wilson, Christopher. *The Gothic Cathedral: The Architecture of the Great Church, 1130–1530*. Rev. ed. London: Thames & Hudson, 1992.

Winternitz, Emanuel. "On Angel Concerts in the 15th Century: A Critical Approach to Realism and Symbolism in Sacred Painting." *Musical Quarterly* 49, no. 4 (1963): 450–63.

Wolfe, M., and R. Mark. "Gothic Cathedral Buttressing: The Experiment at Bourges and Its Influence." *JSAH* 33, no. 1 (1974): 17–26.

Worssam, Bernard C., and Jeremy Ashbee. "The Building Stones of Rochester Castle and Cathedral." In *Medieval Art, Architecture, and Archaeology at Rochester*, edited by Tim Ayers and T. W. T. Tatton-Brown, 238–49. Leeds: British Architectural Association, 2006.

Wright, Craig M. *Music and Ceremony at Notre Dame of Paris, 500–1550*. New York: Cambridge University Press, 1989.

———. "The Palm Sunday Procession in Medieval Chartres." In *The Divine Office in the Latin Middle Ages: Methodology and Source Studies, Regional Developments, Hagiography; Written in Honor of Professor Ruth Steiner*, edited by Margot E. Fassler and Rebecca A. Baltzer, 344–71. Oxford: Oxford University Press, 2000.

Wright, David Frank. "A Medieval Commentary on the Mass: *Particulae 2–3* and 5–6 of the *De missarum mysteriis* (ca. 1195) of Cardinal Lothar of Segni (Pope Innocent III)." Ph.D. diss., University of Notre Dame, 1977.

Wright, Nicholas. *Knights and Peasants: The Hundred Years War in the French Countryside*. Rochester: Boydell Press, 1998.

Wu, Fang-Cheng. "La cathédrale de Langres et sa place dans l'art du XIIᵉ siècle." Ph.D. diss., Université de Franche-Comté, 1994.

Zahora, Tomas. *Nature, Virtue, and the Boundaries of Encyclopaedic Knowledge: The Tropological Universe of Alexander Neckam (1157–1217)*. Turnhout: Brepols, 2014.

Zerner, Henri. *Renaissance Art in France: The Invention of Classicism*. Paris: Flammarion, 2003.

Zukowsky, John. "Montjoies and Eleanor Crosses Reconsidered." *Gesta* 13, no. 1 (1974): 39–44.

INDEX

Italicized page numbers indicate illustrations. Endnotes are referenced with "n" followed by the endnote number.